NO KNOWN CURE

THE COMEDY OF CHRIS MORRIS

EDITED BY

James Leggott and Jamie Sexton

A BFI book published by Palgrave Macmillan

First published in 2013 by
PALGRAVE MACMILLAN

on behalf of the

BRITISH FILM INSTITUTE
21 Stephen Street, London W1T 1LN
www.bfi.org.uk

There's more to discover about film and television through the BFI.
Our world-renowned archive, cinemas, festivals, films, publications and learning resources
are here to inspire you.

Palgrave Macmillan in the UK is an imprint of Macmillan Publishers Limited, registered in
England, company number 785998, of Houndmills, Basingstoke, Hampshire RG21 6XS.
Palgrave Macmillan in the US is a division of St Martin's Press LLC, 175 Fifth Avenue, New
York, NY 10010. Palgrave Macmillan is the global academic imprint of the above
companies and has companies and representatives throughout the world. Palgrave® and
Macmillan® are registered trademarks in the United States, the United Kingdom, Europe
and other countries.

Cover image: *Blue Jam* (Chris Morris, 1997–99), BBC
Cover design: couch
Text design: couch
Images from *The Day Today*, TalkBack; *Brass Eye*, © Channel Four/TalkBack; *Four Lions*,
© Channel Four Television Corporation/Warp Films

Set by Cambrian Typesetters, Camberley, Surrey
Printed in China

This book is printed on paper suitable for recycling and made from fully managed and
sustained forest sources. Logging, pulping and manufacturing processes are expected to
conform to the environmental regulations of the country of origin.

British Library Cataloguing-in-Publication Data
A catalogue record for this book is available from the British Library
A catalog record for this book is available from the Library of Congress
10 9 8 7 6 5 4 3 2 1
22 21 20 19 18 17 16 15 14 13

ISBN 978–1–84457–479–7 (pb)
ISBN 978–1–84457–480–3 (hb)

CONTENTS

ACKNOWLEDGMENTS

The editors want to thank the contributors for their enthusiasm, patience and diligence. Ian Greaves and Justin Lewis deserve special mention for their generous and attentive comments.

James dedicates this book to Karen, Toby and his family.

Jamie would like to thank any friends and colleagues who have provided any support whatsoever during the editing of this book. In particular, colleagues from Film and Television Studies at Northumbria University: Jacky Collins, Russ Hunter, Peter Hutchings, James Leggott, Noel McLaughlin and Alison Peirse.

NOTES ON CONTRIBUTORS

JEREMY COLLINS is Senior Lecturer in Media Studies at London Metropolitan University, where he teaches media theory and history, communication ethics and research methods. His research interests include risk communications, political communications, media ethics and news management, and he has published on moral panics, service journalism, the reporting of drug use and the social rationalities of technological hazards.

ROBERT DEAN is a Lecturer at the University of Glamorgan. He received his PhD from Aberystwyth University in 2010. His thesis was entitled 'Musical Dramaturgy in Late Nineteenth- and Early Twentieth-century Theatre on the British Stage'. He has published work on Ibsen, Chekhov, Wagner and Batman.

SAM FRIEDMAN is Lecturer in Sociology at City University, London. He works on areas of cultural taste, symbolic boundaries and social mobility, and has published recent articles in the *British Journal of Sociology*, *Cultural Sociology* and *Poetics*. He is also a comedy and theatre critic, and is the publisher of *Fest* magazine, the largest magazine covering the Edinburgh Festival Fringe.

IAN GREAVES is a freelance writer and researcher. He is the co-author of *Prime Minister, You Wanted to See Me? A History of Week Ending* (Kaleidoscope, 2008), and has devised and researched radio documentaries on Douglas Adams and Dudley Moore, who is also the subject of a tie-in publication (Faber and Faber, 2011). He was a researcher for and provided additional research for Lucian Randall's 2010 biography of Chris Morris, *Disgusting Bliss: The Brass Eye of Chris Morris* (Simon and Schuster, 2010). An occasional radio presenter, Ian has also appeared on television as an expert on radio comedy and police drama and is archivist to the playwright N. F. Simpson.

RICHARD J. HAND is Professor of Theatre and Media Drama at the Cardiff School of Creative and Cultural Industries at the University of Glamorgan. He has published in the areas of theatre, literature, film, radio, computer games, graphic narratives and popular music.

His publications include *Terror on the Air: Horror Radio in America, 1931–52* (McFarland, 2006) and *The Theatre of Joseph Conrad: Reconstructed Fictions* (Palgrave, 2005).

CRAIG HIGHT is Associate Professor in Screen and Media Studies at the University of Waikato (New Zealand). His research has been based within documentary theory, addressing aspects of the production, construction and reception of documentary hybrids (in particular mockumentary). He has recently completed a book on television mockumentary series titled *Television Mockumentary: Reflexivity, Satire and a Call for Play* (Manchester University Press, 2010). His current research focuses on the relationships between digital media technologies and documentary practice, especially the variety of factors shaping online documentary cultures.

RUSS HUNTER is Lecturer in Film and Television at Northumbria University. He has published on the reception of cult cinema, the reception of horror cinema in Belgium and was a report signatory and researcher for the BBFC-funded research project *Audiences and Receptions of Violence in Contemporary Cinema*. He is also the co-editor of a forthcoming edited collection on the cinema of Dario Argento. His research interests include reception studies, the horror film and Italian genre cinema.

JAMES LEGGOTT is Senior Lecturer in Film and Television at Northumbria University. He has published on various aspects of British film and television culture, including contemporary British cinema, reality television, television comedy, science fiction and the films of the Amber Collective.

JUSTIN LEWIS is a writer, editor and researcher on music and broadcasting, and has contributed to numerous publications. He is the co-author of *Prime Minister, You Wanted to See Me? A History of Week Ending* (Kaleidoscope, 2008) and consulted and researched on Lucian Randall's biography of Chris Morris, *Disgusting Bliss: The Brass Eye of Chris Morris* (Simon and Schuster, 2010). In addition, he has worked as a radio presenter and columnist.

SHARON LOCKYER is Lecturer in Sociology and Communications in the School of Social Sciences at Brunel University. Her research interests are in critical comedy studies and the sociology of mediated culture. She is editor of *Reading* Little Britain: *Comedy Matters on Contemporary Television* (I. B. Tauris, 2010) and co-editor (with Michael Pickering) of *Beyond a Joke: The Limits of Humour* (Palgrave, 2005, 2009).

BRETT MILLS is Senior Lecturer at the University of East Anglia. He is the author of *The Sitcom* (Edinburgh University Press, 2009) and *Television Sitcom* (BFI, 2005) and co-author of *Reading Media Theory: Thinkers, Approaches, Contexts* (Longman, 2008). His research interests are comedy, popular culture, cultural hierarchies, categories and genres, and popular television.

DAN NORTH is Lecturer in Film at the University of Exeter. He is the author of *Performing Illusions: Cinema, Special Effects and the Virtual Actor* (Wallflower Press, 2008), and the editor

of *Sights Unseen: Unfinished British Films* (Cambridge Scholars Publishing, 2008). He has published on topics such as film technology, spectacle and British cinema.

DAVID ROLINSON is Lecturer in Film and Television at the University of Stirling. He is the author of *Alan Clarke* (Manchester University Press, 2005) and articles for various books and journals including *British Social Realism in the Arts since 1940* (Palgrave, 2011). He has written several DVD booklets, including *Tales out of School* (2011), and he contributes regularly to the BFI's *Screenonline*. He is writing a book on Stephen Frears, partly facilitated by AHRC research leave, and edits the website <www.britishtelevisiondrama.org.uk>.

JAMIE SEXTON is Senior Lecturer in Film and Television at Northumbria University. He has written on topics including British avant-garde film-making, experimental British television, cult cinema and independent cinema. He also co-edits (with Ernest Mathijs) the book series *Cultographies* (Wallflower Press).

DAVID WALTON is Senior Lecturer in Cultural Studies at the Universidad de Murcia (Spain). He is the author of *Introducing Cultural Studies: Learning through Practice* (Sage, 2008) and is currently writing a book on cultural theory and practice. He has published on various aspects of cultural studies and postmodernism, including the news satires of Chris Morris.

ADAM WHYBRAY is a PhD student at the University of Exeter writing his thesis on the political encoding of things in Czech animated film. He has previously delivered papers on drag in Canadian comedy *Kids in the Hall*, metatextuality in Jan Švankmajer's *Faust* and upon the fairytale game subversions of Emily Short and Stephen Lavelle. He also performs earnest, neurotic stand-up about having OCD.

INTRODUCTION: WHY BOTHER?

JAMES LEGGOTT

Christopher Morris (popularly known as Chris and henceforth referred to as that in this book) is one of the most singular and controversial figures in British comedy. In various roles as performer, writer, director and collaborator, he has challenged boundaries of taste and acceptability, altered perceptions of current affairs broadcasting, moral panics and celebrity culture, and pushed conventional television genres such as sitcom and sketch comedy to the limits of possibility. He has been labelled the 'Most Hated Man in Britain'[1] for producing the 'sickest television show ever',[2] in the case of *Brass Eye* (Channel 4, 1997; 2001), and has been commonly described as a 'media terrorist' in relation to his hoaxing of celebrities, politicians, broadcasters and members of the public.[3] His inscrutability as a public figure has won both respect and opprobrium. One reviewer went as far as speculating that 'Chris Morris might possibly be God.'[4]

Morris began his career as a disc jockey (DJ) on regional radio, honing his technical and performance style from the mid-1980s onwards through stints on BBC Radio Cambridgeshire, BBC Radio Bristol (where he hosted a show called *No Known Cure* between 1987 and 1990), Greater London Radio and later BBC Radio 1. By the time he came to prominence as anchorman of the BBC Radio 4 series *On the Hour* (1991–2), he had developed a highly distinctive on-air persona, a skill at pitch-perfect mimicry of musical and presentational styles, a flair for surrealist flights of fancy and – most problematically for some of his bosses – a nose for mischief-making that included 'prank calls', re-edited material and hoax interviews with celebrities, politicians and the general public. *On the Hour* was a groundbreaking satire of news programmes that established its team of writers and performers – which included Stewart Lee, Richard Herring, Steve Coogan, Patrick Marber, David Schneider, Doon Mackichan, Rebecca Front and the producer Armando Iannucci – as one of the most important forces in British comedy of the 1990s. Both *On the Hour* and its equally successful television transfer *The Day Today* (BBC 2, 1994) were astonishingly comprehensive in their skewering of the clichés and pomposities of broadcasting, not just in current affairs, but in sport, soap operas, documentaries, youth programming, weather forecasts, candid camera shows, archival television and music videos, among others. Morris took centre stage in the role of an aloof, disdainful presenter, prone to bullying co-presenters and interviewees, and adopting a heightened speech pattern that echoed the cadences and odd emphases of well-known

British news presenters such as Jeremy Paxman and Michael Buerk. Morris's next major project, *Brass Eye*, was broadcast as a six-part series in 1997 and then a one-off 'special' in 2001. Written by Morris in collaboration with a number of others, including Peter Baynham, David Quantick, Jane Bussmann, Arthur Mathews and Graham Linehan, *Brass Eye* purported to be a current affairs magazine-style show focusing upon specific topics of moral or social concern: animals, drugs, science, sex, crime, general 'moral' decline and paedophilia. Alongside the well-crafted and often miniaturist spoofs of national, regional and international broadcasting of the late 1990s – from sensationalist talk and crime shows to reality television – was a greater emphasis upon 'stings' where public figures, ranging from sportsmen and politicians to television personalities and pop stars, were persuaded to lend their support to fictitious and self-evidently ridiculous campaigns; for example, the MP David Amess raised questions in Parliament about the 'made-up' drug 'cake', the actor and writer Steven Berkoff demonstrated the dangers of 'heavy electricity' with a table of household ornaments, and the DJ Dr Fox was made to expound on the genetic connections between crabs and paedophiles. Although only given brief runs, *The Day Today* and *Brass Eye* would lay the foundations for the styles and techniques of prominent comedians such as Ricky Gervais and Sacha Baron Cohen, as well as bearing some influence on satirical programmes like *The Daily Show* (Comedy Central, 1996–) and *The Onion News Network* (IFC, 2011–).

The controversies around the broadcast of *Brass Eye* and later its 2001 special – the subject of tabloid frenzy in the UK and one of the most complained about programmes in British broadcasting history – was in contrast to the muted reception of the no-less adventurous and taboo-breaking 'ambient' sketch show *Blue Jam*, broadcast as three six-part series on BBC Radio 1 between 1997 and 1999 to minimal fanfare but to a warm reception from connoisseurs of experimental, boundary-pushing comedy. Each hour-long episode was an intricately woven flow of music, comedy sketches involving a small repertory of frequent Morris collaborators (principally Kevin Eldon, Julia Davis, Mark Heap, David Cann and Amelia Bullmore), deadpan story monologues and surreal introductions/closings by Morris, fake jingles and 'club music' guides, and a handful of 'prank' celebrity interviews. Although the show incorporated some elements of *Brass Eye*'s iconoclasm, media satire, verbal excesses and assaults on good taste, *Blue Jam* placed greater emphasis on sonic and linguistic disorientation, hypnotising its late-night listener into the same states of somnambulant detachment or paranoia displayed by many of the characters in the sketches themselves. The show returned obsessively to scenarios involving madness, depression, rogue doctors, irresponsible parents and endangered children, but whereas *Brass Eye* mercilessly critiqued the mediatisation of moral panics, *Blue Jam* was more interested in individuals facing knotty moral tests: a notably grotesque example is a sketch where a plumber, called upon by a disturbed mother of a dead infant, agrees for a fee to reanimate the baby with pipes. Although some of the sketches involving individuals coming up against institutional forces evoked traditions of popular comedy (for example, 'doctor doctor' jokes) as well as political and surrealist comedy, their emphasis upon psychic damage pushed them into far darker territory. For example, a scenario involving a man complaining, with increasing despair, about the lizards emanating from his television set can be viewed as a particularly nightmarish take on the Monty Python 'dead parrot' sketch.[5]

The show's translation onto television, the six-part *Jam*, was broadcast on Channel 4 in 2000. Shorn of the full-length musical links of the radio predecessor, but repeating much of the material and using the same performers, *Jam* was closer in format to the traditional half-hour sketch show, but deployed an assortment of unsettling visual manipulations – slow-motion, missing frames, degradation, CGI – as equivalent devices of estrangement. Such devices were taken to further extremes in a 'remix' version of the show, entitled *Jaaaaam*, which was made for late-night broadcast. One of the *Blue Jam* monologues, about a dog apparently getting the better of its sitter, was turned into a twelve-minute film, *My Wrongs #8245–8249 & 117* (2003), directed and written by Morris, and the first film release by Warp, an independent British label hitherto primarily associated with exploratory experimental music, which had also released a compilation CD of *Blue Jam* sketches in 2000. As with the 'lizards' sketch described above, *My Wrongs* pushes a potentially whimsical conceit into dark, Kafka-esque territory. The main character (played by Paddy Considine), tasked with looking after his friend's Doberman, Rothko (voiced by Morris himself), imagines – or so it would seem – the dog informing him that he is on trial for a lifetime of 'wrongs', which stretch back to some sort of childhood indiscretion of parental infidelity. After being impelled by the animal to snatch a baby from a christening ceremony, his already fragile mental state appears utterly fractured, in keeping with the despairing mood of many of the *(Blue) Jam* sketches.

At the turn of the millennium, the various iterations of the *(Blue) Jam* material were at the vanguard of a notable British wave of troubling or surreal television comedy, alongside the likes of *Human Remains* (BBC 2, 2000), *The League of Gentlemen* (BBC 2, 1999–2002), *The Mighty Boosh* (BBC 3, 2004–7) and *Monkey Dust* (BBC 3, 2003–5).[6] Material from one of the longer *Blue Jam* monologues about a suicidal journalist also provided the premise for two spoof columns co-written by Chris Morris and Robert Katz for the *Observer* newspaper in 1999. Appearing under the pseudonym of Richard Geefe, and documenting a narcissistic writer's decision to commit suicide, the 'Second Class Male' and 'Time to Go' columns were ostensibly a critique of self-indulgent broadsheet columnists, as well as a reaction to the vogue at the time for death-related columns by the likes of Ruth Picardie and John Diamond. But the linguistic inflections and content of the twelve Richard Geefe columns betrayed Morris's distinctively absurdist worldview, and his involvement was eventually disclosed by the newspaper. Morris continued his association with the *Observer* with the 'Absolute Atrocity Special' of 2002, a satirical commentary on the reportage of the 11 September attacks, co-written with Armando Iannucci. Similar ideas were explored via the *Smokehammer* website and the *Bushwhacked* series of 'cut-ups' of George W. Bush speeches, distributed online and in a mixture of formats.[7]

Morris's subsequent forays into narrative-led work – the sitcom *Nathan Barley* (Channel 4, 2005) and the 'terrorist' comedy *Four Lions* (2010) – generated debate over their ambivalent political stance and their success in incorporating provocative subject material within the more 'conventional' formats of sitcom and ensemble comedy. *Nathan Barley* was a six-part sitcom, co-written with Charlie Brooker, and based on a reprehensible character in *TVGoHome*, Brooker's satirical listings website.[8] Generally received as a judgment upon cool-chasing urban trendsetters (particularly associated with the Hoxton area of London) as personified by the (in his words) 'self-facilitating media node' twenty-something Nathan Barley (Nicholas Burns),

the show documents the rise of crass reality television formats, vacuous style magazines, musical 'mash-ups', celebrity artists, stylish mobile telephones, Banksy-style graffiti art and self-promoting websites, while also critiquing the commodification and ironisation of emotional subjects such as underage sex, victims of the Twin Towers attacks, and offensive racial epithets, in the service of 'cool' slogans, raps, webpage graphics or fashion-spreads. The 'rise of the idiots', as embodied by Barley, is lamented by the jaded thirty-something journalist Dan Ashcroft (Julian Barratt), but his earnest sister Claire (Claire Keelan), an aspiring serious documentary-maker, sees greater potential – and for a short while, sexual appeal – in Barley's media savvy and charisma. The mutual dependencies of the three main characters, which shift and change as the story progresses, give the show a sense of structural purpose as well as an alignment with the psychological acuteness of *The Office* (BBC 2/BBC 1, 2001–3) and other comedies of embarrassment; Barley's growing self-realisation of his gullibility to voguish nonsense dovetails with Dan's self-destructive hostility towards his ostensibly benign nemesis and Claire's pragmatic exploitation of Barley's facilities and money. Yet *Nathan Barley* received only a lukewarm reception from some fans of Morris, a common criticism being that its rapid editing, nervy camerawork and dense sound mix – often featuring different pieces of music playing simultaneously – was not just overwhelming, but as emptily trendy as the subculture it was mocking.[9] Whatever the intention, *Nathan Barley*'s simultaneous accommodation of the experiential quality of *Jam* (and indeed also of the hyperactively edited *Brass Eye*) and the satirical thrust of the 1990s current affairs shows within a traditional dramatic format was ambitious and quite unique.

Morris's first full-length feature film was the 'jihad' comedy *Four Lions*, concerning the farcical plotting of an Islamic terrorist campaign by four men from the northern English city of Sheffield. In a telling and much-cited quotation, Morris described the film as exposing the 'Dad's Army [BBC 1, 1968–77] side to terrorism', his reference to the beloved BBC ensemble comedy about the bungling exploits of the Home Guard during World War II an apparent defence against any charge of him exploiting a taboo subject merely for satirical ends.[10] Although the film inevitably did generate criticisms for its perceived tastelessness or ineffectiveness as a comedy, international reviews were generally appreciative of Morris's well-researched humanisation of the 'enemy within' and the low-key docudrama style (see Russ Hunter's chapter in this volume). The hand of Morris the absurdist can be felt in the film's disarming cultural incongruities, from the sight of the suicide bombers dressed up as clownish fun-runners, to the use of an innocuous-seeming children's website, 'Puffin Parade', as a means to discuss their plotting under the police radar. But the *Dad's Army* allusion also seemed an apt means of conveying *Four Lions*' debt to the traditions of ensemble capers and comedies, particularly British ones such as *The Full Monty* (1997) – also set in Sheffield – or *Lock, Stock and Two Smoking Barrels* (1998) that explore the habitually faulty mechanisms of the defensive, disenfranchised male gang.

'Find Out Exactly What to Think – Next!': Fact and Fiction

It is striking that the influence and reach of Morris's comedy is somewhat out of proportion to its volume, viewing figures or readership. The infamous 'Paedogeddon' special of *Brass Eye*

may have been one of the most complained about and critically lambasted programmes in the history of Channel 4, yet its appeal was ultimately niche. Morris's work might thus be most comfortably categorised in terms of cult or niche rather than mainstream appeal, for example in the way that his career has been closely observed, not always positively, by comedy aficionados on websites such as *Cook'd and Bomb'd*.[11] As Sam Friedman explores in his chapter in this volume, Morris's comedy has for many an aura of sophistication, requiring a certain 'cultural capital' – in Bourdieu's famous term – to access and enjoy.[12] A sense of the demographic for Morris's output can be gleaned from the kinds of print publications he has tended to work for, give interviews to or find recognition within: the upmarket, left-leaning broadsheets the *Observer* and the *Guardian*, and – particularly in the early stages of his career – the music press such as the *NME* and *Melody Maker* and the monthly music magazine *Select*, for which he produced a cover-mounted flexidisc of material in 1992. In contrast, in the lead-up and aftermath of the Paedogeddon controversy, Morris was vilified in the areas of the British press more associated with the conservative values and perspectives of 'middle-England', most notably the *Daily Mail* newspaper.[13]

Morris's reception by the various institutions he has worked for has been similarly fraught and complex. During his stint as a weekly broadcaster for BBC Radio 1 in 1994, he was suspended, and removed from future live broadcasts, following an episode in which he appeared to announce the death of the MP Michael Heseltine.[14] The culmination of an antagonistic relationship with bosses at Channel 4, and particularly Chief Executive Michael Grade, during the build-up and delayed transmission of the *Brass Eye* series, was the insertion of a subliminal frame in the final episode stating that 'Michael Grade is a Cunt.' In his autobiography, Grade devoted some thought to the problems posed by Morris, noting that he

> recognised a rare talent and felt that Channel 4 had a libertarian tradition that ought to be able to accommodate Chris Morris's satire – though, as with lion-taming, the cardinal rule would have to be: never take your eyes off the beast.[15]

However, five years later, *Brass Eye* had become safely canonised as one of the channel's most important achievements. In a press pack published in November 2002 to celebrate Channel 4's twentieth anniversary, and attributed to the Chief Executive (Mark Thompson), *Brass Eye* was cited as one of the 'top ten channel groundbreakers'.[16]

A challenge, and indeed a pleasure, for Morris fans has been to source the projects – some quite minor and tangential – that have been undertaken, whether deliberately or not, in relative obscurity. In addition to straightforward acting or creative roles in comedies such as *The IT Crowd* (Channel 4, 2006–), *I'm Alan Partridge* (BBC 2, 1997–2002), *Big Train* (BBC 2, 1998–2002) and *Veep* (HBO, 2012–), the less immediately visible work includes collaborative music projects (with artists such as Saint Etienne and Amon Tobin), the spin-off *Blue Jam* CD, hoax newspaper articles and websites, and even a disguised appearance in a real television chat show.[17] If Morris has garnered a star persona of sorts, it is as much the aggregate of both textual and non-textual factors; not just the programmes and films, but the peripheral work, the infiltration of other programmes and institutions, the tabloid controversies and also the mystique around his reluctance to 'break character'.

Morris's cult status can be partially attributed to a reputation for elusiveness and anti-authoritarianism fostered by the circulation of (possibly bogus) legends about his career – particularly its early phase allegedly involving sackings from radio stations[18] – but also by his disinclination (until relatively recently, at least) to engage in public explanation or contextualisation of his methods and meaning. This has opened up a space, most visibly on fan websites such as *Cook'd and Bomb'd*, for speculation about past and future projects, and indeed the extent to which Morris has deliberately created a mystique around himself and his work. Although there has been some academic interrogation of the slippery concept of 'cult' television, in terms of text, institutions, fans and authorship, Morris and his work have rarely been examined in this context, perhaps because of the manner in which Morris has worked across media, avoided long-running formats and had a modest impact beyond the UK. For example, Stacey Abbott's *The Cult TV Book*, Sara Gwenllian-Jones and Roberta E. Pearson's *Cult Television* and David Lavery's *The Essential Cult TV Reader* – which all ignore Morris altogether – tend to focus upon traditions of telefantasy, with the first two confining their coverage of comedy programmes to multiseries sitcoms such as *The League of Gentlemen* and some satirical shows such as *South Park* (Comedy Central, 1997–), *The Daily Show* and *Da Ali G Show* (Channel 4, 2000–4).[19]

One reviewer of *Disgusting Bliss*, Lucian Randall's biography of Morris, and the first full-length book entirely on him, suggested parallels with the notoriously reclusive and perfectionist Stanley Kubrick for his 'indifference to personal celebrity and refusal to supply on-demand defences against outrage', and with Orson Welles for his apparent disdain for authority figures, not least television bosses, his connection with notorious 'stunts' (in Welles's case *The War of the Worlds* radio broadcast of 1938) and the pursuit of a highly individual vision (rather than bankable, repeated formats).[20] Morris's inclination towards privacy, particularly in the lead-up to *Brass Eye*, was in some respects a necessity for the effectiveness of his 'stings' in that show, yet it opened up a space for speculation on his psychological drives and satirical purpose. As insignificant as this apparent reclusiveness might seem given that auteurs are not automatically presumed to be knowable, media-friendly presences, Morris's early career as a radio DJ and a sketch-show performer sharing his own name may well have led to expectations of him pursuing a traditional career as a media celebrity; in fact, since the *Brass Eye* special of 2001, Morris has not appeared on screen in his own work, limiting his role to some apparent cameo vocals in *Nathan Barley*, and the voiceover of Rothko the dog in the short film *My Wrongs*.

This evasiveness of context and category extends to the way in which Morris's projects have often been broadcast, promoted or commodified in a deliberately misleading or cryptic fashion. *Jam* and *Nathan Barley* were broadcast without traditional opening titles, while *Jam* substituted the customary list of credits for a flickering weblink to online information. *Jam* was broadcast on a commercial television station without the customary advertisement break, seemingly so as not to disturb the programme's oneiric mood, but elsewhere Morris has used devices to disrupt the traditional safety buffers between shows and their surrounding flow. Two *Brass Eye* episodes contain sketches purporting to be a live report ('Decline') or an advertisement for another show ('Paedogeddon') that are positioned between the 'end of part one' title and the commercial break proper, and – as Dean and

Hand discuss in their chapter – the first episode of *Blue Jam* incorporates a 'fake' news bulletin at the juncture where a genuine one might logically be positioned.

Such subversion extends to extratextual promotion. As Brett Mills notes in his chapter on the regulatory response to the controversial 'Paedogeddon' episode of *Brass Eye*, the programme received its greatest censure for a brief trailer that was deemed to inadequately establish its status as parody; fans may have been ingratiated or warned by stylistic clues such as Morris's characteristic hyperbolic language, but casual viewers may have missed the satirical and auteurist cues. Similarly, *Nathan Barley* was promoted through an advertising campaign that included posters that seemed, on a casual glance, to be a promotion for a plausible, if ridiculous, new brand of the 'WASP T12 Speechtool' mobile phone; the phone is alleged to have a giant number five button (as the most common number) and to be 'shark-proof'.[21] In keeping with Morris's infamous disinclination to explain or contextualise his work, the British DVD releases of *Brass Eye*, *Jam* and *Nathan Barley* can be considered as further exercises in mystification and parody. In each case, the front and back covers give only vague clues as to genre and authorship; for example, the only text, other than the title, on the initial sleeve of the DVD release of *Jam* were on stickers promising '300+ minutes of disgusting bliss' and 'extras' including 'one crashing airliner, eight tonnes of geese and a fifty foot plutonium bum'. The DVD menu itself was no less playful, featuring visually altered versions of the six programmes in 'miniaturised', 'Lava Lamp', 'FFWD', 'pong', 'speeded up and then slowed again to original duration' and 'first nineteen seconds' form, as well as an option to watch all simultaneously. The *Brass Eye* DVD featured a digressive commentary track on the 'Drugs' episode that would appear to involve Morris soliciting reactions to the programme from six homeless people with assorted drug and drink addictions, while *My Wrongs* has a stilted and transparently pre-prepared commentary from a supposed 'runner' from the film that quickly becomes a rambling survey of dog representations and references throughout movie history. The DVD of *Four Lions*, like many other Morris-affiliated releases, contains hidden features – in this case, behind-the-scenes footage – that require some dedication and patience to locate.

Morris's gravitation towards longer-form storytelling and the broader canvas of film, as signalled by his output of the 2000s, might be considered quite conventional, at least for British comedy writer/performers.[22] Similarly, there are numerous historical precedents, from *Hancock's Half Hour/Hancock* (1954–9 on radio, 1956–61 on BBC television) to *Little Britain* (2000–2 on radio, 2003–6 on BBC television), for the transference of his radio programmes to television. But taken as a whole, his output – straddling media and genres, and encompassing sitcoms, sketch shows, feature films as well as numerous side projects – is a daunting prospect to interrogate.

This may be one of the reasons why, despite being occasionally cited in academic discussions of such issues as satire, mockumentary, news values, postmodernity and comedic taste, Morris has gained only limited critical attention, and mostly in relation to the institutional, regulatory and ethical questions posed by his satirical news shows *The Day Today* and *Brass Eye*. This volume is therefore the first to offer sustained critical analysis of his output, from the 'apprenticeship' years as a regional radio DJ to his work on *Four Lions*, a feature film with international aspirations. The multidisciplinary specialisms of the book's contributors,

which range from film and television studies to media theory, cultural studies, theatre stud-
ies and sociology, give some indication of the continuing relevance of Morris's work across a
broad critical spectrum, and the scope it offers for theoretical enquiry. But they also point
towards the resistance of Morris's oeuvre as a whole to straightforward categorisation or an
overarching critical framework. Moreover, the chapters here demonstrate the necessity for
an interdisciplinary, intermedial approach when dealing with a body of work that is both idio-
syncratic and emblematic of wider comedy trends. In doing so, this collection resists the ten-
dency in existing scholarship on British film and television comedy for a reductively narrow
focus on topics such as nationality, authorship/performance, genre, representation and offen-
siveness. At the same time, Morris's ruthless critiques of systems of language – from the
aggressive tabloid-speak and exaggerated visuals of *Brass Eye* to the irony-laden youth slang
of *Nathan Barley* and the pornographic pillow-talk – 'whack my bonobo!', 'disagree with my
balls!' – of *(Blue) Jam* – offer a challenge to anyone daring to submit them to academic analy-
sis. Writing about comedic strategies, and Morris's in particular, through a theoretical lens is
to risk accusations of humourlessness or of jargonism. Furthermore, Morris's own descrip-
tion of his creative impulse as an 'attack on certainty' can be read as an entreaty of sorts for
a plurality of interpretative strategies.[23]

'Confused Face?': Satire and Surrealism

Any sustained auteurist analysis of Morris's output must carry the caveat that he has tended
to work collaboratively, as indicated by the various co-writing credits mentioned above. But
most accounts take as a starting point the relatively non-contentious notion of Morris as the
dominant, guiding force behind *(Blue) Jam*, *Brass Eye* and *Four Lions*, and also one of the key
drivers behind *The Day Today* and *Nathan Barley*. Any book devoted to the work of an indi-
vidual creative presence inevitably takes as its starting point a degree of coherence, whether
in content and style, or in working method. Possibly as a result of Morris's enigmatic status,
there has been some speculation, by some fans and journalists, upon the significance of his
family background, education and even his visible facial birthmarks (covered by make-up for
appearances in 'character') for the development of his general iconoclasm and certain per-
sistent topics of interest.[24] A pursuit of this autobiographical line of enquiry might well, for
example, uncover connections between his upbringing as the son of two doctors and the
repeated role of 'rogue' doctors in *Blue Jam*, while his undergraduate degree in Zoology (at
Bristol University) goes some way to explaining the recurrence of quirky animal imagery
across his work.[25] As interesting as this may be, it is perhaps more fruitful to consider, for
instance, how Morris's 'apprenticeship' period in broadcast radio, and his status as a music
lover and sometime musician (in performing bands) would inform his craft (see the chapters
by Ian Greaves and Justin Lewis in this volume).

Popular and critical discussion of Morris has tended to identify two driving impulses: a
satirical, iconoclastic critique of popular and political culture through techniques of parody
and exaggeration, and an exploration of comedic language, tone and juxtaposition that can
be related to traditions of surrealism and absurdism. While it is fair to see *The Day Today*,

Brass Eye and *Nathan Barley* as prime expressions of the first, and *Jam*, *My Wrongs* and *Four Lions* of the latter, it is more useful to acknowledge how these satiric and absurdist tendencies intertwine in complex and distinctive ways. To take just one of countless examples from *Brass Eye*, the section detailing a hoax campaign against the evils of 'heavy electricity' flattening Sri Lankan villagers includes a plea from Richard Briers, best known for his career as a sitcom actor, who is made to say: 'can we stand around and eat pies while they're flattened like flies, swatted by the tail of a mad, invisible horse?' On one level, this functions as just one example of the programme's substantial critique of the supposed 'expertise' of celebrities who are persuaded to give voice to erroneous campaigns. And yet, for those who share Morris's sense of the ridiculous, what Briers is tasked to say, and the manner in which he does so, is simply funny in itself, in the same way as the *Monty Python* 'Ministry of Silly Walks' sketch (1970) or Vic Reeves's impression of the then *Masterchef* (BBC 1/BBC 2, 1990–2001) presenter Loyd Grossman in *The Smell of Reeves and Mortimer* (BBC 2, 1993–5) are readable as broad parodies of, respectively, government bureaucracy and a particular celebrity with a mannered delivery style, yet are surrealistically, incongruously funny in themselves.

However, scholarship on Morris has tended to emphasise its satirical purpose. Stephen Wagg, for example, notes a 'direct lineage' between the 1990s current affairs spoofs and the so-called 'satire boom' in Britain during the late 1950s and early 1960s.[26] Its most-famous manifestations were the *Beyond the Fringe* revue (premiered in the 1960s), the magazine *Private Eye* (1961–) and the BBC television programme *That Was the Week That Was* (*TW3*) (BBC, 1962–3), all considered to have helped inaugurate, or at least capture, a declining deference to media, religious and state institutions. As Wagg notes, the association of Iannucci and Morris with a mission to prick pomposity in public figures harks back to the inclination of *TW3* to parody the media as much as politicians. Whereas other contemporary satirists such as Mark Thomas and Michael Moore have challenged prevailing orthodoxies, Morris seeks to 'subvert the idea of orthodoxy' itself, symbolically melting down 'all current affairs discourse and [pouring] it into a pot marked "Pompous"', and in doing so vindicate a 'postmodern' acceptance of the 'futility of political intervention'.[27]

Morris's work has been frequently drawn into analyses of the workings of media power, and discussion of the potential of satire to simultaneously critique and exercise 'symbolic power'. Using a concept derived from Pierre Bourdieu, John Thompson has defined 'symbolic power' as the ability to 'intervene in the course of events, to influence the actions of others and indeed to create events, by the means of the production and transmission of symbolic forms'; such symbolic forms include information and ideas transmitted by media, educational, government, religious and other institutions, with news reporting a significant place and means for the exercise of symbolic power.[28] *The Day Today* and *Brass Eye* can thus be read as an interrogation of the exercise of symbolic power, using exaggeration to expose the conventions of news and current affairs broadcasting. As a 'representation of social and cultural authority, in which authorised storytellers present the pronouncements and activities of other authorities', news can be understood as a system of textual authority, and thus a target for critique.[29] Graham Meikle identifies numerous areas of satirical focus in *The Day Today* and *Brass Eye*: the contemptuous persona of Morris the anchorman, the tendency towards

visual literalism and the use of graphics to impose authority, and the critique of 'high-status sources', supposedly authoritative spokespeople forced to make preposterous statements.[30]

Satirical news programmes, and 'mockumentary' more widely, have been subjected to generous academic scrutiny, not least because of the clear parallels between the workings of satire and the similarly deconstructive purpose of academic analysis, but also because of the ways in which 'fake' news blurs distinctions between fiction and non-fiction.[31] Meikle sums up the significance of fake news shows as follows:

> Fake news is an important part of a television landscape in transition, as producers and viewers respond to the possibilities of increased choice and control (Lotz, 2007); to new technological possibilities for production, distribution and reception (Meikle and Redden, 2011); and to shifting contexts of popular culture, in which contending claims on authority, identity, and attention compete with those of formerly accredited experts (Jones, 2010). Fake news is an important part of a complex televisual environment in which questions of real and fake are in ongoing tension, and in which all forms of factual programming depend on increasing degrees of artifice in the pursuit of the real (Kilborn, 2003; Roscoe and Hight, 2001).[32]

Morris's work has been compared with equivalent 'fake' news shows such as Jon Stewart's *The Daily Show*. Barbra S. Morris describes how both Morris and Stewart 'deftly discredit tired conventions, overblown untrustworthy rhetoric, and simplistic Morse code-like storylines', thus leading viewers towards the 'higher ground of textual discrimination: good television news analysis'.[33] However, while Stewart is able to function as a 'trusted voice on the issues within the news', his show blending news and entertainment, Morris is more interested in exposing the 'textual and cultural machinery of news and current affairs'.[34] If *The Daily Show* is fake in refusing to 'make claims to authority and authenticity, as opposed to those claims repeatedly asserted through the techniques and conventions used by the news media',[35] a programme such as *Brass Eye* '*does* make those very claims to authority and authenticity, through the force of its satire staking out an alternative position from which to critique authority'.[36] In doing so, these programmes come quite close to the ways in which post-modern thinkers such as Baudrillard have conceived of a media-generated 'hyperreal' world of popular culture where the distinction between appearance and substance is blurred. As Morris's presenter figure declares near the start of the 'Sex' episode of *Brass Eye*, after break-ing away from energetic sexual intercourse: 'If this were really happening, what would you think?'

Morris's 'alternative' position has come up against criticisms that, as with much satire, his stance against certain problems of popular and political culture is uncommitted and contra-dictory. Peter Wilkin identifies a 'mockery of a dumbed-down England of mass culture, moral decline, popular idiocy and shallow intellectual depths as personified in the rise of a facile celebrity culture',[37] yet Morris has also been accused – particularly in light of the 'Paedogeddon' furore – of being a symptom of moral decline in pandering to audience pruri-ence and bad taste. For Wilkin, a useful context for Morris's inscrutable position on popular culture is a tradition of what he terms 'Tory anarchy', where Morris can be placed alongside the likes of Evelyn Waugh, George Orwell and Peter Cook, whose satire of British institutions

and social structures might be understood as a lament for their decline. All allegedly 'upper-middle class, public school and university educated',[38] they share a critique of conformity in popular culture, a moral critique of social norms, a surrealistic imagination, and an awareness of the media's power to shape notions of 'reality'.[39] Thus, the *Brass Eye* special was a 'classic example of Tory anarchist provocation, holding up a mirror to the hypocrisy of contemporary society without a need for a didactic moralism in order to make its point'.[40]

Whatever his intentions, Morris's ambivalent satirical stance opens up a space for a range of possible viewer positions, which is not without its potential problems. In an article focusing upon representations of gay sexuality in *Brass Eye*, David Walton acknowledges the possibility of 'double coding'. Jokes about the distinction between 'good' and 'bad' AIDS, the 'gay' practices exposed on the fictitious HMS Watford, or the use of 'Portillo' as prison slang for 'look out behind you', can be interpreted in one or more of the following ways:

> as a satire of arrogant self-righteous journalists and an exposé of their attenuated humanity, dogmatic attitudes and prejudice against drug users or the gay community; pure comedy with no vested interest in the issues; or actually exploiting, and thus reproducing, popular prejudice.[41]

This third possibility is described by Walton as the 'Alf Garnett syndrome', named after a character in the British 'race' sitcoms *Til Death Us Do Part* (BBC 1, 1965–75) and *In Sickness and in Health* (BBC 1, 1985–92) who was intended as a caricature of bigotry, but received sympathetically in some quarters.[42]

Morris's debt to traditions of 'surrealist' comedy and literature has tended to be downplayed in analysis of his satire, but instructive connections can be made, for example, with the 'nonsense' writings of Edward Lear and Lewis Carroll, the musical parodies and experiments of Vivian Stanshall and The Bonzo Dog Doo-Dah Band, the collaborations of Peter Cook and Dudley Moore, and even possibly the work of modernist writers such as Samuel Beckett in the case of *(Blue) Jam*. As Wilkin observes, programmes such as *Jam* and *Brass Eye* are able to fuse surrealist images and ideas with more mundane representations of familiar, everyday life to 'force the viewer to radically revise the way in which they approach and interpret TV shows'.[43] In a neat historical link with a prominent forerunner in British comedy, Morris recorded and edited a series of improvised, discursive radio interviews with Peter Cook in 1993 that were broadcast on BBC Radio 3 in the form of five ten-minute conversations in January 1994. With Cook playing the role of his recurring Sir Arthur Streeb-Greebling character, and Morris adopting his aloof presenter role, *Why Bother?* was essentially a comedic duel between a young pretender and an ageing legend, each drawing the other into bizarre and sometimes subversive flights of anecdotal fancy; Morris taunts Streeb-Greebling/Cook about being at the end of his life (this would prove to be one of the ailing Cook's last projects before his death in 1995), and conversational detours include an outrageous discussion of Streeb-Greebling's plans to clone the fossilised remains of the infant Christ. Tim Crook has evaluated *Why Bother?* as 'probably the most inventive and exciting comedic improvisation [Morris] has been involved in', and Harry Thompson has claimed that Morris was 'one of the few performers able to match Peter [Cook] for speed of thought and surreal invention'.[44]

As Brett Mills points out, in an article on developments in British television comedy of the new millennium, Morris's work exemplifies a move towards 'comedy vérité' as found in landmark programmes such as *The Office*, which deploy an 'observational' style indebted to contemporaneous developments in reality television. Morris's work in *The Day Today* and *Brass Eye* 'demonstrates the active, questioning nature of comedy vérité, in which conventional television techniques intended to disguise processes of mediation are laid bare for comic purposes'.[45] Elsewhere, Mills has suggested how the 'experimentalism in Morris's work is only meaningful because it reacts against, and plays around with, the generic expectations of comedy aesthetics'.[46] But he also laments how the novel aesthetic forms pioneered by Morris, for example in *Jam*, have tended to be 'appropriated purely as visual trickery, detached from the social purposes which were their original aim'.[47]

'What Seems to Be the Problem?': Approaches to Morris

In its sole focus upon one of the key figures of British comedy, this collection identifies the diverse ways in which Morris's work is unique and pioneering, while also giving a nuanced account of how it connects with broader currents in media culture and politics, and how it has been received and understood. The book follows a broadly chronological approach, with most chapters using a case study of a particular programme, film or phase in Morris's output to shed light on its authorial, institutional, generic, regulatory, media or reception contexts. In this way, the contributions here marry textual and historical analysis of Morris's work with insights into the differing ways it can be conceptualised. It is a testimony to the richness of Morris's work that certain projects and themes are given only limited attention within these pages. For example, *Why Bother?*, Morris's radio conversations with Peter Cook, demand further analysis as a 'missing link' between generations of satirists, and there is unquestionably scope for more nuanced consideration of Morris's versatility as a performer and mimic, and the representation of gender across his work.

The first two chapters, by Ian Greaves and Justin Lewis, take as their focus the 'apprenticeship' years that Morris spent as a young radio performer. Greaves considers the period between 1984 and 1991 when Morris worked for a variety of regional UK radio broadcasters. This was a period of significant institutional change in national and local broadcasting, with producers offering opportunities to untested broadcasters such as Victor Lewis-Smith, Armando Iannucci and Morris in an attempt to reach younger audiences. As Greaves explains, Morris and his peers had opportunities to hone skills and comic personae in the relative safety of regional radio, which gave access to editing facilities that allowed for multilayered experimentation, but also in turn provided inspiration for the sequences in *On the Hour* that mocked the parochialism of regional broadcasting. In this way, Greaves's chapter complements the story of Morris's early radio career as told by Lucian Randall in the *Disgusting Bliss* biography, for which Greaves and fellow contributor to this book Justin Lewis were consultants. As Greaves discusses, the general shifts in both broadcasting culture and the comedy industry formed the framework through which Morris developed his craft between 1984 and 1991. For much of this period of obscurity, he was a minor player in the

grand scheme of things, but the story in this chapter is a telling reflection of his determination as a radio innovator, as well as the challenges that face any creative endeavour within the media machine.

Although attention is often paid to the ways in which Morris's various satirical projects have been inspired by the culture of the broadcast newsroom, there has been less consideration of his engagement with traditions of popular music. The chapter by Justin Lewis explores how prior to Morris's national breakthrough via *On the Hour* in 1991, he was primarily a DJ and musician, and as keen to mock the pomposity of the era's broadcast DJs as he was the narcissism of newsreaders. Another parallel between the spheres of music and news during this era was the simultaneous development of soundbite culture among politicians and journalists, and sampling culture among DJs, producers and remixers who would repeat or recontextualise a musical or lyrical motif. Lewis draws a connection between Morris's comedic use of sampling and the techniques of hip-hop producers and, in particular, the pop 'pranksters' KLF, one of whose tracks seems to have inspired the title of his Radio Bristol show *No Known Cure*. As Lewis notes, Morris's fascination with musical cultures would extend into his later career, from the pop parodies in *The Day Today* and *Brass Eye* to the 'mix-tape' format of *Blue Jam*.

The five subsequent chapters by Craig Hight, Dan North, Jeremy Collins, Brett Mills and Sam Friedman offer an array of perspectives upon the televisual satires *The Day Today* and *Brass Eye*, in relation to form, visual language, politics, broadcasting regulation and popular reception. For Hight, in highlighting and critiquing the drift of television news away from public service ideals within an increasingly competitive commercial environment, *The Day Today* and *Brass Eye* can be fruitfully understood as part of a long-established and global strand of mockumentary. Hight compares Morris's work with other prominent examples of news satire, such as *The Daily Show*. Both Morris and *The Daily Show* carefully recreate the codes and conventions of news presentation then tease aspects of it into unexpected directions to reveal the nature of their construction to viewers. But whereas *The Daily Show* offers political commentary, Morris is more concerned with deconstructing the language of news, and using stunts to broaden the critique to television's role itself within the manipulation of social and political debate.

Dan North extends and focuses this consideration of Morris's deconstructive strategies by concentrating on the use of graphics and special effects in the news satires and elsewhere in Morris's work. North identifies Morris's use of a hyperbolic 'news-speak' of neologism and mixed metaphors as one of the distinctive satirical aspects of *The Day Today* and *Brass Eye*, and locates its visual equivalent in the programme's mimicry of the graphics and sound effects of news programming. The pontificatory rhetoric of news programmes is critiqued through graphs, idents and transitions that strive to assert authenticity and certainty, while undermining their authority though exaggeration and nonsensical content. For North, Morris's various projects offer a cohesive thesis on how hypermediation – the foregrounding of format at the expense of truthful or consistent content – is the inevitable consequence of mediated communication.

Using the 'Drugs' episode of *Brass Eye* as a detailed case study, Jeremy Collins draws parallels between the programme's satirical treatment of media and political hysteria and the

findings of theorists of 'moral panics'. Collins's starting point is the formal definition of 'moral panic' by Stan Cohen in the 1970s, since when it has been used and refined by social and media researchers in the analysis of topics relating to public anxiety, criminal activity, risk-taking and deviancy.[48] With its concentration in individual episodes upon particular areas of moral panic, *Brass Eye* can be read as a comedic critique of the issues that have come to dominate the field of moral panic studies, whose proponents have identified and explored key aspects of media construction (such as exaggeration and the promotion of 'moral entre-preneurs'). Collins finds similarities between the way that *Brass Eye* imagines and promul-gates the dangers of the fictitious drug 'cake', and the manner in which the British media dealt, more than a decade later, with the emergence of mephedrone.

Brett Mills's chapter uses the controversy around the *Brass Eye* 'Paedoggedon' episode to raise questions about broadcasting and comedy's place within it. The confusion and out-rage triggered by Morris's work generally, and particularly by *Brass Eye*, can be seen to high-light the social tensions inherent in all comedy, as well as the problems caused for broadcasters and regulators. Mills deconstructs the response of the Broadcasting Standards Commission (BSC) to the complaints made against *Brass Eye*, a programme that triggered public discussion about the acceptable use of humour, the way in which viewers are guided to make sense of programmes and the purpose of regulatory bodies in responding to the diversity of viewers. As Mills puts it, the furore over *Brass Eye* exemplifies discussions about the very purpose of television itself.

The role and reactions of viewers are explored in detail in Sam Friedman's chapter on the reception of Chris Morris by contemporary British comedy audiences. Using quantita-tive and qualitative data from a broader study of comedy taste, Friedman demonstrates that the comedy of Chris Morris appears to strongly divide audiences according to their levels of 'cultural capital', to use a term drawn from Bourdieu's famous conceptualisation of the work-ings of class distinction. In his survey, Friedman found that audiences associated with higher levels of cultural capital tend to report strong preferences for 'difficult' programmes such as *Brass Eye*, those from lower cultural capital backgrounds expressed dislike or indifference, some being offended at the content. Taking this idea further, Friedman demonstrates that for some respondents reacting positively to the 'complexity' or 'darkness' of his work, Morris was a key instrument in the expression of 'distinction'; such aesthetic distancing represents an important means through which the culturally privileged draw significant aesthetic, intellec-tual and moral boundaries between themselves and other social groups.

The achievements and contexts of the radio sketch show *Blue Jam* and its televisual equivalent *Jam* are scrutinised in chapters by Rob Dean and Richard J. Hand, and Jamie Sexton. Both chapters discuss the ways in which the programmes, whether in audiovisual or purely sonic form, attempted to control and sustain a dreamlike mood through language, performance, sound effect and musical choices. While Dean and Hand make a persuasive case for the pre-eminence of *Blue Jam* as a unique experiment in radio soundscape, Sexton counters that to dismiss *Jam* as inferior is to underestimate its own distinctive power as an 'ambient' television show. Both chapters unpick the tensions in the programmes between satirical and 'experiential' content. For Dean and Hand, Morris's experimentation in *Blue Jam* represents an apotheosis of audio comedy, but also an exploration of the alienating essence

of the medium itself, not least through the programme's use of disembodied and comput-
erised voices. At the same time, the deconstructive urges behind *Brass Eye* and other Morris
projects are made manifest in *Blue Jam*'s use of spoof radio 'trailers' and a disorientating 'cut-
up' of a news bulletin. In relation to *Jam*, Sexton explores the connections with musical cul-
tures and the mental states associated with particular drug cultures and depressive states, as
well as the programme's treatment of moral panics (for example around rogue doctors) and
its critique of the way childhood and children are socially sanctified.

David Walton's chapter deals with the 'Absolute Atrocity Special', co-written by Morris
and Armando Iannucci for the *Observer*, as a spoof reaction to the six-month anniversary of
the events of 11 September 2001. Walton examines the reception of the article at a time of
considerable sensitivity around the military response to the terrorist attack, when neither
intellectuals nor celebrities (such as the outspoken country act, the Dixie Chicks) were safe
from censure for daring to comment in an 'unpatriotic' fashion. Walton finds common ground
between the deconstructive strategies of 'Morriucci' (in other words, the combined force of
Morris and Iannucci) and the manner in which theorists such as Baudrillard and Barthes have
conceived, respectively, of processes of mediatisation and 'de-anchorage'. Morriucci's no-
holds-barred approach, described by Walton as a 'blunderbuss' attack, takes as many swipes
at celebrities as world leaders and politicians, but their key area of satirical target is the com-
modification and dislocation of the 'image-event' of the 11 September attacks.

In his chapter on *Nathan Barley*, Adam Whybray argues that the programme's simulta-
neous critique and adoption of an 'ironic' mode is ultimately problematic and self-defeating,
in diminishing the satirical potential of its exaggerated vision of urban trendsetters in the mid-
2000s. As well as considering the show's place within the oeuvre of the co-creator Charlie
Brooker, Whybray explains how the programme responds to, yet also in some respects antic-
ipates, developments in social media and Internet 'memes', and attempts to critique an over-
saturation of irony in Internet culture and, by extension, British culture. Although the
characters and setting of *Nathan Barley* are rooted in a particular time and place, and rep-
resent a geographically narrow phase of youth culture that had lost currency by the time of
the programme's broadcast, they nevertheless prove symptomatic of an insidious 'post-
ethical' mindset, wherein immoral behaviour is justified and excused by irony. For Whybray,
the very nature and style of the series prevents it in the end from ever breaking free of this
airless 'loop' of irony. In this light, *Nathan Barley* can be read as a commentary upon, and for
some as a symptom of, certain tendencies in British comedy of the early twenty-first cen-
tury, namely a wave of programmes and comedians – such as Jimmy Carr, Frankie Boyle,
Ricky Gervais and *Little Britain* – that deliberately transgress boundaries of taste or decency,
but in a knowingly playful rather than immediately satirical fashion.

The final three chapters shed light on the comic mechanisms, reception and broader
political context of *Four Lions*. Sharon Lockyer begins her chapter by noting how media and
public commentary on the film, whether supportive or dismissive, took for granted the film's
status and intention as a comedy. Her analysis of how Morris's comedy operates in his first
feature-length film is informed by what she identifies as the key theoretical explanations of
humour (superiority, incongruity and relief). For Lockyer, *Four Lions* demonstrates a complex
interplay of different types of humour, including linguistic misunderstanding, demonstrations

of the 'stupidity' of the 'enemy' and cathartic explorations of morbid or scatological subjects. Nevertheless, as Lockyer argues, the 'transgressive' possibilities of the film are ultimately hampered by Morris's overarching satirical impulse, and indeed by the restrictions of satire itself, which is usually more concerned with questions than solutions. Indeed, Lockyer identifies the specificities of some of the cultural references in the film – such as to the Sainsbury's supermarket chain or the Alton Towers theme park – as a potential hindrance to non-UK viewers, and this issue of decontextualisation is addressed in Russ Hunter's chapter on the journalistic reactions to the film in the UK and US. Hunter draws from a critical reception studies methodology to examine the way that press reviewers responded to its handling of an emotionally loaded subject with culturally specific frames of reference. Of particular interest here is the way that American correspondents, in many cases, came to *Four Lions* with only a cursory firsthand knowledge of Morris's work and reputation, factors that greatly coloured the way in which the film was dealt with in the UK. The final chapter in the book, by David Rolinson, deconstructs the notion of Morris as 'media terrorist' by focusing upon how his work on the specific topic of terrorism correlates with debates around broadcasting tropes and legislation. Drawing from the field of scholarship relating to terrorism and war in the media, Rolinson makes connections between the satirical 'Bombdogs' sketch of *The Day Today* about a fictitious Irish Republican Army mainland campaign involving explosives hidden in animals, and the sustained treatment of the subject of terrorist campaigns in *Four Lions*. In tracing a line of continuity between a programme and a film at almost opposite ends of Morris's career, and between a sketch-show comedy and a feature-length, theatrically released film, Rolinson implicitly makes a case for Morris as auteur (despite the fact that both texts are of course multiply authored, as highlighted by numerous contributors here). The marriage of detailed textual analysis and contextual elucidation in Rolinson's concluding chapter is in some respects a summary of the dominant impulses within and across all of the chapters here to acknowledge both the richness and density of Morris's work and the way it enlightens our understanding of the media and our relationship to it.

'You've Got Bad AIDS!': Morris and the Academy

One of the many 'extras' on the DVD of *The Day Today* is a short documentary made by the Open University on the subject of news language.[49] It features sections where some of the creative team behind the programme discuss their methods and targets. As if in recognition of the dangers of 'academic' study sapping comedic impact, this feature is described on the DVD menu as 'po-faced analysis'. The editors and contributors to this volume naturally believe that the comedy of Chris Morris, and comedy more generally, is deserving of serious scrutiny, whether or not this might be deemed a somewhat humourless undertaking. A recurrent question raised across the chapters is that of the nature of comedy itself: its limits, its possibilities, its failures and its capacity to say meaningful things.

Many of the contributors, either implicitly or explicitly, make a case for the similarly 'deconstructive' manoeuvres of satirical comedy and academic theory. Furthermore, Morris's work, particularly in news satire, has strong pedagogical value for teachers and lecturers

wanting to demonstrate aspects, for example, of media theory, news values, postmodernity or regulation. But to focus exclusively on the utilitarian aspects of the comedy of Chris Morris at the expense of a consideration of its fascination and pleasures is surely to take it in the wrong spirit. Any reader who has made it this far will probably not need warning that this book not only contains jokes, but citation and discussion of material that some might – and indeed some do – find offensive, upsetting, vulgar, excessive or simply in poor taste. Although the contributors in this book approach Morris's work from quite differing analytical perspectives, and sometimes come to disagreements as to its relative merits or satirical effectiveness, there is overall consensus that it is funny. Not just funny, but inventive and taboo-breaking, rewarding of repeated viewings, listens and readings, and most definitely unworthy of a po-faced response.

Notes

1. Kevin Maher, 'Chris Morris – The Most Hated Man in Britain', *The Times* (3 April 2000), <http://www.cookdandbombd.co.uk/forums/index.php?page=cabkbarticle&id=414>.
2. Tara Conlan and Alison Boshoff, 'Is This the Sickest TV Show Ever?', *Daily Mail* (28 July 2001, p. 1), <http://www.dailymail.co.uk/tvshowbiz/article-62209/Is-sickest-TV-ever.html>. The programme was also labelled 'sick' in headlines in the *Sun* (27 July 2001), *People* (29 July 2001, p. 2), *Daily Star* (30 July 2001, p. 9) and elsewhere.
3. References to Morris as 'media terrorist' are commonplace online and in print. Here is a representative sample: Unknown Author, 'Chris Morris: Camera Shy Media Terrorist', *SkyMovies* (22 February 2012), <http://skymovies.sky.com/feature-chris-morris-camera-shy-media-terrorist>; Dylan Rhymer, 'Chris Morris – Media Terrorist', *Comedy Couch* (date unknown), <http://www.comedycouch.com/reviews/chris_morris.htm>; Xan Brooks, 'Chris Morris: "Bin Laden Doesn't Really Do Jokes"', *Guardian* (1 May 2010), <http://www.guardian.co.uk/culture/2010/may/01/chris-morris-four-lions-interview>.
4. Will Self, 'Chris the Saviour', *Observer* (9 March 1997), <http://www.guardian.co.uk/theobserver/1997/mar/09/featuresreview.review>.
5. The 'Dead Parrot' sketch from the first series of the BBC comedy *Monty Python's Flying Circus* (BBC 1/BBC 2, 1969–74) is arguably one of the most famous in British television comedy. It concerns a confrontation between an angry customer (John Cleese) who returns a deceased bird to a shopkeeper (Michael Palin).
6. See, for example, Claire Monk, 'London and Contemporary Britain in *Monkey Dust*', *Journal of British Cinema and Television* vol. 4 no. 2 (2007), pp. 337–60. For a general overview of television comedy of the period see Ben Thompson, *Sunshine on Putty: The Golden Age of British Comedy from Vic Reeves to* The Office (London: Fourth Estate, 2004); Edwin Page, *Horribly Awkward: The New Funny Bone* (London: Marion Boyars, 2008); Robert Allen Saunders, *The Many Faces of Sacha Baron Cohen: Politics, Parody and the Battle over Borat* (Lanham, MD: Lexington Books, 2010). For a detailed history of comedy broadcasting on BBC Radio 1, see Tim Worthington, *Fun at One: The Story of Comedy at Radio 1* (self-published, available via *Lulu*, 2012), and pp. 206–20 in particular for discussion of *Blue Jam* and the trend for 'ambient' radio comedy.

7. Chris Morris and Armando Iannucci, 'Six Months That Changed a Year: An Absolute Atrocity Special', *Observer* (17 March 2002), <http://www.guardian.co.uk/world/2002/mar/17/september11.terrorism>. The *Smokehammer* websites contained satirical news stories relating to the war on terror, with headlines including 'Chief Aim of War Is Now to "Avenge Death of George Harrison" – Blair'. Produced in two volumes, they are dated 16 November and 6 December (2001). They have been archived at the *Cook'd and Bomb'd* website at <http://www.cookdandbombd.co.uk/forums/index.php?page=morrismirrors>. The *Bushwacked* speeches were 'cut-ups' of speeches by the US President George W. Bush, now made to utter phrases such as 'the American flag stands for corporate scandals, recession, stock market declines, blackmail, burning with hot irons, mutilation with electric drills, cutting out tongues, terror, mass murder, and rape'. The *Bushwhacked* mp3 files, apparently made in 2001 and 2003, have been available in various places and formats, such as on the *Smokehammer* website at <http://thesmokehammer.com/>, the Warp Records website, a twelve-inch single with remixes, *YouTube* and as a 'hidden' extra on the DVD release of *The Day Today*.

8. The *TVGoHome* website, a parody of television listings magazines such as *Radio Times*, was published between 1999 and 2003. It has been archived at <http://www.tvgohome.com/index.html>.

9. For example, see the long message board thread on *Cook'd and Bomb'd* that begins with the website's author's review '*Nathan Barley* – It's Well Rubbish', <http://www.cookdandbombd.co.uk/forums/index.php?topic=6745.0C>.

10. Morris cited in Genevieve Roberts, 'Wannabe Suicide Bombers Beware: Chris Morris Gets Go-ahead Title', *Independent* (6 January 2009), <http://www.independent.co.uk/arts-entertainment/films/news/wannabe-suicide-bombers-beware-chris-morris-movie-gets-goahead-1228152.html>.

11. *Cook'd and Bomb'd* is an online comedy forum which initially had an emphasis upon the careers of Peter Cook and Chris Morris (its name incorporating the name of the former and also that of the 'hoax' anti-drug campaign group of the 'Drugs' episode of *Brass Eye*). The site has also archived recordings of Morris's radio work, as well as media interviews, reviews and discussions.

12. See Friedman's chapter in this volume for a discussion and application of Bourdieu's work on taste and cultural capital, as well as Pierre Bourdieu, *Distinction: A Social Critique of the Judgement of Taste* (London: Routledge, 1984).

13. See Sharon Lockyer and Feona Attwood, '"The Sickest Television Show Ever": Paedogeddon and the British Press', *Popular Communication: The International Journal of Media and Culture* vol. 7 no. 1 (2009), pp. 46–60.

14. For an account of the 'Heseltine' controversy, see Lucian Randall, *Disgusting Bliss: The Brass Eye of Chris Morris* (London: Simon & Schuster, 2010), pp. 134–9.

15. Michael Grade, *It Seemed Like a Good Idea at the Time* (London: Macmillan, 1999), pp. 258–9. For a full account of the build-up and delay of *Brass Eye*, see Randall, *Disgusting Bliss*, pp. 176–97.

16. Channel 4 press pack published to mark its twenty-year anniversary (2002), <http://www.channel4.com/media/documents/corporate/foi-docs/4_at_20.pdf>.

17. Morris appeared on the live daytime discussion programme *The Time, the Place* (1987–8) in June 1996, posing as an academic in a discussion called 'Are British Men Lousy Lovers?'; he was exposed by the host, John Stapleton. This has been posted at <http://www.youtube.com/watch?v=8ecxW3KPUD4>.

18. For an overview of some of the legends attached to Morris, such as the story of his sacking from BBC Radio Bristol after filling a broadcast newsroom with helium, see Randall, *Disgusting Bliss*, pp. 53–67.

19. Stacey Abbott (ed.), *The Cult TV Book* (London and New York: I. B. Tauris, 2010); Sara Gwenllian-Jones and Roberta E. Pearson (eds), *Cult Television* (Minneapolis and London: University of Minnesota Press, 2004); David Lavery (ed.), *The Essential Cult TV Reader* (Lexington: Kentucky University Press, 2010).

20. Ben Walters, 'Chris Morris: The Orson Welles of British Comedy?', *Guardian Film Blog* (14 April 2010), <http://www.guardian.co.uk/film/filmblog/2010/apr/14/chris-morris-four-lions>.

21. For a discussion of the 'subvertising' methods used to promote *Nathan Barley*, see Rick Poynor, *Designing Pornotopia: Travels in Visual Culture* (London: Laurence King Publishing, 2006).

22. Other comedic writers/performers who have made the transition from British radio and television, to films (some with an international aspiration or reception), include Ricky Gervais, Sacha Baron Cohen, David Baddiel, Armando Iannucci and Steve Coogan.

23. Chris Morris in podcast interview with Adam Lippe, *A Regrettable Moment of Sincerity* (8 November 2010), <http://regrettablesincerity.com/?p=6023>.

24. See Randall, *Disgusting Bliss*, p. 33.

25. For an account of Morris's formative years, see Randall, *Disgusting Bliss*, Chapter 2.

26. Stephen Wagg, 'Comedy, Politics and Permissiveness: The "Satire Boom" and Its Inheritance', *Contemporary Politics* vol. 8 no. 4 (2002), p. 330.

27. Wagg, 'Comedy, Politics and Permissiveness', p. 332.

28. Graham Meikle, 'Naming and Shaming: News Satire and Symbolic Power', *Electronic Journal of Communication* vol. 8 nos 2, 3 and 4 (2008), <http://www.cios.org/www/ejc/EJCPUBLIC/018/2/01847.html>; John Thompson, *The Media and Modernity* (Cambridge: Polity Press, 1995); Pierre Bourdieu, *Language and Symbolic Power* (Cambridge: Polity Press, 1991).

29. Graham Meikle, '"Find Out Exactly What to Think – Next!": Chris Morris, *Brass Eye* and Journalistic Authority', *Popular Communication: The International Journal of Media and Culture* vol. 10 nos 1–2 (2012), pp. 14–26.

30. Meikle, 'Naming and Shaming'.

31. For discussion of fake news, see, for example, Geoffrey D. Baym, *From Cronkite to Colbert: The Evolution of Broadcast News* (Boulder, CO: Paradigm, 2010); Jonathan Gray, Jeffrey P. Jones and Ethan Thompson (eds), *Satire TV: Politics and Comedy in the Post-network Era* (New York: New York University Press, 2009); Jeffrey P. Jones, *Entertaining Politics: Satiric Television and Political Engagement* (2nd edn) (Lanham, MD: Rowman and Littlefield, 2010); Janet Roscoe and Craig Hight, *Faking It: Mock-documentary and the Subversion of Factuality* (Manchester: Manchester University Press, 2001).

32. Meikle, '"Find Out Exactly What to Think – Next!"', pp. 14–15; Amanda D. Lotz, *The Television Will Be Revolutionized* (New York: New York University Press, 2007); Graham Meikle and Guy Redden (eds), *News Online: Transformations and Continuities* (Basingstoke: Palgrave Macmillan, 2011); Richard Kilborn, *Staging the Real: Factual TV Programming in the Age of* Big Brother (Manchester: Manchester University Press, 2003); Roscoe and Hight, *Faking It*.

33. Barbra S. Morris, 'Come and Get It!: Television News Criticism: American and British TV Comedy Versions', *Journal of British Cinema and Television* vol. 1 no. 1 (2006), p. 48.

34. Meikle, '"Find Out Exactly What to Think – Next'", p. 25.

35. Jones, *Entertaining Politics*, p. 18.

36. Meikle, '"Find Out Exactly What to Think – Next'", p. 25.

37. Peter Wilkin, '(Tory) Anarchy in the UK: The Very Peculiar Practice of Tory Anarchism', *Anarchist Studies* (January 2009), p. 11. See also Peter Wilkin, *The Strange Case of Tory Anarchism* (Farringdon: Libri, 2010).

38. Wilkin, '(Tory) Anarchy in the UK', p. 5.

39. Ibid., pp. 16–17.

40. Ibid., p. 17.

41. David Walton, 'Britain through the Looking Brass: *Brass Eye*, Homophobia, Deconstructive Manouevres and the Alf Garnett Syndrome', in María José Coperiás Aguilar (ed.), *Culture and Power: Challenging Discourses* (Valencia: Universitat de València, 2000), p. 254.

42. For a more detailed analysis of comedy and issues of representation and taste, see Sharon Lockyer (ed.), *Reading Little Britain: Comedy Matters on Contemporary Television* (London and New York: I. B. Tauris, 2010); Sharon Lockyer and Michael Pickering (eds), *Beyond a Joke: The Limits of Humour* (Basingstoke: Palgrave Macmillan, 2009); Stephen Wagg (ed.), *Because I Tell a Joke or Two: Comedy, Politics and Social Difference* (London and New York: Routledge, 1998).

43. Wilkin, '(Tory) Anarchy in the UK', p. 13.

44. Tim Crook, *Radio Drama: Theory and Practice* (London: Routledge, 1999), p. 127; Harry Thompson, *Peter Cook: A Biography* (London: Hodder and Stoughton), p. 457.

45. Brett Mills, 'Comedy Vérité: Contemporary Sitcom Form', *Screen* vol. 45 no. 1 (Spring 2004), p. 77.

46. Brett Mills, '"Yes, It's War!": Chris Morris and Comedy's Representational Strategies', in Laura Mulvey and Jamie Sexton (eds), *Experimental British Television* (Manchester: Manchester University Press, 2007), p. 180.

47. Ibid., p. 192.

48. Stanley Cohen, *Folk Devils and Moral Panics* (3rd edn) (Abingdon: Routledge, 2002).

49. The Open University documentary on news reporting, featuring some discussion of the making of *The Day Today*, is part of the 'English Language' series, and is included on the DVD of *The Day Today*.

1

BEYOND OUR KEN: CHRIS AND ARMANDO, JANET AND JOHN, AND THE ROAD TO *ON THE HOUR*

IAN GREAVES

C30, C60, C90, Go

One of the most striking developments in comedy fandom since the turn of the century is the free exchange of material previously considered unobtainable by those outside a loose network of industry insiders and habitual hoarders. With so many cassette collections dispersed via online file-sharing facilities such as BitTorrent and Rapidshare, it is now altogether easier to download an entire series in a single swoop, where once a random edition of a twenty-year-old radio comedy would be coveted like a holy relic.

This informal archive helps us to create and recreate a patchwork past in a constant present-tense narrative of our own accumulated obsessions. It is a new and sprawling continent of loving restorations, vinyl rips, hard drives, memory sticks and DVD-Rs, though often matched with the downside of inadequate speed correction, clumsy data compression and guessed-at transmission dates.[1]

But what, if anything, can this expanding mass ever teach us? In the haste to share and keep things simple much of this material's contextual data – even down to transmission dates – is lost. One group that has swum against this tide, however, is the community of Chris Morris fans first brought together by the *Brass Eye* Mailing List (1996–) and later *Cook'd and Bomb'd*, who were greatly intrigued by his work in local radio prior to that first burst of national success with BBC Radio 4's *On the Hour* (1991–2). Fronting somewhere in the region of 700 broadcasts for stations in Cambridgeshire, Bristol and London between 1984 and 1993, only a very small percentage of pre-fame recordings have ever circulated. Those which have are dated by fans with scholarly zeal, according to topical references, music played and scheduling clues measured against back copies of *Radio Times*. By placing complete shows and smaller scraps into an attempted chronology, Morris's artistic development is inevitably better understood.

The mid-1980s period at BBC Radio Cambridgeshire is one characterised by deeply parochial radio in which Morris is not the cerebral rebel of lore but a collegiate broadcaster working within conservative structures and practising the rules of radio. This contrasts with future stints at BBC Radio Bristol and Greater London Radio (GLR) where his

highly developed anti-establishment radio persona was positioned in a weekend slot by sta-
tions keen to test unfamiliar water; a further chapter, as we will see, in the Corporation's
problematic relationship with new comedy.

What emerges from collective historical sifting is a confirmation that Morris was not
alone. During the same period other local radio stations gave vital, early exposure to similar
practitioners of dense and disrespectful satirical comedy. The launch of BBC Radio York in
July 1983, for instance, saw the debut of Victor Lewis-Smith's *Snooze Button* on Sunday morn-
ings, while at BBC Radio Scotland the first broadcast work of Armando Iannucci – co-
creator of *On the Hour* – appeared in the Wednesday-night youth magazine *No' the Archie
Macpherson Show* (1988). All three performers shared a similar approach and it is reasonable
to suppose that the climate of BBC Radio as a whole informed this dovetailing in stylistic
development; not simply the neighbouring shows that were the target of their ire but also
the ready availability of studio facilities in a pre-twenty-four-hour broadcasting world.

In comedy criticism, too little effort is made to understand the role of production
houses: the vagaries of scheduling, budgets and 'outreach' certainly play their part in the fos-
tering of talent, but as we will see there are wider, institutional forces that impact on the *form*
of the comedy in an elemental way.

The Folly of 'Youth'

Ghettoising was the word of choice in the era of *Def II* (BBC 2, 1988–94), when the BBC
endeavoured to reinvent minority programming. It is now far easier to accommodate the
'alternative', although the word has lost much of its charge since the 1980s. Our modern-day
hotchpotch of multichannel television, *YouTube*, DAB radio, podcasts, Internet radio, pirate
radio and social-network sharing provides an extremely fragmented set of platforms, with-
out boundaries but with far smaller audiences. Commentators are often keen to point to
popular drama series like *Doctor Who* (BBC 1, 1963–89; 2005–) or TV talent shows as
examples of unifying, shared experiences for a mass audience, but the simultaneous experi-
ence is increasingly difficult for broadcasters to depend on. A tendency towards atomised
audiences is evident in the manifest obsolescence of newspapers reporting overnight view-
ing figures when so many people experience the same programmes a week or more after
broadcast via BBC iPlayer, Channel 4's on-demand service or through illegal downloads. Look
too at the much feared 'death of the album' in popular music, where the sovereignty of a pre-
scribed set of songs exists alongside a growing tendency towards track-by-track purchases
and personalised playlists.

The BBC has latterly attempted to tackle this new status quo head-on and use its vari-
ous platforms intelligently, to develop new talent away from the cruel glare of mainstream
channels like BBC 1 and provide a coherent career path in tune with the web and the thirst
for 'extra content'. The Corporation's website has been notable for its commissioning of
material from largely unknown comics, while BBC Radio 4 Extra (formerly BBC 7) has
granted several their first series. Partnerships such as David Mitchell and Robert Webb or
Matt Lucas and David Walliams have benefited from precisely this infrastructure, with both

making the journey from niche slots to peak-time terrestrial television over the course of a decade.

Through decades of trial and error, the BBC's present strategy is the product of an evolved approach to tapping into the youth market, a sector broadcasters must nurture if they're to avoid an average audience age which drifts ever higher. BBC Radio 1 is keenly reminded of this, for instance, when quarterly statistics show its average listener age overshooting the fifteen-to-twenty-nine target, often by a number of years. Halting that climb is a constant battle.

To set out the development of youth programming as a whole would require a separate article, if not a book.[2] It would be certain to take in John Birt's mid-1970s commissions at London Weekend Television, uniting Janet Street-Porter and Jane Hewland whose early work, in his words, was 'educative, yet unleashed energy',[3] by way of clumsier efforts like *Something Else* (BBC 2, 1978–82) where totally inexperienced hosts would furtively interview punk rockers. The opening episode of BBC 2 sitcom *The Young Ones* (1982–4) ridiculed this kind of 'community programming' with the cruel parody '*Nozin' Aroun'*. Rik Mayall's angry demolition of the television set spoke unequivocally of a failed relationship between broadcasters and young people: 'Did you see that? "The voice of youth …" . They're still wearing flared trousers!'

Network 7 (Channel 4, 1987–8) and *Def II* – both devised by Street-Porter, the former alongside Hewland – are historically viewed as a sea change in broadcasting, although Victor Lewis-Smith believed that 'despite outward appearances, very little has changed', in this coruscating *Loose Ends* (1986–) package about youth programming from June 1988:

> The programme you're hearing could be called *Def, Network 7, Get Fresh, Night Network, Network Def, Fresh Network, Def 7* or even *Night Fresh*. Whatever it's called, chances are it'll consist of bizarre out-of-kilter camera angles, shot by a team of cameramen all apparently suffering from mania disease, introduced by a twenty-five-year-old chicken from RADA pretending to be seventeen, who interviews unshaven, imbecilic, loathsome pop groups who have spent years fighting to get onto television, but once they're there think it's cool to pretend to be blasé and monosyllabic and uninterested, when all they're being is *uninteresting*. The whole effect being just as or even more patronising than all the previous youth programmes they claim to be rebelling against, and treating youth as though they don't have an attention span of more than 0.3 of a nanosecond.[4]

In the contemporary culture of 2012, the definition of 'youth' remains highly elusive. Some time after the Street-Porter revolution of 1987, as Stuart Cosgrove of Channel 4 has highlighted, it was true to say 'more young people watched *One Foot in the Grave* [BBC 1, 1990–2000] than *The Word* [Channel 4, 1990–5]'.[5] Ultimately, what broadcasters were really driving at was youth in the abstract – less the counter-culture and more a sense of abandon; something wilful and slightly disrespectful that was often sloppy but could still be filleted into a weekly slot. 'Youth', therefore, is a slippery term but unquestionably one that served a means to an end within commissioning, an attempted alchemy that might magically regenerate the audience. The BBC has never been more obsessed by this leap of faith than in the 1980s, a period when its infrastructure for developing talent was far less robust.

Cambridgeshire

As Chris Morris once said of his time in local radio, 'there was never a golden age where people were welcoming crackpots in off the street'.[6] Indeed, all that's shocking about his work on BBC Radio Cambridgeshire in the mid-1980s is how relentlessly prosaic it was. Fellow reporter Jane Solomons asserts that 'the station manager of the time was probably not tuned into Morris humour – it was a case of trying to prove yourself as a "serious" broadcaster by standing in on existing shows'.[7]

Although he found an outlet for comedy via the ensemble show *Bunting Broadcasting Company* (BBC Radio Cambridgeshire, 1985–7), Morris was more usually a team player: hosting drive-time slots on weekday afternoons, out and about in the radio car at weekends, or fulfilling record requests from listeners. His friend and former Cambridgeshire host Trevor Dann claims to

> remember him being castigated for changing the running order for *As You Like It* [a request
> programme Morris hosted semi-regularly in 1986 and 1987]. Because these old dears would write
> in and request "I Love You Because" and "The Old Rugged Cross" every week, he'd say "you want
> to hear *this* track from … X Ray Spex!"'[8]

As Morris explained in 2007, 'I was trying really hard to be well behaved. There wasn't any opportunity to permissively not take it seriously, so you would have to do it "in flight"'.[9] Listening to the handful of trails that survive from his time as a contributor to *Barraclough on Sunday* in 1984, his initial on-air style hints at this in its quiet detachment and air of world-weariness.

Bristol to London

A more familiar persona blossomed at BBC Radio Bristol, where Morris hosted *No Known Cure* every weekend for around three years, beginning in July 1987. Speaking to *Broadcast* magazine, programme organiser David Solomons said that Morris was an exciting talent 'able to take a sideways look at life'.[10] What he actually got was a very sharp presenter – then aged twenty-five – who would also take risks.

In its early days the station had counted Kenny Everett among its regular presenters, and his tape packages – dense assemblies of puns and punches all delivered at a breathless pace – were a profound influence on Morris, who developed a similar style that was a good deal crueller. An example of this is the early Bristol piece about the 'Janets and Johns of BBC Local Radio', which took withering potshots at the bad habits and inadequacies of the radio network as it celebrated its twentieth year 'of being mistaken for the independent opposition'.[11] Blasting his way through soporific jingles, the shallowness of the presenter/listener relationship and the relentlessly parochial priorities of the news, it's a cracked mirror of what Morris had witnessed during time served at Cambridgeshire, the package acting as an inclusive leveller with his new audience, defining him against what he *isn't*. Pointing to the future there's

an early flex of Morris's musical muscle with the 'Radio Toytown' song ('… first with the news, if you're short on the blues/bygone hits, lots of talk about dog shows …') and an early sighting of 'our reporter Peter Porter', a Bristol regular who would resurface for a *tour de force* package about sensationalist war coverage in *On the Hour* (23 August 1991). From the earliest opportunity, Chris Morris hit his stride.

Margaret Howard, presenter of BBC Radio 4's highlights show *Pick of the Week*, was in regular receipt of the Bristol tape packages and would run them frequently, on no fewer than seven occasions during *No Known Cure*'s first year on the air. It represents his first national radio exposure, although as a consequence this greatly annoyed Victor Lewis-Smith, who had been covering startlingly similar terrain since 1983 at BBC Radio York and on national radio from 1984, in Radio 4 programmes like *Rollercoaster* (1984), *The Colour Supplement* (1984–5) and *Loose Ends*. Becoming part of the latter's inner circle of regulars from February 1987, it was understandable that Lewis-Smith was aggrieved at being repeatedly overlooked by Howard, especially in favour of this young pretender from Bristol. As he noted in his 7 May 1988 package for *Loose Ends*, he had been ignored by *Pick of the Week* for almost a year. The final straw came when *Loose Ends* host Ned Sherrin elected to highlight the rivalry in January 1989 by running Morris's 'imitation' ahead of Lewis-Smith's latest tape package.

It is instructive to point out that the 'imitation' in question stemmed from a longer piece for GLR by Morris which mercilessly parodied the BBC's televised Annual Report, *See for Yourself* (1987–92), a jamboree carried out in the name of accountability to the licence-fee payer. Teasing the Managing Director of BBC Radio who had featured prominently in the 1989 broadcast, Morris dubbed the programme *David Hatch Is a Good Bloke* before venturing a comparison of continuity pauses on Radio 3 and Radio 4, a demolition of fellow GLR host Johnnie Walker and a withering imitation of the zoo radio format of Simon Mayo's recently launched Radio 1 breakfast show ('May-o, Simon May-o, Daylight come and you wanna drink Paraquat').[12]

Lewis-Smith and Morris were part of an emerging strain of comics who used the media as their prime material, drilling down to its use of language and closely approximating its construction and sound. Iannucci was operating along these lines too, self-evidently so by the time of *On the Hour* where separate elements of a report – the interview, the linking script, fake vérité – each possess a distinct radiophonic texture which aims to fool the ear with its studied accuracy.

There Is No Alternative

If Chris Morris had felt constrained by the conventions of BBC Radio Cambridgeshire, his frustrations palled in comparison to the young producers joining BBC Radio Light Entertainment (LE) in London. One of their number, future department head Jonathan James-Moore, spoke for many when he observed that 'the kind of strange little hiccup – more than a hiccup, actually – was that radio during the 80s couldn't really take alternative comedy. Ben Elton was unbroadcastable at that time on radio – but broadcastable on television.'[13] His colleague Alan Nixon avers that:

in comedy you always want to be contemporary and ahead of the game. And that's the irony –
we didn't want to work with Kenneth Williams, Frankie Howerd or Arthur Askey, who were
all still vaguely alive – and now you think 'what an icon', but we all wanted to do our stuff and
get away from them. We wanted to represent what we saw as a new wave. We wanted to
reflect it.[14]

As an example, Nixon recorded the pre-Channel 4/pre-*Young Ones* Comic Strip club night
in 1981 with a view to compiling a one-hour special, but the finished programme was firmly
rejected by management with the promise 'it would not even be aired at three in the morn-
ing'.[15] However, when the Pye Award for Radio Comedy was lost to an independent station
for the first time, in October of that year – with Capital Radio's *Alexei Sayle and the Fish
People* the victor – professional envy came into play, and Nixon was duly granted permission
to develop vehicles for alternative comedy at BBC Radio.

What is telling are the lengths to which Nixon went in order to shake up a staid institu-
tion like the BBC. In an age before agencies that specialised in supplying bespoke studio audi-
ences, the producer cannily elected to record shows at venues where alternative cabaret
might ordinarily be found: the Woolwich Tramshed (for *Don't Stop Now – It's Fundation*), the
Latchmere in Battersea (*Son of Cliché*) and the Hemingford Arms in Islington (*The Cabaret
Upstairs*). In a single bound, this bypassed the usual routine of taping at the Paris Theatre,
which Nixon remembers with a shudder:

> Every time we went to the Paris it was full of little old ladies. There was the famous woman with
> the lipstick – Hettie – who used to laugh just for any reason. David Hatch took her out to lunch and
> pleaded with her not to come to any more shows.[16]

It was through adverts in the London listings magazine *Time Out* – another first – that this
targeting of a younger audience was decisively achieved. By having Muhammad come to the
mountain, the reverberating sound of a real club helped transform the sound of radio
comedy in a fundamental way. As a necessity of the medium these programmes tended to
exclude visual comedy, but in most other respects it was a successful and authentic trans-
plant to national radio of a living cultural undercurrent.

Radio 4 listeners, quite apart from the management, are notoriously resistant to change.
Chris Morris once memorably picked up on the kind of controversy that would whip up
over the slightest threat to institutional stasis:

> BBC newsflash time. In a fit of corporate gun-jumping, the BBC has bravely declared 'time's up for
> *Woman's Hour*'. This lightning response to a general feeling which has existed for just ten years
> represents the biggest shake up since Radio 2's mid-morning producer said 'perhaps you would
> consider one or two changes, Jimmy? Though obviously if you prefer not to I quite understand.' The
> facts are that in a quite brutal campaign of reform Radio 4 will be abolishing *Woman's Hour* by
> keeping the programme, not reducing its length, maintaining the same presenter, moving it to a
> morning slot and possibly calling it … *Woman's Hour*.[17]

Faced with the stasis of the BBC, with its countless rules, regulations and habits, producers learnt lessons from the past by putting palatable, often older presenters at the heart of programmes that were otherwise designed to appeal to a younger audience. In its early years, for instance, Ned Sherrin's hosting of *Loose Ends* created the atmosphere of a headmaster dealing with his unruly intake, who at the time included Craig Charles, Stephen Fry, Victor Lewis-Smith, Jonathan Ross and a very young Victoria Coren. Arguably, this approach stretches back to Kenneth Horne on the Light Programme classics *Beyond Our Ken* (1958–64) and *Round the Horne* (1965–8) where all manner of subversive material could sneak through on a programme with the sensible buoy of its presenter. Even Chris Morris's presence on *Barraclough on Sunday* reflected the principle and, as if to demonstrate this thought process in action, Alan Nixon almost chose a then unknown Arthur Smith to present his late-night Radio 4 showcase *The Cabaret Upstairs* (1985–8) until he remembered the more reserved Clive Anderson. 'I thought, rightly, that Clive would be the ideal conduit between the listener and this new world of bizarre and slightly diffident comedy.'[18]

There was one further tactic to allow alternative comedy to inveigle its way into radio, albeit a few inches beneath the surface. Open submission programmes like *Week Ending* (1970–98) and *The News Huddlines* (1975–2001) were the usual entry points for those learning their craft as writers, but in the early 1980s there was a feeling among young producers in Radio LE that many new comedians already had those skills, and in any case neither programme was well matched to their humour. Eventually, more suitable shows – *Radio Active* (1980–7; 2002) and *In One Ear* (1983–6) among them – invited script submissions from fully formed circuit stars like Harry Enfield, Jeremy Hardy and Paul Merton.

The effect on the department was to bring these new talents into BBC offices and have them interact with new producers who could then develop new series ideas. Given the large influx of new producers under Martin Fisher and Jonathan James-Moore in the period 1989 to 1991 – Armando Iannucci among them – this strategy would have a seismic effect on radio comedy in a period where the route to fame was not through television panel games.

The Sound of Young Scotland

Quentin Cooper learnt a valuable lesson about listener and commissioning habits when he became Head of Youth Programming at BBC Radio Scotland in 1988.

> If you can get something that's a bit amorphous commissioned, once you've got it commissioned, and you've got a good run, then you can mess around. You get a youth programme commissioned, [an] innocuous sounding thing and then let it evolve over a year, by the time they [the Controllers] have got around to saying 'this is not what we wanted', they realise the audience likes it and either it's worked or it hasn't.[19]

A media buzzword at the time was 'soundbite', reflecting a drift towards magazine formats and the fast-paced packages seen on *Network 7* and *Def II*. Radio 4 had previously experimented with three-hour slots like *Rollercoaster* and *Pirate Radio 4* (1985–6), both of which

were predicated on the idea that there was a floating audience who would merrily dip in and out of a sprawling miscellany. It was possible to view the move either as recognition of changing audience habits, or to simply cry 'dumbing down' and dismiss it as the death of concentrated listening. What was not under question, thanks to evangelisers such as Janet Street-Porter, was that this was the preferred strategy in capturing a young audience. Cooper recognised this too, and it is precisely because of his tightly edited 'what's on' guide – *Nightlife* with Eddie Mair, airing as a standalone on Friday nights – that he was appointed to run a new department for youth at Radio Scotland.

This 'anxiety of age' in BBC Radio led, in 1988, to the following landmarks in quick succession: Victor Lewis-Smith's DJ *alter ego* Steve 'More Music' Nage debuted on Radio 1 in May, *No' the Archie Macpherson Show* (*NoTAMS*) with Iannucci came to Radio Scotland in July, while Matthew Bannister and Trevor Dann's GLR appeared in October (with Chris Morris in tow), as did Radio 1's *Hey RRRadio!!!*, a more dynamic descendant of *The Cabaret Upstairs*. In November, *NoTAMS* morphed into Radio Scotland's long-running youth magazine *Bite the Wax*. Real experimentation was taking place to find new listeners although, as Cooper reflects 'I think there's that sad danger that radio stations are so determined to get an audience that they don't have that they totally disrespect the audience that they *do* have!'[20]

Bite the Wax represented a whole new approach. Station controller Neil Fraser sought to make better use of researchers and producers so let them loose on slots of their own, with Thursdays on Radio Scotland devoted to youth programming: the *Top Forty*, *Bite the Wax* and then wrapping things up with leftfield music show *Beat Patrol*. 'The station wanted *Nightlife* to continue within the new show,' says Cooper, 'which it did, but otherwise I was given completely free rein.'[21] *Bite the Wax* co-host Siobhan Synnot found it a liberating show: 'You could put almost anything on there, but it was also very unfocused. It catered for an audience it knew.'[22]

During his six months on *Bite the Wax*, Armando Iannucci delivered four short comedy tape packages per week as well as taking on hosting duties alongside Synnot and Clare English. It was a vibrant ninety-minute show with an easy, knowing presentation style, a good mix of entertainment reports and of course the welcome punctuation of Iannucci's comedy. By this stage, his packages were a curious fusion of the kind of political and social satire found in *Week Ending* and the radiophonic media mischief of Victor Lewis-Smith, a confessed influence at the time. On occasion, however, Iannucci's undisciplined, uneven pace was suggestive of his ideas being stretched to order. 'Very early on, I discovered that you got paid by the minute. If your sketch was one minute and one second then that counted as two minutes, which might explain the rather verbose script.'[23]

One interesting progression from Iannucci's packages on *No' the Archie Macpherson Show* was the absence of any other voice, but this too was an institutional factor. On *NoTAMS* the extremely restrictive budget had forced him to use producers and researchers as actors in his comic soap opera 'Gallas', the results consequently being rather wooden. Instead, discovering the obvious solution of playing each part himself, Iannucci's work for *Bite the Wax* moved even closer to that of both Lewis-Smith and Morris.

The Radio Playground

From the outset at GLR, Morris never had a producer and was left more or less to his own devices. The journey from relatively anonymous team player at Cambridgeshire to the wild, untamed Morris of GLR is the product of many such hidden freedoms.

Jane Solomons recalls that at Cambridgeshire 'Chris first joined to help fixing – both technically on location with the radio car, and back in the studio recording and editing items.'[24] His *Barraclough on Sunday* colleague Jane Edwards adds 'You didn't earn any money at first, and you did as much as you could – help out answering the phones, and editing the tapes, all the razor blades, slicing everything up. You could be very useful there.'[25] Presenter Nick Barraclough noted the young helper's keen eye:

> He just came and he sat and he watched; sat next to me in the studio, intently watching absolutely everything that I did. I don't know if he'd ever been in a radio studio before, but he came in to soak it up and see how it all works. Just general sort of local radio – phone-ins, playing records, interviewing guests.[26]

It was an age before twenty-four-hour broadcasting and rolling news, yet it is surprising how quickly this has been forgotten. At the time of writing in 2011, BBC local radio teeters on the brink of cost-cutting measures that could force broadcasting into selected hours only, with link-ups to other stations and a default to BBC Radio 5 Live during off-peak periods. Throughout the 1980s, however, a daily streaming of Radio 2 or Radio 4 to fill dead time on a local station was quite usual. A glance at *Radio Times* listings for the period suggests that BBC Radio Cambridgeshire averaged just eleven hours of programming per day, York twelve, Bristol seventeen and Scotland eighteen.

Bristol station manager Roy Roberts recollects Morris tending 'to work when studio facilities were under least pressure, e.g. in the evening and late into the night',[27] most obviously from January 1989 when there was just a ten-hour gap between his Friday show's midnight finish and the start of the Saturday morning edition of *No Known Cure*. Programme assistant Steve Yabsley:

> He used to work Wednesday through to Sunday, and he usually spent the Wednesday doing the trail. You probably know that all radio programmes do trails and most people just dash them out in [no time], but he used to spend the whole day coming up with a minute or fifty seconds of very intensive, multilayered audio. And listening back to them they weren't really appropriate for the Radio Bristol listenership. They were almost too complicated. It really was a work of art in miniature, and yet it was only used for two or three days![28]

Iannucci experienced similar abandon at Radio Scotland:

> I remember it being a great hoot, having this enormous building in Queen Margaret Drive to play around in, and a massive gramophone library, and sound effects library, and all the sound engineers. If I wanted to do a sketch that sounded like a football report, I'd go to the sound engineers who did

the football. And they'd cut it together and give me the lip-mics that the commentators used. … It was fantastic training.[29]

This fascination with production was infectious and, inevitably, just a few short months into his tenure at Radio Scotland, Iannucci set his sights on a new goal. On 19 to 20 February 1989 he shadowed Bill Dare, John Fawcett Wilson and Jonathan James-Moore in London as they produced shows for the national network, including the pilot episode of Radio 1's hugely popular *The Mary Whitehouse Experience* (*MWE*) (1989–90), a direct descendant of the kind of alternative cabaret show favoured by Alan Nixon, but now recorded at radio comedy's spiritual home of the Paris rather than a room above a pub.

Within three months Iannucci had joined the department on a permanent basis and in less than a year was producing *MWE* himself. Furthermore, 1990 was the year in which Iannucci, Morris and Lewis-Smith all delivered programmes for Radio 1. With Radio 5 launching in August, there was a profound shift in the provision of radio for young people – the original Radio 5, which lasted until 1994, was specifically created for them – with a vastly increased number of programme slots for a significantly larger number of young LE producers to fill.

On the Hour

Having moved to London, Iannucci the radio fan soon searched the radio dial and stumbled upon Morris at GLR. They arranged to meet and from this encounter developed a series idea: *On the Hour*. According to his friend and fellow producer Sioned Wiliam, the idea had been fermenting in Iannucci's mind since university days and had also received a try-out during his training course as a producer. Conceptually, *On the Hour* was an attempt to merge comedy with documentary and commentary[30] but much of this got buried in the final product, leaving just the editorial *sensibility* of a news or documentary programme. Add to that the deliberate false fades, irregular speech, missed cues and found-footage which pepper the series, and the listener gains a real sense of the authentic, a twisted take on Radio 4 current affairs flagships like *PM* (1970–) and *Today* (1957–).

Traces of local radio are also highly evident in that first series of five episodes from August and September 1991; not simply in its production – Morris assembled his packages at the GLR studios, according to Lucian Randall's 2010 biography – but in subject matter. Episode four contains 'Regions Package', featuring a behind-the-scenes report on quintessential local TV news show *Bang on Targett* in which we are privy to the producer's instructions in the presenter's earpiece just before they go to air: 'Remember, Michael – pause in all the wrong places, use confusing inflections, emphasise inappropriate words, and spend the first ten seconds looking at the wrong camera.'[31] It is a distant echo of 1987's 'Twenty Years of Local Radio', though far more sophisticated.

By this stage, Morris's packages almost serve as learned essays on broadcasting behaviour, with a clear moral centre. In the opening episode of *On the Hour* the Big Street Station

disaster sequence presents multiple perspectives on manipulation and insensitivity, be it pop radio's crass efforts to cope with a major incident, journalists at a press conference sniffing out a headline, an eyewitness whose ambition is to become a part of the media circus or the exploitation of victims by television reporter Roger Blatt.

> I'm looking at some large bits of twisted metal, which just an hour ago was a train with people on it, none of whom had ordered the morning menu of mayhem they were about to be served. An *hors d'oeuvres* of bangs, a shriek of tortured metal with a side-order of shattering panel, and for dessert, great cries of dismay and concern expressed by the victims.[32]

According to Morris, this early version of Ted Maul stemmed from

> a guy I knew in East Anglia called Pat Beasley. He was the consummate freelance journalist, knew all the tricks, how to chat up the police, etc. One day, he came rushing into the studio, shouting 'Chris, Chris, you've gotta listen to this: Police are out in force today as the county's roads serve up their traditional pre-Christmas cocktail of carnage.' I said, 'Pat, you *can't* say that.' When he did the news, he read 'The roads have served up their traditional pre-Christmas *menu of mayhem*', smiled at me through the glass, and carried on. This is what goes on. In the 1980s, CNN actually had the slogan 'If it bleeds, it leads.'[33]

It is essential that any understanding of *On the Hour* recognises the series' authorship did not fully belong to any one person. Iannucci was overall editor but credits were dispersed among a number of writers – a brief stint by Iannucci producing *Week Ending* brought in several – with Morris remaining autonomous, of a piece with his self-produced operation at GLR. Carol Smith, Iannucci's assistant of the period, recalls:

> He would go off and come back with a spool of tape and his five-minute piece would be on there, and then he'd play it to us in the studio and that was it. It was in, and we couldn't touch it, because it was so densely produced and so layered. In those days it was analogue editing and you couldn't get a blade in.[34]

The workings of the rest of *On the Hour* were quite different, with separate elements of a sketch assigned to individual writing teams, distributed and then compiled in much the same way as a news report. A case study is 'Barton's Matches' from episode four: a twenty-eight-second studio introduction performed by Morris was in fact scripted by Iannucci, whereas the ensuing tape package consists of two minutes and five seconds by David Quantick and Steven Wells, two minutes and two seconds by Stewart Lee and Richard Herring and a further minute of cast improvisation for which Steve Coogan, David Schneider, Patrick Marber, Doon Mackichan and Rebecca Front were paid equally.[35]

Improvisation was a central part of *On the Hour* and such methodology required long studio hours. The pilot episode and first series were recorded on an *ad hoc* basis throughout the spring of 1991, in much the same spirit as Geoffrey Perkins's fitful production of *The Hitchhiker's Guide to the Galaxy* (BBC Radio 4, 1978–80; 2004–5): the moment a studio was

empty, word spread like jungle drums to Iannucci's office that a few hours could be spent eking out extra minutes of material. Carol Smith confirms that 'in those days it was a lot freer, in that you could take recording equipment, you could get portable Uhrs then, and go off and do something. ... There was no accounting process.'[36]

Producer Choice

Sounding a death knell, the 1992 Green Paper *The Future of the BBC* 'urged the BBC to improve its efficiency',[37] and this instruction found its architect in Director General Designate John Birt. BBC Chairman Marmaduke Hussey agreed that the Corporation was 'shockingly profligate',[38] and so a chain of events resulted in programme budgets being fully costed for the first time. Producer Choice was Birt's most famous innovation while in charge of the BBC. Setting out the previous system in his 2002 memoir, he noted that 'facilities, overheads and support services were not charged to a particular programme, so no one had the slightest idea how much it cost to make programmes, or even to provide individual facilities'.[39] By way of illustration, this poses a question for Alan Nixon, whose innovation of recording at clubs pre-Producer Choice changed radio comedy: did he spend more in order to do so?

> I never knew. I had absolutely no idea. It was sanctioned. You would go to the head of department and say 'I think it would be good if we took it out.' 'Well, do you want an OB van?'[40]

Central services such as studios, transport and library facilities had therefore existed outside of the programme budget, but from April 1993 everything became an 'above-the-line' cost which had to be itemised in advance of production.

The central idea was to create an internal market at the BBC and, if the cost of facilities was cheaper in the commercial sector, then producers were free to go elsewhere. This had the unforeseen consequence that many internal providers became financially unviable due to a lack of demand, whereas in radio, private-sector facilities were at that time so limited there was no real external choice.[41] Of even more relevance to *On the Hour*, too few people had contemplated the impact of Producer Choice on work that would require incubation. Under the threat of extinction was the freewheeling spirit which shaped the work of Iannucci, who used unoccupied studios for sessions of improvisation; and Morris, who would regularly indulge in long, tariff-free nights of studio editing. Nor was the new climate helped by that other Birt obsession, 'rolling news', and the perceived need for twenty-four-hour broadcasting.

Did Producer Choice drive Iannucci and Morris to an independent production company when *The Day Today* was first mooted? The chronology doesn't quite fit as the pilot was already in development, although it is safe to suggest that they along with Victor Lewis-Smith came through at a time when certain beneficial modes within broadcasting were reaching an end.

Conclusion

This moment of restriction was a passing one, which can perhaps be reduced to the transition between a dependence on studios and the rise of digital, domestic editing in the late 1990s. Iannucci became quite hooked on this idea for *Time Trumpet* (BBC 2, 2006), hiring a number of people who had already assembled impressive homemade comedy in their bedrooms. This surely begs the question of whether the democratising nature of free creative technology actually makes it harder for someone radical to emerge. Is there something to be said for honing a style in obscurity, as Iannucci and Morris did, rather than in today's culture of immediate success or nothing? And how can you be heard above everyone else who's doing it? The three subjects of this essay may have viewed the blockades and structures of the BBC as frustrating at the time – Lewis-Smith in particular suffered from considerable censorship – but would they have risen faster without them, or even at all? It may be that historical distance is needed in order to judge the current climate. Perhaps the deficiencies of a more open media landscape are nothing of the sort, with broadcasters increasingly irrelevant alongside the self-selecting broadcast modes of the Internet.

To pursue this logic, are the cracks in the system the abiding mother of invention? If Iannucci, Lewis-Smith and Morris could rise through a corporation almost as a consequence of its uncertainty and institutional panic, what blind spots currently exist at major broadcasters that would allow the same to happen again? *Pick of the Week* gave Morris vital airtime and the programme is still a going concern, as is local radio. There are still producers seeking out new comedians, but this is twinned with a cautious editorial culture birthed from the conclusions of the 2003 inquiry led by Lord Hutton,[42] and the increased levels of compliance following the 'Sachsgate'[43] controversy of 2008. In addition, the hurried 2010 licence-fee negotiations with the Coalition Government – representing a year-on-year cut in real terms for six years[44] – were a terrible blow for budgets. These factors conspire to discourage risk.

Giving his advice to an audience of students in 2007, Morris expressed his conviction that the modern challenge is in 'having to assume you'll have to punch a hole in the wall yourself. I think almost all the time it's will and no talent. Will is probably the absolutely key thing.'[45]

Notes

1. For an excellent meditation on the psychological and cultural effects of online collecting, see Simon Reynolds, *Retromania: Pop Culture's Addiction to Its Own Past* (London: Faber and Faber, 2011).
2. Thankfully there is one: Karen Lury, *British Youth Television: Cynicism and Enchantment* (Oxford: Clarendon Press, 2001). A useful primer during my research was the documentary *Watch This or the Dog Dies – The History of Youth TV* (BBC 2, 11 August 1998).
3. John Birt, *The Harder Path* (London: Time Warner, 2002), p. 178.
4. 'Youth Programmes', *Loose Ends* (BBC Radio 4, 11 June 1988).

5. *Watch This or the Dog Dies.*

6. Stage interview with Paul Lashmar, Bournemouth University, 6 March 2007.

7. Correspondence with Justin Lewis, 30 June 2002.

8. Interview with Ian Greaves and Justin Lewis, 30 August 2002.

9. Stage interview with Paul Lashmar.

10. Nick Higham, 'Bristol Revamp for *Down Your Way*', *Broadcast* (17 July 1987), p. 11.

11. 'Twenty Years of Local Radio' (BBC Radio Bristol, *c.* November 1987).

12. 'See for Yourself', *Chris Morris* (Greater London Radio, 15 January 1989). The edition of *Pick of the Week* transmitted five days later contained an extract of the programme, most likely from the 'See for Yourself' package.

13. Interview with Ian Greaves and Justin Lewis, 10 January 2005.

14. Interview with Ian Greaves, 27 October 2011.

15. Ibid.

16. Ibid.

17. *Chris Morris* (Greater London Radio, 2 December 1990). 'Jimmy' is in reference to housewives' favourite Jimmy Young, an immovable presence in the Radio 2 schedules for many years.

18. Ibid.

19. Interview with Ian Greaves and Justin Lewis, 15 May 2002.

20. Ibid.

21. Ibid.

22. Interview with Justin Lewis, 5 June 2006.

23. *Armando Iannucci: The Radio Scotland Years* (BBC Radio Scotland, 27 December 2006).

24. Correspondence with Justin Lewis, 30 June 2002.

25. Interview with Ian Greaves and Justin Lewis, 5 June 2004.

26. Interview with Ian Greaves, 26 June 2002.

27. Correspondence with Ian Greaves, 9 May 2003.

28. Interview with Ian Greaves, 17 July 2002.

29. *Armando Iannucci.*

30. Traces of this can be heard in the pilot episode of *On the Hour* released by Warp Records in 2008, where Iannucci's then writing partner Andrew Glover delivered an audio 'column'.

31. 'Regions Package', *On the Hour* series one, episode four.

32. 'Train Crash Package', *On the Hour* series one, episode one.

33. Simon Price, 'If It Bleeds, It Leads', *Melody Maker* (4 June 1994).

34. Interview with Ian Greaves and Justin Lewis, 29 October 2002.

35. The BBC's internal 'Programme as Broadcast' documents for *On the Hour* provide all of these timings, including the joint writing credit for cast improvisation. These timings are kept on file and applied to all future licensing and repeats of the shows, so that the same division of payment is always made.

36. Ibid. Uhrs were a type of tape recorder very common in broadcasting at the time.

37. *The Future of the BBC*, November 1992; cited in Georgina Born, *Uncertain Vision: Birt, Dyke and the Reinvention of the BBC* (London: Secker and Warburg, 2004), p. 101.

38. Born, *Uncertain Vision*, p. 101.

39. Birt, *The Harder Path*, p. 312.

40. Ibid.

41. David Hendy, *Life on Air: A History of Radio Four* (Oxford: Oxford University Press, 2007), p. 289.

42. An appearance by journalist Andrew Gilligan on the *Today* (Radio 4) programme in May 2003, where he alleged the UK government had exaggerated intelligence in a dossier presented in 2002 as an argument for the invasion of Iraq, led to the death of Gilligan's informant, David Kelly in July 2003. Lord Hutton was appointed to investigate the circumstances surrounding the death. The inquiry's findings prompted the resignation of Director General Greg Dyke and more stringent verification of incoming news stories at the BBC. The report can be viewed at <http://www.the-hutton-inquiry.org.uk/content/rulings.htm>.

43. A prank call to the actor Andrew Sachs during an edition of *The Russell Brand Show* (BBC, 2006–8) on BBC Radio 2 in October 2008 was followed by a wave of moral outrage, initially in the pages of the *Mail on Sunday*. Brand soon resigned, as did the Controller of Radio 2, while the show's guest and fellow prankster Jonathan Ross was suspended, later exiting the BBC altogether. Questions of creative control and the interference of artist agents in programmes were raised, and the BBC Trust's own inquiry concluded that editorial and compliance procedures were left wanting. The Trust recommended penalties and a register of 'high-risk' programmes, <http://news.bbc.co.uk/1/hi/entertainment/7741322.stm>.

44. The licence-fee settlement of October 2010 froze the cost of a full annual licence at £145.50 for six years. In addition to a new wave of cutbacks at the Corporation, the BBC were also expected to take responsibility for Welsh broadcaster S4C and the World Service, the latter previously having been a budgetary responsibility of the Foreign Office, <http://www.guardian.co.uk/media/2010/oct/19/bbc-licence-fee-frozen>.

45. Stage interview with Paul Lashmar.

2

ROCKARAMA NEWSBANANA: CHRIS MORRIS – MISBEHAVIOUR IN MUSIC RADIO

JUSTIN LEWIS

When *On the Hour* (BBC Radio 4, 1991–2) brought his talents to a national audience, Chris Morris was already established as a fully fledged comic voice with an unusual career progression. He had not braved Comedy Store open spots or performed to a dozen onlookers at the Edinburgh Fringe, but had worked primarily as a presenter and DJ on BBC local radio, beginning at Radio Cambridgeshire in 1984. With influences ranging from the anarchy and technical brilliance of Kenny Everett and Victor Lewis-Smith to the dryly amusing early morning Radio 2 presenter Ray Moore,[1] Morris's flair and ambitious streak landed him secure weekend slots at bigger stations – Radio Bristol from July 1987 and, from October 1988, Greater London Radio (GLR). His freewheeling mix of records, regular characters and offbeat stunts made him a cult figure with listeners, and often acted as dry runs for material he would later expand and develop for major TV and radio projects.

As his career in local radio flourished, Morris grew more interested in providing casual but acute commentary on how a station managed the relationship between speech (epitomised by news bulletins and reports) and entertainment (usually tracks of recorded music). His comic scorn was not only directed towards the prattle of pop radio, with disc jockeys mixing tracks, timechecks, travel information and weather forecasts, but even more so towards those who were contemptuous of the role of DJ, and who yearned to be taken more seriously. It already seemed absurd to him that news content in radio sounded so self-important, without jocks adopting the same pomposity to justify their position on the air. His first national series as a DJ was in 1994 for BBC Radio 1FM (hitherto and subsequently known as just Radio 1), a network which was undergoing radical, brutal reinvention, and which was trying to banish the supposed shallowness of old in favour of a new responsible public service hybrid of music and speech. For a comic commentator like Morris, a station trying to avoid sounding like Tony Blackburn was even more fertile for satire than Blackburn himself, who would cheerfully acknowledge his own role in radio as 'a light-hearted fool'.[2]

The Yawning Gap

Masterminding 1FM's relaunch in the second half of 1993 was Matthew Bannister, a former reporter and presenter on its *Newsbeat* bulletins (1973–), after three years spent at its independent London rival, Capital Radio. Back at Capital in 1985 as Head of News and Talks, he helped create *The Way It Is*, a noisy news magazine with what he later described as 'terrible puns' and 'big jingles blasting'.[3] When, in the spring of 1988, he was appointed to overhaul the directionless BBC Radio London, he hired the help of producer Trevor Dann, an old friend and colleague from Radio Nottingham in the late 1970s. Dann's radio production experience included *25 Years of Rock* (BBC Radio 1, 1980), an early attempt to combine music from a given year with archive news footage.[4]

Bannister and Dann's efforts to create a punchy, vibrant BBC local station for metropolitan grown-ups resulted in GLR, which launched on 25 October 1988. At the time, Dann remembers, radio in Britain was obsessed with youth (Radio 1, Capital) or with much older listeners (Radios 2, 3 and 4, LBC), disregarding '"the yawning gap", ... 25s-to-45s ... who'd grown up with Michael Jackson, or Bruce Springsteen or Bob Dylan ... and they didn't want to listen to Kylie Minogue and Jason Donovan. But they weren't ready for Val Doonican and Mendelssohn.'[5] Heavily used in early publicity to emphasise GLR's music/speech dichotomy was the slogan 'rock and rolling news' which aimed to extend current affairs coverage beyond the fixed points of the news bulletin, punctuating pop throughout the day. 'It wasn't aimed at a literate minority,' believes Dann, 'but the truth is that Matthew and I both felt, possibly instinctively, that we needed to raise the intellectual level of traditional local radio to win an audience at all in London.'[6]

GLR's listening figures were never more than modest, but even with limited budgets, it nurtured a succession of brilliant, original and imaginative presenters like Danny Baker, Chris Evans and someone whom Dann had repeatedly encountered a few years earlier at BBC Radio Cambridgeshire. Because his show usually occupied a Sunday-morning slot associated with relaxation and leisure, Chris Morris was not subject to the 'rock and rolling news' requirements of weekday daytimes, but he would use records and speech to reflect years of experience as a consumer (and latterly exponent) of music and radio. Via these shows, as well as earlier at Radio Bristol and later at 1FM, he could play many roles – not just DJ, but newscaster, reporter, musician, comedian and voice artist, as well as producer and compiler of dense, intricate packages. In all these roles, as early as the late 1980s, Morris was biting the hand that was feeding him. Fan and friend Dann could only shrug as the radio station he helped to build was deconstructed by one of its own presenters. 'We had quite a bit of trouble with him early on. "Chris, don't take the piss out of GLR. We've got enough problems without you doing it."'[7]

Pop radio is mostly for background listening, not designed to be scrutinised or replayed. Stations rarely keep archives of their output for longer than a few months (for the sake of legality), and so there is little known trace of hundreds of hours of Morris's output before 1989, his last full year at Radio Bristol. *Time Out*'s radio columns and the regional pages of *Radio Times* gave the shows some coverage, but it was early 1990, just as he was leaving Bristol, that two plugs for his London show appeared in the rock music weekly, the *New*

Musical Express (NME). In both cases, Chris Morris was in character. Neither a zany nor cutting-edge figure in the first published piece, he expressed profound concern for the wave of inoffensive pop performers who were supposedly indulging in the practice of 'backwards masking', and placing hidden messages in their hit records. Shrouded in the grooves of 'Hangin' Tough' (1989), a hit of the time by New Kids on the Block, was the backwards message 'Your days go whizzing when you're on heroin.'[8]

The consciously self-righteous tone adopted by Morris's character may have been lost on many tabloid newspaper readers, who could have taken the moral panic at face value. Targeted at the *NME*'s generally liberal and informed audience, though, the article acted as an ingenious shop window for the GLR Sunday show, and six weeks later, another integral feature of the programme was highlighted. This time, Morris appeared in the guise of Wayne Carr, an inflammatory, vain and deluded 'hyperjock' with all the worst excesses of Radio 1 behemoths like Tony Blackburn, Simon Bates and Gary Davies. Pictured in his studio, which was strewn with discarded BBC paper cups, and had helpful signs pinned up like 'CATCH-PHRASE: GOOD MORNING!', Carr gabbled the sort of ingrained chauvinism that was legend in old-school radio: 'Chicks in this industry are good for two things – shagging and doing the typing. But not at the same time, OK?'[9]

Carr's role was to deliver a breathless running commentary on the week's big news stories and celebrity showbiz gossip. The character was an enduring but developing one: by 1992 the 'zoo radio' format popularised in Britain by Radio 1's Steve Wright was a frequent target for Carr items, such as on a flexidisc item that year in which, the 'Wayne Carr in the Afternoon' crew discussed the pros and cons of the Mini-CD ('What are they gonna put on the B-side?').[10] Attached to the cover of the glossy rock monthly *Select*, the flexidisc's seven-minute montage of Morris also included a prank phone call (posing as Bono and his manager Paul McGuinness) to the *Sun*'s gormless gossip columnist Piers Morgan, offering an exclusive on a one-off gig with NWA at Alton Towers.[11] As with the Carr story in the *NME*, *Select*'s accompanying text used shock and controversy to push Morris – with constant references to 'sick Chris',[12] reasoning that its discerning readership would surely recognise fake bluster when they encountered it. *Select* would feature further vital coverage of Morris, helping to cement his reputation as a comic force with credibility, at a time when the music press spent many column inches promoting the work of other comedians with particular youth appeal: Sean Hughes, Steve Coogan, Rob Newman and David Baddiel, Vic Reeves and Bob Mortimer.[13]

'It's Got Some Rather Loud Guitars on It'

It was fitting that Morris approached and was accepted by the rock press. Prior to landing his own radio shows, he had been bass guitarist in Cambridgeshire groups Somewhere in the Foreign Office and The Exploding Hamsters. Not quite virtuosic, he was sufficiently proficient on several instruments (including keyboards and guitar) to ape pop's professionals. 'His actual playing is quite rudimentary,' comments Steve Yabsley, a friend and colleague from Radio Bristol days, 'but he jigsaws things together and comes up with quite elaborate

copies.'[14] Like Philip Pope, who devised pop pastiches for programmes such as *Radio Active* (BBC Radio 4, 1980–7) and *Spitting Image* (Central Television/ITV, 1984–96), Morris liked to focus on a group or soloist's musical idiosyncrasies, adding lyrics that drew attention to the musical style itself. Often in collaboration with composer Jonathan Whitehead, Morris would reference several of a target's songs in the space of a brief parody, which often had a contentious title or theme. A Pixies imitation called 'Motherbanger' contained approximations of musical, lyrical and stylistic components from up to half a dozen of their songs.[15] 1994's 'Eat Whale Meat', an 'unearthed' song purporting to be by R.E.M., and supposedly written for the Japanese market, based itself on the sunny singalongability of 'Shiny Happy People' (1991) and 'The Sidewinder Sleeps Tonite' (1992).[16] As hard as he would graft on such material, though, Morris felt it to be ephemeral, and stopped short of the idea of releasing a compilation LP:

> On the show, if they pop out of the blue, that's good, but when you put them all together, it doesn't work. Also, when the Bonzo Dog Doo-Dah Band did musical parodies, they'd cover three or four styles in the space of one song, which actually did merit repeated listening. But to release a straightforward 1980s-style musical satire …[17]

It was as if Morris was sending up his own efforts both as broadcaster and musician. The packages and inserts he would cue into a show would be carefully constructed and perfected, but live in the studio the emphasis was on meddling and messing about. Setting up his keyboards, sometimes to the concern of studio managers, he would improvise his own solos over the top of much-loved recordings – usually during the instrumental breaks, as if he was a frustrated rock star grappling for one last stab at muso glory. Regular listeners came to relish a splurge of Casio keyboard to spoil a classy, polished Steely Dan instrumental break,[18] or the invasion of an Ice Cube track with the top line of 'God Rest Ye Merry Gentlemen'.[19] The uglier and more jarring the intrusion, the better – and yet somehow, Morris's contributions were so warm (after all, he had himself chosen the records in the first place) that they were endearing rather than annoying pieces of aural graffiti.

Collage Boy

What distinguished Morris from other pop parodists of the time, though, was his enthusiasm for the burgeoning sample culture of the mid-to-late 1980s. Recordings which sampled other sounds and tracks had been around since the 1950s, but a particularly arresting form of sampling arrived during the early summer of 1987 from the duo who would later find fame as the KLF. A crude, dislocating collision of pop culture and satire, Bill Drummond and Jimmy Cauty's Justified Ancients of MuMu (JAMs) collected unauthorised extracts from a variety of sources to make something novel and provocative, though they attracted greater notoriety than commercial success in the early days. 'Everything about [them],' wrote music scholar Jeremy J. Beadle, who could almost be speaking of Chris Morris, 'has been shaped into the form of legend by the protagonists themselves. Almost every move they have made, under

whatever pseudonym, has been accompanied by a carefully calculated burst of publicity.'[20] Their debut single, 'All You Need Is Love', released in the spring of 1987, offered wry social comment about the media coverage surrounding the emergence of AIDS, uniting fragments of The Beatles, 'La Marseillaise', Page 3 girl Samantha Fox singing and the nursery rhyme 'Ring-a-ring-o'-roses'.[21] Its introduction was topped off with an extract of actor John Hurt warning that AIDS currently had 'no known cure'.[22] Within weeks, the phrase became the title of Morris's new weekend shows for Radio Bristol, with publicity contextualising the presenter in the grand tradition of radio host as crazy, madcap eccentric: 'No one seems sure if Chris Morris is a habit-forming drug or a contagious illness but one thing seems certain – his weekend style carries an appropriate name, *No Known Cure*.'[23]

The JAMs' messy, disorienting style of collage seemed to inspire Morris's own brand of jingle identifications, which acted as a sort of sonic defacing of thirty years of pop music. Where most stations' official jingles packages at least take care to clearly name-check the broadcaster, station and frequency, Morris's own efforts (usually only ten to fifteen seconds in length) wilfully buried his identity underneath a deluge of clattering rhythms, whooshes and crashes, plus some pilfering from other recordings, among them The Police's 'Roxanne' (1978), Prince's 'Batdance' (1989), De La Soul, Frankie Goes to Hollywood and The Beastie Boys.[24] The camouflages of Morris's identity in such alienating, distancing collages ironically made the texture of his shows all the more distinctive.

Morris was not just fascinated by musical samples. While still based at Radio Cambridgeshire, he was already fluent in the craft of editing, and had experimented with looping a sentence from a Radio 4 news bulletin into the texture of one Exploding Hamsters song.[25] In British political and media circles, the 1980s had seen a trend (imported from the United States) for politicians delivering speeches with easily quotable 'soundbites' – shorter sentences and clearer phrases, constructed to elicit feverish crowd applause and, with any luck, a top story on flagship evening news programmes. Once repeated again and again, soundbites like Margaret Thatcher's 'The lady's not for turning'[26] would become as ubiquitous and catchy as refrains from pop songs or slogans from TV advertising campaigns.

As political parties, especially the Conservative Party, became more reliant on soundbites during the 1980s, politicians tried to embrace popular culture, hoping to shake off the stuffiness that some felt was stifling British politics. Thatcher would appear on Saturday morning children's television assessing pop videos,[27] while Labour Party leader Neil Kinnock had even appeared in one.[28] With politicians often superficially keen to be seen to attract younger voters, comic practitioners like Chris Morris and *On the Hour* co-creator Armando Iannucci saw the soundbite sample clip as ideal fodder for comedy, via inappropriate use. From the formidable wall of cartridges he had amassed, Morris regularly plucked speech samples to use in his DJ shows, often to the point where they became oblique catchphrases. 'Why', wondered James Naughtie off the *Today* (BBC Home Service/Radio 4, 1957–) programme, 'are there so many politicians on the backbenches who are so unhappy?' 'Record number three,' ordered a prim Sue Lawley, on remand from *Desert Island Discs* (BBC Home Service/Radio 4, 1942–).

More contentious were mischievous celebrity soundbites, re-edited so that Cyndi Lauper seemed to be subjecting pop star Phil Collins to verbal abuse, and the high-profile publicist

Max Clifford was heard to admit to mistreatment of baby mice. Stripped of context, any sentence or pronouncement could sound ridiculous and even sinister, a way of disempowering any speech or destroying meaning. Morris didn't spare his own role in proceedings either: he had spent so long in editing suites, either speeding up or slowing down the recorded human voice, that he began to emulate these tape warps at unexpected points when recording conversations with the public or celebrities. He was audibly thrilled on the rare occasions when this vocal mannerism was spotted by a stooge, who would wonder aloud, 'Why are you talking strangely?'[29]

The belittling of the authoritative voice spread to other sections of Morris's shows. In a lofty tone, former TV continuity announcer Michael Alexander St John delivered some of Morris's offbeat, nonsensical ideas for 'Ten Ideas to Change the World', and later voiced his spoof dance charts for 1FM. For the long-running vox-pop item 'Feedback Reports', passersby were grilled on subjects like 'irresponsible saucepan behaviour' or 'beard economics', though as Morris would occasionally confess to his listeners, he would ask completely different questions of the public and drop in his alternative queries during the edit.[30]

To contrive nonsense out of talking heads was 'very exciting', but soon Morris found it even more exhilarating to 'get people to talk this rubbish without actually editing … . It's a fantastic risk … . It really gets your adrenalin going.'[31] The stakes were especially high when he laid traps for the officially informed: politicians, pundits and celebrities who, because of their status, were constantly sought by broadcasting organisations for their opinions on 'hot potato' subjects and issues which lay far beyond their capacity for understanding. These interviews would be one of the most discussed areas on *Brass Eye* (Channel 4, 1997) and on its subsequent one-off special (2001), but many similar ones had already been conducted during Morris's 1994 show for Radio 1FM, either in a slot called 'Call 1FM' or during plugs for a visiting celebrity's new product.

As Morris's knowledge of current affairs and media workings rivalled his expertise on music and popular culture, he would often exploit the ignorance of his interviewees. Few in an interview situation would admit to not understanding a question or a reference point. Pop stars wanted to look intelligent; politicians and pundits sought credibility. A common tactic for Morris was to lead both groups out of their comfort zones, squeezing a tribute to war hero Douglas Bader out of Dutch cod-techno duo 2 Unlimited, or conversely, introducing Eurosceptic Tory MP Teddy Taylor to fictional computer games like 'Chronic the Drug Wasp'. Meanwhile, hapless newsreader Martyn Lewis (plugging his book on careers advice for the young) was asked about obscure and fictional youth icons such as 'MTV's black transvestite Gangster Dogg'.[32] 'People give better value for money if they have a microphone in front of them,' believes Morris's producer at 1FM, Oliver Jones, 'because they feel obliged to talk. And some people are far more willing to do it than others.'[33] In any case, Morris's pop references were often so obscure, they were designed for the sort of music fans who memorised the small print on album sleeves: borrowing the name of a Van Der Graaf Generator founder member for a 1FM correspondent character, or using Sly Stone's real name for *The Day Today*'s weather forecaster.[34]

Worthy Words

Morris's breakthrough series as a national DJ, BBC Radio 1FM's *The Chris Morris Music Show* (or in *Radio Times* billings, simply *Chris Morris*) began on 1 June 1994, and ran until Boxing Day that year, usually at nine o'clock on Wednesday evenings.[35] Appointed to head 1FM from October 1993, Matthew Bannister had set about its reinvention with some zeal, questioning several broadcasters' credentials in appealing to the young:

> There were a number of DJs who were older than the Prime Minister [fifty years' old at the time of Bannister's appointment], the Director-General of the BBC [forty-eight] and the Archbishop of Canterbury [fifty-seven]. Now, you can have people of seventy broadcasting to young people, but if the whole cast of characters is somehow massively out of touch with youth culture, then you have a problem.[36]

That problem was underlined by the ubiquity of Paul Whitehouse and Harry Enfield's DJ characters Mike Smash and Dave Nice on Enfield's television series from 1990. All too reminiscent of many established DJs, Smashie and Nicey were ageing, self-indulgent and complacent. Once Bannister had started to rid the daytime schedules of Simon Bates, Dave Lee Travis and others, further outings for Smashie and Nicey seemed superfluous, and Whitehouse and Enfield retired the pair with an ingenious finale at Easter 1994.[37]

Bannister's predecessor, Johnny Beerling, had since 1985 increased the volume of public service content on the station, with documentaries and campaigns on issues like safe sex and drugs. Some, like the producer and presenter John Walters, were sceptical about the need to pursue public service values, feeling it was merely 'worthy words It wasn't our damned business what kids did in their spare time.'[38] Beerling had also brought original comedy series to the late-night schedules, most successfully *The Mary Whitehouse Experience* (1989–90, produced in its second year by Armando Iannucci) and *Victor Lewis-Smith* (1989–92).[39] Bannister, though, felt that the BBC's pop service had to reposition itself more strongly to withstand competition from new commercial rivals like Virgin Radio. During his tenure as Controller, he approached Armando Iannucci to ask if he would take the reins of the 1FM breakfast show. For Iannucci, who had already fronted enjoyable music and comedy shows for the station but knew far more about Arvo Pärt than The Boo Radleys, it would probably have been a mismatch. 'Sooner or later,' he said in 2006, 'probably within the first day, they would have discovered that I wear cardigans and listen to Schubert. The BBC would have gone into meltdown.'[40] Other comic performers were entrusted with music shows on the revitalised 1FM – from Eddie Izzard to Paul Merton – but few aside from Stewart Lee and Richard Herring seemed able to seamlessly marry pop with comic content. Chris Morris, as Matthew Bannister knew well, could do the latter.

With Smashie and Nicey figures no longer prominent on 1FM, what was ripe for parody on the new, apparently improved station? For Morris, there was plenty, not least the timid presentation. He believed his DJ colleagues were

slightly shellshocked … .You find yourself screaming for a Bruno Brookes or a Gary Davies. Their job is to play records not say, 'I've got a degree', constantly reverting to very clumsy irony. Steve Wright, at least, has a degree of devil-may-care.[41]

Simon Bates – visiting the troops in the Middle East as if he were the reporter John Simpson – had gone, but Nicky Campbell interviewing an author about the troubles in Northern Ireland for forty minutes on drive-time seemed equally misplaced, especially as he was still otherwise best known for hosting the first eight years of *Wheel of Fortune* (ITV, 1988–2001).[42] 'If I play my cards right,' Wayne Carr had prayed during one *On the Hour* package, 'I might just land the guest presentation spot on a lightweight news-based quiz.'[43] For Morris, pomposity on what was still a pop music station was as misplaced as Alastair Cooke hosting the *Top Forty*.

Nor were Morris's 1FM shows about discovering new bands as such, though just as he had flown a flag for They Might Be Giants in Radio Bristol and GLR days, he reserved special enthusiasm for rising stars like Ash and Beck. His was never a John Peel or Andy Kershaw type of programme, designed to explore radical avenues of music. A typical running order was a jukebox of favourite oldies and accessible album tracks, with a cherry-picking of the playlist for good measure. Morris summed up his music policy as 'anti-snob',[44] with no dominant genre, covering everything from 'handbag to gangsta'.[45] It was all a continuation of his determination to play 'ninety-nine per cent brilliant music – the other one per cent will be the most dreadful music ever made'.[46] He often sneaked in the 'dreadful' (Jimmy Tarbuck sings Kylie, David Essex, Derek Jameson) as solace for a fictional traumatised correspondent during a semi-regular spoof request spot modelled on the shamelessly sentimental Simon Bates feature 'Our Tune' (BBC Radio 1, 1980–93).

Radio 1's uneasy mix of music entertainment and worthy public service values had always had its critics. It has been claimed that The Smiths' Morrissey and Johnny Marr wrote their DJ-bashing anthem 'Panic' in 1986 after hearing the station cut back from a newsflash about the Chernobyl nuclear catastrophe to Wham!'s 'I'm Your Man' (1985).[47] It would always be a tall order for the station, running serious, even tragic news content in close proximity to cheerful chart sounds. Though blunt, Morris's parodies of Radio 1 implied that occasional lapses in taste were inevitable: curtailing a report on a fictional train crash to go back to the music, with Dave Edmunds, 'who's still "Crawling from the Wreckage"'.[48] One could not really blame pop. More culpable, Morris seemed to suggest, were those running the station's news magazine shows like *Newsbeat* (BBC Radio 1, 1973–), longing for them to be more bombastic and even sexier, yet somehow also wanting to retain their sense of authority and compassion. It's best illustrated by his 'Newsbanger' package on a school siege, with copious use of rock classics like 10cc's 'Rubber Bullets' (1973): 'But these bullets were not made of rubber, they were real, as the innocent bystanders were about to find out.'[49] Morris's 1FM series would find him confronting the station's two conflicting components – entertainment and 'responsible' information – in increasingly stark fashion. For his fifth show, Morris called up the *Newsbeat* office in a supposedly agitated mood, refusing to open the fader and grant access to the customary bulletin halfway through the show. Instead he rang a convenience store in

London's Oxford Street to ask the counter staff what was on their newspapers' front pages, before asking for a more general overview, 'live from the scene'.[50]

Fake Obits and Focus Groups

But show six on 6 July 1994 would create its own press notices. 'This is BBC Radio 1FM, and if there is any news of the death of Michael Heseltine in the next hour, then we'll let you know,'[51] assured Morris, launching into a succession of records and tributes. The Conservative Cabinet minister, at the time the President of the Board of Trade, had recovered from a heart attack in June 1993, but his health and political future had been endlessly questioned since. Regardless of the perceived state of his physical condition, he remained combative; less than three weeks before the Morris broadcast, Heseltine appeared on the *Today* programme attacking BBC news policy thus: 'I think the BBC is well up to form running an absolute "no-no" of a story at the head of the news as if it is fact when it is fiction.'[52]

Morris's spoof was less an obituary of Heseltine than the theorising of how *Newsbeat* might cover such an event, uniting pop and politics. Heseltine was never a pop fan *à la* Tony Blair or David Cameron, but a standard trick of using music in 1FM's news coverage was to tenuously associate song titles with a news story. Most of Elton John's 'Song for Guy' (1978) was played, with Morris mumbling 'What a guy' over the fade.[53] The 'Michael' song cupboard was already bare after a Prefab Sprout album track, but salvation came with Toni Basil's cheer-leader anthem 'Mickey' (1982), accompanied by various speeches from Mickey Heseltine's glittering career. Exploiting *Newsbeat*'s other practice – find a pop angle in any news story – Morris secured tributes not only from MP Jerry Hayes (on the pretence that they were updating the obit tapes), but also from The Jam's former bass player Bruce Foxton, who advised on suitable basslines for the mournful occasion.[54] 'Within minutes,' recalls producer Oliver Jones, '*Newsbeat* were on the phone.'[55]

The Heseltine stunt aired the same day that the BBC's Charter was approved by the government for a ten-year renewal. Morris was suspended for his next two programmes, and never broadcast live again.[56] Some commentators – like Heseltine's journalist daughter Annabel in the *Sunday Times* – used the media to deplore the stunt, while filling yet more column inches about the meaning of the still-living statesman's legacy.[57] It was some irony. In any case, the item was arguably less to do with Heseltine himself than with the media's obsession with tributes to ailing public figures. 'How would you like to be remembered?' was a common question in celebrity Q&As from the 1990s, while Channel 4's *The Obituary Show* (an occasional strand of the *Without Walls* [Channel 4, 1990–6] arts series) invited subjects like Oliver Reed and Jimmy Savile to present overviews of their own lives as if they had died.[58] The news in the weeks leading up to Morris's 1FM series was dominated by the untimely deaths of Nirvana's Kurt Cobain and Leader of the Opposition John Smith, plus Dennis Potter's 'final interview' for Channel 4, conducted by Melvyn Bragg.[59] It sometimes did feel as if news organisations, including the one at 1FM, were a little too keen to act as both a eulogist and an emergency service, a habit Morris was not slow to highlight.

There is little doubt that some found Morris's brand of humour flippant and even cruel, but he insisted he was not defiantly nudging taste barriers, merely spontaneously reflecting what a casual radio audience – which lacked the rigorous consistency of a taste and decency panel – might laugh at. 'It's not as if I'm on a campaign to make people psychologically less imprisoned, people ought to acknowledge that of course they laugh at sick jokes in the privacy of their own homes.'[60] Focus groups were, for him, a complete waste of time anyway. When it was announced in August 1994 that 1FM was joining forces with one tabloid newspaper, which had spent months attacking Matthew Bannister's new direction, and creating a 'Sound Advisors' panel of experts and lucky listeners,[61] Morris responded with contempt. Imagining the advisors' findings, he pieced together a slogan from tiny lyrical samples by everyone from The Beatles to Midge Ure. The result, 'We/ain't/got/no/far-/-king/i-/-dea',[62] gave a clear indication of how he felt about the notion of policing a pop radio station. Especially with the *Sun* donning the helmets.

The use of music in the shows, an often upbeat and cheery party tape, acted as a release valve from the eccentric, tense and macabre brand of zoo radio practised by Morris and collaborators like roving reporter Paul Garner, and in particular the writer-performer Peter Baynham.[63] Working from a rough script, Morris and Baynham would semi-improvise bizarre sketches triggered by their own fractious on-air relationship: Morris goading Baynham into removing a tortoise's shell and throwing the creature across the studio, before the pair squabbled as to whose fault it was during a phone call to a shocked-sounding vet. This kind of ballooning mayhem, which reappeared the night Baynham claimed to discover the corpse of fellow DJ Johnnie Walker in the next studio, seemed a straight line from Morris's childhood:

> I've always liked to bugger about with sound. I was given a tape recorder when I was quite young, and I used it to record family arguments. I'd press Record, leave it running, go into the room and be mildly provocative. Things would always escalate out of proportion. One time, a row built to a huge crescendo and an aunt says, 'Well, this is a fine way to spend our wedding anniversary' – there's a huge pause – then an uncle says, 'The emotional knockout blow.'[64]

Everything Sticks Like a Broken Record

Morris's creative association with Baynham extended to another radio series of music and speech items, the late-night *Blue Jam* (BBC Radio 1, 1997–9).[65] By now, Radio 1 ran no other designated comedy slot, and the tone of the station had switched back from current affairs to new music first. With a marked deceleration in pace from Morris's previous work, *Blue Jam* was hailed as a radical departure from both his past, and radio comedy in general, but many similarities remained: spoof interviews, club news and charts with Michael Alexander St John, plus jingles modelled as pop pastiches (Eels, Tricky) which graphically described the fates of various Radio 1 hosts. There was even room for a cut-up or two: a *Newsbeat* bulletin, plus the Archbishop of Canterbury's address at the funeral of Princess Diana, and a return of the backwards message, thanks to Elton John's new version of 'Candle in the Wind' (1997). Indeed, had the pilot of *Blue Jam* not already been announced a month before the

Princess's death in August 1997, it would be tempting to view the series as a parody of how pop radio behaved in the aftermath of her demise: a temporary removal of jollity and gregariousness, replaced by sombre, instrumental music and sober voiceovers.[66]

Blue Jam's sketches, presented as mini-dramas or the sort of fly-on-the-wall documentaries common to Radio 4, shared the same sort of escalating crises explored by Morris and Baynham three years before. This time, though the twosome scripted many of the sketches, actors including David Cann, Amelia Bullmore and Kevin Eldon populated them, as dysfunctional or monstrous figures facing nightmarish situations like an infestation of lizards in a television set, or a married couple reacting with polite indifference to a fire in their home. Content-wise, these dramas weren't so far away from mutilating a tortoise or uncovering a DJ's cadaver, except that the tone was deliberately slower, and far less jovial. Unrelenting background noise or a fragment of music persisted underneath each item, usually a locked, looped section from the opening bars of a track, whether the Chemical Brothers or Rupert Holmes's 'The Pina Colada Song' (1979). The demands of drowning a whole show in sound had been facilitated by the technical hardware, which enabled its producer 'to muck about with about twenty different things at once on a computer, as opposed to being stuck in a room drowning in endless spools of tape'.[67]

Though many press notices praised Blue Jam's diverting and occasionally disturbing sketch items, few emphasised the vital importance of music to the programme. Morris would champion plenty of new records from independent dance labels such as Warp and Ninja Tune, but also present were warm forays into lounge mood music (Air, The Cardigans), desolate American rock (Mercury Rev, Lisa Germano) and so on, along with favourite oldies from John Lennon, Scritti Politti and others. This music policy ('anything with character, somewhere between ambient and a groove')[68] suited a programme which, like most pop radio, was to be half-listened to, in this case in a sleepy, inattentive, contemplative fashion. Credited specifically as producer,[69] Morris confined any spoken contributions to monologues penned by Robert Katz,[70] and to the sombre-voiced absurdist and bizarre anti-greetings which bookended each edition. Behind each of these intros and outros lay a ruinous barrage of chaotic, unsettling and even formless sound, with restless percussive effects and stray samples limping in from Lionel Richie, Madonna and The Beach Boys – as if his jingle collages of old were numb and wizened from overuse.

Initial audiences for Blue Jam were tiny – only around 100,000[71] – but what they heard was a perfect balance of alienating, detached comedy with comfort blankets from Morris's record collection, a combination that became sorely missed when the series was adapted for television as Jam (Channel 4) in 2000. Though many Blue Jam items were remade, complete with looped background music, the omission of full tracks meant that what remained, regardless of the slow pace, was a relentless twenty-five-minute sequence of mordant sketches. There was no room for the material to breathe any more. Besides, the original model was such a pure radio invention, an hour-long continuous soundscape of music and speech designed for solitary, half-asleep consumption in the small hours, that a television adaptation show at around 10.30 pm lacked sufficient dynamism to work on its own merits. Much the same could be said of Warp Records' CD compilation of Blue Jam sketches;[72] for best effect, the radio shows needed to be heard in full, tracks and all.

Morris the VJ

If *Jam* failed to reach the heights of its radio ancestor because its musical dynamics were restricted, Morris's other television projects like *The Day Today* and *Brass Eye* used music in an organic fashion much more in keeping with his radio work. These satires on current affairs broadcasting reflected the way that the zappy approach of youth TV had begun to seep into the previously more sedate world of mainstream bulletins and documentaries (for instance using extracts from pop to accompany footage for a spoof sell-through video of the Gulf War).[73] They also revived the 'sick Chris' idea of using pop parody as a launching pad for deliberate provocation: a fictional 'gangsta' rapper shooting members of his audience,[74] or 'Purves Grundy' (a send-up of Jarvis Cocker) penning a creepy tribute to the murderer Myra Hindley.[75] These were parodies of tabloid television tutting at youth culture and despairing at things 'going too far'.

Outlasting his radio career, Morris's screen work as a writer and director has explored multimedia and the Internet as music arenas ripe for lampooning, and he continued to pro-gramme the music for these projects. *Nathan Barley*, the satirical sitcom he co-wrote with Charlie Brooker (Channel 4, 2005), boasts a bewildering score split roughly into three basic categories. One of these is a spread of 'credible' leftfield dance music, while another presents a derivative, clueless bastardisation of dance styles as practised by the likes of Barley's DJ char-acter (for whom 'experimental' will equal 'unlistenable').[76] A third category presents melodic, reassuring oldies as background noise (from Shalamar to Kool and the Gang). Played on radios in cafés, shops and offices, they represent the recognisable outside world, music favoured by mainstream pop stations like BBC Radio 2 and Heart FM. These three ingredients – the spiky, the clumsy, the familiar – collide in various sequences throughout the series, but most notably in a scene parodying a club night showcasing mash-ups: samples of 1980s hits clumsily and ineptly tossed on to contemporary rhythms by DJ Barley. It's tempting to view the scene as what might happen if Morris were to play his fragmentary radio jingles in a live setting.[77]

Morris's award-winning debut feature film, *Four Lions* (2010),[78] a comedy about a British group of budding Islamic jihadists, was far more sparing with music than almost anything else in his career. Even here, though, the soundtrack's selections show some irreverent cross-cul-tural juxtaposition: a rock guitar hero remakes a Nitin Sawhney track, a brass band covers an acid-house anthem, and the central characters bond over an anodyne pop hit, joyfully singing along to its chorus as they travel from Sheffield to London, intent on causing destruction.[79]

The transition from radio to screen work seems permanent for Chris Morris, at least at the time of writing; not since 2000, when he offered two half-hour mixes for Mary Ann Hobbs's *Breezeblock* on Radio 1, has he officially played the role of radio DJ. Friends like Trevor Dann have occasionally speculated that Morris might like to return to the airwaves some day, and certainly he would seem an obvious fit for the BBC digital station 6Music, which has to some extent inherited the fanatical music-loving listenership of both Radio 1[80] and two London radio stations: GLR and the commercial indie-rock station XFM. Many broadcasters have tried to mix stunts and tunes since Morris's day, including the writer–performer Jon Holmes (6Music), while Adam Buxton and Joe Cornish (XFM, then BBC 6Music) have shared Morris's lightness of touch and engaging freshness.

In 1994, seven years after the start of *No Known Cure* in Bristol, Morris publicly analysed the nature of his shows as DJ. Compelled after the Heseltine item to pre-record his 1FM series, he felt its spontaneity to be its strength. 'I don't want to do a one-hour built comedy programme with music, to be an Adrian Juste for the 90s. The whole point is that it's a music show with attitude.' [81] Simon Bates, who had preferred to travel round the world rather than present the Radio 1 Roadshow in Rhyl or Bude, felt it insufficient for a public service pop station to be 'just wacky … . You have duties and responsibilities.' [82] Chris Morris, on the other hand, felt that public service broadcasting's role was to support the freedom to create and misbehave. 'I can't stand that high-handed attitude that there's a proper way to behave,' he told the *Guardian*. 'Everyone's fucking about. You're just displaying it.' [83] And despite the meddling and occasional controversies which surrounded the records throughout his radio days, he never forgot that the music still came first.

Notes

1. Stage interview with Chris Morris by Paul Lashmar, Bournemouth University, 6 March 2007.
2. *The Radio One Story* (BBC 2, 20 September 1997). The venerable Blackburn, still presenting on BBC Radio 2 in 2012, was BBC Radio 1's first breakfast-show host (1967–73) and spent seventeen years at the station, eventually leaving in September 1984. He also broadcast a weekday show for BBC Radio London (GLR's predecessor) between 1982 and 1988. His cheerful on-air approach, with a reliance on corny jokes, has been mocked as well as praised, but this veneer has sometimes disguised a sincere love for music, most notably soul.
3. Simon Garfield, *The Nation's Favourite: The True Adventures of Radio 1* (London: Faber and Faber, 1998), p. 48.
4. Dann's television productions in the mid-1980s included the BBC's *Live Aid* (1985) and the weekly *Whistle Test* series (BBC 2, 1983–7). One *Whistle Test* edition (12 March 1985) featured Chris Morris's first-known TV appearance, as part of The Exploding Hamsters, in a package about the Cambridge rock music scene.
5. Interview with Ian Greaves and Justin Lewis, 30 August 2002.
6. Ibid.
7. Ibid.
8. 'Fear of a Backwards Planet' [no author credited], *New Musical Express* (17 February 1990), p. 5. Later in 1990, the British rock band Judas Priest was involved, but acquitted, in a real-life court case in Nevada, accused of planting satanic messages in several of their songs, which was linked to the suicide pact of two teenage fans in December 1985.
9. Steven Wells, 'Hang the DJ', *New Musical Express* (31 March 1990), p. 27. Wells and colleague David Quantick would soon be invited by Armando Iannucci to join the *On the Hour* writing team.
10. 'Select Flexi', *Select* no. 24 (June 1992); original catalogue number FLOP1. This was included in full as part of the *On the Hour* CD reissue set released in 2008.
11. The two groups would have made for an unlikely pairing: U2's earnest, idealistic worldview against rap icons NWA's bleak and alienating one (typified by their track 'Find 'Em, Fuck 'Em and Flee' [1991]).

12. 'Sun Slams Sick Select Flexi!' [no author credited], *Select* no. 24 (June 1992), p. 5.

13. In issue 44 of *Select* (cover dated February 1994), the television premiere of *The Day Today* was celebrated with a deadpan double-page fake article: 'Is News the New Rock'n'Roll?' by Andrew Harrison, pp. 8–9.

14. Interview with Ian Greaves, 17 July 2002.

15. 'Select Flexi', covermount to *Select* no. 24 (June 1992).

16. *The Chris Morris Music Show* (10 August 1994). Mischievously cast against type by Morris, the real R.E.M. had regularly made their pro-environmental views known.

17. Simon Price, 'Jam Session', *Melody Maker* (29 November 1997), pp. 26–7.

18. *The Chris Morris Music Show* (21 December 1994).

19. *The Chris Morris Music Show* (31 August 1994).

20. Jeremy J. Beadle, *Will Pop Eat Itself?* (London: Faber and Faber, 1992), p. 100.

21. Justified Ancients of MuMu, 'All You Need Is Love' (single release, 1987).

22. Featured in the public service film *Monolith* (commonly known by its slogan 'Don't Die of Ignorance'), shown on British television from 8 January 1987.

23. Suzi Lewis-Barned, 'Morris Mania', *Radio Times* (West edition) (24–30 October 1987), p. 93.

24. 'Kick it!' heralded the start of the Beastie Boys' breakthrough hit, 'Fight for Your Right (to Party)' (1986). Morris often used this cry to halt the radio station's official jingle, and it is tempting to imagine it as a tribute to the way the JAMs used the MC5's 'Kick Out the Jams' (1969) on 'All You Need Is Love' to stop the French national anthem and The Beatles in its tracks.

25. 'Spirit of Adventure' by The Exploding Hamsters, part of a demo tape recorded at Treetop Studios, Ipswich, April 1986.

26. Part of Margaret Thatcher's speech at the Conservative Party Conference, Brighton, 10 October 1980.

27. *Saturday Superstore* (BBC 1, 10 January 1987)

28. 'My Guy's Mad at Me' by Tracey Ullman (single release, 1984).

29. *The Chris Morris Music Show* (29 June 1994).

30. See for instance, *Chris Morris* (GLR, 15 May 1993) during his final show for the station.

31. Andy Beckett ,'Prank Master', *Independent on Sunday* (21 August 1994: The Sunday Review), p. 12.

32. *The Chris Morris Music Show* (8 June 1994).

33. Interview with Ian Greaves and Justin Lewis, 24 July 2002. Jones's role as producer did not involve discussing scripts, nor in programming music, but in protecting Morris and the programme from BBC management.

34. Respectively: Peter Hammill (who, like Morris, had been educated at Stonyhurst College in Lancashire) and Sylvester Stewart.

35. Though this was his first full series for BBC national radio as a DJ, Morris had made previous appearances in this capacity. After winning an award for his GLR show at the International Radio Festival of New York, Morris's first Radio 1 DJ programme was broadcast at 3.00 pm on 25 December 1990, but was not invited to do any further broadcasts. He also spent a week deputising for Danny Baker on BBC Radio 5's *Morning Edition* from 13–17 July 1992.

36. *Blood on the Carpet: Walking with Disc Jockeys* (BBC 2, 16 January 2001).

37. *Smashie & Nicey: End of an Era* (BBC 1, 4 April 1994). The characters had featured regularly on *Harry Enfield's Television Programme* (BBC 2, 1990–2) from the series debut on 8 November 1990.

38. *The Radio One Story* (BBC 2, 20 September 1997).

39. Lewis-Smith's Radio 1 debut came with a one-off special, broadcast on 30 May 1988.

40. *Armando Iannucci: The Radio Scotland Years* (BBC Radio Scotland, 27 December 2006). At 1FM, Iannucci's own self-titled show ran for two short series in the evening schedules (27 March– 3 April 1993, 7–28 March 1994).

41. Simon Price, 'If It Bleeds, It Leads', *Melody Maker* (4 June 1994), pp. 38–9.

42. Campbell's ten years as a Radio 1 DJ ended in October 1997, when he moved to BBC Radio Five Live to present live current affairs programmes. As of May 2012, he is presenting the breakfast slot.

43. *On the Hour*, series one, episode one (BBC Radio 4, 9 August 1991). The item had previously also appeared in the series' untransmitted pilot, completed in April of that year.

44. John Dugdale, 'Taped Up for Auntie', *Guardian* (25 July 1994: G2), pp. 16–17.

45. Price, 'If It Bleeds, It Leads', pp. 38–9.

46. Suzi Lewis-Barned ,'It's Addictive!', *Radio Times* (West edition) (11–17 July 1987), p. 75.

47. For further details, see Johnny Rogan, *Morrissey & Marr: The Severed Alliance* (London: Omnibus Press, 1992), pp. 252–3.

48. *On the Hour*, series one, episode one. Again, this had first appeared in the untransmitted April pilot.

49. *On the Hour*, series two, episode six (28 May 1992). A slightly different edit had been broadcast days earlier on *Chris Morris* (GLR, 25 May 1992). *Newsbeat* bulletins (usually fifteen minutes long) had been a mainstay of the Radio 1 weekday schedule at lunchtimes and drive-time since September 1973. Retitled *News 90* (etc.) from 8 January 1990, it reverted to its original title on 10 January 1994, by which time all the station's shorter summaries were also given the same title.

50. *The Chris Morris Music Show* (29 June 1994).

51. *The Chris Morris Music Show* (6 July 1994).

52. *Today* (BBC Radio 4, 18 June 1994). See also Adrian Lithgow, 'Heseltine Fury over BBC "Lie"', *Mail on Sunday* (19 June 1994), p. 6.

53. The mostly instrumental 'Song for Guy' was composed and recorded by Elton John in 1978 as a tribute to the seventeen-year-old messenger boy at his record company Rocket Records, who had died in an accident.

54. *The Chris Morris Music Show* (6 July 1994). Eventually, Foxton gamely decided that 'That's Entertainment!' (1980) was most appropriate.

55. Interview with Ian Greaves and Justin Lewis, 24 July 2002.

56. *The Chris Morris Music Show* returned to Radio 1 (in pre-recorded form) from 27 July 1994.

57. See Annabel Heseltine, 'Demise of the British Sense of Humour', *Sunday Times* (10 July 1994), p. 11.

58. Savile presiding over his own obituary for the Channel 4 series (20 October 1992) may explain why Morris ran a spoof news item (1 June 1994, and again on 26 December 1994) announcing Savile's death. The former Radio 1 and TV personality was not amused by the item and

announced in January 1995 that he would be suing the BBC. Savile's actual death occurred on 29 October 2011, two days before his eighty-fifth birthday.

59. Dennis Potter died, aged fifty-nine, on 7 June 1994. The interview with Bragg – *Without Walls: An Interview with Dennis Potter* – had been broadcast on Channel 4 on 5 April. Kurt Cobain had been found dead, aged just twenty-seven, on 8 April, while fifty-five-year-old Smith had died suddenly of a heart attack on 12 May.

60. 'Price, 'If It Bleeds, It Leads', pp. 38–9.

61. See Andy Coulson, 'Join the Board of Radio 1', *Sun* (17 August 1994: *Bizarre*), p. 15. The 'Sound Advisors' campaign had been organised with the help of a PR company headed by future *Brass Eye* target Lynne Franks. Also on the panel, according to Coulson's report, would be 1FM's breakfast-show host of the time, Steve Wright, and pop-soul hit-maker Dina Carroll.

62. *The Chris Morris Music Show* (24 August 1994).

63. Baynham was also a regular contributor to 1FM shows hosted by Armando Iannucci (1993–4) and Lee and Herring (1993–5).

64. Price, 'If It Bleeds, It Leads', pp. 38–9.

65. In 1995, 1FM had reverted back to its original name of BBC Radio 1.

66. In the days after 31 August 1997, Radio 1 drastically reduced airplay for chart-topping records like Will Smith's 'Men in Black' (1997) and Chumbawamba's 'Tubthumping' (1997), instead opting for George Michael's elegiac 'You Have Been Loved' (1997) and sensitively chosen oldies like 'Unfinished Sympathy' (1991) by Massive Attack, as well as increasing plays for Puff Daddy's tribute single 'I'll Be Missing You' (1997).

67. Price, 'Jam Session', pp. 26–7.

68. Ibid.

69. As well as being *Blue Jam*'s technical producer, Morris directed the actors' sketch items.

70. The Katz contributions were making a national radio debut via *Blue Jam*, but embryonic readings (this time by its author) had appeared as inserts on Morris's swansong programmes for GLR in April and May 1993 under the heading of 'Temporary Open Space'.

71. Simon Garfield, *The Nation's Favourite: The True Adventures of Radio 1* (London: Faber and Faber, 1998), p. 174.

72. Chris Morris, *Blue Jam* CD (2000).

73. *The Day Today*, episode five.

74. *The Day Today*, episode two. Among the tracks referenced or sampled in Morris and Jonathan Whitehead's Fur Q parody 'Uzi Lover' were Tom Scott's 'Gotcha' (1977, the theme to *Starsky and Hutch*), Carly Simon's 'Why?' (1982) and, inevitably, 'Easy Lover' (1984) by Philip Bailey and Phil Collins.

75. *Brass Eye*, episode six. This item about the group 'Blouse', a thinly veiled tribute to Pulp, contained a pastiche entitled 'Me Oh Myra'.

76. Morris and Whitehead devised the deliberately awful Barley tracks for the series. Whitehead had also invented the music supposedly created by another deluded DJ/musician in a contemporary TV sitcom: Jeremy Usborne, as played by Robert Webb in *Peep Show* (Channel 4, 2003–).

77. See *Nathan Barley*, episode two.

78. In February 2011, Morris won a BAFTA in the category of Outstanding Debut by a British Writer, Director or Producer.

79. *Four Lions* (2010). Respectively: Jeff Beck's 'Nadia' (2001); The William Fairey Brass Band's version of Kevin Saunderson's 'The Groove That Won't Stop' (1997); Toploader's 'Dancing in the Moonlight' (1999).
80. Among former Radio 1 and 1FM voices broadcasting on BBC 6Music, as of May 2012, are Mark Radcliffe and Stuart Maconie, Steve Lamacq, Dave Pearce, Marc Riley, Gilles Peterson and Mary Anne Hobbs.
81. Dugdale, 'Taped Up for Auntie', pp. 16–17. Adrian Juste's programmes for Radio 1 (between 1978 and 1993) inherited the style invented by DJ and former bandleader Jack Jackson for the BBC Light Programme in the 1950s and 1960s, where records jostled for space in a programme with extracts of comedy sketches and other items.
82. *The Radio One Story*.
83. Dugdale, 'Taped Up for Auntie', pp. 16–17.

3

MOCKING THE NEWS: *THE DAY TODAY* AND *BRASS EYE* AS MOCKUMENTARY NEWS SATIRE

CRAIG HIGHT

The news satires *The Day Today* (BBC 2, 1994) and *Brass Eye* (Channel 4, 1997; 2001) are important to the history of both mockumentary and television satire more generally. This chapter argues that Chris Morris's work in these two series helped to lay the foundation for a broader naturalisation of news satire in the television mainstream, in the process creating examples of television satire, which have rarely been equalled. This discussion outlines the distinctiveness of these series in the small but vibrant tradition of mockumentary news satire. A key comparison is made here with the contemporary standard-bearer of the genre, the American-based *The Daily Show* (Comedy Central, 1996–), which proves a useful reference point for assessing the Morris style of news satire and accounting for the difficulty of replicating the rhetorical impact it had in the UK in the late 1990s.

Defining Mockumentary[1]

Mockumentary can be identified through reference to three levels of media practice. First, it arises from different agendas on the part of fictional media producers, drawing in particular from parodic and satiric traditions. Second, at the textual level, mockumentary is closely tied to the development of a broader fact–fiction continuum, one that encompasses non-fiction forms such as documentary, television news and current affairs, together with more explicitly hybrid forms such as those formats typically labelled 'reality TV'. In simple terms, mockumentaries are fictional texts (from different media) that employ a sustained appropriation of codes and conventions from this fact–fiction continuum. Most examples of mockumentary, however, do not develop a clear critique or commentary of such forms, and tend to be easily labelled by audiences as 'playful' rather than subversive. The third part of a definition of mockumentary relates to audiences, who have to receive such tactics *as* mockumentary if they are going to achieve their desired impact and effect.

It is a measure of the complexity of mockumentary that it can be employed to a variety of ends by different media producers, across different media. There are common, overlapping tendencies in the production of mockumentary, which both govern the nature of the

appropriation of non-fiction forms within a given text and cue the manner in which audiences are encouraged to engage with that text.

The infamous 1938 *The War of the Worlds* radio broadcast commonly attributed to Orson Welles is an exemplar of a media prank, a tradition that encompasses all forms of April Fool's Day jokes initiated by various news media. These items are invariably flagged to audiences, either by the absurdity of content, their placement in a news bulletin or simply by announcers reminding audiences of the date. There are other novelty/stunt examples, particularly in television, with skit shows occasionally employing a mockumentary style and both dramatic and comedic television series adopting the mockumentary form for a one-off episode (including series such as *M*A*S*H* [CBS, 1972–83], *ER* [NBC, 1994–2009], *The X-Files* [Fox, 1993–2002], *The West Wing* [NBC, 1999–2006] and *The Simpsons* [Fox, 1989–]).

Often closely related to the use of mockumentary as a novelty style are examples of the appropriation of non-fiction codes and conventions for promotional purposes. Typical of this tactic is a long history of the use of mockumentary in electronic advertising, with several instances of fake 'making of' documentary segments being included as DVD extras (such as the mock-biography of *Star Wars* android R2D2 from the *Attack of the Clones* [2002] DVD) or online promotional material (for example, some of the playful podcasts from director Peter Jackson while working on the set of *King Kong* [2005]).

Another strong pattern, especially in cinematic mockumentary, is the production of a number of non-comedic mockumentaries, or those which utilise the mockumentary form for dramatic purposes. This has proved especially effective in revitalising horror (*The Blair Witch Project* [1999]) science-fiction (*Cloverfield* [2008]) and superhero (*Chronicle* [2012]) generic conventions (there is also a clear overlap here with some forms of drama-documentary which appropriate documentary codes and conventions).

The bulk of mockumentary practice, however, has clearly emerged from within parodic and satiric traditions, producing a broad range of mockumentaries reflective of the complexity of parodic discourse itself. Parody typically exhibits an ambivalence toward its target, both mocking the text it references and reinforcing its authority; what Hutcheon refers to as the 'paradox' of parody.[2] This, however, does not necessarily suggest that parody is only ever parasitic, nor that it does not have the potential to be subversive or transgressive – in the sense of directly challenging or transcending the codes and conventions that it references (*David Holzman's Diary* [1967], for example, anticipates practices of autobiographical and cinema vérité documentary which were still emerging at the time). Harries insists that parody essentially involves 'the process of recontextualizing a target or source text through the transformation of its textual (and contextual) elements, thus creating a *new* text'.[3]

A parodic text's relationship to the text(s) that it references is also partly determined through audience interaction. The ambivalence of parodic discourse toward its target allows audiences to engage with it in numerous ways, and, in a sense, that ambivalence is ultimately decided by the viewer. Whether a text is truly subversive, and to what extent, depends very much on such factors as the levels of extratextual knowledge which audiences bring to this encounter (as discussed below). The most complex and interesting examples of mockumentary practice are those texts with a deliberately satirical agenda, not least because these tend to entail a challenge toward the forms they reference. In general satire establishes a

more political stance toward its target and consequently demands 'a heightened state of awareness and mental participation in its audience (not to mention knowledge)'.[4]

As can be seen from just this initial schematic of mockumentary, the form has involved often conflicting strategies and intentions on the part of media producers. Mockumentary texts can range from a superficial referencing of non-fiction forms to densely layered and innovative textual constructions. In fact, the best examples of mockumentary typically construct a complex set of potential experiences for audiences, drawing upon a number of inter-textual references and seeking to engage with viewers' knowledge of wider visual culture and social-political discourses. They establish characters with which the audience can identify, and develop narratives that do not depend purely upon knowledge of other texts in order to be successful. The specific types of engagements constructed by a text can suggest the overall agendas of a producer or film-maker, but in general mockumentary allows audiences specific forms of *play*, encouraging viewers to draw upon their own detailed expectations of a continuum of non-fiction and hybrid forms. Mockumentary discourse plays with documentary's rhetorical address to its audience, incorporating this within the novelty, promotional, dramatic and comedic aims outlined above. In effect, the most crucial transformation of documentary practice performed by mockumentary is to change documentary's call to action into a *call to play*.

Reading Mockumentary

The degree to which such a text is reflexive toward its intended targets and/or non-fiction forms as a whole is also clearly dependent upon both immediate and wider contextual factors shaping an audience's encounter with that text. The New Zealand television mocku-mentary *Forgotten Silver* (1995), for example, was intended to be recognised as a mockumentary by audiences while they were actually viewing its initial broadcast. Like the radio mockumentary *The War of the Worlds*, the programme's producers assumed a know-ing and sophisticated viewer who would quickly identify the playful way in which New Zealand national identities and historical narratives were being referenced. However, a combination of the sophistication of its extratextual framing and the skill with which directors Peter Jackson and Costa Botes blended archival and fictional material created an unintended resonance with local viewers. Many local audiences only realised it was fictional some time after viewing, and expressed surprise and even outrage at being tricked. Their responses, to this demonstration of how easy it is to fake non-fiction material, suggest that the initial broadcast triggered for many a heightened perception of reflexivity toward the factual forms which the programme mimicked so effectively.[5] This is a quite different response from the appreciation of the playful engagement with cinematic history that subsequent screenings (and foreign viewings) have tended to generate.

A significant issue here is whether or not a text clearly 'flags' its status as a fictional text, and the extent to which audiences are able to recognise these cues and begin to participate in a mockumentary frame of reading. As suggested above, this type of text perhaps demands greater critical and contextual awareness on the part of audiences.[6] On the one hand, there

is something of an iterative loop of reflexivity toward audiovisual non-fiction here, with mock-umentary both drawing upon and helping to intensify the audience's critical literacy toward the broader fact–fiction continuum. Harries argues, in relation to the reception of parodic texts, that:

> Not only do parodies create 'something' (new textual configurations as well as modifications to pre-existing canons), they also foster 'ways' to view texts, developing and nurturing *critical* spectatorial strategies. While parody does indeed rely on and cannibalize other texts, its reworkings affect not only the viewing of previous textual systems but also the construction and viewing of future related canonical texts.[7]

On the other hand, mockumentary series have become part of mainstream television pro-gramming, no longer a form assumed to have a parasitic relationship with documentary and other non-fiction but accepted as another potential style of storytelling. The UK 'mockusoap' *The Office* (BBC 2/BBC 1, 2001–3) is perhaps the most celebrated example of television mockumentary, in part because it transcended its origins as a parody of UK docusoaps to help create a new archetypal form in the sitcom genre. Assessing the nature and impact of a mockumentary text, then, includes identifying the intent underlying its specific appropria-tions from the fact–fiction continuum, and examining its reception by its intended audience.

The Daily Show and Television News Satire

News satire has its own history in television, shaped by often distinct inflections of satiric tra-ditions within different national contexts. Major reference points within the broader history of news satire include sketches within the British series *Monty Python's Flying Circus* (BBC 1/BBC 2, 1969–74), the 'Weekend Update' segment from the American *Saturday Night Live* (*SNL*) (NBC, 1975–), parts of the North American *SCTV* (Global, 1976–81), British and American versions of *That Was the Week That Was* (UK: BBC, 1962–3, US: NBC, 1964–5) and the Canadian series called *This Hour Has 22 Minutes* (CBC, 1992–). Episodic and highly segmented sketch-based series, these all tended to employ non-fictional referencing. Collectively these series have been important in the gestation of mockumentary by helping to establish and popularise techniques for the appropriation of non-fiction that were later taken up by producers of television and cinematic mockumentary.

 A number of satiric television news programmes now circulate globally, all referencing and, to various degrees, deconstructing television news discourses that are familiar to their local viewers. They present a mixture of parodic and satiric treatments of specific current events and the manner in which these are presented to audiences within the increasingly commercialised forms of television news. Not all might be strictly considered mockumen-tary, and not all aim for a sustained appropriation of fact–fiction aesthetics, instead typically featuring mockumentary as one part of a broader palette of comedic styles. But they all share familiar tactics: parodic appropriation of news media, satiric interrogation of television discourses and various forms of commentary on contemporary social and political issues.

Many of these programmes have appeared within primetime, prompted by certain institutional patterns driving post-network televisual systems and the changing tastes of their audiences.[8] Perhaps the most celebrated example of contemporary news satire is the relatively sophisticated and highly popular American 'fake news' programme *The Daily Show* from the Comedy Central network. Running four days a week in the United States, *The Daily Show* is a perfect illustration of the naturalisation of mockumentary discourse in contemporary television satire.

Jon Stewart took over as host of *The Daily Show* in 1999 and serves as writer and co-executive producer. His initial cast of regulars included Stephen Colbert, Rob Corrdry, Samantha Bee, Ed Helms, Lewis Black and Bob Wiltfong. Stewart has taken the programme into the realms of political satire, combining a critique of the lack of real political debate and analysis in contemporary television news media with a sophisticated understanding of the American political process itself. A crucial strategy is the deconstruction of the aesthetics and discourses of television news coverage of current events, with Stewart and his colleagues using various means to reveal the superficial, entertainment-centred agendas shaping such coverage.

Stewart addresses a politically educated audience, although the forms of humour he employs are often very broad. Baym argues that *The Daily Show* should be 'understood not as "fake news" but as an alternative journalism, one that uses satire to interrogate power, parody to critique contemporary news, and dialogue to enact a model of deliberative democracy'.[9] In the words of Day's excellent analysis, 'the program works to blur the line between news and entertainment, recontextualizing and deconstructing current news footage and interviewing actual public figures'.[10] Considerably more sophisticated than the humour of *SNL*'s Weekend Update segments, and that of the comedians of late-night talk shows, *The Daily Show*'s techniques draw partly from mockumentary for their satirical effect. The programme 'acts as a comedically critical filter through which to process the suspect real world of reportage and debate',[11] and audiences 'tune in to watch the cast comedically interrogate, critique and transform the real'.[12]

A typical episode consists of several segments, including an initial monologue from Stewart in which he highlights one or more televised current events, skilfully edited clips or performances from other comedic actors on the programme playing reporters and a studio interview. Stewart's opening address features 'the strategic use of video' to highlight the gaps and contradictions in both political and televisual news discourse.[13] Warner notes that a crucial aspect of this technique is its indirectness, with Stewart typically refraining from a direct critique, instead both guiding a commentary and allowing the audience to make up their own minds.

The address often then segues into a fake 'live' report or commentary from one of his fellow comedians. These apparently live reports feature a correspondent, labelled as the 'resident expert' depending upon the nature of the item, standing in front of an obvious bluescreen projection. The 'correspondent's commentary highlights the absurdities of political discourse by treating them as a given and extending them to their logical conclusion, while Stewart plays with a straight face, expressing surprise at recent political developments and asking rational, common-sense questions as prompts. As Gettings notes, the audience is always

aware of the ontological status of information conveyed throughout these segments, as they are clearly flagged usually through consistent types of performance and comedic graphics.[14]

Another regular segment consists of edited reports from one of the programme's roving comedic reporters, and these most clearly resemble sustained exercises in mockumentary. The correspondents perform with a mostly straight face, asking actual spokespersons to explain themselves in ways that unwittingly reveal the absurdity of their own rhetoric.[15] *The Daily Show* reporters at other times represent themselves as deliberately combative, shallow and manipulative in constructing news items that will play as great television, revealing the tendencies of actual television news reporters by presenting a broad caricature of their interviewing techniques and constructed on-screen personas.[16]

In the other main segment, studio interviews with more knowing guests, Stewart adopts a Socratic interview style,[17] claiming ignorance of guests' expertise and asking for responses which force them to explain themselves. A deliberate irony of this segment is that Stewart, playing a fake news anchor, can often ask pointed and perceptive questions that the interviewee would rarely experience in an actual encounter with American television news media.[18]

The programme's exercises in deconstructing the nature and quality of television news discourse have an American focus, and there have been debates in the local news media over the programme's significance in relation to politics, with widely circulated reports that younger and college-aged viewers were more likely to gain their knowledge of political candidates from the programme than from other sources. In effect, *The Daily Show* has become part of the political process in the United States, playing a major role in 'nurturing civic culture'.[19] Stewart himself has achieved a degree of legitimacy as an expert commentator as a result of the popular and critical success of his programme.

The Daily Show's primary target is the American political process itself and its adoption of different comedic styles (including mockumentary) is central to a strategy of immersing itself in the aesthetics of contemporary television news. The series is central to an emboldened satiric culture, which teaches its viewers both to be wary of the commercial television news mainstream and how to deconstruct its messages. Paradoxically, it is both a high point in contemporary news satire and a telling example of how banal and everyday this mode has become for today's viewers. A comparison with *The Day Today* and *Brass Eye* reveals how distinctive and innovative Chris Morris's satiric style was, and how it retains a deconstructive and subversive edge that *The Daily Show* and contemporary news satire rarely aspire to.

The Day Today and Brass Eye

Unlike *The Daily Show's* sporadic and strategic resort to mockumentary, both *The Day Today* and *Brass Eye* are more sustained exercises. They strive to maintain their appropriation of television news aesthetics, and rely on the audience to pick up on cues to its fictionality. Morris's target was television news discourse itself and its accomplices in political and celebrity circles in the UK at the time. The direct and relative ferocity of these programmes' attacks on the more populist trends in primetime non-fiction programming provoked disquiet and unease

among broadcasting institutions[20] and sometimes uncertainty among their potential audience, but it is also the basis of their eventual cult status (with Morris invariably celebrated for a total commitment to his satire).

The genesis of The Day Today lay in Morris coming together with writer/producer Armando Iannucci, Steve Coogan, Patrick Marber and others to produce an innovative news media parody for the On The Hour (1991–2) Radio 4 programme, before moving the format to television. The initial radio show, as with many mockumentaries, drew on an improvisational approach, which had to be modified for the more complex demands of television production. In stark contrast to The Daily Show, which is performed before a live and very appreciative audience, The Day Today and Brass Eye both eschewed a laugh track, in the process refusing to signpost their comic intent in the same manner.

In The Day Today, Morris played a somewhat smug, aggressive, slick-haired anchorperson, Coogan regularly appeared as hapless sports presenter Alan Partridge and Marber as inept political reporter Peter O'Hanrahanrahan. Other regular characters included weatherman Sylvester Stewart (David Schneider), American reporter Barbara Wintergreen (Rebecca Front), and business correspondent Collaterlie Sisters (Doon Mackichan). Each of the cast also appeared as other more occasional characters, usually either reporters on location or their interviewees.

The Day Today (unlike The Daily Show) was not interested in engaging with contemporary political issues but focused more on satirising the aesthetics of television news presentation. The show faithfully recreated the look and sound of television non-fiction presentation, but then teased elements of this in certain directions in order to highlight the nature of their construction to viewers. The title sequence, created by Russell Hilliard and Richard Norley, was a masterpiece in graphic satire,[21] caricaturing the fluid and densely layered style of television news graphics. (Hilliard and Norley were creators of the ITN news graphics and welcomed the opportunity to spoof their own style.)[22]

Superimposed over a base layer of news footage, a series of rotating globes would emerge out of crosshairs to shoot at the viewer, beginning with a recognisable blue-green earth and moving through globes signifying different news segments. The 'economic' globe had coinage morphed over its surface, the 'sports globe' was a blue soccer ball (football) with white continents superimposed, followed by a sphere with a grid-like mosaic of news items on its surface. This collapsed into a series of intersecting blue and red discs that overlapped each other in rapid sequence before being 'stamped' by the title of the programme that comes flying in from off screen. Where the opening titles of The Daily Show are designed to more deliberately mimic trends within contemporary news presentation, The Day Today's approach was to anticipate such trends (and inevitably the satirical impact of this sequence has lessened since the initial broadcast of the series).

A similar approach informed the visual design of each Day Today episode, with the excessive employment of graphics to mark cuts between scenes or stories (for example, the frame would suddenly shrink to a sphere and speed off screen, with accompanying sound effects). Fittingly, the segment where graphics totally took over was the weather segment – traditionally the scene of the most elaborate experiments with visual technologies as weather presenters are sutured into layered weather maps, photorealistic landscapes and weather footage.

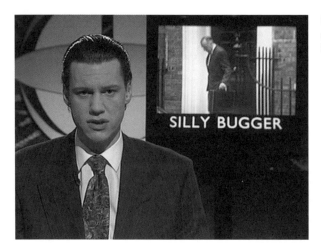

SILLY BUGGER

Chris Morris plays news anchor, one of his many roles in *The Day Today*

In *The Day Today*, weather presenter Stewart was clearly just another graphic layer in a sequence featuring a confusing mass of weather icons moving rapidly across the United Kingdom, at times morphing completely into an icon himself.

Morris and his co-presenters appeared in expensive formal dress, with heavy make-up and carefully coiffured hair, sitting behind enormous, imposing desks in a dark, cavernous studio space with large screens on the wall behind them. As lead anchor, Morris's delivery style was distinctive, his voice particularly so. As with conventional news delivery, he cued viewers' expected responses by either dramatically emphasising key words in a sentence or switching tone when changing from 'hard' news to 'soft' news. What pushed his narration into satire was partly how aggressively he put emphasis on words (and not always the obvious words) and the suddenness of his shifts in tone – highlighting the aspects of performance that are integral to news presentation.

The on-screen relationships between the various presenters suggested a clear hierarchical division between Morris and the others in the news team, who were all portrayed as dysfunctional in some sense. Partridge's sport's commentary was based more on excitement over dramatic footage than any understanding of the nuances of any particular sporting code. Likewise, Sisters's economic news consisted of a morass of incomprehensible statistical information, often communicated graphically, and articulated by her in an almost robotic tone of voice. Instead of the familiar semi-scripted repartee and apparently easy familiarity between the news team, Morris would address his colleagues in unexpected ways; engaging Partridge in long inane conversations that would leave him repeatedly failing to begin his sports news, flirting with traffic reporter Valerie Sinatra (Front), distastefully passing on to Sisters (sometimes with overheard snide comments) and virtually interrogating incompetent on-location reporter O'Hanrahanrahan during a live feed, forcing him to acknowledge that he did not have any actual facts to support his statements.

Many stories made frequent use of Morris's voiceover narration, with rhetorical flourishes matching their absurd content. Each story might contain any number of elements, including real archival footage, presented within a completely new narrative frame. This was

Patrick Marber as hapless
political reporter 'Peter
O'Hanrahanrahan' in
The Day Today

particularly the case with each episode's opening preview, which included actual footage of
public figures familiar to British audiences, such as politicians, with Morris relating an absurd
story in voiceover. These rapid montages were a combination of the absurdity of *Monty
Python*'s non-fiction parodies and the photograph and gag-story technique of *SNL*'s 'Weekend
Update' segments. As noted, these were not designed to comment on topical events but
reflected the overall goal of targeting television discourse itself. The content of stories was
always ludicrous (black-market dentistry, horses loose in the London Underground, the IRA
using 'bomb dogs' to target inner-city Britain) – the focus was instead more on the manner
in which reports were constructed, with correspondents mixing information with specula-
tion, and stories centred on replaying spectacular footage presented in as manipulative a
manner as possible (such as flash zooms into details within a frame, and the inclusion of dra-
matic music). Narratives were constructed out of disparate pieces of footage, each taken out
of context and displayed simply for rhetorical effect or to achieve a meaningless visual flour-
ish. The filmed segments could sometimes just deliver a visual riff on a topic; such as Morris
presenting a story on the suspected brain disease of politicians that simply provided a new
narrative for the stock footage of politicians moving in and out of offices and buildings, the
familiar visuals for political news stories.

 Other sequences targeted recognisable segments of television news. Rebecca Front
appeared as American reporter Barbara Wintergreen from the fictional 'CBN' network with
a large, static hairstyle and a broad accent. Her stories were carefully crafted to highlight dis-
tinctive aspects of American news feeds incorporated into British news programming.
Wintergreen presented endless variations on one story; the execution of serial killer
'Chapman Baxter' (Marber), focusing on the trivial, banal or bizarre aspects of Baxter's
(repeated) execution. These CBN stories were visually distinct from the rest of the series,
with a washed-out video aesthetic, a constantly moving camera and rapid cutting between
shots within a single scene, often including blurred footage. The series also directed its atten-
tion toward the (at the time) recent emergence of hybrid formats such as the dramatic
reconstructions of crime in *Crimewatch UK* (BBC 1, 1984–), emergency rescues in *999*

American reporter 'Barbara
Wintergreen' (Rebecca Front)
in a regular segment from
The Day Today

(BBC 1, 1992–2003), and the packaging of spectacular incidents caught on amateur cam-
corders that constituted *You've Been Framed* (ITV, 1990–). In each case the series' commen-
tary was dismissive of such trends, effectively arguing that these resulted in a 'dumbing down'
on the part of their audiences as much as television networks. Over the course of the series
other television genres were targeted, including MTV-style music programmes, youth-
education programmes and docusoaps.

A regular vox-pop segment titled 'Speak Your Brains' took the series into the territory of
more stunt-based comedy, with a disguised Morris asking members of the British public nar-
rowly framed and leading questions about obscure topics. Here the message was not only
to suggest the highly selective and manipulative manner in which such notions of 'public opin-
ion' were constructed, but also the lack of any attempt by interviewees to counter or ques-
tion the premise of the questions themselves. In the fifth episode of *The Day Today*, Morris
invented a story on the clamping of homeless people on city streets, and elicited a shocked
response from singer Kim Wilde. This segment proved to be a forerunner of the style Morris
adopted for his follow-up series, which took the rhetorical approach of *The Day Today* into
more aggressive stunt-based satire.

Morris's deconstruction of television non-fiction discourse was taken to its next logical
development with *Brass Eye*, comprised of a 1997 series and a notorious special episode in
2001. The original series consisted of episodes centred on a single theme ('Animals', 'Drugs',
'Science', 'Sex', 'Crime' and 'Decline') allowing Morris to adopt a pseudo-current affairs
approach, including developing a more coherent overall frame for each. Like *The Day Today*
familiar aspects of televisual presentation were recreated, although with a higher degree of
visual density, incorporating sequences with rapid-paced, free-association visual puns that
drew more generally upon the audience's familiarity with television aesthetics.

Instead of an ensemble cast for support, Morris played multiple characters himself,
appearing as the in-studio presenter and in various reporter roles. The same satiric tech-
niques from Morris's earlier series were repurposed here to construct a seemingly rational
frame for barely plausible (fictional) issues that each episode could 'campaign' against. The

Kim Wilde is shocked to hear
of the clamping of homeless
people (*The Day Today*)

intention of this series, in other words, was to target the agenda-setting power of media and
the dangers this power could have within a competitive media environment. Here *Brass Eye*
acted upon specific assumptions about the purpose of television news. It attacked the ten-
dency for news media (especially but not exclusively television news media) to focus, inten-
sify or even generate public hysteria over social and political issues. These media-heightened
panics could then be positioned as flashpoints for the national psyche, and employed both
as a means of generating ratings for the networks and reinforcing efforts to position them-
selves at the centre of social-political debates.

 Morris often invented an interest group campaigning on a fake issue, then approached
prominent celebrities and politicians for their endorsement of a seemingly worthy cause. The
programme's approach involved elaborate preparation and planning, in part because it was
to be broadcast much later and there needed to be complete secrecy even after filming to
maintain the full impact of the actual broadcast itself.

> Virtually every premise Morris offered had at least one element in it that looked as it if might be
> true. And that was generally good enough for most people to overlook the fact that his questions
> were nothing more than gateways to a mad world – albeit one with its own internal and consistent
> logic. The breathtaking aspect of the interviews was the readiness with which people stepped into
> the alternate existence with him.[23]

Morris, dressed in a token disguise, was able to get these public figures to repeat on camera
often absurd public service announcements (PSAs). In the 1997 series, the 'Drugs' episode
was particularly effective as a hoax for its participants, enticing a Member of Parliament
(David Amess) to sound the alarm in the British House of Commons over the emergence
of the completely fictional drug supposedly nicknamed 'cake'.

 The overall agenda was generally hostile and subversive towards the position of these
'participants', in contrast to the more collaborative approach adopted for the same kind of
segments in *The Daily Show*. In Gray's words:

> The show gouges at public figures' images, both to send a loud and clear message to public figures to actually know what they are talking about and to send an equally loud and clear message to audiences to be wary of assigning extra value or significance to any political or social cause simply because a public figure implores one to.[24]

This is the template for a kind of 'ambush satire' followed by other UK comedians such as Sacha Baron Cohen with his 'Ali G' and 'Borat' personae. In comparison, the ambush segments on *The Daily Show* are less confrontational and collaboratively performed in an entertainment-centred style. *The Daily Show*'s guests might be occasionally uncomfortable over their performances but ultimately they are willing participants in the show's premise, whereas Morris's 'guests' were explicitly targeted and many felt compelled to threaten legal action later.

The 2001 *Brass Eye* special extended this approach to the subject of paedophilia. The programme itself is a densely layered template for mockumentary news construction, including sophisticated graphics, fake 'live' broadcasts, historical narratives using archival footage, dramatic 'reconstructions', vox-pops and fake focus groups using real people, fake undercover reporting and various stunts including an apparent studio invasion by a militant paedophile organisation. One sequence manoeuvres Michael Hames, former head of the Obscene Publications Branch into ruminating on the relative obscenity of grotesque (fictional) works of art. The usual celebrity PSAs focused this time on anxieties over online games, with Morris getting even reporters and broadcasters to warn viewers to be vigilant against (fictional) technologies that allowed paedophiles to prompt the keyboards of remote internet users to release date-rape gases or turn a child's computer screen into a remote camera.

The clear target of the special was widespread public anxiety over the online sexual predation of children, fed by numerous high-profile television specials.[25] From Morris's perspective, this was media-generated hysteria, which tended to overwhelm more rational public debate. A continuous narrative strand in the programme consisted of a series of live reports on an increasingly angry protest outside a prison over the possible release into the community of a known paedophile, despite the fact that he was near death and in a coma. The hypocrisy of television coverage is made explicit by Doon Mackichan when introducing a lurid reconstruction of the man's crimes, as she explains: 'We believe his story is too upsetting to transmit. We only do so tonight with that proviso.' The presence of television news crews at the prison protest is seen to intensify the hysteria and possibilities for violence – quite literally, as one crew throws a dummy into the crowd and encourages its members to demonstrate how they would stomp on the convict.

While the programme was designed to be a sustained satiric exercise directed at broader currents in mediated political and social debate, such intentions were overwhelmed by political, media and public criticism of its more confrontational aspects. The programme infuriated those who had unwittingly participated in its satire and prompted over 2,000 complaints to broadcaster Channel 4 over what many viewers considered Morris's unforgivably comedic treatment of a serious social issue.

Mockumentary news satires following in the wake of *The Day Today* and especially *Brass Eye* have rarely achieved anything like their satirical bite. Many of these programmes rely more

on parodic pastiche than on an attempt to develop a committed satiric subversion of their targets. The virulent criticism, which Morris in particular attracted for *Brass Eye* has served as an important caution for television producers seeking to create similar material. At another level, however, perhaps any attempts to replicate the initial impact of *Brass Eye* are a lost cause. Morris's work in these two programmes is analogous to the early assault of punk on the music establishment; much of their rhetorical snarl (and satiric impact) was directed towards their immediate political and media context and it is difficult to achieve the same anarchic edge within a broader climate which acts as a comfortable home for television satire. In this sense, it is instructive to look at the work of the *Onion News Network* (IFC, 2011–), which specialises in providing print and audiovisual material that closely resembles the form and agenda of the news satires discussed here. Their segments often adopt a more muted version of the rhetorical template developed by Morris and his collaborators, and partially adopted as a comedic style by programmes such as *The Daily Show*. However, they have inevitably also become somewhat formulaic exercises in televisual satire, part of a well-established multiplatform production line that provides content for distribution through print, a half-hour television series and online site, and available for convenient delivery through an iPhone app. In this kind of mediascape, Morris's focused, innovative and strikingly effective deconstruction of the core programming of the dominant medium of its time is unlikely to be matched.

Notes

1. This is an abbreviated form of arguments that are provided in Craig Hight, *Television Mockumentary: Reflexivity, Satire and a Call to Play* (Manchester: Manchester University Press, 2010).

2. Linda Hutcheon, *A Theory of Parody: The Teachings of Twentieth-century Art Form* (Chicago: University of Illinois Press, 2000), p. 68.

3. Dan Harries, *Film Parody* (London: BFI, 2000), p. 6.

4. Jonathan Gray, Jeffrey P. Jones and E. Thompson, 'The State of Satire, the Satire of State', in Jonathan Gray, Jeffrey P. Jones and E. Thompson (eds), *Satire TV: Politics and Comedy in the Post-Network Era* (New York: New York University Press, 2009), p. 15.

5. Craig Hight and Janet Roscoe, '*Forgotten Silver*: A New Zealand Television Hoax and Its Audience', in Alexander Juhasz and Jesse Lerner (eds), *F Is for Phony. Fake Documentary and Truth's Undoing* (Minneapolis: Minnesota University Press, 2006), pp. 171–86.

6. A consequent issue is whether the increasing popularity of mockumentary discourse suggests that it might be perfectly suited to wider trends toward such textual complexity within contemporary culture.

7. Harries, *Film Parody*, p. 7.

8. Gray *et al.*, 'The State of Satire, the Satire of State', pp. 19–28.

9. Geoffrey Baym, '*The Daily Show*: Discursive Integration and the Reinvention of Political Journalism', *Political Communication* vol. 22 no. 3 (2005), p. 261.

10. Amber Day, 'And Now … the News? Mimesis and the Real in *The Daily Show*', in Gray *et al.*, *Satire TV*, p. 85.

11. Ibid.

12. Day, 'And Now … the News?', p. 92.

13. Jamie Warner, 'Political Culture Jamming: The Dissident Humor of *The Daily Show*', *Popular Communication* vol. 5 no. 1 (2007), p. 27.

14. Michael Gettings, 'The Fake, the False, and the Fictional: *The Daily Show* as News Source', in Jason Holt (ed.), *The Daily Show and Philosophy: Moments of Zen in the Art of Fake News* (Malden, MA: Blackwell Publishing, 2007), pp. 19–23.

15. Ibid., p. 22.

16. Aaron McKain, 'Not Necessarily Not the News: Gatekeeping, Remediation, and *The Daily Show*', *Journal of American Culture* vol. 28 no. 4 (2005), p. 419.

17. Warner, 'Political Culture Jamming', pp. 69–80.

18. Baym, '*The Daily Show*', p. 273.

19. Gray et al., 'The State of Satire, the Satire of State', p. 6.

20. See Lucian Randall, *Disgusting Bliss: The Brass Eye of Chris Morris* (London: Simon and Schuster, 2010) for accounts of Morris's often tense relationships with his host institutions.

21. John Ellis, *Seeing Things: Television in the Age of Uncertainty* (London: I. B. Tauris, 2000), p. 96.

22. Mark Lewisohn, *Radio Times Guide to TV Comedy* (London: BBC Worldwide Ltd, 2003), p. 534.

23. Randall, *Disgusting Bliss*, p. 141.

24. Jonathan Gray, 'Throwing Out the Welcome Mat: Public Figures as Guests and Victims in TV Satire', in Gray et al., *Satire TV*, p. 163.

25. Sharon Lockyer and Feona Attwood, '"The Sickest Television Show Ever": *Paedogeddon* and the British Press', *Popular Communication* vol. 7 no. 1 (2009), p. 51.

4

'ONLY THIS CAN MAKE IT A NEWS': THE LANGUAGE OF NEWS MEDIA

DAN NORTH

This lone, hapless 'fact' (see below) is represented by the word 'fact' embossed onto a metal block. It falls through 'infospace', away from the camera, against a backdrop of churning pixels. As it plunges into the vortex of information, the programme logo for *The Day Today* (BBC 2, 1994) emerges out of a cross of celestial light, its familiar granite base and red, white, blue badge dissolving the clouds. We know exactly what is being represented here: the programme is professing its ability to present solid facts, gleaned from an otherwise confusing and dense fog of mediatised knowledge. This, we are told, is a show that protects and preserves pre-existing information (it is, after all, 'gamekeeper to the events rhino'), repackaging it for the viewer's edification. It is a perfectly legible proclamation of newsgathering prowess, but it is also nonsensical. However much we try to reify or spatialise information by referring to it in terms of 'networks', 'streams' and 'flow', that which we might call a fact is an abstract, contingent and subjective thing, and there is no such thing as '*a* news': that is, there are no quantifiable *units* of news (in this picture, the fact is unitised like bullion) where we might recognise a discrete and complete piece of intelligence about a current event. Yet this brief 'ident bumper' (a transitional insert between items in a broadcast) seeks to substantiate these things, to claim mensurability for something that is diffuse and intangible. In doing so, it

'A fact, alone and tumbling through infospace. Without help, it could vanish forever'; 'Because only *this* can make it a news'

encapsulates much about how graphics are deployed in *The Day Today* and more broadly in the work of Chris Morris.[1]

Several types of graphics are used in *The Day Today* to mimic the look of an actual news broadcast – the abstract spaces of the bumpers that extol the show's journalistic brilliance at regular intervals, the transitional spaces of the shifters that move the news from one report to the next, and the secondary spaces of windows, on-screen text and infographics that frame, name and summarise the main points of each item.

While the control centre of the show is the studio where Morris's anchorman is stationed, the bumpers, titles and other inserts reside in a separate zone. Margaret Morse has described this virtual space as a 'miniature cosmos' where animated logos and graphics exist and move and draw the television viewer into an alternative conceptual arena; as such, these cosmic objects serve as metonymic placeholders for the fantasy of television as *access to* (as opposed to passive and distant *observation of*) a world 'inside' the screen, even as they perform the more direct textual function of naming and describing shows and people.[2] Prior to digital animation, TV graphics would have been produced in-camera. Graphs and illustrations for the news might have been drawn up on boards and then photographed using a studio camera. Later they would be presented in their own sections in animated sequences. A technique such as slitscan or streak-timing could be used, coupled with long exposures, to blur the text of a logo or title, giving it the illusion of effulgent life. These effects create an extra-realistic (i.e. outside reality) symbolic space in which the themes and ideas of the show are given some concrete expression; the granting of powers of movement to words and logos might give them the impression of self-determination and importance, or it might reflect positively on the show's makers, who are able to marshall these regimented symbols into a disciplined display.

The digital depiction of 'infospace' is cosmic in this same sense, in that it implies a boundless environment of indeterminable scale, but instead of positing this as a utopian territory of equally boundless informational opportunities, *The Day Today* appears to argue that television puts it to the most banal use in the service of the most obvious metaphors, where words point directly to their referents, shutting out the ambiguities of something as complex as a fact and attempting to condense it into something more manageably literal. Words in logos and bumpers are more direct than pictorial insignia might be, and *The Day Today* grants them a kind of mythic prominence, no more demonstrably so than in the 'tumbling fact' sequence. This is all in defiance of decades of sociolinguistic, structuralist and psychoanalytic thought (Saussure, Barthes, Lacan) that sought to undermine any suggestions of an iconic, essential link between words and their referents: it is no longer controversial to argue that language constructs and restricts the subject's conception of the world rather than innocently describing a fixed and eternal external universe. But *The Day Today* depicts a news programme whose visual design is founded upon a grandiose and aggressive dumb faith in words as solid, iconic vessels of fact, blurring the line between announcing *itself* (the show, like *On the Hour* [BBC Radio 4, 1991–2] before it, is repeatedly interrupted by bumpers that profess its excellence) and promulgating the news. Another bumper during episode two informs viewers that *The Day Today* is 'aware that while the world looks round, it is in fact a cube. And from this, we know that FACT times IMPORTANCE equals NEWS'. This little syllogistic vignette collapses

figurative and factual language in the image of a graph that is supposed to pictorialise quanti-
ties and calculations, but is actually charting abstract, immeasurable things.

Margaret Morse has traced a historical shift in the twentieth century from multiple
printed accounts of events to a singular objective account (however mythical) known as *the
news*.[3] *The Day Today* (and I am referring here to the stance of the news show *within* the
show) is a perfect illustration of the notion that the news is a *thing* that can be apprehended
and packaged in a pure form. She suggests that news constructs a sense of credibility out of
formal strategies, i.e. actuality is not something that inheres in the content of the news, but
is manufactured out of a series of presentational techniques. Formal markers of objectivity,
transmission of the message through the apparatus, the machinery, together strike a posture
of impersonal remove, of non-mediation.

But the apparatus can intervene to play a constitutive, as well as a communicative role,
especially when graphics simulations are deployed, as Mary Ann Doane notes:

> Television knowledge strains to make visible the invisible. While it acknowledges the limits of
> empiricism, the limitations of the eye in relation to knowledge, information is nevertheless
> conveyable only in terms of a *simulated visibility* – 'If it could be seen, this is what it might look like.'
> Television deals in potentially visible entities.[4]

By way of example, Ashley Holmes has shown how graphic visualisations, animatics and other
pictorial representations can fill in the gaps in a story, such as that of the Beaconsfield mining dis-
aster, where two miners were trapped underground for two weeks, and no video footage was
available.[5] In that instance, fabricated rather than 'gathered' visual material, including animated dia-
grams of the inside of the collapsed mine, served as a kind of 'technologically prosthetic obser-
vation' of the real world. This requires the spectator to have a degree of faith in the truth-telling
intentions of the news media, and to allow the reconstruction to stand in for photographic evi-
dence of the event. Morris seems unwilling to grant evidentiary status to the computer simula-
tion, which he characterises as the gloss that covers up rather than reveals external truths,
substituting a sanitised, de-noised and reductive picture for direct access to the real world.

One of the most consistently distinctive threads running through Morris's satires of news
and current affairs is his use of a kind of mangled, hyperbolic 'news-speak', which throws out
streams of neologisms and mixed metaphors that reflect the shows' central motif of a news
format shifted only slightly out of its recognisable patterns. This satirical vein finds its visual
equivalent in the mimicry of the graphics and sound effects of news programming. These sty-
listic devices are perhaps the most coherent and radical way in which Morris deconstructs,
through a slightly refracted imitation, the pontificatory rhetoric of television news. Such
moments are most pronounced in *The Day Today* and *Brass Eye* (Channel 4, 1997; 2001) with
the inclusion of graphs, idents and elaborate transitions serving to authenticate the pro-
grammes by proving their mastery of their targets' techniques, even as they undermine that
authority through comic exaggeration and the solemn presentation of illogical conclusions.

Often, *The Day Today* invokes the 'fact' and 'the news' as palpable entities by forcing
them semi-grammatically into any kind of sentence ('Peter, you've lost the news!', 'news
jiffy', 'bag-piping fact into news', 'fact me till I fart', 'news from telly to belly', 'news felch',

'Drug use among children has for many in education and with obvious alarm to both parents on the increase almost yearly.'

'news in a tablet'; note the bodily, digestive detail of these analogies, a point to which I will return later). Many jokes, which are also linguistic tricks (e.g. 'The Bank of England Has Lost the Pound' etc.) hinge upon an abstract thing being imagined as a solid object. Nonsensical statements can also be delivered with confidence when accompanied by a visual that speaks through the spatial clarity of graphed ideas.

Word and image are reciprocally awry: the diagram can appear authoritative because it seems to map the causal relationships between things in visual rather than abstract terms, but without an explanatory framework, it is all authority and no substance. We might wonder what is being satirised here: although some characters are recognisable from actual news broadcasting (Morris's amalgamation of Jeremy Paxman and Michael Buerk in his alternately bullish and mournful anchorman act, for instance), *The Day Today* is not a direct, *ad hominem* impersonation of individuals, but an act of systemic mimicry. We might see *The Day Today* and *Brass Eye* as part of a broad swathe of criticisms of news media's deterioration into sensationalism, and 'infotainment', as described famously in Chomsky and Herman's *Manufacturing Consent*, where the authors argue that news media's vulnerability to market forces has diminished their capacity for objective analysis, and recently in Nick Davies's *Flat Earth News*, which denounces as 'churnalism' the tendency for journalists to regurgitate advertising copy as original, investigative reporting.[6] For Bob Franklin, news too often fails to report upon events in the external world because it has been transformed by commercial interests into 'a product designed and "processed" for a particular market and delivered in increasingly homogeneous "snippets" which make only modest demands on the audience'.[7]

Recognising that attacks on the news media for their perceived sensationalisation at the expense of sober reflection 'have become a periodic ritual', Kleemans and Henriks Vettehen set out to build a 'theory of sensationalism'.[8] They note that sensationalistic coverage is not just a description of the content, the stories that are prioritised, but also of form, the means of expression used in conveying information. Uribe and Gunter have defined sensationalism as 'a characteristic of the news packaging process that places emphasis upon those elements that could provoke an effect on the human sensory system'.[9]

What some are calling 'infotainment', Franklin, after Malcolm Muggeridge, has called 'Newszak', a form of disposable news reporting devolved from some prelapsarian state back when journalism was a democratic requirement, a system of truth-gathering and dispassionate, impartial reporting: whether such a state of affairs really ever existed is another matter, but Franklin blames the corporatisation of newsgathering, its subordination to commercial interests and pandering to the undemanding consumer for the descent of news into infotainment:

> Entertainment has superseded the provision of information; human interest has supplanted the public interest; measured judgment has succumbed to sensationalism; the trivial has triumphed over the weighty; the intimate relationships of celebrities, from soap operas, the world of sport or the royal family, are judged more 'newsworthy' than the reporting of significant issues and events of international consequence.[10]

In his critique of television, Pierre Bourdieu begins by discussing how a culture of self-serving, competitive journalism has disengaged audiences from the analysis of political substance and prioritised the scandal-based, narrative aspects of the political process. Politicians in turn get to make short-term promises that will be forgotten quickly in the rapid turnover of news cycles: their announcements make brief news items, but need not be substantial in nature:

> Clearly, these dramatic 'coups' they favour create a climate hostile to action whose effect is visible only over time. This vision is at once dehistoricised and dehistoricising, fragmented and fragmenting. Its paradigmatic expression is the TV news and the way it sees the world – as a series of apparently absurd stories that all end up looking the same, endless parades of poverty-stricken countries, sequences of events that, having appeared with no explanation, will disappear with no solution – Zaire today, Bosnia yesterday, the Congo tomorrow.[11]

For Bourdieu, TV news fills up time with banalities, selected for their immediate sensational content, so that it ends up denying people the information to which they are entitled in a democracy. The pressure to compete for scoops accelerates the process of newsgathering, eliminates any space for thought or reflection, and the reduction of events to second-order spaces (in Herbert Zettl's terminology) further removes these events from reality. News reporters think in clichés and 'received ideas'.[12] There is therefore no actual communication, only the repetitive circulation of the same doctrines. Analysis would be subversive, because it disassembles those 'received ideas' to subject them to evidence-based inspection.

In *Television: The Medium and Its Manners*, Peter Conrad characterised television as a system not for channelling and reflecting the world to its audiences, but for selecting and reconstituting filtered elements of the world to reinforce its own primacy:

> Each of television's genres, though deferring to the world outside the set, is actually self-reflecting. The medium refracts the realities in which it deals, scaling them down and locking them inside the box which is their theatre. The medium will only tolerate things if they can be made televisual.[13]

Conrad uses news broadcasting as the most egregious example of television's self-fulfilling agenda. TV, he says, alters content 'to match its hermetic, transistorised form'.[14] Television's methods of processing content necessarily compensate for the absence of any inherent factuality with a kind of ersatz *language* of factuality. The relative rigidity of the news format does not bend to the delicacies of the world's infinitely varied forms of information: 'The broadcasts are constructed so as to absorb the news into the safe, enduring community which its alarms and surprises might seem to menace.'[15] Graphics and idents assist with this process by giving rhythm and shape to the news, regulating its flow. Regular idents remind the viewer of the ownership of the information, and provide a mono-formal receptacle for footage and reports that might have been taken from multiple sources; it does not flex to reflect the flow of information, but translates it into something recognisable as news.

Morris has referred to *Brass Eye* as 'an assault on certainty', and what could be a better metonym for that certainty than the rigid grids and graphs that serve as a kind of texture map of the news itself, all granite, steel, clocks, globes.[16] Hard, straight lines, segmented time, all of the solidity and regularity, *containability* that real-world events do *not* have. The graphics brandish those same properties that are frequently attributed to all digital images, namely seductive simulationist powers, and an ontological remove from direct experience. They might therefore be seen to distance the news from the world, wrapping it up in the visual syntax of electronics over organics.

There is a risk, when analysing Morris's media satires, of simply describing what the shows are attempting to 'say' about the media. Morris himself withdrew from interviews about the work, not for esoteric reasons, but because it would have been hypocritical to engage with the system of reduction and simplification which he had been critiquing: the shows are designed to speak for themselves by becoming 'a news'. His claim of 'an assault on certainty' seems succinct and eloquent enough to require no further explanation in terms of the satirical telos of the show, but the means through which that assault is mounted, and how similar tactics infiltrate the rest of his work, offer instructive material for viewers. Neil Postman and Steve Powers, in *How to Watch TV News*, ask 'what do viewers have to know about language and pictures in order to be properly armed to defend themselves against the seductions of eloquence'?[17] We might see *The Day Today* as offering an answer to this question: by reverse engineering a news broadcast before our eyes, exaggerating its absurdities without ever distorting its architecture, the news can be made to stand before us denuded of its truth claims, an empty formal structure without analytical content. The show makes fun of the spatial paradoxes in TV news, schooling the spectator in the illogicalities and constructedness of the spaces that they may have been taking for granted – it shows how they have become codified to the point of invisibility, despite their unnatural, arbitrarily non-referential presentation of space. In this critique of the graphic design of news lies the show's broader assault on the truth-telling claims of TV news.

Postman and Powers argue that the use of graphics gives the anchor 'the illusion of control', since the charts, graphs and diagrams seem to 'suddenly appear on screen and disappear on cue': the technical scheduling, ordering and arrangement of news presentation treats graphics as 'symbols of a dominant theme of television news: the imposition of an orderly world – called "the news" – upon the disorderly flow of events'.[18] The form constructs a

Morris sits at the heart of the newsroom (first-order space), addressing foreign correspondent Peter O'Hanrahahanrahan (Patrick Marber), who reports from the subordinate position of second-order space

narrative in order to flatter and 'build the viewership' rather than to scrutinise or contextualise events.[19]

In her essay 'Information, Crisis, Catastophe', Mary Ann Doane suggests that, although 'catastrophe' might be defined as a sudden discontinuity in a continuous system, TV is usually defined as a medium of discontinuities that risks wiping out the possibility for interruptions because of the way it levels disparities and incongruities to make them fit into televisual containers:

> The televisual construction of catastrophe seeks both to preserve and to annihilate indeterminacy, discontinuity. On the one hand, by surrounding catastrophe with commentary, with an explanatory apparatus, television works to contain its more disturbing and uncontainable aspects.[20]

But if the catastrophic aesthetic of television news is forged in the essence of the instant, the identifying graphical labels of the station/programme are what lodge it in a fixed temporality. The grids and graphs that pepper *The Day Today* and *Brass Eye* like a cyberspatial parallel world, as if they represent a pure-truth transliteration of the chaos of information and ideology that is life, seem to stretch into infinity.

Lynne Cooke uses the word 'scannable' to describe the features of news presentation (in print or broadcast media) that make the page/screen legible to the distracted viewer and aid the eye in gleaning the most important aspects of the story. Scannable designs are those which use 'spatial cues' to connect disparate elements and thus 'enable the eye to quickly grasp the relationship between items'.[21] Herbert Zettl has another term for this, 'graphication', which he describes as 'the deliberate attempt to render the television image two-dimensional and graphiclike'.[22] This can be achieved through the use of windowed images and frames, on-screen text and 'computer-generated images that move about the screen while undergoing topological changes'.[23]

Zettl divides the news into first- and second-order spaces. The anchor occupies first-order space, while the picture or graphics 'behind' him (usually superimposed, or 'keyed in')

inhabit a second-order space. It is common in TV news for the newscaster to be flanked by another TV screen, a kind of *mise en abyme* that only emphasises the circularity, or the inward focus of the medium. Graphication makes us perceive second-order televisual spaces as two-dimensional, as a 'purposely abstracted form of reality'.[24] The frame that borders the graph-icated image marks it out as representational space, a reminder that one is watching 'pictures of an event, rather than the event itself'.[25] The layering of windowed spaces on screen is a spatial paradox – there is only a 'truncated Euclidean space' (three-dimensional forms reduced to one-dimensional panels), no consistency or actual depth to the image, just the illusion that these are flat pictures that can be moved into position according to the needs of the programme-makers.

One consequence of graphication, aside from alienating the viewer from the events depicted, even as the rhetoric of the news is about bringing the world to your living room, is the personification of the news anchor. The first-order space is granted a privileged status as more *real* than the represented space, creating a human presence to whom the spectator can relate and in whom they can have faith. This process of personification happens when, for instance, the anchor interacts with the people in second-order space, the correspondents in the field who deliver their reports in windowed, framed zones; the anchor is seen to be 'watching' the news along with the viewer, in a shared experience. The unstated implication that aligns Zettl's analysis with criticisms of the tabloidisation of news is that graphication *flattens* the image and attenuates its relationship to its reference points in the external world, making news more homogenous and digestible, containing its possibly unsettling aspects and dressing it up as the tamed component of a broader system of news presentation.

The ostensible aim of the graphics is to impose order on disparate packages of visual information gathered from multiple sources, strengthening the evidentiary force of the infor-mation on show by giving it clarity and a spatial location. But their visual language speaks of containment, a hierarchical and prissy sensitivity about the arrangement of elements that replaces ambiguity and diversity with reductive dogmatism.

Karen Lury notes that graphs 'represent an abstraction of information and they appear scientific and rigorous. Often, their appearance can be redundant – the information is also presented within a voice-over. In many situations, then, the use of graphs is primarily spec-tacular'.[26] The role of graphs and charts should be to provide a distillation of information or additional information in digestible form; they spatialise data (i.e. they operate in 'infospace'), once again implying a physical locus for abstract ideas, as in the graph from *The Day Today*, which appears to show an alarming rise in something, but which does not define what con-stitutes 'evidence'. It performs a diagrammatic function and purports to present proof, but is, ironically, anything but evidential. Zettl suggests that misused graphics might just 'operate as a delimiting paradigm, a schema, for the way viewers are to interpret the news story', the ultimate upshot of all this being that 'the popularity, and perhaps even the authority, of the anchor person is determined by video manipulation rather than by story content'.[27]

Both Zettl and Morse are looking for ways to characterise the graphic space as onto-logically *separate* from the rest of a show's content: they represent secondary worlds that attenuate the spectators' access to real events. As Morse says of the animated sequences that introduce the news:

Graph to show an 'increasingly muscular body of evidence', from *The Day Today*

> The magical appearance of abstract shapes gradually takes on the gestalt of letters of the alphabet and symbols, seen in a perspective and scale often impossible in 'real life'. These animated logos are a combination of rational, literate modes and the dream logic of primary process in which words become 'things'.[28]

'Primary process' is the psychoanalytic term that describes how the id thinks in non-rational, non-verbal ways. Secondary process is when the ego seeks an object that corresponds to the desires of the id as visualised in the primary process. For Morse, then, it is as if the graphics embody the psychology of the news anchor, wrapping the news around his subjectivity. The window that appears behind Morris as he presents the news on *The Day Today*, 'frames a symbol connected with the story topic':

> The 'window' shows 'story space' to be ambiguously related to the interiority of the anchor. It is positioned like a thought balloon in the comics and appears in conjunction with his narration like a visual realization of his thoughts. Thus, another visual convention offers an odd proof that the anchor *really does* harbor knowledge inside him; he *is* sincere.[29]

'Shifters', the methods through which the scene or space is switched between items or components of a news broadcast, construct causal relations between disparate news items, performing a kind of sense-making secondary process, and Morse suggests that they serve more than decorative purposes, representing 'a "toss" of the position of subject in discourse'.[30]

According to John Ellis, 'Digital image technologies allow television to treat its images as pictures that can be manipulated in an electronic space, rather than as photographic images which reduplicate three-dimensional space.'[31] This profusion of manipulated images lends the graphicated result a potential elasticity that calls into question its representational status. The benefit for news editors has been, says Ellis, the ease with which narratives and connections between images and incidents can be constructed: 'It is now easy to display simultaneous

events together so that their concurrent, yet separate, nature is emphasised. Cause can be piled up on effect.'[32] More importantly, digital imaging technology

> serves to anchor the wild and the unexpected within a very explicit framework of understanding and speculation. News graphics play an important role in organizing the incoherent world of news footage into the coherent world of news explanation. Wars become maps, the economy becomes graphs, crimes become diagrams, political argument becomes graphical conflict, government press releases become elegantly presented bullet points.[33]

While all of this organisation might be designed to increase the viewer's comprehension of the message, Morris's shows undercut this assertion, showing how graphics might patronise and mislead the viewer, bludgeoning 'the wild and the unexpected' into rigid, reduced, barely recognisable shapes. Ellis suggests that news is 'an unresolved dialectic between these two extremes of order and control',[34] containing the disorder of the world, from multiple sources, in the safehousing of a codified, standardised and branded graphication framework. This is not just explanatory, but constructive of meaning, and is 'a crucial part of television's constant, even neurotic, attempt to place, classify, relate, give a semblance of order and generic meaning to the images that TV generates from the world and from itself'.[35]

In a similar vein, Richard Grusin's conception of *premediation* describes the way media, particularly news media, do not just report upon past events, but continually work to shape those events, to mitigate their shocking unpredictabilities (Grusin suggests that 11 September 2001 was the watershed moment where American broadcasters developed coping strategies that would prevent them from ever again being so unprepared).[36] Similarly, Conrad states that 'news on television is no longer a retrospective absorption of what happened during the day but a breathless report on what's happening at the moment. Television's ambition is to bring us the news before it happens.'[37] In a comedic anticipation of premediation taken to its logical extreme, in *The Day Today*, episode five, Morris's anchorman goads two diplomat interviewees into declaring war: he plays the men off against one another as he mediates the argument, manipulating the interplay between first- and second-order space until they have no choice but to say the word 'war' (yet another instance of the presence of the word bringing a situation into reality), at which point the studio set is transformed into its war outfit, as if it has been primed and ready for a war that it esuriently instigates. Form precedes content; it is a preformatted vessel whose subject matter is immaterial: if the show is on a permanent war footing, it treats every story, however trivial ('car drives past window in town' announces one solemn headline) with the same level of intensity.

Station logos and programme insignia serve connotative as well as nominative functions; they iconically refer to the names of things, but their designs also activate meaningful associations for viewers. The graphic design template of each show is firmly established in its title sequence. Ellis has analysed *The Day Today* title sequence, noting that it is characterised by 'a sense of excess of meaning, of heady overstatement within familiar forms'; it exaggerates the tropes and clichés of the opening of a news show.[38] A montage of library footage filtered through digital surface simulations shows the multiple focuses of the programme (politics, war,

'Literally bursting with war.'
The Day Today instigates a war,
then immediately transforms
the studio into its war outfit

celebrities, sport) in a mixed arena of metallic, granite and liquid structures that fluctuates between solidity and fluidity: the design connotes encyclopaedic versatility, the image speaks of confusion.

We might therefore find a skewed logic at the heart of these title sequences, where solid things float or hang in the air, or change their form spontaneously. See, for example, the Channel 4 news idents first broadcast in 1985, where a rotating metal logo comes into view – such logos are almost always moving, seemingly under their own agency, or forming a single, finished shape over the course of the sequence (as if to suggest a coming-into-view, a clarifying of the obscure or a bringing together of miscellaneous elements into a cohesive whole). From October 1984, work was undertaken to overhaul and standardise the look of ITN news titles as metallic lettering, and this extended to typography, with Cal Video's 'Chrome' software creating the appearance of metallic surfaces.[39] It would probably have been possible to make and shoot the logo practically, using real metal, but the digital simulation permits the ideal and paradoxical combination of malleability and apparent solidity.

The *Brass Eye* title sequence is, like *The Day Today* titles, a sequence of morphing snippets of found footage, shuttling between banal celebrity and world-changing events – we cut from Kate Moss to Liam Gallagher to an exploding fireball, as if his flipping of the V-sign at reporters triggers the bomb. It looks as though the show might be insinuating connections between famous people and events of global significance, but at another level this is in keeping with *Brass Eye*'s thesis that celebrities rarely have anything productive or interesting to add to current debates: they are merely part of the promotional surface; because they are all passed through the same televisual gauze, we are supposed to infer that they should be subject to the same interpretive schema.

Brass Eye replaces the blue and red corporate design template of the *The Day Today* with an even more intense, infernal aesthetic, as if insisting that the content of the show will be as incendiary as its idents. The title sequence agglomerates many of the clichés of its genre, mixing them into a surfeit of style and symbolism. The 'brass eye' itself, another metallic digital

The CBS network logo, designed by William Golden, which has been in use since October 1951 and the *Brass Eye* logo, as seen in the title sequence

structure, resembles the 'eye' logo that has represented the American CBS network since November 1951. It simultaneously reflects both the watching eye of the spectator, and the surveilling gaze of the show's cameras as they watch the world.[40]

The eye emerges from a spinning globe, and is then shown to be Morris's own eye, and the title sequence ends with Morris emerging from the fiery chaos in the form of Leonardo da Vinci's 'Vitruvian Man' (*Homo ad circulum*, c. 1490). It is well-chosen hyperbole. Da Vinci's drawing embodies connections between art and science, positing the human body as a centred, symmetrical structure, as measurable and quantifiable as a geometric shape or an astronomical constellation. We are thus given a hyperbolic convergence of the artistic, the mathematical, the scientific and the natural, all cohering around the body of Morris himself in the *Brass Eye* title sequence. Once again, he is proffered as the conduit of meaning, the central point of knowledge and perspective: if the show is seeking to establish in its titles that it bestrides and surveys the world, the visual effect puts forward the contrary notion that the world is instead diminished, contained.

Sean Cubitt has argued that popular media, so capable when it comes to human-interest stories, tend to struggle with abstract concepts such as 'labour', 'class' or the flows of trade and power in globalised industry. As a result, he says, globalisation is often conceived in spatial rather than historical or temporal terms, and the prominence of globes in the idents of news shows is 'symptomatic' of this 'anti-dialectical understanding of the world', since it gives the impression that the world can be interpreted, even as the world has become ever less readily comprehensible, drawing the chaos of human events 'into an objectifiable unity that can be addressed as content: as stories, as graphics, as maps'.[41] Again, the globe graphic serves the function of reducing the world to an illusion of certainty and containability. As Cubitt continues, he is concerned with the constitution of:

> the world as videographic, implicated as it seems to be in nostalgia for an authoritative discourse
> while knowing that no such authority exists. This constitution of the world builds an ideological
> image of the world-object as author of its own authoritative statement, a statement which,
> however, is limited to the merest announcement of existence and the solitary statement of its own
> unity. Such a limited conception of truth is the bread and butter of documentary analysis.[42]

For Cubitt, 'machine-drawn images' have the quality of externality: the video graphics of globes seem to take place in an abstract space devoid of human presence, as in Morse's 'miniature cosmos', and yet, he argues:

> in the context of news titles, imagery of the world rarely uses the kind of humanist expression of icons like the Vitruvian Man … . Unlike Leonardo's sketch, our representations of the Cosmic Man are neither cosmological nor expressions of a transcendent mathematical ideal.[43]

However, the opening titles of *Brass Eye do* incorporate Morris himself as Vitruvian Man, establishing the presenter as the ideal man, the centre of intellect and space, tapping a seam of Renaissance certainty about the mappability of the external world. This is not really an omission from Cubitt's analysis, since *Brass Eye* is not a real news programme; instead, it shows how *Brass Eye*'s titles transgress a borderline of taste by anthropomorphising its worldview, subjectivising the perspective that it would otherwise have you perceive as an objective, worldly gaze.

Morse notes that the term 'anchor' seems to denote a fixed point around which the news pivots, and that the figure of the news anchor 'centres the discourse of the news and himself occupies a zero-degree of deviation from the norm'.[44] She refers to anchors as the 'supersubjects of the news as a totality'; through the situation of the anchor in Zettl's first-order space, apparently responsible for the mediation of the graphicated second-order space, Morris can appear to be not just reading the news but 'responsible for its enunciation'.[45] If Morris is the personification of the news, the video graphics link his body and the flow of information itself, most notably (and literally) in *The Day Today* when shifters emerge from his body to effect a transition to the next report.

Here is the visual equivalent of the corporeal language noted above (e.g., 'news felch'), the end point of the graphication and personification that locates Morris as the source of news that is ultimately reduced to an excremental or abject metaphor, a second-order space emanating from inside him.

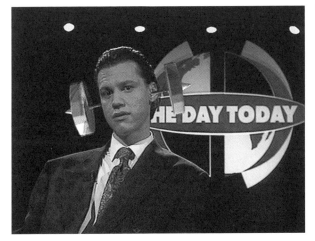

The next report emerges out of Chris Morris's head

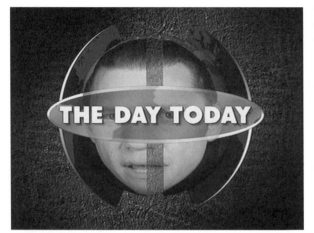

The bodies of the presenters
fused with the machinery of
the news: the disembodied
heads of Chris Morris, Alan
Partridge (Steve Coogan)
and Sylvester Stewart (David
Schneider)

Elsewhere, his disembodied head is superimposed onto reports, inserted into the video-graphic space, as are those of other personnel on the show, including weatherman Sylvester Stewart (David Schneider), who crosses the border of second-order space to *become* his forecasts, and Collaterlie Sisters (Doon Mackichan), whose robotic mannerisms and intonation reflect a too-keen ingestion of the tone and form of her profession. The news system has fused with the people who make it, absorbing them into its structures.

Morris's news parodies carry out a consistent satirical project, a detailed and sustained mimetic performance, cemented by the shows' graphic simulacra, which can be traced even through his subsequent work. His interest in the presentational postures of news reports has extended into print, with a parody of the 11 September coverage, 'Six Months That Changed a Year: An Absolute Atrocity Special' published in the *Observer*, and online, with *TheSmokehammer.com*, 'Earth's Premiery News Node', both produced in collaboration with Armando Iannucci.[46]

Jam (Channel 4, 2000) is an innovative, ambient sketch show adapted from Morris's radio show *Blue Jam* (BBC Radio 1, 1997–9), in which each sequence emerges from the static of a broadcast from a nightmarish parallel world where everyday life is shoved sideways into grotesquerie and violent depravity: a man marries himself, a doctor makes pedantic, often sexually kinky requests of his bemused patients, another doctor seduces a man while his wife is in labour, a plumber is called to fix the pipes of a dead baby. The pictures stretch, smear and distort, soundtracks are slowed, disrupting the rapid-fire rhythms that might be expected from a sketch show, giving an attenuated sense of time and space. Each sketch is given a different graphic or sonic quirk, making the diversity of form as much of a component as the variety of characters and situations. Abstract transitional effects segment the sketches like a funhouse mirror of the news satires' structured absurdism.

Nathan Barley (Channel 4, 2005) might be interpreted as a despairing howl at the children of *The Day Today* and *Brass Eye*, a character study of the end product of the kinds of vapid reportage that dislodges the viewer from the real world instead of promoting direct engagement with it. Barley is repeatedly shown to lack empathy or personal responsibility, evaluating every professional opportunity or personal exchange through how it might gild his media profile or public reputation. His artwork is a loose mockery of Banksy's street art, but while Banksy is renowned for the closely guarded anonymity that allows him to enact some sort of extended performance piece about the authorship of his stencilled, remixed images, Barley can't help but announce himself as the genius behind a series of prank videos and digital animations that mash-up popular culture and historical documents into the same register of mulched imagery. At one point, we see that Barley has adapted Eddie Adams's iconic 'Saigon Execution' photograph to a loading gif on his website: the significance of the content, the meaning behind it, is rendered immaterial, appropriated for the most mundane of purposes. The show's protagonist Dan Ashcroft (Julian Barratt), through whose eyes the viewer is expected to look scornfully upon the self-satisfied Shoreditch media types at whom the satire is aimed, is a journalist whose latest article 'Rise of the Idiots' has been misconstrued by said idiots, who believe it to be referring to some other idiots. The article has echoes of Carl Bernstein's 1992 essay 'The Idiot Culture', which decried the degradation of America's investigative journalism in favour of a celebrity-obsessed trash culture, and points

up the link between *The Day Today*, *Nathan Barley*, and the critiques of sensationalist news media mentioned above,'which is always turning away from a society's real condition'[47] and where 'speed and quantity substitute for thoroughness and quality, for accuracy and context'.[48]

Four Lions, ostensibly about an inept UK terrorist cell, is also about a group of men struggling to master the codes of media presentation so that their acts of martyrdom will achieve maximum visual impact, whether they're producing their own jihadi videos or communicating covertly through the online children's forum 'Puffin Party', which requires them to speak via puffin avatars.

In each of these shows, the formal codes of media are appropriated in the service of a malign or perverted intent. *The Day Today* portrays a news show in thrall to crime, violence and scandal, cowering before the monarch and the flag, hungry for the spectacle of war yet mindless of its consequences. Its passionate interest in and facilitation of corporate and nationalistic endeavours through military conquest, hints at an expanded (and sinister) definition of television as part of a broader network of military, corporate and technological exchanges. By invoking a visual language of electronic control and precision, the graphics sequences frame the shows' contents as subject to the same degrees of control and authority. At the same time, the impression is of a machine-tooled aesthetic that behaves like a quasi-independent outgrowth of the programme, as if it is acting upon some constant need to assert, reassert and sloganise its own perfection, its own worth as a contributor to that global system. The veneer of professional structure is crucial in creating the impression that the news is the world, and that this is the way the world is and must be.

Notes

1. Although Morris was not directly responsible for the graphics sequences and worked collaboratively with Armando Iannucci and a team of writers on *The Day Today* in particular, I am using him as the connective, organising force through a number of shows over which he exerted increasing authorial control.

2. Margaret Morse, *Virtualities: Television, Media Art, and Cyberculture* (Bloomington and Indianapolis: Indiana University Press, 1998), p. 72.

3. Margaret Morse, 'The Television News Personality and Credibility: Reflections on the News in Transition', in Tania Modleski (ed.), *Studies in Entertainment: Critical Approaches to Mass Culture* (Bloomington: Indiana University Press, 1986), p. 56.

4. Mary Ann Doane, 'Information, Crisis, Catastrophe', in Marcia Landy (ed.), *The Historical Film: History and Memory in Media* (New Brunswick, NJ: Rutgers University Press, 2001), p. 273.

5. Ashley Holmes, 'Syncretism in Narrativity, Visuality and Tactility: A Case Study of Information Visualization Concerning a News Media Event', *Reconstruction* vol. 8 no. 3 (2008), <http://reconstruction. eserver.org/083/holmes.shtml>.

6. Noam Chomsky and Edward S. Herman, *Manufacturing Consent: The Political Economy of the Mass Media* (New York: Pantheon, 1988); Nick Davies, *Flat Earth News: An Award-winning Reporter Exposes Falsehood, Distortion, and Propaganda in the Global Media* (London: Random House, 2011).

7. Bob Franklin, *Newszak and News Media* (London: Hodder Arnold, 1997), p. 5.

8. Mariska Kleemans and Paul Hendriks Vettehen, 'Sensationalism in Television News: A Review', in Ruben Peter Konig and Paul Willy Mare Nelissen (eds), *Meaningful Media: Communication Research on the Social Construction of Reality* (Nijmegen: Tandem Felix, 2009), p. 227.

9. Rodrigo Uribe and Barrie Gunter, 'Are Sensational News Stories More Likely to Trigger Viewers' Emotions Than Non-sensational News Stories? A Content Analysis of British TV News', *European Journal of Communication* vol. 22 no. 2 (2007), p. 209.

10. Franklin, *Newszak and News Media*, p. 4.

11. Pierre Bourdieu, *On Television* (New York: New Press, 1998), pp. 7–8.

12. Ibid., p. 29.

13. Peter Conrad, *Television: The Medium and Its Manners* (Boston, MA, London and Henley: Routledge & Kegan Paul, 1982), p. 125.

14. Ibid., p. 126.

15. Ibid., p. 140.

16. Chris Morris, podcast interview with Adam Lippe, *A Regrettable Moment of Sincerity* (8 November 2010), <http://regrettablesincerity.com/?p=6023>.

17. Neil Postman and Steve Powers, *How to Watch TV News* (New York: Penguin, 1992), p. 98.

18. Ibid., p. 110.

19. Ibid., p. 112.

20. Doane, 'Information, Crisis, Catastrophe', p. 280.

21. Lynne Cooke, 'A Visual Convergence of Print, Television, and the Internet: Charting 40 Years of Design Change in News Presentation', *New Media and Society* vol. 7 no. 1 (2005), p. 29.

22. Herbert Zettl, 'The Graphication and Personification of Television News', in Gary Burns and Robert J. Thompson (eds), *Television Studies: Textual Analysis* (Westport, CT: Praeger, 1989), p. 139.

23. Ibid., p. 140.

24. Ibid., p. 155.

25. Ibid., p. 156.

26. Karen Lury, *Interpreting Television* (London: Hodder Arnold, 2005), p. 152.

27. Zettl, 'The Graphication and Personification of Television News', p. 161.

28. Morse, 'The Television News Personality and Credibility', p. 70.

29. Ibid., p. 70.

30. Ibid., p. 72

31. John Ellis, *Seeing Things: Television in the Age of Uncertainty* (London: I. B. Tauris, 2000), p. 93.

32. Ibid., p. 95.

33. Ibid., p. 97.

34. Ibid., p. 98.

35. Ibid., pp. 100–1.

36. Richard Grusin, *Premediation: Affect and Mediality after 9/11* (London: Palgrave Macmillan, 2010).

37. Conrad, *Television*, p. 129.

38. Ellis, *Seeing Things*, p. 96.

39. Douglas Merritt, *Television Graphics: From Pencil to Pixel* (London: Trefoil, 1987), pp. 82–3.

40. See Morse, *Virtualities*, p. 73.

41. Sean Cubitt, 'TV News Titles: Picturing the Planet', *Jump Cut: A Review of Contemporary Media* no. 48 (Winter 2006), <http://www.ejumpcut.org/archive/jc48.2006/CubittGlobe/text.html>.

42. Ibid.

43. Ibid.

44. Morse, 'The Television News Personality and Credibility', p. 57.

45. Ibid.

46. Chris Morris and Armando Iannucci, 'Six Months That Changed a Year: An Absolute Atrocity Special', *Observer* (17 March 2002), <http://www.guardian.co.uk/world/2002/mar/17/september11.terrorism>.

47. Carl Bernstein, 'The Idiot Culture', *New Republic* (8 June 1992), p. 22.

48. Ibid., p. 24.

5

REPORTING THE 'ILLEGALISATION OF CAKE': MORAL PANICS AND *BRASS EYE*

JEREMY COLLINS

Introduction

Brass Eye (Channel 4, 1997; 2001) was a spoof current affairs television programme first broadcast in 1997, which satirised the conventions and obsessions of broadcast news journalism. Each of the six episodes focused on a specific topic – including drugs, crime, sex and (in the one-off Special 'Paedogeddon' episode) paedophilia – in order to allow a satirical emphasis on media concerns for these risk issues. It could be argued that each episode to some extent applies a 'moral panic' critique to their topics as they are mediated.[1] The 'Crime' episode for instance is introduced with the presenter (Chris Morris) following a police raid capturing a 'recidivist' and demanding to know why he has 'gone back to crime'; the next sequence shows Morris standing in the hackneyed crime reporter's position in front of the Metropolitan Police's New Scotland Yard sign, asserting that while UK used to mean United Kingdom, it now stands for 'unbelievable krimewave'.[2] Similarly, in the 'Sex' episode, Morris reads out absurdly sexualised newspaper headlines (*The Times*: 'Bono Offers Sex to "Anyone from the Former Yugoslavia"') before raising the key question of the episode: 'Is a baby born today a baby born into a world in sex crisis?'. The audience discussion format is satirised in a following segment, in which a young girl is interviewed about seeing her parents die when a 'frozen dog fell from a plane and killed them while they were making sex'. After asking the girl whether this is going to lead to 'psychosexual problems', Morris turns to camera and solemnly acknowledges that 'we will have to see that little girl being upset in a rather more sustained way later on'. Morris then distinguishes between 'good AIDS', transmitted through blood transfusions, and 'bad AIDS' caused by homosexual sex. In this way, the show addresses both the genre conventions of current affairs as well as the prurience, distortion and exaggeration surrounding particular controversial moral issues common to 'infotainment' news.[3]

This chapter will analyse how the key aspects of the media construction of social problems identified and explored by moral panic studies (such as exaggeration, sensitisation to particular issues at the expense of others, and the claims making of 'experts' and 'moral entrepreneurs') are also those targeted for satirical criticism in *Brass Eye*. A comparison can be made with the academic analysis of news coverage of similar topics to argue that *Brass*

Eye represents a comedic, surrealist critique of the issues which have dominated moral panic studies in recent times.

Brass Eye has of course itself generated controversy, and has been subjected to critical media attention from its inception. The original series was briefly postponed due to the concerns of broadcasters Channel 4 about its reception from a 'hostile press',[4] and the 'Paedogeddon' special edition in 2001 became 'the most complained-about television programme in British broadcasting history'[5] following a campaign of vilification involving ministers, pressure groups and newspaper columnists.[6] While it could be argued that this episode of *Brass Eye* in particular can be understood itself as an object of moral panic, in this chapter I want to set out the extent to which an earlier episode – the 1997 'Drugs' edition – reflects and makes use of some of the main aspects of moral panic analysis. As an example of a contemporary moral panic, I will be discussing the news coverage of the emergence and banning of mephedrone in 2009–10; in reporting this moral threat as an apparently new, unknown substance, it presents clear similarities with the 'Drugs' episode of *Brass Eye*.

Since its formal definition by Stan Cohen in the early 1970s,[7] the notion of moral panic has been employed by social theorists and media researchers as a tool for the investigation and analysis of causes of public anxiety, such as criminal activity, risk-taking and deviancy, and in particular when these have been represented – or constructed – in media accounts. These concerns to a great extent overlap with those lampooned and satirised in the *Brass Eye* series.

Mephedrone in the News

In 2009 the British media began to report on a new 'legal high' drug called mephedrone, also known to its users under a variety of names including meow meow, M-cat and bubbles. Many of the reports emphasised the danger that the drug represented because of its relative novelty and the lack of significant research into its composition and effects. On 27 November 2009, the *Sun* reported the experience of a mephedrone user:

Legal Drug Teen Ripped His Own Scrotum Off
A LEGAL drug known as 'meow meow' led one lad to rip off his own SCROTUM, police said today.
The lad hallucinated for 18 hours and mutilated himself because he believed centipedes were crawling over his body and biting him.
Cops warned people to stay away from the drug Mephedrone which is sold legally on the internet as **PLANT FERTILISER**.

(*Sun*, 27 November 2009)

The story was also reported by local newspapers, and the *Daily Star* under the headline:

Sex-tear Injury on 'Cat' Drug

(*Daily Star*, 27 November 2009)

A subsequent investigation by the *New Scientist* magazine interviewed the police officer who wrote the report on which these stories were based, and found that the story was taken, uncorroborated, from an anonymous post on a website. The owner of the website (<www.mephedrone.com>) insisted that the story was a 'joke'.[8]

Exaggerated, extreme responses to drugs such as this have been represented in media news coverage of drugs in the past,[9] and have been argued to be part of the process of exaggeration and misrepresentation that is key to the construction of moral panics.[10] However, the discussion of media coverage of controversial issues in terms of moral panics has not been limited to academic analyses; indeed, the phrase 'moral panic' has gained a widespread acceptance since its seminal use in Cohen's study of 'Mods and Rockers' in the early 1970s. The term has been used both positively and disparagingly in newspapers themselves,[11] and has also provided an implicit backdrop to satirists and critics of media representations of social problems such as Chris Morris, the writer and main performer of *Brass Eye*. In the 'Drugs' episode, the fictional drug 'cake' is discussed and its dangerous side effects are represented through the following newspaper headline (shown briefly in passing):

Drugged Bankers Pulled My Wife's Head Off and Puked Down the Neck-hole

This headline, used to illustrate the extreme exaggerations that UK newspapers sometimes produce, is clearly echoed by the later coverage of mephedrone, which suggested the drugs could induce irrational violence in its users. The implicit critique of *Brass Eye* overlaps with the explicit analyses of academic moral panic studies of news media and particularly with newspaper accounts of particular instances of the 'war on drugs'. The 'Drugs' episode of *Brass Eye* can therefore be usefully compared with moral panic analysis of the coverage of mephedrone in the UK press in 2009–10.[12]

Brass Eye: Spoof and Satire

Brass Eye was first broadcast in 1997 as a six-part parody of current affairs TV. Each week a particular subject was chosen and discussed in a way which highlighted the absurdity of the genre and its presentational conventions. This emphasis on the *form* of TV news documentary was evident from the very beginning of each show in the over elaborate computer-generated title sequence, as well as in Morris's own grotesquely exaggerated portrayal of the pompous, egotistical presenter – 'bullying, sneering, Paxmanning'[13] – and the impulse to reduce complex issues to simplistic soundbites and solutions. In an episode addressing the topic of national (moral) decline, Morris addresses the viewing audience: 'You haven't got a clue have you? But you will do – if you watch for thirty minutes.' In more than one episode, celebrities were asked to provide 'yes/no' or 'right/wrong' answers to complex moral questions.

Current affairs television's burgeoning reliance on celebrity was similarly spoofed. The show convinced celebrities to present ridiculous, nonsensical ideas as part of spoof campaigns against particular social or moral 'threats', in order to ridicule the notion that such figures should be considered to have any influence or impact on issues of public concern: 'It is

this conjunction of television's authority and the authority of those who appear on and use it, which the series particularly set out to highlight and undermine.'[14]

Mills notes that the comedic effects of the series' surreal language and exaggeratedly authoritative presentational style contained a 'serious intention': 'to show how both television and celebrity can be used to create and maintain media-induced "moral panics"'.[15] 'Cleverness with language' has indeed been argued to be a key element of satirical writing along with the ability to amuse and entertain while also adopting a critical stance towards its object.[16] The satirist therefore adopts the position of both entertainer and 'moral policeman'.[17]

Meikle makes the link between academic and satirical analyses of media techniques explicit by emphasising their shared interest in exposing the use of 'symbolic power' by the media.[18] Both media studies scholars and satirists, Meikle suggests, see satire as a potentially powerful vehicle for 'resistance to cultural and political hegemony'.[19] In both of these fields questions about power are asked, and (moral) judgments are made about social, cultural and political flaws; they attempt to expose the taken-for-granted and unexamined. In this way, both media studies and satire 'try to reveal the uses of symbolic power'.[20]

Similar to the moral panic analyses of academics, *Brass Eye*'s critical edge lay in its insistence that news is engaged in the social construction (and not simply the reporting) of social problems. The 'Paedogeddon' Special episode in 2001 addressed the apparent media obsession (particularly with regard to tabloid newspapers) with paedophilia and in doing so generated hundreds of complaints to the broadcasting regulator and a good deal of tabloid outrage; the *Daily Mail* described it as the 'Sickest TV Show Ever'.[21] The coverage, in its arguable implication that the episode represented some kind of defence of paedophilia,[22] could perhaps be understood as the kind of exploitative, sensationalist response which *Brass Eye* was attempting to spoof.

In keeping with the notion that the satirist employs humour to address serious and important issues,[23] and notwithstanding Morris's own rejection of that label,[24] *Brass Eye* clearly attempted to target and critique media constructions of social issues in a similar way to media theorists' use of the moral panic concept. In order to allow a comparison between such a study and the 'corrosive satire'[25] of *Brass Eye*, we need to look at a recent model for moral panic analysis.

A Model of Moral Panics

Cohen's *Folk Devils and Moral Panics* was a sociological study of the social construction of deviance, taking as a case study the concerns around the clashes between Mods and Rockers in the mid-1960s. While ranging across a wide frame of reference and situated within the transactional approach to deviance,[26] one key element emphasised the role of the media in defining a 'new' social problem. Cohen suggested certain aspects evident in the initial media coverage which he linked to the notion, derived from studies of reactions to physical disasters such as hurricanes and floods, of the 'inventory': the period in which a 'preliminary picture' of events begins to be formed by those involved.[27] Cohen used three headings to

describe the media inventory of the Mods and Rockers coverage: exaggeration and distortion, prediction and symbolisation.

Cohen also discussed the need for the various actors in the social construction of the Mods and Rockers panic to be considered 'in terms of the sociology of moral enterprise'.[28] The notion of moral entrepreneurship provides the opportunity to discuss the individuals and organisations who comment on, and therefore attempt to shape, the developing debate.

Critcher's reformulation of Cohen's 'processual' model, adapted in part to acknowledge Goode and Ben-Yehuda's 'attributional' model,[29] suggested eight elements in the construction of a moral panic: emergence, inventory, moral entrepreneurs, experts, elite consensus, coping and resolution, fade away, legacy.[30] We can pick out the most relevant and important of these and present examples from both the mephedrone coverage and from *Brass Eye* in order to illustrate how closely the TV show followed this generalised model. Clearly not all of these elements are likely to be relevant to *Brass Eye*, not least because as a satire primarily of the media, it would be difficult for the show to represent the later aspects of the moral panic process (e.g. fade away, legacy) which are assumed to emerge after the media *inventory* – the main focus of the satire.

Emergence

The moment at which a new social threat becomes identified is a crucial first step in the development of a moral panic. One of the ways in which concern is justified is by a focus on its novelty. Mephedrone emerged in 2009 and the press emphasised the fact that its newness meant its effects were not known. Because mephedrone was a new substance, it had not been banned and easy availability (not least via the Internet) made it more of a threat. The *Daily Telegraph*, for instance, reported that its users could have 'little knowledge of ingredients or their effects', while the *Sun* announced that 'Police last night issued a warning to clubbers over a new legal designer drug which health experts want banned.'[31] The concern for 'clubbers' to some extent echoes earlier coverage of ecstasy,[32] while the notion of the 'designer drug' emphasises the manufactured nature of mephedrone, and therefore its novelty. While drug use is often represented as a problem for – or threat to – young people, mephedrone was often explicitly constructed as a (new) danger to schoolchildren:

Marlow Grammar School Pupil Faces Exclusion after Drug Find
(*Bucks Free Press*, 7 December 2009)

Legal Drug Is Destroying My Son's Life: £15 Online 'Bubbles' Available to Teens Says Mum
(*Huddersfield Daily Examiner*, 7 December 2009)

Top School Drug Storm
(*People*, 13 December 2009)

Pupils in Trouble over Use of Drugs

(Sunday Sun, 13 December 2009)

Similarly, further news items provided warnings from and to parents about the emergence of this 'deadly new drug' (*Staffordshire Newsletter*, 14 January 2010).

The opening 'hidden camera' sequence of the 'Drugs' episode of *Brass Eye* shows Chris Morris, in the guise of a 'punter', attempting to buy drugs with improbable names from the dealers of West London. The voiceover explains that even the dealers are unaware of the names of the newest drugs, and Morris goes on to ask a bemused dealer for 'triple sod', 'yellow bentines' and 'clarky cat'. This latter invented name now seems a prescient choice given the supposed nickname for mephedrone as explained by the *Daily Mail*:

> Mephedrone is often combined with Ketamine, a horse tranquilliser, which helps to relax you after the Mephedrone high. The street name 'meow meow' derives from the fact Ketamine is sometimes called Ket. Ket sounds like cat (as in meow meow).
>
> *(Daily Mail*, 28 November 2009)[33]

Brass Eye illustrated the dangers of 'cake' by reference to its use in 'raves' and the threat of users developing 'Czech neck', a condition in which (according to the explanation given on camera by TV personality Rolf Harris) 'enormous water retention' leads to the neck swelling to 'engulf the mouth and nose'. This eventually means the user dies 'through not being able to breathe at all'. A later section of the programme describes the activities of the Schools Heightened Aversion Drug Therapy (SHADT) project, where schoolchildren are shown a drug addict with the head of a horse to illustrate the assumed dangers of 'new drugs'. The narrator explains that 'Sometimes drugs are so new we can only guess what the effects would be.' While the risks of other (real) drugs are satirised, the novelty of 'cake' provides a clear link to the structure of moral panics as illustrated by the mephedrone coverage.

Inventory

The media inventory consists of a 'preliminary explanation of the nature of the threat',[34] and with the mephedrone coverage the threat is explained via the key strategies of exaggeration/distortion and prediction. The death of fourteen-year-old Gabi Price generated considerable news coverage at the end of November 2009. The *Sun's* headline 'Meow Drug Kills Girl of 14' (*Sun*, 25 November 2009) is illustrative of the extent to which mephedrone was highlighted even though the following article suggested that Gabi had taken a 'drug cocktail', which also included ketamine. Other newspaper headlines contained a similar emphasis:

Death of Girl, 14, Linked to Party Drug 'Miaow'

(Daily Telegraph, 25 November 2009)

Girl 14 Dies after Trying Drug 'Meow'

(*Daily Star*, 25 November 2009)

Did Legal Party Drug Kill Girl Aged 14?

(*Daily Mail*, 25 November 2009)

In March 2010, the deaths of two young men provoked further coverage. Louis Wainwright and Nicholas Smith apparently collapsed after taking mephedrone while out with friends in Lincolnshire, and front page headlines on a number of newspapers made the link clear:

Plea to Outlaw 'Legal Drug' after Two Teenagers Are Killed

(*Daily Telegraph*, 17 March 2010)

Meow Meow Kills 2 Teens

(*Sun*, 17 March 2010)

Meow Meow Kills 2 Teenage Friends

(*Metro*, 17 March 2010)

A few weeks after her death, and following a pathologist's report, it was briefly reported that Gabi Price had in fact died from pneumonia following a streptococcal throat infection (*Daily Star*, 17 December 2009). Similarly, Louis Wainwright and Nicholas Smith were later reported not to have taken mephedrone at all, and while their deaths were unexplained, some reports, derived from the police, suggested that they had been 'drinking and taking methadone [sic]' (*Mirror*, 29 May 2010).

What these two examples suggest is that the news coverage of apparent drug deaths among young people was likely to be understood within the framework of concern around this new substance, and that any ambiguity would be eliminated in the attempt to link the deaths to mephedrone.

The absence of any scepticism can also be seen in *Brass Eye*'s descriptions of the hazards of 'cake'. The celebrities who explain these supposed dangers can in one sense be understood as moral entrepreneurs, adopting a public role in enforcing social moral norms, but at this point we should simply note that they seem to accept the absurdities they spout (presented to them by the fake pressure groups and charities set up by the *Brass Eye* team) with no questioning of their exaggerated nature. Rolf Harris's description of the threat of 'Czech neck' is one example of this; another is the description by comedian Bernard Manning of the negative effects of 'cake'. He is shown pointing to an oversized model of a 'cake' tablet: 'If you're sick on this stuff, you can puke your fucking self to death. One girl threw up her own pelvis bone, before she snuffed her lid. What a fucking disgrace.'[35]

The notion that anyone could vomit her own pelvis is presented here, despite its obvious absurdity, because it fits the framework of the moral panic around drugs. As with the deaths discussed above which were linked, erroneously, with mephedrone, the need for clear and careful assessment of risks and dangers (in this case, perhaps by the celebrities

themselves and their advisors) seems to be jettisoned in favour of a pre-established discursive frame in which any and all extremes are unquestioned. This then suggests that Morris's satirical critique is very much aimed at the kind of moral panic exemplified in the mephedrone coverage.

 Despite regular assertions that 'little is known about [its] side effects or circulation' (*Independent*, 25 May 2009), the mephedrone coverage included some predictions about the individual consequences of its use as well as the wider social impact. The 'potentially lethal side-effects' (*Herald*, 27 July 2009) of mephedrone are therefore presented as assumed and largely unquestioned. One article described the popularity and availability of the drug before noting that 'however, the long-term effects are currently unknown and the drug has already been linked to a spate of deaths across Europe' (*Mirror*, 15 September 2009), making a clear implication that information might emerge in the future to substantiate such links. Some news stories quoted police warnings either in headlines or in the subsequent text:

Police Warn Someone Could Die from Legal High Sweeping Region

(*Northern Echo*, 20 November 2009)

'Legal' Drug Could Have Devastating Side Effects

(*Newcastle Journal*, 27 November 2009)

In the introductory section of the 'Drugs' episode of *Brass Eye*, Chris Morris, in his news presenter guise, suggests that the programme is going to 'shatter some myths', the first of which concerns the effects of heroin. Morris points to a corpse on a medical examination table: 'The effects of a heroin overdose are lethal. Yes, in the short term, but there has been absolutely no research into the long-term effects.'

 In a later segment, the (fictitious) pressure group Free the United Kingdom from Drugs, incorporating British Opposition to Metabolically Bisturbile Drugs (FUKD and BOMBD) produces a press release:

HELP US ACT NOW BEFORE ITS TOO LATE

1984: Crack… 1988: Ecstasy … 1997: …?

In the UK drug use is increasing every year while the age of those involved continues to fall. 51% of children between 14 and 16 now admit to taking drugs and police estimate that, if current trends continue, 70% of teenagers will be using drugs by the year 2005.

The unsubstantiated statistics here can be understood as an attempt to create a credible 'factual' approach; this will be discussed later. The predictive element of this press release lies in its assertion of a measurable trend which leads to a supposedly extreme outcome. The heroin overdose comment similarly uses the language of 'research' to satirise this aspect of the media coverage.

Moral Entrepreneurs

As previously mentioned, the police emerged in the mephedrone coverage as a key actor, taking a particular stance on the risks of the drug. Several stories reported police claims about the drug, not least the assertion, mentioned above, that mephedrone had caused a young man to mutilate himself. Other examples include an early warning in the *Aberdeen Press and Journal* ('Police Warning of Drug's Misuse', 24 July 2009), and reports of police activity despite the drug being 'technically legal' ('Police to crack down on bubbles', *Daily Star*, 26 November 2009).

Politicians also became part of the news, mostly requesting a ban ('MP on the Case to Get "Meph" Banned', *Liverpool Daily Post*, 15 February 2010; 'Whitby MPs concerns at legal drugs', *Whitby Gazette*, 16 February 2010). Occasionally, politicians became more directly linked to the 'mephedrone craze', with one MP's son labelled a 'dealer' ('Meow Mum MP Is Drug Fighter', *Sun*, 26 March 2010). It should also be noted that in the spring of 2010, the approaching general election meant that the issue became enmeshed in political point-scoring. This was often evident in criticism of the supposed delays in bringing in a ban, despite critics also – and somewhat contradictorily – attacking the government's failure to listen to official advice group the Advisory Council on the Misuse of Drugs (ACMD).

In keeping with the focus of the coverage on young people and children as 'victims' of mephedrone, parents became moral entrepreneurs, particularly when apparently affected by their children's experience of the drug. These reports often linked parents' descriptions of negative effects with calls for a ban ('My Sixteen-year-old Is Addicted to Mephedrone', *York Press*, 22 January 2010; 'Mephedrone Killed My Son', *Belfast News Letter*, 26 March 2010). In such cases, the parents become legitimate sources; but their value stems less from the informative aspect of their comments and more from the moral force of their claims and demands.

Critcher also suggests that the media can take on the role of moral entrepreneurs attempting to 'frame' the discussion within a particular moral agenda.[36] Certain newspapers explicitly called for a ban on mephedrone in editorials (e.g. *Scotland on Sunday*, 'Outlaw "Legal High"', 31 January 2010). The *Sun* criticised the government for the 'deadly delay' in introducing a ban, while comparing mephedrone with (class A) ecstasy (*Sun*, 10 March 2010).

Brass Eye's investigation into the perils of cake also made reference to parents as a key constituency in the war on drugs. In the Schools Heightened Aversion Drug Therapy (SHADT) section, an 'at risk' schoolgirl is shown going through a process in which she is told that her parents have died from a drug overdose. She attends their 'staged funeral' before the truth is revealed, after three days, that this was an attempt to warn her against drug use, and she is then reunited with her parents. The father argues that while it has been difficult for their daughter, the aversion therapy was better than her 'being off her mash on ecstasy pipes'.

In the mephedrone coverage, science and scientists became moral entrepreneurs only occasionally, not least because of the lack of research on this relatively new substance, and the equivocal position of those who might otherwise be seen as powerful sources, such as some of the members of the ACMD. Indeed the resignations of some members of the

ACMD in protest at the government's approach ('Expert Quits to Sink Drugs Ban', *Daily Mail*, 29 March 2010) indicate that scientific opinion was unlikely to provide strong support in the construction of a moral panic around mephedrone. Similarly, although in other episodes of *Brass Eye* (such as the 'Animals' and 'Science' episodes, in which science is often presented itself as the focus of a moral panic),[37] science as an institution is represented, in the 'Drugs' episode it is not a key element. Instead, it is largely restricted to representation in the form of pseudo-scientific charts and graphs, and references made to apparently scientific 'facts' by other moral entrepreneurs.

As Meikle suggests, *Brass Eye* drew particular attention to broadcast news and current affairs' reliance on 'authoritative sources' through its use of broadcasters, politicians and celebrities to present absurd arguments.[38] The contributions of Bernard Manning and Rolf Harris have already been mentioned; other celebrities involved include Bernard Ingham, former chief Press Secretary to Margaret Thatcher, and 'agony aunt' broadcaster Claire Rayner. TV presenter Noel Edmonds's contribution was a description of how cake's active ingredient, 'a dangerous psychoactive compound known as dimesmeric ansonphosphate', affects the area of the brain which processes the perception of time, known as 'Shatner's Bassoon', with potentially fatal consequences.

Perhaps the most notable example of *Brass Eye*'s use of public figures as unwitting examples of moral entrepreneurship is the sequence in which MP David Amess is convinced by a 'researcher' to take part in the FUKD and BOMBD campaign against the drug in which he describes it as a 'bisturbile cranabolic amphetamoid', a 'made-up psychoactive chemical'. Amess then suggests asking a question in Parliament about the threat posed by cake, and the show cuts to an image of the *Hansard* record of the question. In this way his authority is both illustrated and ridiculed.

Resolution

The newspaper coverage suggested that there were two possible ways to resolve the threat of mephedrone. The most prevalent option was a ban; this, as we have seen, was *implicit* in much of the reporting whereby the dangers were emphasised, and *explicit* in comment and editorial in most newspapers. However, the second option satisfied a small minority. Thus some newspapers reported, sometimes grudgingly, the suggestions of former ACMD chairman David Nutt for a more nuanced, non-criminalised approach ('Meow Meow Ban Won't Work', *Metro*, 1 April 2010; 'Nutt: Don't ban deadly dance drug', *Mirror*, 1 April 2010). Other newspapers – usually broadsheets – explicitly criticised the idea of banning mephedrone ('Mephedrone Madness: Leading Article', *Independent*, 3 April 2010) and criticised 'kneejerk' government action against a drug whose effects had not been investigated. The approach advocated by Nutt and others – the harm minimisation approach – offered an alternative to a ban, but was referred to only marginally in the coverage.

Brass Eye similarly offered two key alternative solutions to the dangers of cake. The harsh aversion therapy discussed above was one; the other referred (in the form of a spoof period documentary) parodically back to a 1979 'experiment' at a boarding school ('Drumlake') in

which drugs were not just allowed but encouraged. Children were allowed to 'find their own level of drug intake', and by the age of eighteen were 'generally rather bored with it'. While the form of this 'liberal alternative' segment was clearly intended to signify a *reduction ad absurdum*, Morris in his guise as presenter immediately comments: 'Well, Drumlake may have worked, but that doesn't stop it from being complete guff.'

While apparently dismissing the results the school produced, the acknowledgment that it 'worked' suggests, perhaps implicitly, that Morris himself, as the writer of the series, perhaps sees some value in a more liberal perspective; certainly, the weight of *Brass Eye*'s critiques is aimed at the exaggeration and distortion of moral panics which emphasise the need for authorities to 'do something'; its critique of liberalised approaches is relatively muted.

Conclusion

The study of moral panics provides the opportunity to itemise the specific ways in which the media play a key role in the perception of social problems. Some of the elements of the model set out by Critcher are less relevant than others; certainly, those which refer not to the media but to other social institutions would, I would argue, be difficult to fit into the spoof current affairs format that *Brass Eye* represents. However, the key elements of the model – particularly the media inventory containing exaggeration, distortion and prediction, and the use of moral entrepreneurs – are represented clearly within the show.

The coverage of mephedrone, as discussed here and elsewhere,[39] can clearly be understood as part of the wider moral panic over 'legal high' drugs. Some academic and popular accounts have suggested that *Brass Eye* was, at least in part, a satire on media constructions of moral panics,[40] 'highlighting the po-faced prurience of the media' (Gallagher, 2004).[41] Indeed, the satirical anger represented in *Brass Eye*'s critique of the media illustrates Morris's own 'moral crusade', even if he himself dismisses the idea.[42] The hint (even in the absurdly extreme form depicted at Drumlake School) that a liberalised approach to drugs might 'work' suggests that Morris does implicitly take a position within the debates around drug use. The evidence presented here suggests that some of the key elements of moral panic analysis are employed in *Brass Eye* to support a sometimes surreal, absurdist critique of mediated constructions of social issues. The final pre-credit sequence of the 'Drugs' episode illustrates this point, when Morris's presenter suggests that his own heroin habit is perfectly unproblematic, while it would be very different if the user was someone 'less stable, less educated, less middle class than me – builders, or blacks for example. If you're one of those, my advice to you is to leave well alone.'

Notes

1. Brett Mills, '*Brass Eye*', in Glen Creeber (ed.), *Fifty Key Television Programmes* (London: Edward Arnold, 2004), p. 27.

2. *Brass Eye*, 1997.

3. Mills, '*Brass Eye*', p. 26.

4. Lucian Randall, *Disgusting Bliss: The Brass Eye of Chris Morris* (London: Simon and Schuster, 2010), p. 183.

5. Mills, '*Brass Eye*', p. 26.

6. Sharon Lockyer and Feona Attwood, '"The Sickest Television Show Ever": Paedogeddon and the British Press', *Popular Communication* vol. 7 no. 1 (2009), pp. 49–60.

7. Stanley Cohen, *Folk Devils and Moral Panics* (3rd edn) (Abingdon: Routledge, 2002).

8. Nic Fleming, 'Miaow-miaow on Trial: Truth or Trumped-up Charges?', *New Scientist* (29 March 2010), <http://www.newscientist.com/article/dn18712-miaowmiaow-on-trial-truth-or-trumpedup-charges.html?full=true>.

9. Philip Jenkins, *Synthetic Panic: The Symbolic Politics of Designer Drugs* (New York: New York University Press, 1999).

10. Kenneth Thompson, *Moral Panics* (London: Routledge, 1998), p. 33; Cohen, *Folk Devils and Moral Panics*.

11. John Eldridge, Jenny Kitzinger and Kevin Williams, *The Mass Media and Power in Modern Britain* (Oxford: Oxford University Press, 1997), p. 71; Chas Critcher, *Moral Panics and the Media* (Maidenhead: Open University Press, 2003), p. 2.

12. Jeremy Collins, 'Moral Panics, Governmentality and the Media: A Comparative Approach to the Analysis of Illegal Drug Use in the News', in Julian Petley *et al.* (ed.), *Moral Panics in the Contemporary World* (London and New York: Continuum, 2013).

13. Randall, *Disgusting Bliss*, p. 164.

14. Mills, '*Brass Eye*', p. 27.

15. Ibid.

16. Jane Ogborn and Peter Buckroyd, *Satire* (Cambridge: Cambridge University Press, 2001), p. 13.

17. Arthur Pollard, *Satire* (London: Methuen, 1970), p. 2.

18. Graham Meikle, 'Naming and Shaming: News Satire and Symbolic Power', *Electronic Journal of Communication* vol. 8 nos 2, 3 and 4 (2008), <http://www.cios.org/www/ejc/EJCPUBLIC/018/2/01847.html>.

19. Ibid.

20. Ibid.

21. Lockyer and Attwood, '"The Sickest Television Show Ever"'.

22. Randall, *Disgusting Bliss*.

23. Kernan, cited in Lockyer and Attwood, '"The Sickest Television Show Ever"', p. 55.

24. Randall, *Disgusting Bliss*, p. 195.

25. Meikle, 'Naming and Shaming', p. 1.

26. Cohen, *Folk Devils and Moral Panics*, p. 3. The transactional approach is that in which deviance 'is *not* a quality of the act the person commits, but rather a consequence of the application by others of rules and sanctions to an "offender"', such that a key focus is the construction of social rules and conventions which label any particular activity as 'deviant' (Becker, quoted in Cohen, *Folk Devils and Moral Panics*, p. 4.)

27. Ibid., p. 12.

28. Ibid., p. 97.

29. Erich Goode and Nachman Ben-Yehuda, *Moral Panics: The Social Construction of Deviance* (2nd edn) (Chichester: Wiley-Blackwell, 2009). While similar in many respects, Critcher argues that Cohen's model was *sequential*, focused on the process by which a moral panic passes through various stages, whereas Goode and Ben-Yehuda emphasised the particular attributes by which a moral panic might be recognised without a necessary sequence of events.
30. Critcher, *Moral Panics and the Media*, p. 153.
31. *Daily Telegraph* (30 April 2009); *Sun* (24 July 2009).
32. Ibid.; Sarah Thornton, 'Moral Panic, the Media and British Rave Culture', in Andrew Ross and Tricia Rose (eds), *Microphone Fiends: Youth Music and Youth Culture* (London : Routledge:, 1994), pp. 176–92.
33. It has however been suggested that the name meow meow was popularised, if not effectively invented, by the newspapers that first reported on mephedrone: *Observer* (17 July 2011); *Private Eye* no.1259 (2–15 April 2010: 'Street of Shame').
34. Critcher, *Moral Panics and the Media*, p. 17.
35. The absurdist language used here ('snuffed her lid') heightens the surrealism of Morris's comedy.
36. Critcher, *Moral Panics and the Media*, p. 152.
37. In 'Animals', scientists interfere with the genes of cows so that they become 'big balls of meat'; in 'Science', domestic power lines are found to carry 'heavy electricity' which falls dangerously from the cables like 'a ton of invisible lead soup'.
38. Meikle, 'Naming and Shaming', p. 5.
39. Collins, 'Moral Panics, Governmentality and the Media'.
40. Mills, '*Brass Eye*', p. 28.
41. Cavan Gallagher, '"You're Wrong and You're a Grotesquely Ugly Freak!": Brass Eye Remembered', *Metro* (1 October 2004).
42. Randall, *Disgusting Bliss*, pp. 155, 195.

6

'COMPLAINTS WERE RECEIVED': MORRIS, COMEDY AND BROADCASTING IN CONTEXT

BRETT MILLS

213 complaints were received concerning the initial Channel 4 broadcast of the programme and a further 29 about the repeat. Four viewers complained about the transmission on S4C. A large number objected to the subject matter, which they did not consider an appropriate subject for an entertainment programme. Other complainants believed that the programme condoned paedophilia and mocked victims. Some considered that the programme's warning and format had deliberately blurred the intention of the programme and misled the audience. Others were offended by the images of children taking part in items of a sexual nature. There were also concerns about the involvement of children in the programme, as some felt that this might have been harmful to the actors and placed them at risk. A number of complainants were also concerned by the involvement of celebrities in the programme.

The Commission also received 171 letters supporting the programme.[1]

So begins the special publication released by the Broadcasting Standards Commission (BSC)[2] in 2001 reporting on its investigation into the complaints it received about the 'Paedophilia' episode of *Brass Eye*. This half-hour programme, first broadcast on Channel 4 at 10.35 pm on 26 July 2001, occupies a key position in debates about the social role of television because it was, at the time, 'the most complained-about television programme in British broadcasting history'[3] and has been referred to by Channel 4 itself as a 'nice little stink bomb'.[4] As this chapter will show, the ensuing storm led to wide-ranging discussions about the acceptable use of humour in broadcasting, the relationships between audiences and broadcasters, how viewers can understand programme content and the roles governments and regulators have in balancing rights of freedom of speech with the ambition of protecting diverse viewing communities.[5] In that sense, we can examine this episode of *Brass Eye* because it exemplifies discussions over what television is *for*.

Debates about the functions of broadcasting were not only the consequences of this programme; they were also incorporated into the content of the programme. *Brass Eye* is a parody of a current affairs programme, and its humour arises from the exaggeration and misapplication of the tropes and conventions of such 'serious' fare, resulting in a

'deconstruction of television non-fiction discourse'.[6] A full series of six episodes was broadcast by Channel 4 in 1997 covering topics such as animals, drugs and sex. For Chris Morris, the programme was a logical progression from his work on *The Day Today* (BBC 2, 1994) and *On the Hour* (BBC Radio 4, 1991–2) where the conventions of broadcast news and journalism were similarly parodied. *Brass Eye* returned in 2001 with the one-off special under discussion here, which took paedophilia, and the media's treatment of it, as its theme. In interviews, Morris made clear at the time that reactions to the programme that resulted in it being dubbed 'The Sickest TV Show Ever' demonstrated 'that the standard of public debate [in the UK] is so lamentably low; what's good or satisfying about that?'[7] Yet the investigations by broadcasting regulators, alongside the parallel debates in the media, show that a public discussion *did* take place over this programme, and it was one that highlighted the assumptions that underpin broadcasting in the UK, but which are rarely centre stage in debate. By doing things that, it seems, many people assumed television should not do, *Brass Eye* can be explored to delineate that which the medium does all the time without anyone noticing.

As the BSC report signals, many forms of broadcasting regulation in the UK work on the principle that programmes can only be complained about once broadcast, and regulators can only investigate such programmes if a complaint is received. That is, while there are many regulatory and legal frameworks related to media ownership and the aims of broadcasters, issues such as those related to offence are regulated by a system that assumes censure can only begin after the fact. There were, of course, many concerns about the programme *before* it was broadcast,[8] but the role assigned to the BSC prevented it from becoming involved until after the episode was shown. Such regulations clearly place the responsibility for the appropriateness of broadcast material on the broadcasters' shoulders and television regulators in the UK have been keen to point out that they are, therefore, not censors. Perhaps more importantly, the system is intended to empower viewers as citizens, with regulators merely responding to a public mood evidenced by complaints, and thereby speaking on behalf of an engaged and vocal citizenry. This mode of regulation prioritises the behaviour and responses of the audience, a fact supported by the ongoing research that media regulators carry out on audience opinions on media issues and representations.[9] The precise ways in which such regulation constructs the public as citizens will be explored in more detail below; what needs to be understood here is the foregrounding of a reactive role for regulators within this system and, therefore, how this assumes that television broadcasting is a *public* good, intended to respond to perceptions of a national mood or societal norms. Of course, coalescing millions of people from a range of communities and backgrounds into something called the 'national consciousness' is nigh on impossible, yet ideas of national broadcasting have always worked from this assumption of an 'imagined community'.[10] Indeed, disagreements over programmes such as *Brass Eye* – as evidenced by the 171 letters of support the BSC received – actively highlight the fissures in such national norms, demonstrating the difficulties regulators repeatedly face in making decisions that purport to reflect 'the audience'.

'An Appropriate Subject for an Entertainment Programme'

Central to the debates about the *Brass Eye* episode were concerns over its comic nature. As reported by Conlan, participants in the programme insisted that paedophilia 'is no laughing matter', while a spokesperson for the charity National Children's Home[11] stated that '*Brass Eye* made light of an issue that we believe should not be trivialised.'[12] Similarly, a spokesperson for the then Home Secretary, David Blunkett, attested that Blunkett was 'pretty dismayed by the programme and did not find it remotely funny'.[13] Day reports that the companies whose adverts appeared during the broadcast were similarly unhappy with the programme's comic tone, with Boots the Chemist insisting that 'paedophilia itself was satirised' by it.[14] The insistence on rejecting the idea that paedophilia is an appropriate topic for humour is perhaps most clearly evident in Clench's article for the *Sun*, the headline of which has the word 'comedy' in inverted commas.[15] And this context was one acknowledged by the programme's makers and broadcaster, for as the BSC Special Finding attests, Channel 4's defence of the programme 'stated that it would never make light of paedophilia' and that 'the programme was not intended to mock or ridicule the victims of child sex abuse or those that worked with them'.[16]

Such debates need to be placed in context; paedophilia has changed in the UK from a marginal issue in public discourse and newspaper reporting to a much more central one throughout the 1990s. Concerns over the safety of children, the nature of crime and criminals and the ability of governments to successfully respond to such concerns, have 'tapped a vein of public anxiety running through the body politic of Britain in the latter half of 2000'.[17] There was at the time, therefore, much 'social anxiety about paedophilia'[18] and real confusion about how it was constituted and what should be done about it. Feeling that 'official' sources were failing to do their job properly, the British newspaper the *News of the World* published an edition on 23 July 2000 that 'declared its intention to name and shame 100,000 known paedophiles',[19] which can be seen as a key moment in British cultural and policy understandings of child sex offences; it is to these events that *Brass Eye* refers, querying the content and standard of the debate on display, and, via its humour, critiquing the 'dominant media scripting of pedophilia [sic]'.[20]

Therefore, *Brass Eye* raises serious questions about what is and is not perceived to be 'an appropriate subject for an entertainment programme'. As was clear from the participants in the discussion, no one rejected the idea that television should talk about or refer to issues of paedophilia and the treatment of children; indeed, some would argue that television's public funding and social role requires it to engage with what are perceived to be the biggest issues of the day. Yet this debate demonstrates that there are clear assumptions for many audiences (as well as, perhaps, for regulators and members of the government) that some topics *must* be engaged with in a public arena in particular ways. In this instance, this presents itself as an assumption that comedy and entertainment are arenas with specific purposes and, by extension, able to engage only with certain topics; as van Zoonen asks, 'Can politics be combined with entertainment?'[21] This highlights assumptions about the consequences and functions of entertainment and comedy, especially when they exist within a mass public arena such as broadcast television.

The regulations make it clear that comedy is a troublesome beast, which regulators have trouble making sense of. For example, the BSC's special finding attests to the specific social functions of comedy while simultaneously recognising that undefined boundaries still restrict it:

> The Commission affirmed the right of broadcasters to produce satirical programmes, even on such sensitive topics as paedophilia. It also recognised that satire will often only achieve its purpose by shocking and offending some people. However, whilst there can be no taboo areas for satire, it does not have unlimited licence.[22]

It is telling here that the comedy in the programme is defined as 'satire', for satire is a form of humorous interaction that, with its foregrounded sociopolitical intentions, is often permitted freer rein than other types of comedy. For example, Gray, Jones and Thompson distinguish between the comedy of mainstream sitcom which they see as tending to 'flatter their viewers' and satire which pokes fun at 'the people who run things', with the latter clearly perceived as of more 'worth' than the former.[23] The regulations uphold this view, for we can see that comedy is given more licence when it is perceived to be doing more than 'simply' making people laugh; in essence, when it is serious.

This assumption draws on wider perceptions about the nature of public discourse. As Gray notes, 'following [Jürgen] Habermas, many scholars have exhibited significant suspicion or outright disbelief of entertainment's abilities to contribute to such a project [as the public sphere]',[24] and many still view politics as ruled by the 'old, serious, rich and male'.[25] Yet it has been shown that the dominance of serious discourse is a contributing factor to many audiences' avoidance of public debate, precisely because it is a way of communicating such audiences associate with dominant power structures and communities other than those they belong to. For example, empirical research shows that 'popular culture, in its various forms, [has been] found to offer young people particularly salient points of identification with the national and international arena in a way that news media do not'.[26] The battle in *Brass Eye*, then, is one over *how* certain kinds of topics can and cannot be discussed, rather than over *what* is being discussed.

It is, then, unsurprising that Channel 4 should be the home of *Brass Eye*, for it is the broadcaster with the public service remit of 'providing a broad range of high quality and diverse programming ... which, in particular, ... appeals to the tastes and interests of a culturally diverse society'.[27] Indeed, throughout its history, Channel 4 has been conceived as a broadcaster with the intention to 'give new opportunities to creative people in British television, to find new ways of finding minority and special audiences and to add different and greater satisfaction to those now available to the viewer';[28] in other words, it has 'a licence to be different'.[29] This has meant that it has repeatedly broadcast programming which has, for different reasons and different audiences, been controversial.[30] Peter Oborne argues that Channel 4 has always had a 'mischievous agenda' and that, via its factual programming, its aim is to produce 'the unofficial history of Britain'.[31] While reaching younger audiences was never officially part of the channel's early remit, the kind of programming its 'different' licence resulted in has meant that 'Channel 4 has always attracted a far higher percentage of younger viewers than its rivals'.[32]

This outcome was formalised as an intention by the Digital Economy Act (2010), which requires Channel 4 to make 'relevant media content that appeals to the tastes and interests

of young children and older adults'.[33] In making programming for a 'diverse' society, Channel 4 inevitably produces fare deemed problematic by other members of that society, and humour is a social phenomenon whose content and functions are closely tied to demographic factors.[34] In that sense, broadcasting will inevitably be bedevilled by problems when it tries to make comedy for 'everyone', and we can see the regulators' desire to allow different kinds of comedy in their acknowledgment of the roles of satire and, most visibly, in their rejection of the complaints against *Brass Eye* in this instance. That said, it is also telling that the justification the regulators cite to outline why a comedy about paedophilia is acceptable is one that foregrounds the programme's serious, satirical intention, thereby showing how it contributes to national debate and ideas of public service broadcasting. What this shows is that regulations allow for comedy; but that humour functions within a regulatory framework that prioritises serious intent, even if that intent is achieved via joking.

'Misled the Audience'

The fact that the Commission investigated whether *Brass Eye* 'misled the audience' highlights the assumption that one of the things broadcasting is *not* meant to do is mislead. About a third of the Commission's report examines scheduling of the programme and the warning that preceded it, and these are clearly both indicators, within a broadcasting context, to viewers of the kinds of material they are about to encounter. In its conclusion, the report states that 'the Commission accepted that the disturbing nature of the programme and its subject matter had been made clear' and it had therefore 'not exceeded acceptable boundaries'.[35]

There are several possible ways in which audiences could have been misled. Concerns over scheduling simply point towards a long-standing working practice in British television which, as the BBC notes, sees 9.00 pm as the 'watershed', after which 'more adult material' may be broadcast while the 'strongest material should appear later in the schedule'.[36] Current regulations, outlined by Ofcom, regard 'context' as paramount, which includes channel, time, the programmes before and after a particular series, and the probable audience.[37] This very clearly sees television programming as a part of broadcasting; indeed, quite different regulations apply to television when it is viewed on other formats such as DVD, where the adjudications of the British Board of Film Classification apply.[38] But another problem arises when television functions as broadcasting, and Ofcom notes that, in making decisions about the appropriateness of material, 'context' also acknowledges 'the effect of the material on viewers or listeners who may come across it unawares'.[39]

That audiences can encounter material 'unawares' is demonstrated by the fact that the BSC *did* uphold a complaint about the *trailer* for *Brass Eye* that was broadcast on Channel 4 on 28 June 2001 at 11.05 pm and 30 June 2001 at 10.05 pm. While the Commission rejected some of the complaints about the trailer's content, it did argue that:

> the brevity of the trailer would have made it difficult for the viewing audience to sense it was a
> satire or that it was promoting a satirical programme. It was too subtle and too refined for this to

be easily understood. … The Committee considered, in the circumstances, that this had exceeded acceptable boundaries for a programme trailer.[40]

The trailer, it seems, failed to make clear that the programme was a parody of a current affairs programme and so instead may have 'fooled' audiences into thinking it was a real edition of such a series. In noting that the trailer was too 'subtle' and 'refined', the Commission makes clear assumptions about the viewing public's media literacy, and highlights the expectation that trailers should unambiguously state the nature and content of a programme. Of course, the possibility that audiences might be fooled into thinking a fictional programme is a factual one because it has exhibited certain characteristics is the *raison d'être* of series such as this, as they intend to 'make plain what documentary as a genre tends to deny: the fluidity between fiction and non-fiction'.[41] By this account, the fact that people can be fooled is the point, because it shows how easy it is for media forms to adopt the tropes of genres and texts which purport to signal expertise and authority, thereby revealing them as nothing more than conventions.

But the fear that audiences can be misled also highlights the ubiquitous assumption that the media have significant social and political power and therefore are *capable* not only of fooling audiences, but also that a process of duping disables audiences' ability to appropriately engage in their roles as citizens. As John Street outlines, media power can be judged in many ways, but two of the most commonly used frameworks draw on ideas that the power stems from who gets to speak ('access power') and what is said ('discursive power').[42] The fear of the discursive power of broadcasting underpins the notion that media must be regulated and audiences must be able to determine what is acceptable for broadcast. This becomes crystallised in the concept of 'trust', which runs through contemporary discourses concerning media activity; for example, the BBC insists that it wants to be 'a benchmark of quality and trust in all its output'.[43] Yet trust, of course, raises serious problems for programmes such as *Brass Eye* that work by fooling participants and, to an extent, audiences, just as 'mockumentary' repeatedly has via its 'call to play'.[44] That the BSC did not uphold the complaints about audiences being misled (other than those concerning the trailer) demonstrates the flexibility of contemporaneous regulatory practices that acknowledge a range of possible audience readings and encourage such experimentation on the part of broadcasters. Yet, the fact that contextual factors play such a significant part in regulators' decisions demonstrates that, while such flexibility exists, it is also carefully managed.

'The Involvement of Children'

The only part of the complaints that the BSC upheld concerning *Brass Eye* was that relating to the representation of children. In its finding, the Commission states that it was 'concerned by the cumulative impact of the images of children seen in a sexual context in the programme', going on to note that this had caused 'strong and genuine distress in viewers'.[45] Tellingly, this aspect was upheld in spite of the fact that the Commission realised that most viewers 'would have been unaware of the circumstances surrounding their [the children's] filming'.[46] While this acknowledgment of viewers' ignorance of television's production

processes could be a rationale for rejecting the complaints, the Commission instead appears to see this as something broadcasters should take into account. For the regulator, the fact that viewers may have perceived child actors to be in problematic situations is more important than whether they actually were or not; the distress is weighted as more significant than the production origins of the material that caused it. In making such a decision, the BSC clearly sees itself as a protector of audiences. Here, the Commission's role is not to educate the public or promote media literacy: quite the opposite, its function is to protect those lacking media literacy from the consequences of their 'misreadings'.

In doing so, the Commission exhibits a paternalistic attitude towards the public akin to that that audiences appear to adopt towards children on television. That the *Brass Eye* special was about children is key, and it's telling that audiences complained about both the representation of children *and* the use of children in the programme's production. Much of the discussion in newspapers foregrounded these aspects. For example, a lengthy article in the *Daily Mail* focuses on a principal actor in the programme – Doon Mackichan – highlighting in its headline the fact that she has two children.[47] Another article from the same newspaper includes quotes from the children's charities the National Society for the Prevention of Cruelty to Children (NSPCC) and the National Children's Home, and features a suggestion from a duped programme participant that, in recompense for the offence, Channel 4 should 'give some [money made from the adverts] to a children's charity'.[48] In defence, Channel 4 explained that 'all the photographs of children seen in the programme were pictures of the crew when they were young' and that all the child actors in the episode 'were aware they were taking part in a satire about paedophiles'.[49]

Television's structures demonstrate that children are understood as a discrete and special category within broadcasting. While a wide variety of programming can be understood in terms of the ages of those likely to consume it (for example, 'teen TV'),[50] children's programming is the only age-defined genre category that has consistently been enshrined within British ideas of television production, regulation and policy.[51] Defining television as 'children's' is problematic not least because that genre contains many others; dramas, news programmes, sitcoms, sketch shows and any other television genre might feasibly exist within the overarching category of 'children's'. Yet the BBC has two channels – CBBC and CBeebies – devoted to children, and Channel 4 reaches a similarly age-defined audience via its schools' programming. The significance is such that industrial and regulatory structures assume there is something specific and particular about the relationships between children and television, and this process must therefore demonstrate that, within broader culture and societal norms, there is something about 'the child' which is deemed to be of particular importance when thinking about what television does, who it is for and how it is consumed.

Of course, one aim of the *Brass Eye* episode was precisely to question the assumptions commonly made about children. As Ferguson notes, one of the motivations for the making of the programme was Morris's increasing frustration 'at the way children, and the idea of childhood, had become deified'. This reverence, Morris felt, meant that parents now appeared to behave as if having a child 'conferred on them a divine right to make endless pronouncements unfettered by such restrictive critical considerations as logic, fact or honesty'.[52] In essence, the concern is that childhood is considered so inviolate in contemporary society that anyone

daring to question this is labelled dangerous; and broadcasting regulations uphold and realise this premise in practice.

As has been noted by many, constructing children as vulnerable denies power to young people. As Monk shows, the development of the idea of 'the child' within the law 'represents a site of struggle between competing and often conflicting moral, "scientific" and political discursive understandings of childhood'.[53] Such laws often centre on the relationships between young people and media, for 'debates over children's media uses have repeatedly resurfaced since the advent of modern mass media in the nineteenth century',[54] with concerns over their potential harm 'providing the major motivation for conducting and, certainly, funding research on children and media over decades'.[55] Such research simultaneously constructs children as innocent *and* a problem, and reasserts adults' rights and responsibilities in deciding what is and is not appropriate for them culture-wise. It is telling that the BSC upheld only this aspect of the complaints against *Brass Eye*, for this demonstrates the reverence with which adults' fears for children are held, and the sympathy regulation has for adults who, the finding acknowledges, fail to understand how television is made. In that sense, it is not children who are being protected here at all (after all, the programme-makers made sure the child actors had been protected), it is adults' cultural understandings of what childhood is and how it should be represented. Regulations therefore legitimise adult–child understandings and see, in this case, their transgression as an offence ripe for sanction.

'The Involvement of Celebrities'

A key component of the programme was its use of celebrities to endorse fictitious campaigns. Many famous people – such as the footballer Gary Lineker and the musician Phil Collins – give pieces to camera spouting nonsense about the behaviour of paedophiles and the threats they pose to children. The aim of such sequences was to show how celebrities are willing to give 'their voice to something they didn't bother to question'.[56] The interviewing of people in such ambiguous situations has repeatedly been used by comedians to sociopolitical ends, by characters such as Ali G and in the 'postmodern' performance of Stephen Colbert.[57] With *Brass Eye*, some of the duped celebrities made complaints to the BSC citing 'unfairness'; that is, that they had not fully known what they were agreeing to and the ensuing footage had been used for ends they had not condoned. Of course, the programme's intent was to highlight the fact that famous people are allowed a privileged place in public debate even when demonstrably ignorant about the subject; but the television regulations at the time saw 'fairness' as a crucial component of responsible media behaviour, and so the complaints were fully investigated.

Perhaps tellingly, the BSC rejected all such complaints. For example, the television presenter Nicholas Owen had his complaint thrown out because, according to the BSC:

> he agreed to make a number of statements that, by his own acknowledgement, he did not
> understand without making any checks about the organisation or probing in any depth on [sic]
> some of the bizarre statements he was being asked to make.[58]

This followed a similar rejection of complaints by the Members of Parliament Barbara Follett and Syd Rapson, because, according to the BSC, the programme was successful in showing that public figures 'were willing to speak "with apparent authority about matters they do not understand"'.[59]

This decision, and the complaints that prompted it, highlight conflicting ideas over the role of public faces on television. Who is and is not allowed to speak on television depends on the intentions of particular agents and the conventions of genres. In factual programming, 'ordinary' people are commonly allowed to talk about themselves and their own experiences but rarely get the opportunity to make explicitly political statements. This activity is instead reserved for politicians, pundits and celebrities; the authority that is bestowed upon such speakers is predicated on their 'difference' from 'ordinary' people, no matter how such difference is defined and maintained. As Marshall argues, the celebrity functions as some kind of 'charismatic prophet' able to speak about the world, and therefore 'the celebrity system [functions] as a central element of political culture'.[60] The 'special-ness' that imbues the celebrity with the right to speak is predicated on their not being ordinary, whether that is via 'talent', knowledge, expertise or authority. In that sense, the representation of experts on television is vital to the upholding of ideas of authority and expertise; we listen to those on television telling us things because, it is assumed, they know more than we do.

The complaints made to the BSC by Owen, Follett and others acknowledge, of course, their ignorance in the matters they were talking about, which would appear to be troubling for the system of authority in play. But they did not complain about being made to look as if they didn't know anything when they did; they complained that the production system that led to their display of ignorance was one which failed to tell them the truth about what they were involved in. In that sense, the perceived 'unfairness' here was one about the misappropriation of representation, as well as what are assumed to be unacceptable production practices. This means that what is being complained about here is a breaching of the code that says audiences can trust what famous people say on television because famous people on television can trust the media system they work in. Yet the BSC – insisting that it is on the side of audiences – instead sees the system of trust as dependent on speakers ensuring they carry out their own checks on what they are filmed saying and doing. While the 'unfairness' clause within the BSC's code of practice may appear to be one that protects performers, it seems that, in practice, the regulator only deems such behaviour unfair if audiences are fooled, not participants. The fact that Brass Eye's meaning rested on the assumption that audiences understood that participants had been fooled means that there is no 'unfairness' here, even if the participants had not understood their own behaviour themselves.

According to an ITN spokesperson, a possible outcome of the programme was, at the time, that 'when prominent people are asked to work with charities in the future they could be put off it'.[61] This means that, even in the discussion following the programme, the role of celebrities in public realms remains up for debate, with ITN (a news broadcaster, no less) willing to bemoan the possible loss of 'prominent people' from the public sphere. It's hard not to see this as a desire from the programme-makers to maintain both 'access power' and 'discursive power'[62] within broadcasting, even if the regulator insists that questioning such normalised power structures could be a worthwhile activity. In that sense, the BSC appears

to be more progressive in its desire to engage citizens within the public realm than broad-casters (and charities) are.

'Complaints Were Received'

As the quote from the BSC Special Finding at the start of this chapter attests, 'complaints were received' but also many letters of support congratulated the *Brass Eye* programme. Indeed, Channel 4 reported that it received *more* telephone calls of support for the broad-cast than it did of complaint, including ones from 'victims of paedophiles' and 'one social worker'.[63] How is a regulator to make sense of this, especially when regulatory proceedings are initiated by complaint and regulation is assumed to function as a system that reacts to audience responses?

Running through these debates are the problems regulators and broadcasters encounter because television is primarily defined nationally; how can there be such a thing as 'British' television when societies are made up of a wide range of communities with different atti-tudes, ideologies and beliefs? Ofcom's current regulations work from the starting point of 'generally accepted standards'[64] which is, of course, a fairly meaningless term. Debates over such standards have continued to arise within British culture: a race row on the 2007 series of *Celebrity Big Brother* (Channel 4, 2001–10; Channel 5, 2011–) resulted in 44,500 com-plaints to Ofcom and 'opened up a broader public discussion about casual racism in British society';[65] prank phone calls by Jonathan Ross and Russell Brand broadcast on BBC Radio 2 in 2008 resulted in 42,000 complaints and, eventually, the resignation of the station's con-troller;[66] and the international response to the publication of cartoons of the prophet Mohammed in the Danish newspaper *Jyllands-Posten* in 2005 shows that debates over acceptable culture in mass media are not restricted either to television or to the UK con-text.[67]

In order to define these 'generally accepted standards', Ofcom – like the Broadcasting Standards Commission before it – commissions a wide range of audience research in an attempt to ensure that its work reflects the public mood. But such research must, inevitably, foreground majority rule, with alternative voices rendered problematic or shunted to the margins. Channel 4 itself can be seen as a fruitful outcome of a desire to welcome such voices into broadcasting, and to allow a range of communities access to the public sphere. But, as this case shows, such texts remain bound by regulations and responses from the wider community who, via a storm in various national newspapers, might be seen as dis-couraging similar programming in the future. In that sense, it's worth thinking about what the legacy of the *Brass Eye* debate is. That many mass cultural forms – such as those mentioned above – have continued to motivate large numbers of people to complain suggests not only that there remain topics and representations which some see as unacceptable within broad-casting, but also that individuals and communities remain committed to an idea that the roles that popular culture plays in society should be taken seriously. Fortunately, this is also the position adopted by policy and regulators; it may be easy to see such institutions as censors, but their existence demonstrates a societal consensus that culture matters.

Notes

1. Broadcasting Standards Commission, 'Finding: *Brass Eye* Special' (*Ofcom*, 2001), <http://www.ofcom.org.uk/static/archive/bsc/pdfs/bulletin/brasseyespecialfinding.htm>.
2. The Broadcasting Standards Commission's role was to investigate and adjudicate upon 'two types of complaints: standards and fairness', related to British television broadcasting. It ceased to exist in December 2003 when its duties, along with those of other broadcasting regulatory bodies, were given to the newly formed Ofcom. For more information, see Broadcasting Standards Commission, 'About the Commission' (*Ofcom*, 1996), <http://www.ofcom.org.uk/static/archive/bsc/plain/about.htm#comm>.
3. Brett Mills, '*Brass Eye*', in Glen Creeber (ed.), *Fifty Key Television Programmes* (London: Arnold, 2004), p. 26.
4. Michael Jackson, quoted in Maggie Brown, *A Licence to Be Different: The Story of Channel 4* (London: BFI, 2007), p. 253.
5. Not covered here, but also important, are the problems *Brass Eye* caused within Channel 4, as executives at the broadcaster disagreed over whether it should be broadcast or not; see Brown, *A Licence to Be Different*, pp. 201–4.
6. Craig Hight, *Television Mockumentary: Reflexivity, Satire and a Call to Play* (Manchester and New York: Manchester University Press, 2010), p. 230.
7. Quoted in Euan Ferguson, 'Why Chris Morris Had to Make *Brass Eye*', *Observer* (5 August 2001), p. 13.
8. Mark Jagasia, 'Collins May Sue after TV Cons Him into Giving Child Sex Alert', *Daily Express* (19 July 2001), p. 10; Gareth Morgan, '*Brass Eye* Spoof Has Stars Fuming', *Daily Star* (19 July 2001), p. 6; Brown, *A Licence to Be Different*, p. 201.
9. For example, the current UK broadcasting regulator, Ofcom, says it is 'committed to evidence-based decision-making' which therefore requires it to carry out a 'comprehensive programme of market research'; see Ofcom, *Annual Plan 2011/12* (London: Ofcom, 2011), p. 23.
10. Benedict Anderson, *Imagined Communities: Reflections on the Origin and Spread of Nationalism* (London: Verso, 1983).
11. The National Children's Home became Action for Children in 2008.
12. Tara Conlan, 'The Brass Neck of *Brass Eye*', *Mail Online* (2001), <www.dailymail.co.uk/news/article-71158/The-brass-neck-Brass-Eye.html>.
13. Quoted in Nigel Morris and Louise Jury, '*Brass Eye*: Ministers Threaten New Curbs on TV', *Independent* (30 July 2001), p. 1.
14. Julia Day, 'Ads Were Pulled from *Brass Eye*', *Guardian Online* (1 August 2001), <http://media.guardian.co.uk/Print/0,3858,4231947,00.html>.
15. James Clench, 'Charity's Fury at TV Child Sex "Comedy"', *Sun* (28 July 2001), p. 5.
16. Quoted in Broadcasting Standards Commission, 'Finding: *Brass Eye* Special'.
17. Chas Critcher, 'Media, Government and Moral Panic: The Politics of Paedophilia in Britain 2000–1', *Journalism Studies* vol. 3 no. 4 (2002), p. 532.
18. Catharine Lumby, 'No Kidding: Paedophilia and Popular Culture', *Continuum: Journal of Media and Cultural Studies* vol. 12 no. 1 (1998), p. 48.
19. Critcher, 'Media, Government and Moral Panic', p. 524.

20. Sharon Lockyer and Feona Attwood, '"The Sickest Television Show Ever": *Paedogeddon* and the British Press', *Popular Communication* vol. 7 no. 1 (2009), p. 58.

21. Liesbet van Zoonen, *Entertaining the Citizen: When Politics and Popular Culture Converge* (Lanham, MD: Rowman and Littlefield, 2005), p. 1.

22. Broadcasting Standards Commission, 'Finding: *Brass Eye* Special'.

23. Jonathan Gray, Jeffrey P. Jones and Ethan Thompson, 'Foreword', in Jonathan Gray, Jeffrey P. Jones and Ethan Thompson (eds), *Satire TV: Politics and Comedy in the Post-Network Era* (New York and London: New York University Press, 2009), p. x.

24. Jonathan Gray, *Television Entertainment* (New York and London: Routledge, 2008), p. 133.

25. Sanna Inthorn and John Street, '"Simon Cowell for Prime Minister?": Young Citizens' Attitudes towards Celebrity Politics', *Media, Culture and Society* vol. 33 no. 3 (2011), p. 482.

26. Martin Scott, John Street and Sanna Inthorn, 'From Entertainment to Citizenship: A Comparative Study of the Political Uses of Popular Culture by First-time Voters', *International Journal of Cultural Studies* vol. 14 no. 5 (2011), p. 513.

27. Ofcom, *Channel 4 Licence* (London: Ofcom, 2004), Section 7.

28. This is a quote from a speech by the then British Home Secretary, William Whitelaw, in 1979, announcing the aims for the channel; see Dorothy Hobson, *Channel 4: The Early Years and the Jeremy Isaacs Legacy* (London and New York: I. B. Tauris, 2008), p. 5.

29. Brown, *A Licence to Be Different*.

30. A good overview of many of these controversies – covering both regulatory matters and programme content – can be found in Edmund Dell, 'Controversies in the Early History of Channel 4', in Peter Catterall (ed.), *The Making of Channel 4* (London and Portland, OR: Frank Cass, 1999), pp. 1–52.

31. Peter Oborne, 'Provoking Debate', in Rosie Boycott and Meredith Etherington-Smith (eds), *25 X 4: Channel 4 at 25* (London: Cultureshock Media, 2008), p. 34.

32. Boycott and Etherington-Smith, *25 X 4*, p. 225.

33. Ofcom, *Annual Plan 2011/12*.

34. Giselinde Kuipers, *Good Humour, Bad Taste: A Sociology of the Joke* (New York: Mouten de Gruyter, 2006); BBC, *Taste, Standards and the BBC: Public Attitudes to Morality, Values and Behaviour in UK Broadcasting* (London: BBC, 2009), pp. 21–34; Sam Friedman, 'The Cultural Currency of a "Good" Sense of Humour: British Comedy and New Forms of Distinction', *British Journal of Sociology* vol. 62 no. 2 (2011), pp. 347–70.

35. Broadcasting Standards Commission, 'Finding: *Brass Eye* Special'.

36. BBC, 'Editorial Guidelines', *BBC*, 2011, <http://downloads.bbc.co.uk/guidelines/editorialguidelines/pdfs/Editorial_Guidelines_in_full.pdf>, p. 39.

37. Ofcom, *The Ofcom Broadcasting Code (Incorporating the Cross-Promotion Code)* (London: Ofcom, 2011), p. 16.

38. British Board of Film Classification, *BBFC Classification Guidelines 2009* (London: BBFC, 2009).

39. Ofcom, *The Ofcom Broadcasting Code*, p. 16.

40. Broadcasting Standards Commission, *The Bulletin: Number 48* (London: Broadcasting Standards Commission, 2001), p. 4.

41. Hight, *Television Mockumentary*, p. 17.

42. John Street, *Mass Media, Politics and Democracy* (Basingstoke: Palgrave, 2001), pp. 232–6.

43. BBC, *Taste, Standards and the BBC*, p. 5.

44. Hight, *Television Mockumentary*.

45. Broadcasting Standards Commission, 'Finding: *Brass Eye* Special'.

46. Ibid.

47. Nick Pryer and Gill Martin, 'Why Doon, a Mother of Two Young Children, Is in Tears at Appearing in Show That Shamed TV', *Daily Mail* (5 August 2001), pp. 34–5.

48. Conlan, 'The Brass Neck of *Brass Eye*'.

49. Lisa O'Carroll, 'Channel 4 Defends *Brass Eye*', *Guardian Online* (27 July 2001), <http://www. guardian.co.uk/media/2001/jul/27/channel4.broadcasting3>.

50. See Glyn Davis and Kay Dickinson (eds), *Teen TV: Genre, Consumption and Identity* (London: BFI, 2004).

51. For an overview of this history, see David Oswell, *Television, Childhood and the Home: A History of the Making of the Child Television Audience in Britain* (Oxford: Oxford University Press, 2002).

52. Quoted in Ferguson, 'Why Chris Morris Had to Make *Brass Eye*', p. 13.

53. Daniel Monk, 'Childhood and the Law: In Whose "Best Interests"?', in Mary Jane Kehily (ed.), *An Introduction to Childhood Studies* (2nd edn) (Maidenhead: Open University Press, 2009), p. 193.

54. Sonia Livingstone and Kirsten Drotner, 'Editors' Introduction', in Kirsten Drotner and Sonia Livingstone (eds), *The International Handbook of Children, Media and Culture* (London, Thousand Oaks, CA, New Delhi and Singapore: Sage, 2008), p. 2.

55. Livingstone and Drotner, 'Editor's Introduction', p. 3.

56. O'Carroll, 'Channel 4 Defends *Brass Eye*'.

57. Geoffrey Baym, 'Stephen Colbert's Parody of the Postmodern', in Gray *et al.*, *Satire TV*, pp. 124–44.

58. Jessica Hodgson, 'ITN Newsreader Loses *Brass Eye* Case', *Guardian Online* (5 March 2002), <http://media.guardian.co.uk/Print/0,3858,4367747,00.html>.

59. Jason Deans, 'MP Loses *Brass Eye* Battle', *Guardian Online* (31 January 2002), <http://www.guardian.co.uk/media/2002/jan/31/politics.labourparty>.

60. P. David Marshall, *Celebrity and Power: Fame in Contemporary Culture* (Minneapolis and London: University of Minnesota Press, 1997), pp. 54, 76.

61. Quoted in Jason Deans, 'NSPCC Asks C4 to Ditch *Brass Eye* Repeat', *Guardian Online* (27 July 2001), <www.guardian.co.uk/media/2001/jul/27/channel4.broadcasting5>.

62. Street, *Mass Media, Politics and Democracy*, pp. 232–6.

63. Lisa O'Carroll, 'Thousands Call in to Praise C4 over *Brass Eye*', *Guardian Online* (30 July 2001), <http://media.guardian.co.uk/broadcast/story/0,7493,529764,00.html>.

64. Ofcom, *The Ofcom Broadcasting Code*, p. 15.

65. Philip Drake and Andy Miah, 'The Cultural Politics of Celebrity', *Cultural Politics* vol. 6 no. 1 (2010), p. 61.

66. Paul Sturges, 'Comedy as Freedom of Expression', *Journal of Documentation* vol. 66 no. 2 (2010), p. 287.

67. Ferruh Yilmas, 'The Politics of the Danish Cartoon Affair: Hegemonic Intervention by the Extreme Right', *Communication Studies* vol. 62 no. 1 (2011), pp. 5–22.

7

'HANDLING' THE DARKNESS: CHRIS MORRIS AS CULTURAL CAPITAL

SAM FRIEDMAN

Introduction

In July 2001, following the broadcast of *Brass Eye*'s 'Paedophilia' Special, Chris Morris stood at the very summit of his notoriety. Politicians, journalists, art critics, academics; it seemed everyone had something to say about Morris and his impact on British society. For many, Morris was an unequivocal force for good, a satirist of the very highest order who was bravely challenging uptight Brits to laugh 'despite our better judgment'.[1] The critics agreed. *Brass Eye* (Channel 4, 1997; 2001) was 'grimly hilarious', noted Kathryn Flett in the *Guardian*, 'funny and necessary' argued BBC comedy critic William Gallagher.[2] However, according to others, Morris had appalled the nation. Riffing off *Brass Eye*'s record number of television complaints, the *Daily Mail* branded the programme 'The Sickest TV Show Ever', and many other tabloids echoed the sentiment. Such was the extent of the uproar that even government minister Beverley Hughes waded into the debate, describing the show as 'unspeakably sick' despite having never actually seen it.

Yet what was perhaps most perplexing about these disparate voices was that they all seemed supremely confident that they had captured the mood – that they alone definitively understood how audiences had responded to *Brass Eye*. However, this could not have been further from the truth. Apart from the obvious sentiments of 2,000 viewers who phoned Channel 4 to complain – only a fraction of the episode's estimated audience of one million – there was absolutely no empirical indication of how British audiences had *really* reacted to *Brass Eye*, or indeed the other myriad comic outputs of Chris Morris.

Unfortunately, such presumptive leaps are not just confined to politics or the media; they also dominate academic literature on comedy. In disciplines as wide as English literature, cultural studies, media studies, film and television studies and sociology, there is a long tradition of taking reactions to comedy for granted. Whether presupposing patterns of taste from analysis of comic representation[3] or from simply examining authorial intention,[4] comedy scholars have continually made assumptions about what people do and don't find funny.

This chapter aims to address this problem by purposefully switching the analytical focus to comedy *audiences*. Concentrating specifically on the work of Chris Morris, its primary aim

is to home in on how different audiences read and make sense of his comedy, and in turn what their tastes reveal about their more general sense of humour.

Underpinning this exercise is also a second, more sociological, aim. Beyond simply understanding who likes Chris Morris and why, the chapter also seeks to understand whether certain sociodemographic variables may be related to the patterning of comedy taste. In this way, the research is partly designed to replicate Pierre Bourdieu's (1984) classic sociological work on the relationship between French social class and cultural taste.[5] Bourdieu argued that children from the dominant classes (middle and upper-middle class) inherit certain dispositions from their parents that orientate them towards 'legitimate' cultural tastes and a cultivated way of seeing art – described as the 'disinterested aesthetic disposition'.[6] When these highbrow tastes are activated in social life they become a form of 'cultural capital', acting as potent signals of membership in a high status group and indicating one's symbolic distance from those outside. Each application of highbrow taste thus becomes an act of 'symbolic violence' against dominated groups, who accept the authority of a cultural hierarchy defined and imposed by the dominant.

However, in recent years researchers have questioned the concept of cultural capital.[7] Taste hierarchies, they argue, are now being replaced by more open and tolerant orientations to culture, with the middle classes now readily consuming both high *and* low culture.[8] Some even argue that contemporary markers of distinction or 'cool' actually involve refraining from cultural snobbery, and derive instead from being seen to embrace cultural diversity.[9] However, other authors have pointed out that while the traditional highbrow–lowbrow divide may be eroding, this has not necessarily led to the disappearance of stratified tastes.[10] On the contrary, there is strong evidence that high–low taste distinctions are now being detected *within* the popular arts. In particular, some (sub)genres of popular arts, like alternative rock music[11] or arthouse films[12] are now perhaps best described as upwardly mobile, having acquired higher status and elite audiences.

The central concern of this chapter, then, is to understand whether comedy, and more specifically the comic works of Chris Morris, should be added to this list of upwardly mobile popular art. In particular, it examines whether Chris Morris has joined the ranks of British artists now considered legitimate or highbrow, and subsequently how possessing preferences for, and knowledge about, his comedy may endow audiences with a tangible resource in social life – a form of cultural capital.

Outline of the Research

I draw upon data from a mixed methods study of the British comedy field carried out in 2009 and consisting of a survey (with 901 respondents) and twenty-four follow-up interviews. The survey measured people's 'comedy taste', with respondents asked to indicate preferences for sixteen stand-up comedians and sixteen TV comedy shows, including Chris Morris's *Brass Eye*.[13] The survey also asked a number of demographic questions relating to gender, age and notably – 'cultural capital resources'. This latter variable was made up of equally weighted measures for social origin (parental occupation and education), education and occupation.[14]

The main objective of the interviews was to understand respondents' sense of humour and more specifically their *style* of comic appreciation. Before meeting, subjects were sent *YouTube* clips of each comedy item on the survey[15] and interviews then explored their thoughts on these comedians and any others they liked or disliked. Although the interviews did not aim to focus on the work of Chris Morris, his comedy invoked unusually strong reactions. Whether positive or negative, discussions of his TV and radio programmes often predominated in the interviews.[16]

To analyse my survey data I used Multiple Correspondence Analysis (MCA), a form of principal component analysis which transforms statistics into more visually appealing taste 'maps'. First, individual responses to survey questions were categorised as modalities and then, using geometric analysis, the relationship between different modalities was assessed and axes identified that separated the modalities relationally in the form of a visual map. By comparing one respondent's comedy taste in relation to every other respondent, it was thus possible to plot the symbolic distance between the mean points of each modality in the map. In short, this meant that if everyone who liked Eddie Izzard also liked Bernard Manning then these modalities would occupy the same position in the map and vice versa. MCA therefore provided a visual representation to aid understanding when investigating patterns in the respondents' comedy taste.

It has not escaped me that such visualisations may appear, at first, suspiciously similar to the nonsensical mock-graphics used in *Brass Eye* and *The Day Today* (BBC 2, 1994). However, I would urge sceptical readers to persevere with MCA. It may seem 'a bit *Brass Eye*', but in reality the method is an efficient means of plotting the relational distribution of tastes. Not only was it Bourdieu's favoured analytic technique, but it has also become one of the most widely used methodological instruments in cultural sociology.[17]

Brass Eye as an 'Object' of Cultural Capital

The figure on p. 114 displays the coordinates of the comedy tastes that contributed significantly to Axis 1 (displayed from top to bottom). As Axis 1 was by far the most important axis in the analysis (contributing 61 per cent of the variance), it is this axis I concentrate on here. Where a taste symbol has a plus sign this indicates it was liked, a minus sign indicates that it was disliked, an equals sign that it was neither liked nor disliked and a question mark that it was unknown.

At the top of Axis 1 are a cluster of preferences for comedians such as Stewart Lee and Mark Thomas, TV comedy *The Thick of It* (BBC 4 / BBC 2, 2005–) and most notably for this chapter, Chris Morris's *Brass Eye*. There are also a cluster of dislikes for comedians such as Roy 'Chubby' Brown, Bernard Manning, Jim Davidson and Karen Dunbar. In contrast, at the bottom of Axis 1, although there is no cluster of dislikes, there is a clear group of preferences for comedians Bernard Manning, Benny Hill, Roy 'Chubby' Brown and Jim Davidson. There is also a cluster of unknown comedians.

Thus, the comedy taste division in Axis 1 appears to separate what is widely considered 'highbrow' comedy preferences at the top from 'lowbrow' comedy taste on the bottom.[18]

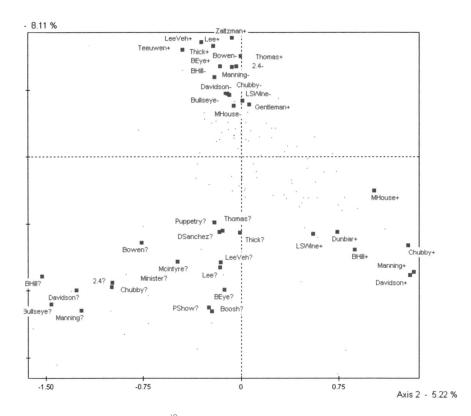

Axes 1 and 2, indicating modalities[19] contributing to Axis 1

Brass Eye and other comedy items at the top can be characterised as 'highbrow' because each has been extensively consecrated by comedy critics. Critics are not only key gate-keepers in the communication of comedy to the public but they are also bestowed with the 'authority to *assess* artistic works'.[20] Through the deployment of influential reviews and awards, they are therefore able to endow certain comedians with a widely recognised legit-imacy.[21] *Brass Eye*, for instance, has not only been repeatedly venerated by television and comedy critics[22] but also by academics,[23] a fact further illustrated by the publication of this book. In contrast, the comedians preferred at the bottom of the axis have largely received low consecration, either eliciting bad reviews or even more tellingly, being ignored by reviewers.[24]

It is important to note here that, although Axis 1 is constructed entirely from the posi-tioning of comedy tastes, it is possible to superimpose demographic variables onto the axis to see whether they are associated with taste differences. In the figure on p. 115, then, gender, age and cultural capital are overlaid onto Axis 1. While the deviations in gender and age along the axis are relatively small, the deviation in cultural capital resources is very large ($d = 1.23$). This indicates that the variance on Axis 1 is primarily associated with cultural cap-ital – with high cultural capital resources (HCC) strongly associated with 'highbrow' comedy taste, such as *Brass Eye*, at the top of the figure, and low resources (LCC) with preferences

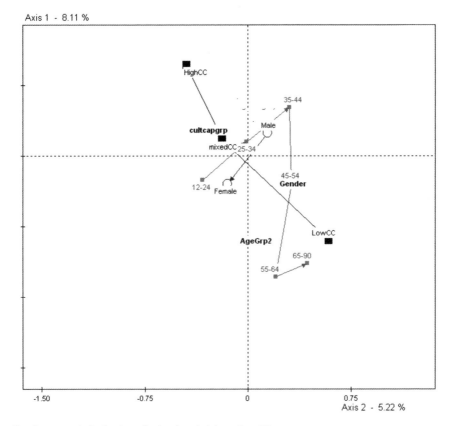

Gender, age and distribution of cultural capital, Axes 1 and 2

for 'lowbrow' items at the bottom. Indeed, while *Brass Eye* was liked by 72 per cent of HCC respondents, the figure among LCC respondents was just 22 per cent.

The main point here is significant enough to reiterate. Contemporary British comedy taste appears to be strongly differentiated according to one's resources of cultural capital. Culturally privileged HCC respondents thus do not like *all* forms of British comedy, but instead report a clear cluster of preferences for more legitimate or 'highbrow' comedy items. In contrast, LCC taste is characterised by preferences for less legitimate 'lowbrow' comedy.

The findings are also important because they suggest that *Brass Eye* is among a number of highbrow comedies and comedians that are now being used by the culturally privileged as an instrument of cultural distinction. *Brass Eye* has been so extensively consecrated (by critics and other cultural intermediaries) that it has become a 'rare' comedy taste – rare in terms of its unusual level of legitimacy and also rare in its restriction to a taste community largely consisting of the 'cultured' middle classes. This heightened legitimacy has also endowed *Brass Eye* with a special place in the cultural field, a reputation that can be traded as cultural currency in everyday conversations about taste. In other words, it is now a cultural 'object' that arguably commands its own unique power as a form of cultural capital.

Moreover, the main implication of *Brass Eye* as 'objectified cultural capital' is that, in turn, it is imbued with social stratificatory power. As an object of rarity, what Goffman[25] called a 'status symbol', *Brass Eye* infers a certain cultural aptitude on the part of the comedy consumer, an ability to handle the show's (perceived) interpretative 'difficulty', and therefore 'successful' appreciation bestows a special status on the consumer. Conversely, as I will explore in the next section, for those that don't laugh at this 'high status' comedy, *Brass Eye* often acts to elicit a sense of exclusion. As Mills[26] has noted of audience reactions to critically acclaimed TV comedy *The Office* (BBC 2/BBC 1, 2001–3), most respondents that did not find the show funny 'maligned themselves' for not having the 'interpretative expertise' to access the humour. Indeed, it is interesting to note that while only 22 per cent of LCC respondents liked *Brass Eye*, only a fraction (6 per cent) actually reported disliking the programme. Thus while most LCC respondents didn't like *Brass Eye*, or find it funny, they were simultaneously reticent about expressing dislike for such critically acclaimed culture.

More Than 'Just Funny': Morris and HCC Styles of Comic Appreciation

Although survey findings indicated that *Brass Eye* may now belong to a characteristically British list of legitimate cultural objects, such quantitative data is not without drawbacks. The most pertinent of these is perhaps the fact that statistics can only ever offer a temporary snapshot of people's tastes. However, in a constantly changing field like comedy, it is nearly impossible to definitively categorise artists as highbrow or lowbrow, legitimate or illegitimate. Not only do reputation and legitimacy fluctuate continually, but artists themselves often purposively mix comic styles to suit different audiences or to cater for different performance mediums. Thus while MCA may have revealed that certain comedians carry cultural capital in 2009, this status is inherently unstable. Moreover, in terms of Chris Morris, the survey only covered taste for *Brass Eye* and couldn't allow insight into the many other comic outputs in Morris's oeuvre.

In order to fully understand the concept of taste, I believe it is important to look beyond preferences for certain objects and instead home in on the *way* culture is consumed. Therefore in my interviews I set out to explicitly examine *how* respondents consumed comedy and what this revealed about their style of appreciation and sense of humour. In fact, this stress on the *practice* of comedy taste yielded the most revealing data. It demonstrated, in particular, that respondents with different resources of cultural capital read and decoded comedy in very different ways; they employed distinct comic styles.[27] And situated very much at the heart of this interpretative diversity was the comedy of Chris Morris.

For those with high cultural capital, the comedy of Chris Morris was often cited when explaining an overall desire for comedy that was clever and sophisticated. There was a sense that Morris used comic styles considered inherently complex, such as satire, irony and pastiche, and this ability to play with the form of comedy lifted him above other comic producers:

> When *The Day Today* came out, I was a student and I remember thinking 'Oh my god this is
> unbelievable.' It was just so smart. It still is. It's parody, it's satire, it's about our approach to what

matters, to news programmes but much bigger than that, how we deal with massive, horrifying global events and how pathetic we all are that we need things chopped up into bitesize bits and fed to us. (Frank, arts professional)

As well as complexity, there was also a sense that Morris epitomised the HCC commitment to 'originality' in comedy. For these respondents, the best comedians were the ones that 'take a risk' (Dale, lawyer), who offer a 'completely different perspective' (Andrew, IT consultant), and Morris was frequently celebrated as the arch experimenter. For Steve, a postgraduate student, the fact that Morris was willing to explore controversial subject matter in *Brass Eye* illustrated his commitment to 'pushing the boundaries of comedy':

> The thing about paedophilia and the AIDS thing. I think that's in that realm of satire of the sort of *Daily Mail* obsession with these issues. That was what he was doing with it, and I think it was a really brave thing to do. Again it has that level of intelligence and satire.

For Steve, then, as well as many others, Morris's dedication to originality, invention and form-bending comedy indicated 'bravery' and 'intelligence'. Indeed, what appeared to unite HCC accounts concerning Chris Morris was the notion of comic 'difficulty'. HCC respondents were looking for 'more than just cheap pleasure' (Frank), comedy that was not *just funny*. They sought to interpret comedy for its messages and meanings:

> I think it [*The Day Today*] was one of the first programmes to really lay into the media and really lay it all bare for everyone to see how ridiculous it was. It really was a beautiful pastiche. If you turned it on late at night you almost thought it was a real programme (laughs). Very clever. (Marilyn, actress)

> I remember I was at uni, having a few buckets with a pal of mine Gordon and we were watching *Brass Eye*. And we turned it off and the news was on. And there had been some massive, awful train crash. And it was a horrible story. But because of the tone of voice, words used, the posture of the presenter, this terrible story, I'm ashamed to say, it had us laughing a lot. It's such a perfect piece of satire, Chris Morris is such a wonderful writer, and has this constant air of the 'you're fucking crazy'. Which I like. (Graham, photographer)

> I think there's always a way to deal with subjects. In the case of *Brass Eye* it wasn't about paedophilia, it was making fun of the media hysteria *about* paedophilia. And I'm sure they thought carefully about it, because I'm sure they knew there was going to be a wee bit of outrage. I don't think there would be anything funny about a comedy paedophile. So it's all about how you come at a subject. And I think the media should have the piss ripped out of them as much as possible, because they take themselves so bloody seriously. I think anything that has got an air of pomposity about it should get the piss ripped out of it. That's where Chris Morris comes in because he's so good at pricking that pomposity. (Kira, environmental consultant)

In each of these passages, it was possible to discern a sense that the quality of Morris's comedy was rooted in the fact that it was always doing something else at the same time as

being funny. The real quality of *The Day Today* and *Brass Eye* was thus their ability to 'make fun of media hysteria', or 'lay into the media'. They were of interest because their satirical message, in the end, '*is as serious as it is funny*'.[28] Indeed, the general sentiment was that good comedy involved HCC respondents 'working' for their laughter, carrying out a certain aesthetic labour, and through doing this somehow feeling they had reached a higher plain of comic appreciation.

It is also important to note that the HCC desire for comic difficulty was strongly bound up with the knowledge that this aesthetic approach set them apart from other comedy consumers. The ability to understand comedy often relies on 'humour-specific knowledge'.[29] Without this knowledge, audiences lack the tools to 'decode' certain comedy and are excluded from appreciation. Sometimes, this exclusion is a side effect of humour, but in other cases it is purposively sought out. Thus when HCC respondents described the comedy of Chris Morris, there seemed to be a strong perception that many people simply didn't 'get' Morris's satirical approach. Respondents enjoyed the fact that they were able to extract what Trevor, a TV writer, described as a 'whole other level' in Morris's work. Interestingly, though, this accusation that some couldn't get the humour was rarely substantiated with concrete examples. Instead, it was invariably conflated with frustrations at the outrage expressed by people who hadn't even watched Morris's comedies:

> What I thought was particularly hilarious with *Brass Eye* was that all the people who got offended by it hadn't actually watched it. I had a girlfriend at the time who said 'How can you watch this crap about paedophilia, it's wrong, it's disgusting', and one night we got drunk and she came back and watched it. She didn't laugh but she certainly wasn't offended. I don't quite understand how you could be offended by it, when it was so clear in its aims. (Dale)

> I thought the paedophilia episode [of *Brass Eye*] was just what was required. It was an important statement. I mean socially. We have a really stupid world with really stupid media and so many people buying really bad papers. But not many actually even saw it. People will openly condemn things they haven't even seen. Wind 'em up and it'll sell. But he was taking the piss out of that. He was poking that with his sharp stick. And at that time a paediatrician in Wales even had his house burned down and paedophile scrawled over the remnants. So, y'know, if you feed stupid people then … (Graham).

> It's [*Brass Eye*'s 'Drugs' episode] about exposing ignorance. And everyone likes to see celebrities they despise being exposed as idiots, really, and that's what it did really well. Explore public opinion and how ridiculous it is. (Sarah, undergraduate student)

For Dale, Graham and Sarah, then, there seemed to be something knowingly exclusive about their appreciation of Chris Morris. Each of them strongly separated themselves from the 'ignorant' and 'stupid' people who were offended by *Brass Eye* (even when they hadn't seen it), or those that didn't have the expertise to understand its 'aims'. Indeed, for all three, this sense of exclusivity seemed central to their enjoyment. Their appreciation appeared to be heightened precisely by the awareness that their knowledge was not evenly distributed, that

some people simply didn't 'get it'. There seemed to be an almost 'conspiratorial pleasure' between themselves and Morris; a sense that together they both belonged to an exclusive in-group that enjoyed mocking those who followed 'ridiculous public opinion'.

HCC respondents also sought to distinguish their appreciation of comedy by distancing themselves from the common-sense notion that comedy must be pleasurable. Instead, most saw the function of humour as much more ambiguous. 'Good' comedy provoked a wide range of emotions, and many respondents expressed preferences for 'dark' or 'black' comedy – where disturbing subjects are probed for humorous effect. Again, the comedy of Chris Morris was pivotal in such descriptions of black comic taste. These respondents argued that by deliberately invoking negative as well as positive emotions, Morris's comedy was better able 'to challenge' them intellectually. One striking example of this emerged during discussions about the 'Paedophilia' episode of *Brass Eye*, which a large proportion of the population 'simply couldn't handle', according to Sarah. A conversation with Frank highlighted the pivotal role Morris's black humour played in delineating aesthetic boundaries:

> FRANK: If you sat a *Daily Mail* reader or a *Sun* reader in front of *Brass Eye* … well certainly I think there's something in people that is so scared of the badness that they can't come on the journey of, ok, there is a terrible, hideous thing called paedophilia but the way we're treating it, the way we're defining it, it's a complex thing.
>
> FRIEDMAN: Why do you think some people can't 'come on the journey' to the humour in *Brass Eye*?
>
> FRANK: We have a brittle, animal reaction to stuff and to take us from there to a place where we think philosophically, and in a civilised way, as part of a civilisation about these things is a hard journey. So it's not a simple thing to view a complex and difficult issue with sensitivity and with a desire to get on top of all the complexities. It's much fucking easier to say (puts on a faux cockney accent) 'These paedos, they're getting our children, watch out, name and shame 'em, could be in the park, could be next door.'

What is striking about these comments is the way HCC respondents like Frank implied that audiences who do not perceive *Brass Eye* as funny were somehow aesthetically deficient. Such a difference was not considered a neutral quirk of perception but instead immediately ordered as inferior. Again, this was a boundary predicated on knowledge: specifically the *knowledge to recognise* a particular joke or sketch as deliberately and humorously transgressive. However, the main way HCC respondents explained such negative reactions to *Brass Eye* was not through a lack of knowledge but more presumptuously via an implied lack of intelligence. Such audiences, according to Frank, were confined to first-degree 'animal' reactions to black comedy, and 'can't come on the journey' to the 'complexity' of *Brass Eye*, or as Sarah noted, 'simply can't handle it'.

These damning judgments illustrated the way HCC respondents often used the comedy of Chris Morris to draw stark and sometimes aggressive aesthetic boundaries. By deliberately suppressing initial emotional reactions to black comedy, such as disgust and offence, these respondents claimed to reach a higher plain of appreciation, beyond the direct visceral pleasure of 'just funny'. They also showed how HCC respondents tended to envision other

comedy audiences as 'imagined communities',[30] inferring that one´s sense of humour revealed deep-seated aspects of their personhood and connecting taste to other characteristics such as newspaper readership, regional accent and linguistic choice. Moreover, in Frank's case, these assumptions were arguably class-based, drawing on largely derisive and stereotypical parodies of working-class taste and values.

Confusion, Rejection and Failure: Morris and LCC Styles of Appreciation

Among LCC respondents, the comedy of Chris Morris also acted as a strong marker of comedy style. Although most LCC interviewees had not heard of Morris prior to being interviewed, the *YouTube* clips of *Brass Eye* and *The Day Today* provoked strong reactions. In general, LCC respondents expressed very different styles of comic appreciation to HCC respondents. They emphasised that comedy was first and foremost about pleasure and laughter, and that good humour should never invoke negative emotions. In this way, many seemed puzzled by Morris's black approach to comedy, which they felt defied the pleasurable spirit of comedy. For instance, Laura, a secretary, didn't like 'dark' comedy such as *Brass Eye* because it dealt with subjects like paedophilia or disability 'which just aren't funny'. Similarly, Duncan and Ivan didn't understand why Morris tried to make comedy from 'morose' subjects:

> To be honest with you I see enough shit in the newspapers and the news every day, I'd rather see things that make me laugh, that I get enjoyment out of. I don't want to see anything too highbrow or too morose. I just want to be entertained in a light-hearted way, y'know. (Duncan, picture framer)

> Things he [Morris] talks about, you start thinking about things that are really going on in life and it just makes you angry, because all this stuff is going on and you can't do anything about it. It's probably more true to life than people think. And you think I've come here to escape, to be entertained, I don't want it stuck in my face. (Ivan, hairdresser)

In other cases, negative reactions to Morris's humour seemed to be based on misinterpretations of his comic intent. Perhaps misrecognising the devices Morris uses to signal humour, or lacking the requisite humour-specific knowledge, many LCC respondents misjudged his comedy, taking his sketches at face value or as straightforward observational humour:

> The AIDS one, I didn't find that funny. Because I thought, well, it's quite a serious subject and y'know the guy's saying 'There's good AIDS and bad AIDS' and I thought 'Well no, there's not.' It doesn't matter how you got it, you've still got it. And his whole attitude about 'Get away from me, and don't do this.' That's not funny. I don't think it helps to promote people's education of the disease. I found it offensive.

> Now I actually didn't like his approach to HIV. I mean I've got personal reasons, not that anyone in the family has HIV but my husband works a lot with people who have had HIV and I wasn't quite

so sure where he was going with it. And I felt uncomfortable. He was probably trying to make everyone feel relaxed about it. But I felt he was almost cashing in, almost like poking fun at someone who had a mental disability.

Finally, as well as misinterpretation, some LCC respondents also registered feelings of confusion and failure when talking about Morris's comedy. Some, like Dave, an events assistant seemed acutely aware of their inability to decode the humour: 'I didn't particularly find that scene funny. I did for about a second, because it was perhaps more uncomfortable humour, was it?'

Others resorted to simply opting out of Morris's work, noting that his highbrow approach 'just goes over my head' (Dan, retail assistant) or is 'beyond me' (Laura, personal assistant). Indeed, the sentiment that Morris's comedy somehow passed 'over' the aesthetic capability of LCC respondents – that they simply couldn't 'get it' – was mentioned frequently. These accounts demonstrated what Bourdieu termed the 'misrecognition' of cultural value among some LCC respondents. Although there is arguably nothing intrinsically superior about Morris's comedy, the frequent use of hierarchical metaphors such as 'over my head' and 'beyond me' implied that many LCC respondents had conceded its 'higher' legitimacy.

Conclusion

The comedy of Chris Morris strongly divides British comedy audiences. Among those well resourced in cultural capital, the TV show *Brass Eye* sits alongside a cluster of TV comedies like *The Thick of It* and stand-ups like Stewart Lee that have become hallowed cultural objects, items of critically acclaimed popular culture that 'must' be liked, consumed and frequently referenced. In this way, *Brass Eye* has arguably become an object of cultural capital, a taste that communicates a tangible sense of cultural distinction in contemporary Britain.

But, of course, *Brass Eye* is only one work in Chris Morris's extensive repertoire. Over the course of his career, Morris has been involved in an array of other comic projects – some, like *The Day Today* and *On the Hour* (BBC Radio 4, 1991–2) were somewhat similar to *Brass Eye* but others like *Nathan Barley* (Channel 4, 2005), *Four Lions* (2010) and *Jam* (Channel 4, 2000) were very different in style and tone. Which begs the question, are these comedies also markers of cultural capital? Unfortunately, a robust answer to this question is simply beyond the reach of this chapter, as large-scale survey data were restricted to taste for *Brass Eye*. However, more tentative answers can perhaps be derived from the study's interview material.

What emerged from these lengthy discussions was that the communication of cultural capital was less about specific objects of comedy and more about the cultural currency of a certain *cultivated style* of comic appreciation. HCC respondents, for instance, employed a knowingly 'disinterested' appreciation for comedy that they often assumed was out of the reach of others. This involved the valorisation of certain comic themes and the clear rejection of others. For example, comedy that was sophisticated, complex and original was appreciated whereas the 'prosaic' comedy of the everyday was discarded. Similarly, comedy that

taps the entire emotional spectrum was considered valuable while comedy that aims for only laughter and pleasure was rejected. In short, this was the inverse of LCC comedy styles. For HCC respondents, comedy should never be *just funny*, it should never centre purely around the creation of laughter, or probe only what Frank referred to as 'first-degree' emotional reactions. Instead, the form or substance of 'good' comedy should have a meaning or a message and the consumer should have to 'work' for his or her laughter.

It is perhaps here then, through this broader exploration of 'sense of humour', that it's possible to understand how audiences may receive Morris's other work. For example, if HCC respondents most value comedy that is original, complex and dark, it perhaps logically follows that they would venerate his darker, more obscure works like *Blue Jam*, *Jam* and *Jaaaaam* (Channel 4, 2000). In a similar vein, if the legitimate mode of comic appreciation implies a distinct air of disinterestedness, it might follow that more recent work, such as *Four Lions* and *Nathan Barley*, which are arguably more conventional – in terms of comic form – and more clearly geared toward laughter, may be less valued by HCC respondents and have more crossover appeal. However, I would reiterate here that such analysis is speculative and certainly requires closer empirical examination.

Moreover, by placing such a strong emphasis on the reception of particular comedy texts and performers, there is a danger that one begins to obscure the most significant findings of this research. For example, beyond the individual works of Chris Morris, I found that by far the strongest 'object' of cultural capital was Morris himself. Thus when HCC respondents spoke about Morris's comedy, they rarely considered his works in isolation. Instead, conversations about individual programmes invariably led back to Morris; to his career, to his style, to his overarching comic vision. His individual works may therefore vary in legitimacy, but this variation is likely to be small because Morris himself continues to be the linchpin of cultural value. He is not only extensively decorated by critics and awards, but his overall body of work exemplifies the overarching aesthetic ideals so valued by the 'cultured' middle classes.

Rivalled perhaps only by Stewart Lee, then, Morris appears to be the exemplar of the legitimate contemporary comedian. The perceived interpretative 'difficulty' of his comedy bestows special status on 'successful' consumers and he provides the perfect vehicle for those wanting to showcase and demonstrate a *cultivated style* of comic appreciation. Indeed, armed with an appreciation of Morris, those with high cultural capital frequently drew a symbolic boundary between themselves and those whom they perceived to be unable 'to get' his humour. In many cases this boundary seemed to police the borders of social class, with respondents inferring that one's sense of humour revealed deep-seated aspects of social background and personal 'worth'.

This finding is also significant because it points towards an important shift in the relationship between social stratification and British cultural taste. While traditional class-based divisions between high and low culture may have receded, this does not necessarily mean that taste snobbery is disappearing. Indeed, the contemporary legitimacy of an artist like Chris Morris only illustrates that taste hierarchies are evolving, and that fine-grained distinctions are now developing *within* the popular arts. Here, in previously discredited cultural realms such as comedy, the British middle classes are marking out new forms of

cultural distinction, carefully consuming the 'right' kind of comedy and above all demonstrating the cultural currency of a 'good' sense of humour.

Notes

1. Euan Ferguson, 'Why Chris Morris Had to Make *Brass Eye*', *Observer* (5 August 2001), <http://www.guardian.co.uk/uk/2001/aug/05/news.film>.
2. Kathryn Flett, 'Morris Karloff', *Observer* (20 March 2000), <http://www.guardian.co.uk/theobserver/2000/mar/26/features.review7>; William Gallagher, '*Brass Eye*'s Necessary Comedy', *BBC Website* (30 July 2001), <http://news.bbc.co.uk/1/hi/entertainment/1464790.stm>.
3. For example, see Stephen Wagg, 'At Ease Corporal: Social Class and the Situation Comedy in British Television: From the 1950s to the 1990s', in Stephen Wagg (ed.), *Because I Tell a Joke or Two: Comedy, Politics and Social Difference* (London and New York: Routledge, 2008), p. 2; Deborah Thomas, 'Murphy's Romance: Romantic Love and the Everyday', in Peter William Evans and Celestino Deleyto (eds), *Terms of Endearment: Hollywood Romantic Comedy of the 1980s and 1990s* (Edinburgh: Edinburgh University Press, 1998), p. 59; Andrew Stott, *Comedy* (London: Routledge, 2005), p. 119; James Harvey, *Romantic Comedy in Hollywood from Lubitsch to Sturges* (New York: Knopfler, 1998), pp. 665–78.
4. Frances Gray (2005), 'Privacy, Embarrassment and Social Power: British Sitcom', in Sharon Lockyer and Michael Pickering (eds), *Beyond a Joke: The Limits of Humour* (New York: Palgrave Macmillan, 2005), p. 154; Peter Rosengard, 'Gong!!', in Peter Rosengard and Roger Wilmut (eds), *Didn't You Kill My Mother-in-Law: The Story of Alternative Comedy in Britain* (London: Methuen, 1989), p. 9; Andy Medhurst, *A National Joke: Popular Comedy and English Cultural Identities* (London: Routledge, 2007), pp. 194–9; David Sutton, *A Chorus of Raspberries: British Film Comedy 1929–1939* (Exeter: University of Exeter Press, 2004), pp. 23–32.
5. Pierre Bourdieu, *Distinction: A Social Critique of the Judgement of Taste* (London: Routledge, 1984).
6. Ibid., pp. 28–42.
7. David Halle, 'The Audience for Abstract Art: Class, Culture and Power', in Michèle Lamont and Marcel Fournier (eds), *Cultivating Differences: Symbolic Boundaries and the Making of Inequality* (Chicago, IL: Chicago University Press, 1992), pp. 131–51; Bethany Bryson, '"Anything But Heavy Metal": Symbolic Exclusion and Musical Dislikes', *American Sociological Review* vol. 61 no. 5 (October 1996), pp. 884–99; Bonnie H. Erickson, 'Culture, Class and Connections', *American Journal of Sociology* vol. 102 no. 1 (1996), pp. 217–51.
8. Richard Peterson and Roger Kern, 'Changing High Brow Taste: From Snob to Omnivore', *American Sociological Review* vol. 61 no. 5 (1996), pp. 900–7; Mike Featherstone, *Consumer Culture and Postmodernism* (London: Sage, 2007).
9. Alan Warde, Lydia Martens and Wendy Olsen, 'Consumption and the Problem of Variety: Cultural Omnivorousness, Social Distinction, and Dining out', *Sociology* vol. 33 no. 1 (1999), pp. 105–27; Guy Bellevance, 'Where's High? Who's Low? What's New?', *Poetics* vol. 36 no. 1 (2008), pp. 189–216.
10. Douglas Holt, 'Distinction in America? Recovering Bourdieu's Theory of Tastes from Its Critics', *Poetics* vol. 25 no. 2 (1997), pp. 93–120; Philippe Coulangeon, 'Social Stratification of Musical

Tastes: Questioning the Cultural Legitimacy Model', *Revue Français de Sociologie* vol. 46 (2005), pp. 123–54.

11. Motti Regev, 'Producing Artistic Value: The Case of Rock Music', *Sociological Quarterly* vol. 35 no 1 (1994), pp. 85–102.

12. Shyon Baumann, *Hollywood Highbrow: From Entertainment to Art* (Princeton, NJ: Princeton University Press, 2007).

13. In order to avoid bias towards particular taste communities, the items were selected on the advice of a panel of professionals working in the comedy industry. It must be noted, however, that such a process was still subjective and many other comedy items could have been chosen.

14. The calculation of the Cultural Capital 'Score' was made as follows: 'Education' was calculated on a scale of seven of 'highest completed' and 'Occupation' on a scale of nine corresponding to which jobs most emphasise 'cultural skills'; Richard Peterson and Albert Simkus, 'How Musical Tastes Mark Occupation Status Groups', in Lamont and Fournier, *Cultivating Differences*, pp. 152–86. Finally, 'Family Socialization' was calculated by recording both parents' education and both parents' occupation when the respondent was fourteen years' old. The figure for each of these three measures was then collapsed into a score out of five to make a total score out of fifteen. This is an updated version of the scale used by Holt (1997).

15. The *YouTube* clips of Morris's comedy were the 'Good Aids vs. Bad Aids' sketch from *Brass Eye* and the '11 September Coverage' skit from *The Day Today DVD Bonus Material*.

16. For more detail on the project's methodology, see Sam Friedman, 'The Cultural Currency of a "Good" Sense of Humour: British Comedy and New Forms of Distinction', *British Journal of Sociology* vol. 62 no. 2 (2011), pp. 347–70.

17. For more detail on MCA, see: Brigitte Le Roux and Henry Rouanet, *Geometric Data Analysis: From Correspondence Analysis to Structured Data Analysis* (Dordrecht: Kluwer, 2004); and more generally Tony Bennett *et al.*, *Class, Culture, Distinction* (London: Routledge, 2009), pp. 262–4.

18. It is important to note that my concern here is not to address whether this high–low division is normatively just. Following Bourdieu and Passeron, my suspicion is that such a system of cultural classification is largely 'arbitrary', with no taste culture able to validly claim universal and essential value. Instead, the cultural hierarchy is a system of meaning that I believe is largely imposed by dominant groups and then 'misrecognised' as legitimate by society as a whole. However, for my purposes, what is more important is that the legitimacy of a cultural hierarchy is widely *perceived* to exist and has historically held considerable social power in the British cultural field (Stott, *Comedy*; Featherstone, *Consumer Culture and Postmodernism*). Pierre Bourdieu and Jean-Claude Passeron, *The Inheritors: French Students and Their Relations to Culture* (Chicago, IL: University of Chicago Press, 1979), pp. 4–15.

19. The modalities on Axis 1 are best read alongside this key: 'Zaltzman' = Andy Zaltzman; 'LeeVeh' = *Stewart Lee's Comedy Vehicle* (BBC2, 2009–); 'Lee' = Stewart Lee; 'Thick' = *The Thick of It*; 'Bowen' = Jim Bowen; 'BEye' = *Brass Eye*; 'Thomas' = Mark Thomas; 'BHill' = Benny Hill; 'Bullseye' = *Bullseye* (ITV/Challenge, 1981–2006), ; 'Gentleman' = *The League of Gentleman* (BBC 2, 1999–2002); 'LSWine' = *Last of the Summer Wine* (BBC 1, 1973–2010); 'Chubby' = Roy 'Chubby' Brown; 'Manning' = Bernard Manning; '2.4' = *2point4 Children* (BBC 1, 1991–8); 'Mhouse' = Bob Monkhouse; 'Puppetry' = Puppetry of the Penis; 'Davidson' = Jim Davidson; 'McIntyre' = Michael McIntyre; 'PShow' = *Peep Show* (Channel 4, 2003–); 'Boosh' = *The Mighty Boosh* (BBC 3, 2004–7);

'DSanchez' = *Dirty Sanchez* (MTV, 2003–7); 'Dunbar' = Karen Dunbar; 'Thomas' = Mark Thomas; 'Minister' = *Yes, Minister* (BBC 2, 1980–4/*Yes, Prime Minister* (BBC 2, 1986–8)).

20. Pierre Bourdieu, *The Field of Cultural Production* (Cambridge: Polity Press, 1993), p. 229.

21. Shyon Baumann, 'Intellectualization and Art World Development: Film in the United States', *American Sociological Review* vol. 66 no. 3 (2001), pp. 404–26.

22. Will Self, 'Chris the Saviour', *Observer* (9 March 1997), <http://www.guardian.co.uk/theobserver/ 1997/mar/09/featuresreview.review>; Flett, 'Morris Karloff'; Gallagher, '*Brass Eye*'s Necessary Comedy'; Sameer Rahim, '*Disgusting Bliss: The Brass Eye of Chris Morris* by Lucian Randall: Review', *Daily Telegraph* (15 April 2010), <http://www.telegraph.co.uk/culture/ books/bookreviews/7594826/Disgusting-Bliss-the-Brass-Eye-of-ChrisMorris-by-Lucian-Randall-review.html>.

23. Stott, *Comedy*; Brett Mills, *Television Sitcom* (London: BFI, 2004).

24. Michael Deacon, 'Review of *Last of the Summer Wine*', *Daily Telegraph* (30 August 2010), <http://www.telegraph.co.uk/culture/tvandradio/7968500/Last-of-the-Summer-Wine-BBC-One-review.html>; Jay Richardson, 'Old School Champion Jim Davidson Aims to Turn Standup on Its Head', *Guardian* (16 September 2010), <http://www.guardian.co.uk/stage/theatreblog/2010/ sep/16/jim-davidson-play-standup-comedy>; Unknown Author, 'Review of Roy "Chubby" Brown', *Scotsman* (5 July 2008), <http://living.scotsman.com/comedy/Comedy-review-Roy-39Chubby39-Brown.4259007.jp>; Simon Hattenstone, 'It's an Act, Innit?' (Interview with Bernard Manning), *Guardian* (23 June 2003), <http://www.guardian.co.uk/stage/2003/jun/23/comedy.artsfeatures>; for a defence of Roy 'Chubby' Brown, see Medhurst, *A National Joke*.

25. Erving Goffman, 'Symbols of Class Status', *British Journal of Sociology* vol. 2 no. 4 (1951), p. 295.

26. Brett Mills, *The Sitcom* (Edinburgh: Edinburgh University Press, 2009), pp. 112–13.

27. For more detail, see Friedman, 'The Cultural Currency of a "Good" Sense of Humour'.

28. Mills, *Television Sitcom*, p. 58.

29. Giselinde Kuipers, 'Humour and Symbolic Boundaries', *Journal of Literary Theory* vol. 3 no 2 (2009), pp. 219–40.

30. Benedict Anderson, *Imagined Communities: Reflections on the Origin and Spread of Nationalism* (New York: Verso, 1984).

8

'BASHED BE BIFF BY ALL WITH EARS': *BLUE JAM* AND TABOO RADIO

ROBERT DEAN AND RICHARD J. HAND

Introduction

Chris Morris is a product of radio. A graduate trainee on BBC radio, he began his professional career at BBC Radios Cambridgeshire and Bristol and was a presenter on Greater London Radio.[1] In the early 1990s, *On the Hour* (BBC Radio 4, 1991–2) brought Morris to a national audience as part of an ensemble comprising a new generation of audio satirists. *The Chris Morris Music Show* (BBC Radio 1, 1994) and the comedy dialogues between Morris and Peter Cook titled *Why Bother?* (BBC Radio 3, 1994) are also distinctive achievements in audio comedy. However, the focus of this chapter is *Blue Jam*, Morris's three-season music/comedy series for BBC Radio 1 and, arguably, his greatest achievement in audio form. *Blue Jam*'s three series – each comprising six one-hour episodes – ran from November to December 1997;[2] March to April 1998; and January to February 1999.

Blue Jam combines music, comedy sketches and monologues with an ambient soundtrack. Each episode of the programme is carefully measured and controlled in pace and yet they contain an extraordinary wealth of comedic styles. As well as writing and producing the show, Morris appeared as a performer along with highly versatile comic actors such as Amelia Bullmore, Julia Davis, Kevin Eldon and Mark Heap. Significantly, these performers also contributed to the scripts as part of a writing team which featured established and rising stars of comedy writing such as Peter Baynham, Jane Bussmann, Robert Katz, Graham Linehan and David Quantick. *Blue Jam* enlists these individual styles to present its social satire of taboo subjects through abstract, even dream-like, humour assimilated in Morris's distinctive and innovative production style. For a contemporaneous reviewer, Sue Arnold, the radio critic of the *Observer*:

> It's impossible to describe *Blue Jam* in anything as conventional as print. Preposterous situations are acted out against a background of soporific music, leaving you wondering if, like Keats, you're awake or asleep. … *Blue Jam* sets out to shock and succeeds but the shock is deadened partly by the transcendental music and the fact that you are laughing so much.[3]

For Arnold, *Blue Jam* is an extraordinary achievement in its amalgamation of the oneiric, the hilarious and the genuinely shocking. Given the frequently taboo content of *Blue Jam* and its generic definition as radio comedy, it may be surprising that Arnold is drawn to make an intertextual allusion between Morris's show and one of the zeniths of English Romantic poetry (John Keats's 'Ode to a Nightingale' [1819]).

For Tim Crook, not a journalist but one of the leading scholars of radio studies, Morris's provocative audio work warrants comparison with Orson Welles. Writing in 1999, the year of the final *Blue Jam* series, Crook places Morris in the context of UK 'prank calling' (namely in relation to the audio work of Victor Lewis-Smith) and US 'shock jocks' (such as Howard Stern and Alan Berg). Morris, therefore, emerges out of the genre of 'spoof broadcasting' which in the 1990s had developed into 'a "skit genre", which engages its listeners in ironic entertainment rather than fooling them'[4] through the use of mimicry and verisimilitude. Arguably, this type of radio comedy is developed into its highest level of sophistication with Morris's *Blue Jam* in which, as Crook writes, 'the irony was in a pure form'.[5] For Crook, the 'pure irony' of *Blue Jam* is that, while its listeners are fully aware that Morris is assuming a character, his satirical targets are 'fooled into caricaturing themselves in a funny, cruel and embarrassing way'. This, however, just relates to the 'prank calling' element to *Blue Jam*, which is just one component of its complex system of comedic languages.

This chapter will assess *Blue Jam* as an example of distinctive radio comedy, the scope of which encompasses social satire as much as linguistic humour through the use of techniques which range from the obscene to the surrealistic. In addition to analysing the comedic languages in various sketches and sequences from *Blue Jam* as illustration, the chapter will devote attention to key aspects of the programme integrally linked to its status as a 'Radio 1 show': in particular, the '*Newsbeat*' sketches and its exploration and subversion of the station's use of 'jingles'.

The Comedic Languages of *Blue Jam*

A variety of comedic languages are employed in *Blue Jam*, the most prominent of which are: *idioglossia* (the use of 'nonsense' speech which, despite being unorthodox, can also be seen as belonging to a rich cultural tradition); *incongruity* (the ironic and even provocative conjoining of diverse elements); *the satire of social and cultural rhetoric* (ridiculing both the mundane and pretentious languages of society at the time); and *obscenity* (the scatological or sexually explicit challenge to conventional language and morality).

Each episode of *Blue Jam* opens with Morris's abstract, even surrealistic, monologue conveyed in *idioglossia*, a mode of speech that can include abstraction and 'nonsense'. To take one example from the opening of series one, episode four:

> When you fly, so wingish speed. Then thwack. Ee path be glass, and broke-beak slump on ground, all quiver-pigeon. While rattus rub hands in the shadow. And when ee sing so full with bursting soul, ee heart fly out of mouth! And then bashed be biff by all with ears, who cry 'shut, shut, shut it up, oo cackamuffin ...'

The speech walks a tightrope between meaning and nonsense. Its precursors are as diverse as Lewis Carroll's 'Jabberwocky' (1872), James Joyce's *Finnegan's Wake* (1939) and the mono-logues of the British comic Stanley Unwin (1911–2002). Like all of these, Morris's idioglossia forms a unique language, which contains standard words in interplay with invented terms. Meaning sometimes comes through via sound and rhythm themselves rather than seman-tics. In the example above, Morris creates, in part, the scenario of a bird in flight that crashes into a window and dies while a rat waits to feast on it. Morris also invents a word: 'cacka-muffin'. This perhaps combines 'ragamuffin' (a grubby street urchin) with 'cock-a-doodle' (noise of a rooster) and 'cack' (excrement). Idioglossia can also be evidence of psychosis and depression. In a *Guardian* feature about a stand-up comedy show called *Warning: May Contain Nuts*, which was performed by people with a history of mental-health issues, one of the per-formers, Seaneen Molloy, explains:

> 'You could say surreal comedy has an element of psychosis because it's disconnected from reality. [Chris Morris's] *Blue Jam* refers to depression. The intros and outros are the ramblings of someone who's going mad. And they're really beautiful, lyrical and funny.'[6]

These monologues also demonstrate Morris's most powerful evocation of the alienating essence of the radio medium: the 'disembodied voice'. In considering suspense thrillers on radio, Allison McCracken writes of the 'horror of the disembodied voice':[7] the voice is detached from visual stimuli, a detachment, which, when used appropriately, can amount to an uncanny experience because we hear the voice so clearly and intimately but cannot see the source or 'body'. Whether Morris's idioglossia captures the alienating experience of the disembodied voice or is in the comic tradition of 'Unwinese', the English literary tradition of Carroll or Joyce (just as, for some, *Blue Jam*'s overall style alludes to Keats's 'Do I wake or sleep'), or the beauty, lyricism and hilarity of someone 'going mad', idioglossia is just one aspect of the *Blue Jam* corpus.

 Blue Jam frequently employs *incongruity* for comic effect. In series one, episode one, there is the 'baby fight' sketch, which satirises the coverage of the underground world of bare-knuckle boxing contests or animal fighting but conflates this with child abuse: babies with knives attached to hands and feet are set against each other, which extends to adults being able to pay to fight a baby. The humour of this is that it takes two taboo realms and puts them together in an unlikely yet appalling way. In fact, many examples of *Blue Jam*'s incon-gruity humour revolve around children: in series two, episode three, there is the ruthless four-year-old gangster Maria who is brought in to 'fix' a crime scene like Mr Wolf (Harvey Keitel) in *Pulp Fiction* (1994). As well as whole sketches, incongruity can also function within a single phrase as in the 'shrinking car' sketch (series one, episode four): 'Who am I? Fucking Noddy!?' The phrase conflates the obscene word 'Fucking' with Noddy, Enid Blyton's enduringly pop-ular children's character. Incongruity can also work by including an extraordinary abstract image as in series two, episode one when a distressed criminal explains that his would-be hold-up was thwarted by the unnerving sight of 'a plastic arsehole with a duck sticking out of it'. *Blue Jam*'s startling incongruity has a parallel in the contemporaneous British art scene: Jake and Dinos Chapmans' various sculptures of the 1990s – such as the 1995 'Zygotic

Acceleration Biogenetic De-subliminated Libidinal Model (Enlarged × 1000)' – which feature child mannequins with misplaced genitals or sex toys replacing other parts of their physique. The Chapman Brothers' sculptures similarly conflate incongruous components for shocking and ironic impact.

Another type of comedy in *Blue Jam* is the *satire of rhetoric*. This can include cultural pastiche such as the 'Berence Oslo' art-scene monologue (series one, episode two) which is a sustained parody of 'BritArt': the speaker is a man locked in glass case with a maggot-infested piece of kidney that a cleaner tried to feed him. This evidently brings together 'The Maybe' (Cornelia Parker's 1995 performance installation at the Serpentine Gallery in which Tilda Swinton lay in a glass box) with 'A Thousand Years' (Damian Hirst's 1990 installation consisting of a rotting cow's head surrounded by maggots and flies) for ruthlessly satirical ends. Although the sketch remains a successful pastiche of a particular epoch of British contemporary art, as with the Chapman Brothers parallel, Morris's own sense of taboo-flaunting and provocation is not dissimilar in effect.

A recurrent example of *Blue Jam*'s satire of rhetoric are the 'doctor sketches' which usually feature David Cann as the doctor, an actor extraordinarily skilled in deadpan comedy.[8] Some of the doctor sketches in *Blue Jam* can be very traditional 'doctor, doctor' jokes which are reworked into the mundane rhetorical dialogue of consultation:

MAN: I, uh … I feel … um … like … a pair … of curtains.
DOCTOR: A pair of curtains?
MAN: Yeah.
DOCTOR : Hmm. Okay … I think the best thing you can do is … pull yourself together. See how that goes.
MAN: Right.
DOCTOR : Okay.
MAN: Yeah. Right, thanks.
DOCTOR : Bye, then.
MAN: Bye.[9]

The humour here lies in the bland and straight-faced delivery and, in using the hesitations and glib comments that most of us will have experienced in a consultation with a GP, refreshes a tired joke. This can be seen, in fact, as quite ground-breaking. For example, in her book *The Language of Jokes* (1992), Delia Chiaro gives the example of how an anecdote about a medical procedure can be recounted in a 'humorous' or a 'serious' way[10] and yet these *Blue Jam* sketches deliberately use 'non-humorous' rhetoric to create an even greater comic impact. *Blue Jam* deploys the language of medical authority as a conduit for ironic comedy. The result feels like an audacity, a subversion of the syntax of authority with the semantics of irreverence. Other doctor sketches are very different in approach, such as when the doctor kisses a man's penis better (series one, episode one). The 'kiss of the doctor' extends to other uses (prevention of tropical diseases; an outbreak of head lice; and slipped discs). It is partly an extrapolating satire of how a parent might kiss their child's minor injury better but it is also a parody of the cult of both medicine and faith healing which reflects the

alienation concerning medical knowledge (in other words, the common lack of knowledge about how medicine works). Morris's simple conceit becomes profoundly satirical of the times within which it was produced: the late 1990s.

Another use of the doctor in *Blue Jam* extends to deliberate malpractice and the abuse of power. In one sketch, the doctor makes his patient with sinus problems take out his penis and swing it around rapidly before joining in himself (series two, episode two). The sketch concludes with a discussion with another doctor about how many times he can do this before he is reported and struck off. Other doctor sketches involve calculated violence, such as when a patient has the sides of his throat stitched together (series one, episode one), a procedure which will evidently be fatal: 'You can pop back in a couple of weeks if you must. But I don't expect you will.'[11] In Morris's doctors, we are presented with practitioners of contemporary medicine who are fallible, negligent or deranged. This takes on an additional significance when we consider its context; it was broadly contemporaneous with the case of Dr Harold Shipman (1946–2004), the notorious serial killer arrested in 1998 who abused his position as a GP and murdered possibly hundreds of people.

Blue Jam also satirises what we could call the 'rhetoric of the bedroom', making absurd the language of sex:

MAN: Shove your tits up my arse! Oh, cold chicken!
WOMAN: Fart them out![12]

Indeed, one very important aspect to the humour of *Blue Jam* is *obscenity* in terms of language and situation, not least in its radio context. Throughout its history, radio has been able to be surprisingly radical in the scenes it can present. For example, while cinema in the US had the Hays Code and in the UK the BBFC still regulates film content,[13] radio can be surprisingly forthright and risqué. Extant examples from popular genres of US radio during the all-live era of the 1930s and 1940s are a case in point: horror and crime drama could include scenes of uncompromising (sometimes sexualised) violence unimaginable in contemporaneous cinema. It was a similar story with comedy. For example, Arch Oboler's 'Adam and Eve' sketch for Mae West when she appeared on 'The Edgar Bergen and Charlie McCarthy Show' (broadcast on 12 December 1937 as part of the *Chase and Sanborn Hour*) achieved notoriety and led to West being effectively banned from the US airwaves for over ten years.[14] By the time of *Blue Jam*, the world of radio drama has moved beyond the perils of *double entendre*. Although the BBC's ultimate control over *Blue Jam* – as evidenced in the censoring of series one, episode six – should never be forgotten, Morris had a freedom with language that permitted him to broadcast any word ('taboo' words such as 'cunt' or 'fuck' are often used) or situation. This liberty was further enhanced by the scheduling of the broadcast (after midnight) which allowed a freer rein on style and content than other timeslots on Radio 1. Nevertheless, the essential non-visual dynamic of radio itself also granted Morris considerable freedom: while the television series *Jam* presented a version of the aforementioned doctor and patient 'synchronised cocks' sketch or series two, episode four's 'the gush' sketch (the endless ejaculation syndrome that kills male porn stars), it did so with discreet editing and point-of-view. Ironically, although the radio listeners cannot 'see' anything they

might nevertheless acquire a fuller 'picture' of this sketch. Some *Blue Jam* sketches seem to deliberately exploit 'seeing the unseen', playfully making the listener an implicated 'viewer':

> And, er, about six months ago I had a transplant operation to give me the penis and testicles of a baby. Um … I can probably show you, there … that's just the very tiny little white penis, and underneath, see there, the small pink sac with the as yet undescended testes. I'm very happy with it. (series one, episode two)

The sexualised comedy of Chris Morris is clearly in the tradition of other artists such as Frank Zappa, Robert Crumb or Charles Bukowski who also take the clichés of sexual relationships and taboos and make them outrageously humorous and provocative. In *Blue Jam*, this mode of obscene comedy can stray into direct social comment:

> LAWYER: You raped this woman in good faith. Did she tell you she had AIDS?
> CLIENT: … No.
> LAWYER: Right, well, I think you're entitled to compensation for that.[15]

In this sketch, the rhetoric and unscrupulousness of the legal world is sent up, but it can also be seen as making a statement about the misogyny of society.

Blue Jam: Sound, Music and Radio 1

Thus far, we have examined the various comic languages of *Blue Jam* and how they function as abstract idioglossia, rhetorical satires or obscenity. However, it is important to look at *Blue Jam* as an example of radio form in its entirety. In order to do this, we need to consider *Blue Jam* with respect to sound and music, most critically in its context as a Radio 1 programme.

The extreme nature of the content and the innovative production techniques are two prominent characteristics of *Blue Jam*. This combination of subject matter which pushed beyond the accepted boundaries of 'good taste' and a sonic environment that was more closely aligned with electronic ambient music than radio drama set the show apart from anything else on the BBC radio schedule, let alone anything else on Radio 1. To return to contemporaneous journalism, Sue Arnold's aforementioned glowing review of *Blue Jam* is titled 'He's Funny, Clever and Original. Why Is He on Radio 1?' Arnold's praise of *Blue Jam* which claims that it 'has the same effect on this structureless and often shambolic station as a Loch Linnhe oyster turning up in a tub of jellied eels',[16] is a statement of ironic elitism that would not be out of place in one of Morris's satirical sketches. For Arnold, the effect of *Blue Jam* within Radio 1 is as liberating as it is powerful:

> Every radio station in danger of being stuck in a rut needs its very own *Blue Jam* to kickstart it into a new direction or just kick it in the seat of its complacent pants. Congratulations Radio 1 for having the balls to give it air-time.[17]

Indeed, it is certainly the case that, within its Radio 1 context, the unconventional sonic texts Morris employed and developed continually underlined the programme's non-conformist credentials. However, the impact and effect of this atypical approach was equally dependent on the preservation and reiteration of key characteristics associated with Radio 1's more conventional programmes. It is this simultaneous retention, imitation and mutilation of redundant communicative codes[18] that informs the programme's parodic features.

Blue Jam Case Study: The '*Newsbeat*' Parodies

A good example of how this approach worked in practice is the '*Newsbeat*' sketch which was broadcast thirty-two minutes into the first episode of series one. *Newsbeat* is a programme that provides Radio 1 listeners with brief current affairs bulletins throughout the day.[19] Often these updates are broadcast every half an hour and therefore momentarily interrupt whatever show is on air at the time. The programme's style and structure is clearly designed to fulfil the station's obligation to provide 'news and current affairs … coverage in a tone and language appropriate to the target audience'.[20] The mid-show '*Newsbeat*' segment is essentially a distilled rundown of the main news headlines (generally a mixture of current affairs, celebrity gossip and sports). In order to appeal to Radio 1's target audience of fifteen- to twenty-nine-year-olds,[21] the presenters' voices project youth and enthusiasm (rather than wisdom and authority). The bulletins are accompanied by frenetic sound effects, musical themes and repeated references to the name of the station and segment. In *Blue Jam*, the '*Newsbeat*' sketch begins in the usual fashion. The sketch opens with a loud whirring sound effect which underscores an emphatic female voice reciting the station's current catchphrase 'New Music First' and the show's title '*Newsbeat*'.[22] To an extent the inappropriateness of this awkward segue is emphasised by the manner in which it unceremoniously dismantles the delicate aural atmosphere evoked by the preceding song. The piece of music playing prior to the '*Newsbeat*' sketch is a track called 'Rain' by Baby Fox. At the end of the composition the drum track drops out leaving only a solitary female voice and a gentle piano melody. Just after the vocals finish the melody moves up an octave for the final sustained note, the natural conclusion of which would be a slow and gentle fade. Instead, this delicate ambient atmosphere is instantly destroyed and juxtaposed by the sudden sforzando chord heralding the beginning of '*Newsbeat*'. The jarring impact of this contrapuntal interruption underlines the strained relationship between musical content and corporate branding.

From the listener's perspective the sudden switch from music to '*Newsbeat*' is not an unusual occurrence and therefore the change of focus is interpreted as a momentary break in the scheduled programme. Indeed, this assumption is confirmed when the familiar female voice of the newsreader begins to speak. Up until this point there is nothing unusual about the name, style, format or positioning of the segment. If the headlines had been recited by Morris or the opening jingle had been manipulated in some way listeners would have been instantly alerted that the segment was still part of *Blue Jam*. The first headline begins ordinarily enough as the newsreader informs the listener that: 'Inflation's hit a two year high.'[23] However, as the story continues the cause of this rise is blamed on 'three elephants, a hippo,

a leopard and a giraffe, and Cyprus'.[24] This unexpected deviation into a *non-sequitur* is the first sign that something is amiss. By sampling and seamlessly re-editing actual recordings of *Newsbeat*, Morris creates bulletins that do not seem out of place aurally or linguistically, but are otherwise counterfeit combinations in which the source material has been entirely recontextualised and assigned new meanings. Through this process the announcer's role is diminished to a type of ventriloquist's puppet who can be made to say anything the operator is able to concoct from the subject's previous statements. Therefore, even though the listeners don't see Morris's lips move, it quickly becomes apparent that he is working the controls.

After the '*Newsbeat*' title theme has been repeated the nonsensical yet innocuous mismatch of cause and effect described in the first headline is developed to relay a more sinister story: 'The government's set to announce a new concession for students planning to crush their skulls before going to university; a spokeswoman has denied there's a risk to safety!'[25] On this occasion, beneath the apparent absurdity of the headline lies a more subversive implication. A literal interpretation of the story presents 'the government' as inept and dishonest. It is portrayed as a seat of power which conceives of a concession designed to injure young people and claims that the effects will not be harmful. Furthermore, the extreme form of state-sponsored trepanning described conjures a far more gruesome mental image than the fanciful idea of animals being held responsible for a rise in inflation. From another perspective, the idiomatic phrasing used to describe this self-inflicted injury draws on associations with intoxication (e.g. out of my skull).

This definite yet gentle progression from *non sequitur* to subtle satire is suddenly accelerated into the realms of 'shock radio'[26] when the third headline is read out:

(sforzando chord)

MALE VOICE: Radio 1 – Newsbeat.

FEMALE ANNOUNCER: A huge cunt is the killer of a British tourist.

(sforzando chord) Twenty-two-year-old Max Geoffrey

(sforzando chord) was shot dead by the *(sforzando chord)* cunt, who'd given him a lift. *(sforzando chord)*[27]

Hearing a broadcaster swear is a moment that always commands the listener's attention and while many swear words have lost a degree of potency due to their frequent usage in the media and society at large 'the C word' is still regarded as a taboo term.

Beyond the shock of the expletive, the first half of the announcement makes a very blunt kind of sense and the polarised interpretation of events cuts through any superfluous information. The candidly phrased bulletin is liberally peppered with the sforzando chords that have previously only punctuated the beginning and end of each story. However, during this headline the unabashed accompaniment is repeated so often that it overlaps and threatens to obscure the announcer's voice. Such frequent repetition aurally caricatures the programme's production process and by exaggerating this convention, Morris highlights the absurdity of a current affairs programme that values style, sensation and brevity over substance, accuracy and detail.

The last bulletin is thematically similar to the second one; the satirical target is a power-
ful state institution and the subject is its treatment of the younger generation: 'Police in
Northumberland have sex with schoolgirls, and it's all legal.'[28] Once again the stakes are
raised, this time with a headline which establishes that even the potentially noxious taboo of
underage intergenerational sex is not off limits in *Blue Jam*. After another sforzando chord,
the newsreader repeats the name of the station and programme title before delivering the
final punchline, 'I'm suspended';[29] a prediction that clearly recognises the corporate rules and
regulations broken in this sketch. Next there is a short beep signifying the end of the
'*Newsbeat*' transmission, followed by a sound effect which gives the impression that
the studio's power has been disconnected. This provides an indexical sign which suggests
that the plug has literally been pulled on the show.[30] The sound of this seemingly enforced
break in transmission does not take effect and the descent towards silence is interrupted by
a heavily Vocoded voice blurting out the station number ('one'). Throughout the section that
follows this monosyllabic utterance is modulated and played as a kind of demented refrain.
Like the sforzando chord in the '*Newsbeat*' sketch, this reiteration parodies the station's
predilection for bombast and self-promotion.

The sketch itself is the second in a set of alternative Radio 1 jingles that are repeated
throughout all three series. It is common practice on Radio 1 to promote the station and
advertise other shows in the schedule with pre-produced jingles that are played in between
songs and programmes.[31] In *Blue Jam*, these reoccurring sketches follow the usual conventions;
they bridge songs and sketches, incorporate musical material, are repeated across episodes
and reference both the station name and the DJs who host the shows. However, with regard
to style and content, Morris adapts the aural iconography associated with this type of com-
position and in doing so subverts the 'brand personality'[32] Radio 1 projects and promotes.

JAM and *Blue Jam*: Radio Jingles

Radio 1 has always used jingles.[33] The technique was adopted in order to emulate the style
and format introduced by the pirate stations Radio 1 was created to replace.[34] To ensure
this was achieved, the BBC commissioned jingles from the same American company that
produced them for Radio London,[35] but in 1976 the corporation switched to a newly
formed company called the JAM Jingle Company.[36] In an interview for *Mailbag* broadcast in
1978, Johnny Beerling[37] plays an excerpt from JAM's promotional audio presentation as a
response to the question, 'Why do we have jingles to start with?' The explanation provided
succinctly sums up the marketing ethos and branding functions that inform the composition
of these pseudo-musical sound bridges:

> Radio programming has gone through many changes in the past few years and so has the thinking
> behind the use of jingles … many programmers are realising once again that a jingle can convey
> more than just the name of the station. It can also convey an image, some slogan, or a thought
> about the radio station. In other words a jingle can do more than just name the product; it can say
> something about it and this can make the product more memorable.[38]

In the context of this chapter the instructive description above inevitably leads to a question: what 'image' do Radio 1 jingles convey, and to what extent is this 'image' distorted by their *Blue Jam* counterparts?

Like the other *Blue Jam* jingles, the one that plays immediately after the '*Newsbeat*' sketch features a synthesised voice. Although the text-to-speech system used in the *Blue Jam* jingle carries associations with disability,[39] it also draws on a convention Radio 1 established in the jingles broadcast during the 1970s and 80s. Before computer-aided methods were developed to replicate the human voice, musicians had already begun to experiment with vocal synthesis. In the 1930s, a system known as a Vocoder was developed which enabled the encryption of radio broadcasts. This process was adapted by Robert Moog to create a musical Vocoder in 1968. The Moog Vocoder allowed the user to superimpose the envelope of a human voice onto a synthetic sound which could then be played on a keyboard to create the impression that the music was speaking. During the 1970s, various musicians used this technique to give vocal tracks a novel futuristic sound.[40]

The singles chart show *Solid Gold 60* (1973–4) was one of the first programmes to incorporate this new sound into its jingles.[41] Throughout the 1980s, variants of the distinctive Vocoder sound became a prominent feature in numerous jingles, which referenced the station name or frequency, as well as being used to sonically transform other frequently repeated buzz words and phrases like 'Stereo', 'Music Now' and 'Action Radio'.[42] The fact that the Vocoded voice was generally employed to orate the 'core brand',[43] programme title and current advertising slogans, certainly indicates that the associations it encouraged were intended to convey the type of corporate 'image' described in the JAM promotions audio presentation. From this perspective, the synthesised voice appears to have been intentionally developed as an iconic aural signature devised to reflect a new musical trend while simultaneously capitalising on the progressive connotations the sound evoked. However, in the *Blue Jam* jingles the synthetic voice and the technical prowess it alludes to is undermined to the point of sabotage. The short, one- to two-word, Vocoded interjections (often used to reinforce a positive characteristic of the station's image) are expanded into subversive sentences as the voice assumes the role of an emotionless whistleblower revealing disturbing secrets about the station and its DJs.

In series one of *Blue Jam*, Steve Lamacq, Mary Anne Hobbs, Jo Whiley, Mark Goodier, Mark Radcliffe and Simon Mayo all have a jingle 'dedicated' to them. The synthesised voice describes Steve Lamacq as a 'frail old man in a wheelchair trying to shake hands with an elephant'.[44] This representation of Lamacq as an aged, out-of-date disc jockey is supported by two additional sound effects; a voice saying 'Huh!' and what is best described as a laughing monkey. Significantly, this monkey sample has immediately followed Serge Gainsbourg and Brigitte Bardot's 'Bonnie and Clyde' (1968), a song which features the *cuíca*, the Brazilian friction drum prevalent in samba music which typically emulates a 'laughing simian' sound.[45] In the context of the jingle, the first of these sounds represents either the monosyllabic utterance of a vacant mind or an outdated attempt to sound young and hip, while the monkey laugh carries obvious imbecilic connotations (i.e. the 'world music' register of the *cuíca* has become an idiot's laughter). The subjects of the second jingle are Whiley and Goodier. In this segment, the synthesised voice informs the listener that while Jo Whiley is 'slowly chopped

to pieces', Mark Goodier can be seen 'rubbing his genitals in the warm, gloopy mess'.[46] An electronic beat and modulations of the word 'one' accompany the dialogue and at the point where Goodier's genitals are mentioned a second rhythm is introduced to punctuate the grotesque sexualised activity he is engaged in. Mary Anne Hobbs receives similar treatment and is reduced to 'little more than a bag of lymph' which is 'rolled from the studio and drained into a sink',[47] while Zoë Ball is discovered 'hanging from the ceiling by a flex around her neck', a sight which invites only indifference and laughter from her colleagues.[48]

In the Simon Mayo jingle, the synthesised voice is modulated to the melodic pattern of a well-known piece of classical music. The tune Morris adapts is Grieg's composition *In the Hall of the Mountain King* (1876). After the usual reference to the station name the voice describes the following scene to the tune transcribed below:

49

I could see a gi ant Si mon May o crash ing round the fun fair and piss ing on the flee ing wo men's heads

Although using this instantly recognisable tune introduces a number of potentially imperti-nent intertextual connections,[50] there is a far more basic comic principle at work. Put simply, the combination of a synthesised voice singing about a giant DJ urinating on women to the tune of *In the Hall of the Mountain King* is funny because the content and delivery are so con-spicuously ridiculous. The final sonic components of the Simon Mayo sting are a short burst of operatic singing followed by the closing phrases of Ronald Binge's composition 'Sailing By' (1963). This piece of music is commonly associated with Radio 4 as it is played every night prior to the shipping forecast. As such, it provides another 'aural logo',[51] appropriated and realigned with the alternative station image conveyed in *Blue Jam*.

The process of adding new lyrics to a popular tune draws on another convention that was frequently adopted in Radio 1 jingles. Typical examples of the practice include a ver-sion of The Who's 'My Generation' (1965), which featured the alternative refrain, 'talking about my favourite station'; a jingle version of The Beatles song 'Drive My Car' (1965), which was used to introduce traffic news segments; and James Brown's track 'Living in America' (1985) adapted to fit the slogan 'Britain's favourite radio'.[52] The appropriation of musical reference points is a technique which Morris both parodies and relies upon in the *Blue Jam* jingles. Indeed, just as the Vocoded voice used in Radio 1's jingles borrowed from contemporary musical practices, the text-to-speech system employed to create the syn-thesised voice for the *Blue Jam* jingles had been recently popularised in the alternative music scene.

Three of the most successful tracks to use this technique were released in 1997, just a few months before the first episode of *Blue Jam* was broadcast. A female version of the syn-thesised voice was used in Rick Smith's remix of Rob and Goldie's track 'The Shadow' (21 April 1997). In this track, the voice recites various dictionary definitions of the word shadow and as such many of the words it orates are associated with darkness and mystery (a ghost, a phantom, a dark figure). Aphex Twin's *Come to Daddy* EP included a composition entitled 'Funny Little Man' (6 October 1997),[53] at the end of which a synthesised voice sings the following lyrics: 'I would like to fuck you up the bunghole, and then I will sneak into your

room, I will cut your cock off, and stuff it in my mouth, and chew it up with my little pearlies.'[54]

Despite pre-dating *Blue Jam* by just a few weeks, the way in which this composition uses technology to articulate a mixture of explicit words, suggestive idioms and violent sentiment clearly invites parallels between the two.

Radiohead was the most mainstream act to release a song that year which used a text-to-speech system. Their album *OK Computer* (16/17 June 1997) featured a track called 'Fitter Happier' in which the lead vocals were synthesised. The solitary voice begins the composition with a list of affirmative lifestyle choices relating to diet, exercise and work. However, the robotic timbre and inherent emotional detachment of the artificial voice subverts conventional reflexive interpretations of these pursuits.[55] Consequently, the medium employed drains away the optimism and buoyancy usually associated with the actions described and portrays such behaviour as a result of social and technological conditioning. This initial reading is reinforced as the track continues and the lyrical focus gradually shifts towards the final unsettling summation: 'no longer empty and frantic like a cat tied to a stick that's driven into frozen winter shit, the ability to laugh at weakness. Calm, fitter, healthier and more productive, a pig in a cage on antibiotics.'[56]

When the *Blue Jam* jingles are considered against this cultural backdrop, it is apparent that Morris contributed to a contemporary musical zeitgeist which aligned the emotionless synthesised voice with disquieting descriptions and imagery. Indeed, it could be argued that Morris himself adhered to a Radio 1 marketing tactic: 'We've [Radio 1] always tried to make our jingles reflect the style of music that's currently popular'.[57] From this perspective, these production techniques align the programme with the alternative music scene as a way of attracting Morris's 'target market'.[58] However, the close analysis of the *Blue Jam* jingles and the readings they provoke reveal a far more complex process of signification. The satirical focus, visceral imagery and the repellent behaviour these jingles describe provide a subversive counterpoint to the unabashed promotionalism, technical sophistication and friendly dynamism these prefabricated compositions are usually designed to project. Or to put it another way, Morris uses the *Blue Jam* jingles to figuratively roast Radio 1 on its own spit.

Conclusion

We have seen how the three series of *Blue Jam* contained a rich range of comic languages that encompass the absurd, the obscene, the satirical and the provocative. Chris Morris and his talented team of performers and co-writers collaborated in the creation of a groundbreaking example of radio comedy. Most significantly, we have seen how Morris, in his role as producer, comprehensively explored the sound and music of radio form. Although *Blue Jam* seemed at odds with the Radio 1 schedule, close analysis reveals how consummately Morris understood the style, function and history of the station. For Tim Crook, Morris's achievement in *Blue Jam* represented a possible 'reorientation of a new ideological stance' which was what he believes Orson Welles also came near to with his greatest achievements

as a radio artist in the 1930s.[59] Crook stresses that with Morris 'there is no evidence that the reorientation is based on political dogma': its ideological objective is, in fact, simply 'to attack and expose hypocrisy'.[60] Considered this way, we realise that Chris Morris belongs to a long heritage of provocative satirists who understand how to use their chosen form effectively while, simultaneously, dismantling it so thoroughly.

Notes

1. Tim Crook, *Radio Drama, Theory and Practice* (London: Routledge, 1999), p. 125.
2. The sixth episode of the first series (18 December 1997) was faded out by BBC Radio 1 after approximately fifteen minutes when the broadcasters heard Chris Morris's re-edited version of the Archbishop of Canterbury's speech at Princess Diana's funeral (6 September 1997). Morris's sketch – which satirised the British royal family and AIDS – had not been approved by Radio 1 and they instantly replaced the programme with a rerun of the first episode of the series.
3. Sue Arnold, 'He's Funny, Clever and Original: Why Is He on Radio 1?', *Observer* (7 February 1999), <http://www.guardian.co.uk/theobserver/1999/feb/07/featuresreview.review1>.
4. Crook, *Radio Drama*, p. 125.
5. Ibid., p. 126.
6. Brian Logan, 'Funny, Haha: The Comedy of Mental Health Issues', *Guardian* (6 October 2010), <http://www.guardian.co.uk/stage/2010/oct/06/comedy-mental-health-may-contain-nuts>.
7. Allison McCracken, 'Scary Women and Scared Men: *Suspense*, Gender Trouble, and Postwar Change, 1942–1950', in Michele Hilmes (ed.), *Radio Reader: Essays in the Cultural History of Radio* (New York: Routledge, 2002), p. 184.
8. 'The closest we have to a British Leslie Nielsen' as an interviewer in the *Londonist* (4 February 2011) puts it; Franco Milazzo, 'Actor Interview: David Cann', *Londonist* (4 February 2011), <http://londonist.com/2011/02/actor-interview-david-cann.php>. Cann would also go on to play doctor roles in episodes of *EastEnders* (BBC 1, 1985–) in 2005 and *Psychoville* (BBC 2, 2009–) in 2011.
9. *Blue Jam*, series one, episode two.
10. Delia Chiaro, *The Language of Jokes* (Oxford and New York: Routledge, 1992), pp. 119–20.
11. *Blue Jam*, series one, episode one.
12. *Blue Jam*, series one, episode two.
13. The Motion Picture Production Code – more commonly known as the Hays Code – was a set of censorship guidelines established in the 1930s in order to regulate cinema in the US. The British Board of Film Classification (BBFC), established in the early days of cinema, continues to be responsible for film censorship.
14. The sketch allowed West as 'Eve' to use her characteristic innuendo, helping the serpent – stuck in a fence next to the Tree of Knowledge – to break free: 'Oh, shake your hips! Yeah, you're doing all right. Get me a big one, I feel like doing a big apple.'
15. *Blue Jam*, series one, episode five.
16. Arnold, 'He's Funny, Clever and Original'.

17. Ibid.

18. Jonathan Baldwin and Lucienne Roberts, *Visual Communication: From Theory to Practice* (Lausanne: AVA Publishing, 2006), p. 33.

19. *Newsbeat* was first broadcast in 1973.

20. BBC, *Radio 1 Service Licence* (London: BBC Trust, 2009), p. 1.

21. Ibid., p. 1.

22. *Blue Jam*, series one, episode one.

23. Ibid.

24. Ibid.

25. Ibid.

26. Walter Cronkite, cited in Robert L. Hilliard and Michael C. Keith, *Dirty Discourse: Sex and Indecency in Broadcasting* (Oxford: Blackwell Publishing, 2009), p. 64.

27. *Blue Jam*, series one, episode one.

28. Ibid.

29. Ibid.

30. An ironic prediction in the light of the fact that Morris's plunderphonic interpretation of the speech given by the Archbishop of Canterbury at the Princess of Wales's funeral resulted in the last episode of series one being taken off air mid-broadcast.

31. Pete Wilby and Andy Conroy, *The Radio Handbook* (London: Routledge, 1994), p. 131; Bob Gilmurray, *The Media Student's Guide to Radio Production* (Lulu.com: Mightier Pen Publishing, 2010), p. 12; Johnny Beerling, *Interview on 'Mailbag'* (BBC, 1978), <www.radiorewind.co.uk>; Johnny Beerling, 'The JAM–BBC Story', *The First 20 Years* (JAM Productions, 1994), <www.jingles.com/jam>.

32. Gilmurray, *The Media Student's Guide to Radio Production*, p. 12.

33. Indeed when Radio 1 was launched in 1967 a jingle was played immediately after the broadcast countdown.

34. 'The BBC was commissioned to set up … a new sort of pop service which was to replace the then illegal pirate stations. It was necessary that we should run the same sort of sounds' (Beerling, *Interview on 'Mailbag'*)'.

35. The company was known as PAMS (an acronym for 'Promotions and Merchandisers').

36. Beerling, *Interview on 'Mailbag'*.

37. A DJ instrumental in the formation of Radio 1 who was also the Station Controller from 1985 to 1993.

38. Beerling, *Interview on 'Mailbag'*.

39. Most familiarly, text-to-speech is associated with Professor Stephen Hawking (born 1942), who has motor neurone disease.

40. Probably the most well known of these is ELO's track 'Mr Blue Sky', released in 1977.

41. It is possible that the effect for this jingle was created with either a 'Sonovox' or a 'Talk Box'. However, both these alternative techniques create a sound very similar to a Vocoder.

42. BBC Radio 1, '1980's Jingles', *Jingles and Themes*, <www.radiorewind.co.uk>.

43. Kevin Lane Keller, Tony Apéria and Mats Georgson, *Strategic Brand Management: A European Perspective* (Harlow: Pearson Education Limited, 2008), p. 36.

44. *Blue Jam*, series one, episode one.

45. In mainstream popular music, it is probably most familiar from Paul Simon's 'Me and Julio down by the Schoolyard' (1972).

46. *Blue Jam*, series one, episode one.

47. *Blue Jam*, series one, episode two.

48. Ibid.

49. *Blue Jam*, series one, episode one. Thanks to B. Challis for this description.

50. For instance, the composition is associated with trolls; a connection which has descended from the composition's original use in Ibsen's play *Peer Gynt* (1875) as it is to this mythical race that the mountain king belongs. This association with the mythical creatures known for kidnapping (and sometimes consuming) children was recontextualised in Fritz Lang's 1931 film *M*, which features a child-killer who whistles Grieg's tune while on the prowl for his victims.

51. Frances Dyson, *Sounding New Media: Immersion and Embodiment in the Arts and Culture* (Berkeley: University of California Press, 2009), p. 136.

52. BBC Radio 1, '1960's, 1970's, 1980's Jingles', *Jingles and Themes*, <www.radiorewind.co.uk>.

53. This was released on Warp Records, the same label that released a compilation of sketches from *Blue Jam* in October 2000.

54. Aphex Twin, 'Funny Little Man', *Come to Daddy* (1997).

55. In the background, an audio sample from *Three Days of the Condor* (1975), which is incorrectly cited as 'Flight of the Condor' in the album liner notes, repeats the following announcement: 'This is the Panic Office. Section 917 (nine seventeen) may have been hit. Activate the following procedure.'

56. Radiohead, 'Fitter Happier', *OK Computer* (1997).

57. Beerling, 'The JAM–BBC Story'.

58. Rhonda Abrams and Eugène Kleiner, *The Successful Business Plan: Secrets & Strategies* (Palo Alto, CA: Planning Shop, 2003), p. 87.

59. Crook, *Radio Drama*, p. 135.

60. Ibid., p. 135.

9

LOST IN TECHNO TRANCE: DANCE CULTURE, DRUGS AND THE DIGITAL IMAGE IN *JAM*

JAMIE SEXTON

Welcome … in *Jam*

A televised version of the radio show *Blue Jam* (BBC Radio 1, 1997–9), *Jam* marked a return to television for Morris after the high-profile series *Brass Eye* (Channel 4, 1997; 2001), but it was – like its radio predecessor – a more low-key affair than that programme. Aired on Channel 4 between 23 March and 27 April 2000 and shown late in the midweek schedules, *Jam* was not subject to the media hullabaloo that surrounded *Brass Eye* despite its controversial content.[1] Unlike its radio counterpart, which was broadcast at midnight or 1.00 am, *Jam* was transmitted at the slightly earlier time of 10.30 pm, wedged between two other comedy programmes, *Drop the Dead Donkey* and *The 11 o'Clock Show* (1998–2000), on Thursday evenings. It was accompanied by a later 'remix' programme – *Jaaaaam* – which was programmed within Channel 4's '4Later' slot in the early hours of Sunday morning between 15 April and 20 May.[2] 4Later ran between Friday and Sunday in the early hours of the morning in the late 1990s/early 2000s, and was described as being devoted to 'the experimental, the arcane, and the downright weird'.[3] Unusually, Morris was able to persuade Channel 4 to allow the programme to be shown without advertising breaks. While there were rumours that this decision may have been partly influenced by advertisers' objections to the disturbing content of the series, Morris has emphasised that he requested no ad breaks so that the atmosphere of the show was not disrupted.[4] This demonstrates that Morris was a particularly well-regarded figure at this stage; despite his history of agitation and irritation, he was held in enough esteem to be deemed worthy of taking a risk upon. It was arguably Morris's position as one of Britain's most critically celebrated comic figures that allowed him to push the boundaries of televisual humour. As such, I will treat *Jam* as an authored text. While authorship can problematically downplay collaborative input – and Morris has long worked with a number of other important creative figures – *Jam* was undoubtedly *his* project and was also the first complete television series that he directed.[5] This does not, however, negate the importance of the other contributors; in particular, the main actors in *Jam* – Amelia Bullmore, David Cann, Julia Davis, Kevin Eldon, Mark Heap – and many behind-the-scenes consultants and collaborators including Peter Baynham, Graham Linehan and David Quantick,

played a significant role in shaping the programme (and many of these people had previously worked with Morris).

Jam was, like *Blue Jam*, a very dark comedy sketch show which blended music and comedy. *Blue Jam* was itself a more experimental extension of the traditional DJ set, in which a musical playlist is interspersed with comic banter (Morris had, of course, previously been a radio DJ). Compared to the more traditional DJ set *Blue Jam* was meticulously mixed and edited to create a continuous soundscape, with music a constant presence that slipped between the foreground and background of the mix; Morris and sound collaborator Adrian Sutton also created new sounds and carefully blended these with both the dialogue and music on the playlist. Both radio and television versions were not only dark in tone but also sometimes sickly uncomfortable; many of the sketches felt as though they were informed as much by the genre of horror as they were by the traditions of comedy, while the sonic qualities of the show – featuring extensive use of ambient music, spoken dialogue which was often quiet and detached, and frequent use of manipulated voices – created a distanced and uneasy atmosphere.

Though not extensively reviewed, *Jam* was received quite positively at the time of its transmission, with some critics drawing attention to its ambient, experimental and surreal qualities. It has not, though, been as generally well received by Morris's fan base; though not vilified, it is generally considered less successful than *Blue Jam* on Internet forums devoted to Morris and comedy (with such a view echoed by Justin Lewis in this volume).[6] Many praised the purely sonic mix of the radio show and argued that the visuals diluted its alienating, disorienting force; because *Blue Jam* contained dark, surreal content, the listener's mind could conjure its own nightmarish mental visions in response to the aural mix. Such opinions seem to have stymied the exploration of *Jam* as a specifically televisual experience, and one that is particularly innovative and experimental when placed within the traditions of television comedy. This chapter aims to rectify this imbalance; it does not deny that *Jam* is (at least partly) an adaptation, but neither does it reduce its status in this way.[7]

Ambient Comedy

In the critical reception of *Jam*, the programme's relationship to ambient music was frequently mentioned. This topic has not been scrutinised in any detail, though, so I will begin my analysis of the programme by relating its qualities to ideas about, and the historical developments of, this musical mode. The concept of ambient music was first theorised by Brian Eno, who wrote in the sleevenotes to his 1978 record *Music for Airports*:

> An ambience is defined as an atmosphere, or a surrounding influence: a tint. My aim is to produce
> original pieces ostensibly (but not exclusively) for particular times and situations with a view to
> building up a small but versatile catalogue of environmental music suited to a wide variety of
> moods and atmospheres.[8]

Eno distinguished ambient music from forms of canned, environmental music (such as Muzak), by claiming that the latter aimed at 'regularising environments by blanketing their

acoustic and atmospheric idiosyncracies', whereas ambient music 'is intended to enhance these'.[9] As such, ambient music is positioned as contemplative and reflective, capable of heightening the listener's awareness of music's relationship with environmental space; canned music is, contrastingly, perceived as reducing brain activity and offering comfort in the midst of stressful environments.

Since Eno coined this term, ambient has splintered into a number of different directions. One of the most prominent of these is 'ambient dance' music, which developed out of rave music and culture. This was the lineage from which Morris primarily drew upon in *Blue Jam* and *Jam*, as emphasised by the mixtape form of the show. The mixtape – or more specifically the DJ mixtape – flourished as rave and dance cultures grew in the late 1980s and 1990s. This led to a greater emphasis on creating a seamless flow of music in which musical tracks were treated more like liquid segments in a fluid sequence than self-contained sonic units.[10] A seminal release in ambient dance culture was The KLF's *Chill Out* (1990), an ambient sonic collage made from a variety of samples (including Elvis Presley, Glen Campbell and Acker Bilk, as well as samples of radio broadcasts, including the report of a fatal road accident), which had been used on *Blue Jam* though did not feature on the *Jam* soundtrack.[11] *Chill Out* became a cult favourite among post-clubbers relaxing into the early hours of the morning and led to a surge in ambient dance mixes, including series such as *Late Night Sessions* (beginning in 1996) and *Back to Mine* (beginning in 1999), in which guest DJs or musicians created mixes for each edition.[12] Such fascination with musical mixes was not surprising considering Morris's longstanding interest in audio sample culture. As Justin Lewis points out in his chapter, Morris had previously created brash jingles from multiple sources for his radio shows; these seemed at least partly inspired by The Justified Ancients of Mu Mu's (aka The JAMs) 'messy, disorienting style of collage' on controversial records such as *1987 (What the Fuck Is Going On?)*.[13] Just as The JAMs – another alias for The KLF (Bill Drummond and Jimmy Cauty) – had progressed from this messy collage style to the more seamless ambient mix of *Chill Out*, so Morris now seemed equally attracted to the more subtle, ambient mix style that had become particularly attractive to post-clubbers.

Blue Jam and *Jam* created seamless sonic mixes by continuously segueing music and sound effects across sketches, usually through crossfading, while Morris's successful appeal to omit ad breaks further contributed to an ambient flow. The ambient nature of these programmes, though, is not limited to this technique alone. Many dialogue scenes are blended with the music; while it is true that many forms of film, radio and television use music to underpin dramatic scenes featuring dialogue, in *Jam* sketches this is done in a particularly distinctive manner. Often, for example, the dialogue and music tracks are mixed at a reasonably similar volume, so that there is no conventional distinction between background or foreground audio. This is evident in the very first sketch in episode one of *Jam* (following the introductory monologue), in which a couple and their friend talk in quiet, measured voices, their dialogue (concerning the provision of sexual favours to protect their son from becoming gay) competing for attention with the music track (Bark Psychosis's melancholy 'Pendulum Man' [1994], whose measured guitar pattern complements the speech style). The creation of distinctive speech patterns here reflects Morris's interest in treating sound, including speech, in a musical sense. From an early stage he was already, according to Randall, particularly interested in 'the noise and

rhythm of comedy';[14] *Blue Jam* and *Jam* are the shows in which this area is most fully explored. This technique also connects to Eno's original conception of ambient music: music which blends with environmental space, so that the listener can either focus on it intently or let it fade into the background and become a mere tint within a broader soundscape. Eno wrote that ambient music should be 'as ignorable as it is interesting',[15] a mode of listening facilitated by the *Jam* programmes, which encourage viewers to flit between different positions.

The actual content of the sketch material in both *Jam* programmes is, on the face of it, at odds with the ambient presentational form. Many of the sketches are quite extreme in nature and push the limits of humour; in this sense they are more closely related to some of Morris's previous work than the actual style of the programmes is. The segued mixtape flow and the frequently measured, unemotional delivery of lines – sometimes heightened through actors lip-synching existing *Blue Jam* material – often feel anempathetic to the extremely fraught nature of some of the sketches. This enmeshing of grotesque material within an ambient idiom is an unusual juxtaposition of form/content which can be connected to the surrealists, who stressed the importance of juxtaposing disparate materials, believing they were capable of producing a 'spark' that could jolt one out of 'familiar reality' and liberate us from 'routinised thought'.[16] This mode of intertwining unusual elements was also evident in Morris's summation of the programme as 'ambient wrong' and the description on the DVD release of *Jam* – used as the title of Lucian Randall's biography of Morris – as 'disgusting bliss': both of these phrases point to the oxymoronic nature of *Jam*, whereby opposing principles are juxtaposed and overlaid. While I do not want to reduce the aesthetics of *Jam* to the ideals and practices of the surrealists, there are nonetheless evident connecting threads to be made (and it was listed in the *TV Times* as a 'surreal comedy').[17] These are sketches which seem to emerge from, and tap into, the subconscious and move us away from the more rational domain of consciousness. They can therefore be linked to various forms of altered states: dreams, hypnagogic and hypnopompic states, delirium, depression and the drugged condition (which I will return to in more detail below).

While the unusual juxtaposition of (ambient) form and (horrific) content in *Jam* creates a heightened sense of strangeness on the one hand, it is also possible to understand this mixture as an extension of a particular strand of ambient music. Around the mid-1990s some forms of ambient music had strayed into darker, queasier territory in an attempt to move away from the more comforting strains of ambient dance music that had become widely produced by this stage. This music placed a greater emphasis on sinister sounds and an unsettling mood. Kevin Martin's liner notes to one of the key compilations of 'dark ambient' from this period, *Isolationism* (1994), distinguished this form of ambient from what he termed 'New Ambient' (here he was referring to more comforting, soothing forms of ambient, particularly music which was associated with 'New Age' spiritualism):

> Drifting inwards instead of reaching out, this compilation's furtive music sounds as paranoic as it does panoramic, and is in direct contrast to its mellow relative. Where New Ambient seeks to avoid discomfort, this Isolationist strain uses the studio as a monastic retreat to encourage self-confrontation.[18]

Many artists identified with making dark ambient sounds were going back in time to find inspiration, or at least being linked to older musical forms by critics. A key release, which alerted critics to connections between newer and older forms of ambient music, was Aphex Twin's *Selected Ambient Works Volume Two* (1994). In the early 1990s, Aphex Twin – real name Richard D. James – was one of the most acclaimed young artists in the electronic dance music scene following a number of techno tracks (some recorded under aliases) and the esteemed ambient dance album *Selected Ambient Works 85–92* (1992). *Selected Ambient Works Volume 2* was a very different record from its predecessor, however, largely eschewing the 4/4 beat-driven template of the former in favour of sparser, more unsettling soundscapes. Many reviews of the album mentioned that the sounds on this album were more similar to some forms of experimental music than to contemporary dance music, with Brian Eno's more challenging ambient works – such as *On Land* (1982) – being referenced heavily, as well as work by minimalist composers such as Philip Glass and Steve Reich. (It is important to note that ambient tracks by Aphex Twin and Eno were used on *Jam*'s soundtrack.)[19]

A related development was the emergence of 'intelligent dance music' (IDM), a controversial and rather broad category comprising music that had developed out of dance culture but which was geared more towards home listening than the dancefloor. IDM encompasses ambient dance forms as well as more experimental forms of electronic music which don't fit comfortably into the ambient strand. It is particularly important to mention in relation to Morris and *Jam* because of its link to Warp Records: Warp's compilation of electronic music *Artificial Intelligence* (1992) – which was promoted with the tagline 'electronic listening music' – is often considered a key IDM release, and many Warp acts would be linked to the category, including Aphex Twin, Autechre and Boards of Canada. Morris himself would forge links with Warp Records: the label released a CD compilation of *Blue Jam* highlights (2000) and went on to produce his short film *My Wrongs #8245–8249 and 117* (2002) and his first feature *Four Lions* (2010). Both *Blue Jam* and *Jam* also featured several acts who had been signed to Warp.[20] More broadly, they also featured a number of musical tracks linked to ambient dance, dark ambient, and other 'downbeat' dance music styles, including downtempo modes of hiphop and electronic music. In *Blue Jam*, though, while ambient/IDM constituted a significant presence, it was mixed with other musical styles, particularly independent rock and pop, but also occasionally vintage soul and funk, as well as a few other generic selections. The music in *Jam*, while containing some variety, has a greater generic consistency overall and is geared towards the creation of a more coherent atmosphere. *Jam*'s mood was largely one of dread and unease; while this was created through various means, sound was crucial to this dread-infused ambience.

Of course, sound has long been considered essential in the creation of specific moods in film and television and attempts to arouse dread and fear via the soundtrack have been of great importance in horror cinema. Morris certainly draws on elements of horror cinema in *Jam*. This is evident not only on the soundtrack but also in the general content and atmosphere of some of the sketches, which sometimes recall surrealist forms of horror in which logic breaks down and nightmarish dread begins to infiltrate, or merge with, 'reality' – see particularly Lynch's *Eraserhead* (1977), Zulawski's *Possession* (1981) and Cronenberg's *Videodrome* (1983).[21] The manner in which Morris formatted the music was,

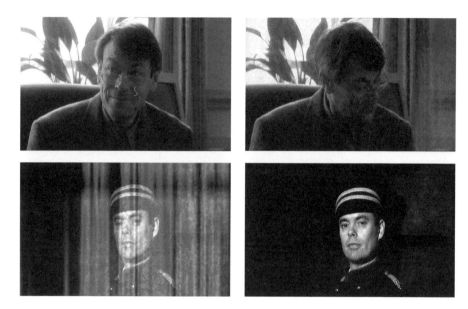

A typical abstract segue between sketches, which involves fade ins/outs and superimpositions (episode two)

however, peculiarly distinctive and avoided merely retreading prominent audiovisual conventions familiar across many forms of horror cinema. And while the programme can, in many ways, be considered a televisual counterpart to dark ambient music, the fact that it is a comedy programme prevents it from being reduced to such a categorisation, as humour wasn't a notable component of such music. Aphex Twin did, however, increasingly incorporate dark humour into his work after the release of *Selected Ambient Works Volume Two* and the video for 'Come to Daddy' (1997), directed by Chris Cunningham, may well have been an influence on *Jam*, consisting as it did of a mixture of the horrific and the darkly comic.[22] Shot in a rundown industrial estate, it features a gang of children wearing Aphex Twin masks who, after being summoned by an evil spirit emerging from a discarded television set, wreak havoc.

Then there was the difficulty of translating this ambient form into televisual terms. The most obvious way it achieved this was through segueing visual sketches, most frequently through fading out into an intermittent moving abstract image, which then fades into the next sketch. Some transitions involve more straightforward fades to black (or a different colour) and fades into new scenes, or lap dissolves, but the abstract transitions are nevertheless prominent. In practical terms, they would have made it easier for Morris and his team to blend both the audio and visual tracks into a seamless continuum. These transitions also, like the formal mixing process, link to music culture. The use of projected images within live music performances has a long history, but most pertinent to this discussion is the role of the VJ (video jockey) in club culture. The VJ generally works with a database of images and creates image sequences on the fly to accompany the music being played by the DJ. VJ club sets often feature abstract imagery, which acts as textural enhancements to

the club experience. Abstract imagery also has a privileged relationship to music more broadly, in that conceptions of 'visual music' within painting and film – explored by figures such as Wassily Kandinsky and Oskar Fischinger – have frequently turned to abstract imagery to represent musical form. Stemming from the idea that music is one of the most abstract of arts, many artists interested in visual music were influenced by the concept of synesthesia, in which the stimulation of one sense triggers another sense. While there are various forms of synesthesia, the ability to see colours in response to different sounds is a particularly common mode, with subjects often reporting corresponding visual sensations in largely abstract terms, commonly associating different sounds with particular colours or geometric configurations.[23]

Not Raving But Drowning: Experiential Satire

Synesthesia and some forms of visual music have occasionally been associated with mind-altering drugs. It has been argued that some drugs – particularly hallucinogenics – can enable non-synesthetes to experience synesthetic sensations.[24] There are also connections between drugs and abstraction in certain pockets of artistic production: the film-maker Harry Smith, for example, created abstract visual music films after experiencing synesthetic perceptions under the influence of hashish,[25] while certain psychedelic films in the late 1960s commonly downplayed linear narratives in favour of aural and visual spectacle, so that colour, music and abstraction achieved heightened significance.[26] Drugs were also important within club culture, particularly MDMA (ecstasy). Simon Reynolds has argued that drugs – ecstasy in particular – were crucial factors in the development not only of rave culture (through increasing the ability to dance long hours) but also the music: MDMA's effects increase appreciation of texture and timbre, and therefore fed into the production of tracks that did not rely on more conventional musical properties such as melody and harmony.[27] Sadie Plant went so far as to argue that ecstasy 'was the music, and the music was a means of engineering and exploring its effects'.[28]

I have already mentioned how *Jam* can be related to altered states, but it is the drugged state which is arguably the most relevant in view of the programme's relation to dance cultures. Some of the effects, such as ghosting, polarisation, visual and audio speed manipulations, can be seen as attempts to create aesthetic analogues of the drugged state. While different types of drugs create their own distinctive effects, *Jam* doesn't seem to be aping the experience of one specific substance. This is appropriate for a programme with links to club culture in that – though ecstasy was the most prevalent drug – many different substances were often ingested at and after club nights, including (but not limited to) LSD, hashish and amphetamines. Rather, the programme taps into certain sensations and experiences common to different substances, including the blurring, enhancement and distortion of everyday perception. Its mood is deflated rather than euphoric, though, and in this sense it is more closely related to the drug comedown and more negative drug experiences. Just as *Jam* tailors its sound mix to tap into ambient mixes and late-night listening, its drugged aesthetics also tap into late-night/early-morning comedowns; its bleak atmosphere reflects some

of the more negative comedown experiences, both the loss of euphoria and energy and also the commonly felt sensations of paranoia of some users. The former state, in which energy levels lower and perceptions are dulled, is evident in the programme as a whole, in particular through its ambient nature and frequently measured, distanced performances.

In addition to recreating a drugged ambience, *Jam* incorporates a satirical dimension. Paranoia was one of the negative effects of drug-taking commonly highlighted in mainstream media coverage. When the British mainstream media began to document rave and club cultures, they often focused on drugs in a sensationalist manner. Matthew Collin has noted that the summer of 1988 saw the first wave of media hysteria in response to the growth of acid-house parties.[29] In June 1988, the first 'ecstasy death' was reported in the tabloids: twenty-two-year-old Ian Larcombe reportedly swallowed a bag of eighteen tablets and suffered a fatal heart attack.[30] This set in motion a moral panic. Vernon Coleman, medical correspondent for the *Sun*, warned that ecstasy is a 'danger drug that is sweeping the discos and ruining lives'. He further warned potential users of the drug:

> You will hallucinate. For example, if you don't like spiders you'll start seeing giant ones … . There's a good chance you'll end up in a mental hospital for life … . If you're young enough there's a good chance you'll be sexually assaulted while under the influence. You may not even know until a few days later.[31]

Written at a time when there was not a great deal of evidence about the effects of MDMA, this was a typically exaggerated tabloid report, the kind that Morris had so mercilessly satirised in his previous work (of course, hysteria around drugs more generally was the theme of a *Brass Eye* episode).[32] Such hysteria would increase throughout the 90s, with the most publicised 'ecstasy death' occurring in 1995 when Leah Betts died after taking two tablets at a club. A controversially emotive photograph of Betts in a coma was widely circulated in the tabloids and her image was eventually used in government-backed, anti-drugs posters with the headline: 'Sorted: Just One Ecstasy Tablet Took Leah Betts.' This was typical of the reductive ways in which such deaths were exploited by the press, as it ignored the more complex reasons for Betts's death.[33]

If Morris had earlier lampooned media panic through parodying its language, in *Jam*, he at times created environments that existed only in segments of the British media's imagination. For example, in the introductory 'welcome' sketch in the very first episode, a female dancer (Amelia Bullmore) is presented in medium close-up: she is dancing energetically to a steady 4/4 techno pulse and is obviously meant to recall a drugged-up raver, a point emphasised by the spoken narration – 'When dancing, lost in techno trance, arms flailing, gawky Bez …'.[34] As the sequence progresses, however, we realise that the dancer is not in a club, but in a hospital, 'jazzing to the beep tone of a life support machine … that marks the steady fading, of your day-old baby daughter'. This sequence can be considered a satirical play on the types of hysterical stories peddled by sections of the media; in fact it is not too far removed from the previously quoted scare story printed in the *Sun* (there aren't any sketches in *Jam* which portray giant spiders but there is a sketch in which lizards emerge from a couple's television set!)

Jam contains other satirical sketches, which draw upon contemporary fears propagated by the media. Fears over healthcare in particular inform several sketches: there are recurring doctor sketches, in which a doctor behaves entirely inappropriately (for example, continually interrupting a discussion with a patient to have phone sex [episode two]; inspecting a patient's penis size for a head complaint and then asking him to jump up and down [episode three]), and various sketches are set in hospitals (such as 'symptomless coma' [episode one], or the sketch in which a midwife neglects her duties and offers sex to the father-to-be [episode two]). Such material again relates to fears being propagated in the media following a series of high-profile scandals in the 1990s.[35] Parenting is another prominent theme which recurs in *Jam* sketches, and this relates to material that Morris has become well known for addressing through the controversial *Brass Eye* Special on paedophilia which would follow in 2001. Many of the issues he confronted in that infamous programme can also be found in *Jam*: in particular, the sexualisation of children (e.g., the sketch in which a young daughter has had an operation to equip her with testicles because her parents think she is a forty-five-year-old man trapped in a young girl's body [episode six]); middle-class parents' obsession with getting their children into a good school (addressed in the sketch where parents get other children hooked on drugs and alcohol so as to sully their reputations [episode three]); over- and under-responsive parenting (the previously mentioned sketch in which parents get their son to have sex with a man so as to lessen his chances of becoming gay; a sketch in which parents barely register that their child has been abducted and then murdered [episode five]); and the particularly controversial material exploring parental responses to child death (the baby plumber sketch [episode 2]; two sketches featuring coffins for miscarried foetuses [episodes three and four]).

Yet even though the satirical elements of *Jam* relate to the types of humour found in *The Day Today* (BBC 2, 1994) and *Brass Eye*, the mode of satire is slightly different from that in Morris's previous work because he combines satirical observations with experiential aesthetics. There is a push and pull between feeling and experiencing the dreadful, nightmarish atmosphere of the programme, and commenting on social and cultural trends and how they are filtered through particular media. If *The Day Today* and *Brass Eye* satirise media presentation through (largely) simulating a particular programme mode – television news and current affairs – *Jam* feels more diffuse, mimicking as it does a range of different televisual images.

Digital Images

Jam abounds with different types of images. There are constant shifts throughout the programme between full-frame and widescreen frames; visual quality contrasts greatly from grainy and blurred, to more painterly, abstract compositions; black-and-white footage often punctuates a predominantly coloured palette; image motion is frequently manipulated, particularly through being slowed down. In the 'remix' programme *Jaaaaam*, such visual experimentation is extended and pushed to abstract extremes, incorporating techniques such as rotoscoping.[36] This remix again relates to music culture, with Morris providing the original material to a company (Aldis Animation) to remix in a similar manner to how music tracks

are sent to musicians and producers to create new versions.[37] For a comedy programme, such visual experimentation was rather unusual, though it did extend *Blue Jam*'s emphasis on audio manipulation into the visual domain.

Within the visual arts, the abstract image has, historically, been linked to self-reflexive explorations of the artist's medium. Art critic and Abstract Expressionism advocate Clement Greenberg wrote in 1939 that abstraction in modern art marked the artists' movement away from concrete representation toward a focus 'upon the medium of his own craft'.[38] Emerging from entirely different institutions and traditions than the modern art that Greenberg was discussing, *Jam* nevertheless shares this turn towards abstraction and self-referentiality in television comedy. Reflexivity in *Jam* can be categorised into three major types, in which the following forms are interrogated:

1 Digital images in general.
2 Television comedy.
3 The changing nature of television images.

I'll consider the first two in this section, before moving onto the third point in more detail in the next section.

The playful experimentation with images in *Jam* is a formal technique made possible by digital technology, but it also comments on image technologies more generally. As *Jam* was a relatively low-budget television programme, reasonably cheap digital cameras and post-production editing equipment enabled Morris and his team to create numerous effects. The ease with which image and sound can now be manipulated draws attention to a feature that many commentators consider to be a crucial aspect of digital media: *variability*. In comparison to analogue media, the algorithmic substratum of digital media enables media objects to be modified with relative ease; consequently the new media object, according to Lev Manovich, becomes less fixed, typically giving 'rise to many different versions'.[39] Manovich goes on to discuss how digital technology has affected cinema – many of his points can also be applied to television – arguing that it moves it much closer to painting:

> If live-action footage were left intact in traditional filmmaking, now it functions as raw material for further compositing, animating, and morphing. As a result, while retaining the visual realism unique to the photographic process, film obtains a plasticity that was previously only possible in painting or animation.[40]

While objections may be raised about Manovich's tendency towards essentialism in his distinctions between analogue and digital cinema, his general points about the possibilities of manipulating the film image in a manner more akin to painting are sound. In *Jam*, Morris and his team certainly seem to explore the new plasticity of the digital image in a manner unusual for television at this time, while the remix *Jaaaaam* further attests to the increased variability of digital media objects.

I have already mentioned connections to visual music experiments, yet the experimentation contained in *Jam* – in addition to its often controversial content – can also be linked

to more recent and more specifically televisual modes of avant-garde practice. The screen-ing of avant-garde film and video has historically been extremely limited on UK television. The advent of Channel 4 in 1982 – the first new terrestrial channel in the UK since BBC 2 launched in 1964 – temporarily offered artist film-makers spaces to produce experimental work for the screen, though by the 1990s such exposure was becoming more difficult as Channel 4 had to adapt to increasing commercial pressures.[41] Much of this was critical of the medium of television. Antagonism towards the medium was evident in earlier artists' work which found its way onto the schedules; in particular David Hall's television 'Interruptions' pieces (1971), made for Scottish Television, were an important precedent. Hall made ten short pieces which were scheduled between programmes unannounced and which were designed to 'worry the borders of televisual language and its preconceptions'.[42] Much artist video work appearing on television in the 1980s shared this critical stance; though it took many different forms, there was a strain that experimented with the visual nature of video and created works that were unusual by television's standards. These include George Snow's *Muybridge Revisited* (Channel 4, 1988), which combined colour manipulation and animation; David Larcher's *Granny Is* (Channel 4, 1990), which created complex, layered surfaces combining live action and animation; and Tom Phillips and Peter Greenaway's *A TV Dante* (Channel 4, 1989), which experimented extensively with video imagery, particularly through its composite layering of images.

While these video pieces stemmed from very different contexts and traditions, they share with Morris's oeuvre an experimental interrogation of, and critical intervention into, the medium. *Jam* is arguably Morris's most experimental audiovisual production and the clos-est he's come to avant-garde. Yet, much like his previous work, it still places itself within estab-lished conventions of television comedy. Morris's work in both *The Day Today* and *Brass Eye* was, of course, firmly placed in the traditions of media satire but it experimented with this televisual mode and, as Mills has argued, pushed its conventions 'into new configurations'.[43] *Jam* operates similarly within the traditions of the comedy sketch show (while also retaining the satirical dimensions of previous work). The sketch show itself is quite a rigid mode of pro-gramming in which disparate sketches are presented in succession, sometimes with recur-ring characters and often ranging in length from a few seconds to four or five minutes. The nature of the sketches themselves can vary, though political issues and social mores are com-monly addressed within the format.[44] As satire is often a component of the sketch show, and as the format itself has connections to the musical mixtape, it may have appealed to Morris as a format through which he could experiment with ambient mixing while retaining his crit-ical, satirical voice.

Despite the conventional nature of much television sketch comedy, there have been some notable attempts to experiment and innovate with the form, stretching back to the pioneering work of *Monty Python's Flying Circus* (BBC 1/BBC 2, 1969–74). *Python* adopted a particularly self-reflexive position towards both comedy material and the conventions of broadcasting itself through techniques such as disrupting sketches to comment upon them and parodying the conventions of different modes of television (such as reportage or the quiz show).[45] It has also been considered innovative because of how it connects disparate sketch items, not only via links between sketches but also by the concept of 'flow', with 'one

thing leading to another by association of ideas'.[46] While *Jam* is very different from *Monty Python's Flying Circus* in many ways, these overarching similarities importantly link the shows. Both *Python* and *Jam* have been regularly considered surreal sketch shows, too, and this was also a category that was often applied to the work of Reeves and Mortimer in shows such as *The Smell of Reeves and Mortimer* (BBC 2, 1993–5). While Reeves and Mortimer's sketch-based surrealism is more firmly rooted in vaudeville than Morris's work, the more light-hearted moments of *Jam* – which I will come back to – are somewhat similar in tone.[47]

More recently, there has been the subtle innovation of *The Fast Show* (BBC 2, 1994–7) and *Big Train* (BBC 2, 1998–2002), in which existing conventions are tweaked. Morris was a script consultant and occasional director on the latter, which also featured many actors who would appear in *Jam*. *The League of Gentlemen* (BBC 2, 1999–2002) is also worth mentioning because of its particularly macabre content. *Jam* extends the experimentation and pushing of taboos set in place by such precedents through heightening the formal play with sounds and images, and by pushing the controversial nature of the comedy material into particularly uncomfortable directions. Comparing two notoriously dark sketches concerning child death from *The League of Gentleman* and *Jam*, Leon Hunt argues that the *Jam* sketch 'is more disturbing, and there's a sense that it's quite prepared not to be funny'.[48] *Jam* experiments with tone and form to such a degree that many sketches may not even be recognisable as comedy. Nevertheless, while Hunt rightly notes that *Jam* strips comedic markers – such as the laugh track – to a degree that *The League of Gentlemen* doesn't, I do think that the actual sketch-show format and the fact that it was scheduled in a broader comedy slot influence the programme's identity as a comedy. Some of the sketches are also more obviously marked as comedy through their connections to comic traditions: the recurring doctor sketches, for example, take the traditional 'doctor, doctor' gag template and push it into perverse and surreal directions. All these factors act as 'metacues' – particular codes and conventions – which are signals that encourage people to interpret certain material *as* comedy (Morris's increasing profile would have been another comic metacue for those who were already familiar with his work). Brett Mills has argued that such signals 'are necessary partly because humour works more effectively when its intention to be funny is unambiguous. However, their presence is also representative of the need to distinguish between seriousness and humour as clearly as possible'.[49] *Jam* thus signals its position as comedy, even if it does then complicate its own status through presenting material not usually considered funny.

Reality Screens

The third category of reflexivity in *Jam* – the changing nature of television images – is where the programme most consistently reflects upon the functions and status of images. The 1990s has seen the proliferation of screens across different areas of society. Anne Friedberg, writing not long after *Jam* was first transmitted, noted that 'a variety of screens – long and wide and square, large and small, composed of grains, composed of pixels – competes for our attention without any convincing arguments about hegemony'.[50] This process also

Simulation of hidden camera
device in the Lucy Tiseman
sketch

impacted upon the changing nature of the television screen itself; in particular, so-called 'ama-
teur' footage (from personal camcorders) and CCTV images became prevalent on televi-
sion. Jon Dovey has argued that, from the 1990s, television was host to a 'sudden viral
contamination by camcorder and surveillance footage'.[51] These developments reflect how
citizens were increasingly likely to have their own forms captured by moving-image tech-
nologies both consciously (camcorders, webcams) and unawares (CCTV cameras, hidden
cameras). As television incorporated increasing amounts of citizen-generated footage, it was
also – like CCTV – expanding the surveillance of citizens with its own cameras as 'reality tel-
evision' grew in popularity.

The latter development was reflected in *Jam* in that many of the sketches are set up as
though they were isolated fragments plucked from documentary programming featuring
'ordinary' citizens. In the first episode, for example, four of the sketches (constituting around
a third of the programme) are framed as though they are part of a documentary or current
affairs item, with people talking to the camera as though being interviewed: the man who
decides to marry himself; the agency that hires thick people to win arguments; the man who
repeatedly jumps off a first-floor balcony; and the doctor who treats 'symptomless coma'.
And this is a technique that is featured in all six episodes. These four sketches are also typi-
cal of the series as a whole in that they all combine these talking-heads sequences with other
types of footage – in these cases CCTV footage and camcorder footage. By combining dif-
ferent types of images in this manner, there is a continued emphasis throughout *Jam* on real-
ity television and how it has both instituted, and incorporated, an increasingly diverse
selection of images centred on 'ordinary' citizens. In episode four, there is even the simula-
tion of a hidden camera – another prominent feature of documentary television of the
period – as Lucy Tiseman (Davis) films herself entrapping potential friends through a camera
hidden in her bag.

In many sketches, CCTV and camcorder imagery are mixed with framing shots of talking
heads discussing an issue, thus mimicking prominent documentary codes. In such sketches,

the CCTV and camcorder footage is differentiated from the framing discussions via image quality – the chief markers of status in these images are the low-resolution, black-and-white CCTV images and the low-resolution, hand-held shakiness of the camcorder footage. Framed as past events within the actual sketches, these seem to denote a closer relationship to unadorned reality than the framing sequences, which narrativise and make sense of this raw material.

Examining CCTV images in crime programmes, Deborah Jermyn has argued that 'the primary appeal of CCTV is very much historically evident in longstanding cultural discourses celebrating "actuality"'.[52] She contends that such images have become part of a 'spectacle of actuality'; while they do not provide spectacle in terms of special effects, they offer spectacle through their privileged relation to the 'real', so that viewers witness reality unfolding. Norris and Armstrong have argued that it is the prevalence of CCTV imagery on television that has helped to normalise its presence as a social staple and also reinforced its rarely questioned relationship to 'truth'.[53] *Jam* was made at the end of a decade that saw a huge increase of CCTV systems; by 1995, 78 per cent of the Home Office budget for crime prevention was spent on funding schemes to install CCTV in public places.[54]

The technique of constructing many sketches approving different types of reality programming continues Morris's previous – more explicit – interrogation of televisual form in *The Day Today* and *Brass Eye*. Here, though, it is more subtle because these elements are encased within a sketch-show format (and one whose ambient characteristics also may divert attention from its more satirical intentions). Nevertheless, it continues the rather critical, questioning line of those former programmes. *Jam*'s variety of filming techniques draws attention to the ways in which television was becoming host to a greater diversity of images, including the low-resolution ones associated with actuality and more painterly images, which overtly signal their manipulated status. As such, it implicitly drew attention – via the technique of juxtaposition – to how 'actuality' images can be simulated, despite the fact that they often signal unadorned 'reality' when used in television.[55]

The use of such images in *Jam* also critiques the often sensationalist and voyeuristic ways they are used in television. Sensationalism is particularly evident in programmes that display home video and CCTV footage of disasters or accidents. Jon Dovey argues that such programmes move away from traditional modes of documentary programming – which commonly used moving images to support an argument or narrative – in that they use images as the *raison d'être* around which the narrative is constructed:

> The voyeuristic gaze threatens to overwhelm the narrative structure of the conventional documentary. The video clip is more reality fetish than evidence, as it is replayed over and over, slowed down, grabbed, processed, de- and re-constructed for our entertainment and horror.[56]

Sensationalist moving images were also finding their way onto the web when *Jam* went into production, including among others, pornography, unregulated by the broadcasting industry. Such sensational imagery could also be found in more routine settings, as exemplified by *JenniCam* and related lifecasts. The most famous early example of self-surveillance on the web, *JenniCam* was a (mostly) continuous lifecast from the room of then student Jennifer

Ringley. Started in 1996, the website gained huge attention and popularity; while it was notable for featuring nudity and sexual activity, such moments were presented as part of Ringley's everyday life and punctuated more mundane moments. *Jam* incorporates imagery suggestive of prominent audiovisual trends on the web around the late 1990s. For example, the sketch featuring a man and woman engaging in bizarre, extreme sexual acts (episode six) not only parodies pornographic amateur video in terms of content – the man sticks his balls up the woman's nose and ends up shooting his leg off – but also through how it is presented: there is a camera (possibly a webcam) nestled on the actual bed, displaying a grainy, motion-lagged image whose jagged positioning on the bed reveals only vague glimpses of the figures.

Shutter lag was a particular problem with early digital cameras, including webcams, particularly those at the lower end of the market. Early webcasting was also marked by motion disruption: *JenniCam*, for example, refreshed every three minutes when it first started and the breaking up of moving images via media streams would have been continual issues until the widespread adoption of broadband in the 2000s. Motion lag and disruption frequently feature in *Jam*: many of the doctor sketches are either slowed down or feature slightly jagged motion effects, while the 'Noddy' sketch (episode two) is presented as a montage of still images, thus recalling the slow frame-refresh rate of early webcams.

The mixture of mundane and sensationalist content in both reality-based programming and livecasting is also reflected in *Jam*. While the majority of the sketches pounce upon sensationalist trends and distort them through extreme and grotesque filters, these are also mixed with more innocuous material, such as the recurring 'Mr. Bentham' sketches. These sketches involve a man (Bentham) arriving at a building, sitting in a waiting room and then visiting a consultant to gain advice. The sketches are marked by a distanced aesthetic: the space between the receptionist (Julia Davis) at the far end of the room and Bentham (Mark Heap) is distorted through a wide-angle lens and saturated light from the window behind the receptionist contributes to a mysterious and slightly foreboding atmosphere. Yet the mysterious, distanced nature of the sketches – compounded by Bentham's barely intelligible nervous mumbling in the waiting room – is bathetically deflated when Bentham finally meets an advisor and receives guidance on the most minor of issues (for example, advice on what to do on a Saturday night). In the context of the programme, these sketches at first seem to be heading towards uncomfortable territory, yet they ultimately provide light relief from the bleakness characterising the majority of *Jam* material; this is underlined by the light music loop playing throughout these sketches, a manipulated sample from Jim Reeves's 'He'll Have to Go' (1959). Though this is the most obvious example of a recurrent sketch providing light relief from the more extreme elements of the programme, there are a few other instances (such as the man whose car is crushed into a Noddy-sized vehicle [episode one] and the Range Rover covered with urinals [episode five]). Additionally, some sketches – in a kind of reversal of the Bentham sketch – present perverse material in a more light-hearted style: examples here include the sketch in which a police search is interrupted by a gaudily dressed woman and a man in bondage underwear who cavort through the woods to the sounds of Piero Umiliani's 'Mah Na Mah Na' (1968) (which would have been recognisable from its use in *The Muppet Show* [CBS, 1976–81]); and the piece (featuring the same actors) where a woman flagellates a man in bondage gear with a spacehopper, accompanied by Minnie

Riperton's 'Lovin' You' (1975). Both these sketches again play with tone and sequence in order to provide surprise and variation in a manner that still connects (either stylistically or thematically) to other sketches. The tone of both of these sketches is highly dependent on the music tracks used, both of which had already been famously recontextualised: the former through its use in family entertainment programming (it was originally used in an Italian *mondo* film), the latter through its use in The Orb's 'A Huge Ever Growing Pulsating Brain That Rules from the Centre of the Ultraworld' (1989).[57] As such, they hint at the variability which is so crucial to digital culture and to *Jam* as a whole.

Conclusion

The lighter material discussed above can be seen as another way in which *Jam* signals itself as comedy; such sketches not only provide light relief from the more nightmarish moments but also act as metacues to reinforce the comic identity of the programme. This comic identity is important, for it sets up expectations and then challenges them, daring to make people feel uncomfortable. This identity is also a crucial factor in assessing how Morris has experimented with the television sketch show, which he does to an unusual degree. In fact I would argue that it is one of the most experimental television sketch programmes in the history of British television, challenged perhaps only by the aforementioned *Monty Python's Flying Circus*. There were, in addition to the earlier programmes discussed, other comedy shows made either around the same time or after *Jam* which can nevertheless be related to it in various ways. For example, the use of the mixtape format – with music creating a segued flow – was also evident, at times, in *Trigger Happy TV* (2000–3), which first screened on Channel 4 only a month before *Jam*'s maiden broadcast. That show did not, however, sequence its musical tracks into a continuous mix as in *Jam*, neither did it create a blend of music/dialogue in ways that sometimes blurred foreground and background distinctions on the soundtrack (when music occurs in *Trigger Happy TV*, it is usually at the expense of dialogue). The types of music were slightly different, too: whereas *Jam* opted for a sonic palette chiefly characterised by forms of electronic dance music, *Trigger Happy*'s selections were often (though not always) from 'indie guitar' bands. Further, *Trigger Happy TV* shared with *Jam* a filmed aesthetic which borrowed from documentaries and reality television; yet whereas *Jam* created simulations of a variety of different reality-television techniques, *Trigger Happy TV* used actual hidden cameras so that the comedy often arose from an unaware public's reactions to Dom Joly's pranks. Connections to other comedy programmes can also be made: the very dark humour of *Jam* was extended into sitcom format in Julia Davis's *Nighty Night* (BBC 2, 2004–5), as well as Davis's and Jessica Hynes's television pilot *Lizzie and Sarah* (BBC 2, 2010), though without the experimental format; dark, controversial material (and a prominent music track) was also evident in the animated sketch show *Monkey Dust* (BBC 3, 2003–5); while the incorporation of documentary-style techniques within comedy – dubbed 'comedy vérité' by Brett Mills[58] – began to increase in the early 2000s with sitcoms such as *The Office* (BBC 2/BBC 1, 2001–3), *Marion and Geoff* (BBC 2, 2000–3), and – again featuring Julia Davis (with Rob Brydon) and including some rather bleak material – *Human Remains* (BBC 2, 2000).

If *Jam* were placed in the context of comedy and scheduled as such, its comic identity was not so rigid that it would not fit other contexts. It could also be classified as a horror programme, an experimental programme or a music programme. The scheduling of the remix version, *Jaaaaam*, would seem to place it more firmly in the experimental and music categories: rather than being sandwiched between comedy slots, *Jaaaaam* would have nestled in a range of programmes primarily aimed at capturing the post-pub and post-club crowd. This scheduling would have undoubtedly been influenced by its relation to club culture, and it was no surprise that the 4Later slot included several music shows: an example is *The Trip* (1999–2001), which overlaid NASA space footage with a selection of dance music tracks. Various dance releases had used the idea of the journey as a drug metaphor (i.e. taking a 'mental trip'), including The KLF's *Chill Out* (which was conceptually based around a car journey from Texas to Oklahoma); while space imagery was also prominently related to drug experiences through the linking of outer- and inner-space exploration. *Jaaaaam*, then, would have fitted neatly into this post-club slot because of its druggy aesthetics and dance music. How its nightmarish, bad-trip vibes would have been received at the time is open to question, though it demonstrates how Morris's work has often been embraced by niche music cultures. Coming from a background in DJing, this is perhaps no surprise, and Morris has encouraged this through not only providing a number of interviews to the music press (particularly *NME* and the now-defunct *Melody Maker*), but also through the material he has produced and his relations with Warp Records.[59] And yet, despite his continuing relationship with Warp, subsequent work by Morris has not quite tapped into music culture in the same way as *Jam* and its remix *Jaaaaam* did, just as it has not extended further the experimental aesthetics of that programme. While *Jam* can be firmly linked to Morris's other work through its satirical dimensions, risqué material and key collaborators, it still stands – along with its radio ancestor – as a rather unique programme in his wider oeuvre.

Notes

1. The programme did, nevertheless, receive complaints and was partially rebuked by the Broadcasting Standards Committee. Compared to the furore over *Brass Eye*, however, these were not subject to the same level of media scrutiny. See Unknown Author, 'Channel 4 Rebuked for Chris Morris Show', *Broadcast* (6 October 2000), <http://www.broadcastnow.co.uk/channel-4-rebuked-for-chris-morris-show/1202631.article>.
2. Only five episodes of *Jaaaaam* were screened, however. According to *Cook'd and Bomb'd*, this was because of a dispute over including excised material from *Jam* for episode five of *Jaaaaam*. As such, episode six of *Jaaaaam* was shown when episode five was due to be shown. Episode five of *Jam* was shown in the last slot of *Jaaaaam*, which meant that episode five of *Jaaaaam* was never transmitted. All episodes of *Jaaaaam* can, however, be seen on the *Jam* DVD, <http://www.cookdandbombd.co.uk/forums/index.php?PHPSESSID=7f39babb420df1edb896de70cec20da6&page=jam>.
3. Channel 4 Press pack published to mark Channel 4's twenty-year anniversary (2002), <http://www.channel4.com/media/documents/corporate/foi-docs/4_at_20.pdf.>.

4. Robert Hanks, 'The Distorted World of Chris Morris', *Independent* (20 April 2000), <http://www.cookdandbombd.co.uk/forums/index.php?page=cabkbarticle&id=122..>

5. He had previously directed the pilot of *Big Train* (BBC 2, 1998–2002) as well as occasional sketch material for that series.

6. Some of these can be found on the Chris Morris-related forums hosted by *Cook'd and Bomb'd*, <http://www.cookdandbombd.co.uk>.

7. Not all sketches in *Jam* had appeared in *Blue Jam* although the majority of them had. Only a small percentage of sketches from *Blue Jam* appeared in *Jam* as the radio version was three series of six hour-long episodes, whereas the television version contained only one series of six half-hour episodes.

8. Reprinted in Brian Eno, 'Ambient Music', in Christoph Cox and Daniel Warner (eds), *Audio Culture: Readings in Modern Music* (New York: Continuum, 2004), pp. 96–7.

9. Ibid., p. 97.

10. David Toop, *Ocean of Sound: Aether Talk, Ambient Sound and Imaginary Worlds* (London: Serpent's Tail, 1995), p. 44.

11. Series one, episode one of *Blue Jam* featured two tracks from The KLF's *Chill Out* (1990): 'Pulling out of Ricardo and the Dusk Is Falling Fast' and 'Brownsville Turnaround on the Tex-Mex Border'.

12. *Chill Out* was followed by The Orb's influential ambient house long player, *Adventures beyond the Ultraworld* (1991). Both these records were closely connected: Jimmy Cauty from The KLF was a member of The Orb and contributed to tracks on *Adventures beyond the Ultraworld* before leaving in 1990, while Paterson played on the *Chill Out* sessions. Paterson did not want to be too closely identified with The KLF, which further led to his contributions to The KLF's *Space* (1990) album being excised by Cauty (and which is sometimes referred to as a solo record by Cauty).

13. Controversial in particular because of extensive samples of Abba's 'Dancing Queen' (1976) on the track 'The Queen and I'. Copies of the album were eventually withdrawn and a 12" version of the album minus samples was released as *The JAMs 45 Edits* later in 1987 (which provided advice on how listeners could add their own samples).

14. Lucian Randall, *Disgusting Bliss: The Brass Eye of Chris Morris* (London: Simon and Schuster, 2010), p. 35.

15. Eno, 'Ambient Music', p. 97.

16. Ben Highmore, *Everyday Life and Cultural Theory* (London and New York: Routledge, 2002), p. 51.

17. *TV Times* (18–24 March 2000), p. 83.

18. Kevin Martin, 'Fantastic Voyage – A Personal Take', liner notes to *Ambient 4: Isolationism* CD (Virgin, 1994).

19. A few tracks from Aphex Twin's *Selected Ambient Works Volume 2* were used (all the tracks on this release are untitled), while Eno's 'An Ending (Ascent)' (1983), 'Thursday Afternoon' (1985) and 'Deep Blue Day' (1983) also featured.

20. Another record label whose artists feature in *Jam* is Ninja Tune: Amon Tobin, Coldcut and Funki Porcini. Morris collaborated with Ninja Tune artist Amon Tobin on a track entitled 'Bad Sex', which was released as the B-side of Tobin's 2000 single 'Slowly'.

21. Morris would have certainly been familiar with Lynch's work: he had already used Peter Ivers's 'In Heaven (The Lady in the Radiator Song)' – which first featured in *Eraserhead* – in *Blue Jam*.

22. Aphex Twin had increasingly begun to incorporate a form of grotesque humour into his work in the late 1990s. On the EP of *Girl/Boy*, he included a track entitled 'Milkman', which features the lyrics 'I would like some milk from the milkman's wife's tits' sung through a ring modulator. *Come to Daddy* (1997) featured the track 'Funny Little Man', which is discussed in Hand and Dean's chapter in this volume.

23. Richard E. Cytowic and David M. Eagleman, *Wednesday Is Indigo Blue: Discovering the Brain of Synesthesia* (Cambridge, MA: MIT Press, 2009), p. 309.

24. Cretien van Campen, *The Hidden Sense: Synesthesia in Art and Science* (Cambridge, MA: MIT Press, 2008), p. 111.

25. P. Adams Sitney, 'Interview with Harry Smith', *Film Culture* no. 37 (Summer 1965), p. 5.

26. Harry M. Benshoff, 'The Short-lived Life of the Hollywood LSD Film', *Velvet Light Trap* no. 47 (Spring 2007), p. 31. Examples of such films include *The Trip* (1967), *Head* (1968) and *2001: A Space Odyssey* (1968), though the latter was not deliberately created as an LSD film.

27. Simon Reynolds, *Energy Flash: A Journey through Rave and Dance Culture* (London: Picador, 1998), p. xxvi.

28. Sadie Plant, *Writing on Drugs* (London: Faber and Faber, 1999), p. 166.

29. Matthew Collin, *Altered State: The Story of Ecstasy Culture and Acid House* (London: Serpent's Tail, 1997).

30. Ibid., p. 77.

31. Ibid.

32. *Brass Eye*, episode two ('Drugs').

33. It was eventually confirmed that her death resulted from drinking too much water in a short space of time after taking the tablet.

34. For those not familiar with Bez: he was the dancer in The Happy Mondays and was usually associated with drugs as he would talk freely about his drug-taking, while his dancing was usually considered to be spasmodic and 'druggy'.

35. These include the case of Beverley Allitt, a nurse who was convicted in 1993 of murdering four children (and attempting to murder, as well as harm, others) on the children's ward at Grantham and Kesteven Hospital between February and April 1991; the child heart operation scandal at the Royal Bristol Infirmary, in which a number of children died from open-heart surgery between 1984–95; and – most notoriously – the murders committed by Dr Harold Shipman, who was arrested in 1998 and eventually imprisoned for killing fifteen of his patients (though it is widely thought that he killed many more).

36. It should be noted that *Jaaaaam* also further experiments with sound (in one of the doctor sketches, for example, sound slips out of synch with the image significantly), though the visuals are remixed to a greater degree.

37. Aldis Animation actually won a Best Television Graphics Award at the BBC 2 Awards for this remix (Aries Brooker was the main artist). See Unknown Author, 'Aldis Wins BBC2 Graphics Award for Jaaaaam', *Broadcast* (17 November 2000).

38. Clement Greenberg, 'Avant-Garde and Kitsch', in Greenberg, *Collected Essays and Criticism : Vol.1, Perceptions and Judgments 1939–1944* (Chicago, IL: University of Chicago Press, 1986), p. 9.

39. Lev Manovich, *The Language of New Media* (Cambridge, MA: MIT Press, 2001), p. 36.

40. Ibid., p. 301.

41. Channel 4 began broadcasting in 1982 and was radically different to the existing channels because of its remit to appeal to tastes and interests not generally catered for, and to experiment and challenge. Although financed by advertising, ITV companies subscribed a percentage on net advertising revenues, which gave the channel an unprecedented degree of creative freedom. Under the 1990 Broadcasting Act the channel had to sell its own advertisement space, which directly linked the programmes that it made to commercial interests.

42. Hall cited in Catherine Elwes, *Video Art: A Guided Tour* (London and New York: I. B. Tauris, 2005), p. 120.

43. Brett Mills, "'Yes, It's War!'": Chris Morris and Comedy's Representational Strategies', in Laura Mulvey and Jamie Sexton (eds), *Experimental British Television* (Manchester: Manchester University Press, 2008), p. 191.

44. Ian Mowatt, 'Analysing *Little Britain* as a Sketch Show', in Sharon Lockyer (ed.), *Reading* Little Britain: *Comedy Matters on Contemporary Television* (London and New York: I. B. Tauris), p. 20.

45. Steve Neale and Frank Krutnik, *Popular Film and Television Comedy* (London and New York: Routledge, 1990), pp. 196–208.

46. Terry Jones quoted in Leon Hunt, *The League of Gentlemen* (London: BFI, 2008), p. 16.

47. There are also more literary surrealist influences apparent, particularly in the opening monologues in *Jam*, such as Lewis Carroll, which are mentioned in Hand and Dean's chapter. (Carroll was not a surrealist but was, importantly, a huge influence on the surrealist movement.)

48. Hunt, *The League of Gentlemen*, p. 31.

49. Brett Mills, 'Comedy Vérité: Contemporary Sitcom Form', *Screen* vol. 45 no. 1 (Spring 2004), p. 67.

50. Anne Friedberg, 'CD and DVD', in Dan Harries (ed.), *The New Media Book* (London: BFI, 2002), p. 30.

51. Jon Dovey, *Freakshow: First-person Media and Factual Television* (London: Pluto Press, 2000), p. 57.

52. Deborah Jermyn, *Crime Watching: Investigating Real Crime TV* (London and New York: I. B. Tauris, 2006), p. 112.

53. Clive Norris and Gary Armstrong, *The Maximum Surveillance Society: The Rise of CCTV* (Oxford and New York: Berg, 1999), p. 55.

54. Ibid., p. 54.

55. This was a period in which CCTV and amateur images were being consolidated as authentic 'reality markers' but the emergence of digital photography and film-making was leading some critics and theorists to bemoan film's waning relationship to 'indexical reality'. For an example of the latter argument, see Dai Vaughan, 'From Today, Cinema Is Dead', in Vaughn (ed.), *For Documentary: Twelve Essays* (Berkeley: University of California Press, 1999), pp. 181–92.

56. Dovey, *Freakshow*, p. 59. Dovey mentions the programmes *Caught on Camera* (ITV, 1994), *Disaster* (BBC, 1998–9) as examples of the sensationalist documentary.

57. Riperton's estate forced them to remove the sample, so only initial pressings of the single featured her singing. Later pressings featured a soundalike singer voicing the song.

58. Mills, 'Comedy Vérité'.

59. It is also worth mentioning that figures from the music press – such as David Quantick and Steven Wells, both of whom worked as music journalists for the *NME* – worked on *On the Hour* (BBC Radio 4, 1991–2) and *The Day Today*, while Quantick continued to work with Morris on *Brass Eye*, *Blue Jam* and *Jam*.

10

I REMAIN, SIR, DISGUSTED OF AMERICA. 'MORRIUCCI' AND 9/11: 'AN ABSOLUTE ATROCITY SPECIAL'[1]

DAVID WALTON

Introduction. The Split Subject: Morriucci

On 17 March 2002 Armando Iannucci and Chris Morris published 'Six Months That Changed a Year: An Absolute Atrocity Special', a spoof article on the events of 11 September 2001 printed in Britain in the Sunday newspaper the *Observer*. This was only six months after the tragic events summed up by the cipher '9/11'. That it was destined to receive hostile reviews can be gleaned from the opening lines which read:

> The planes strike – as Martin Amis memorably describes them – 'sleeking in like harsh metal ducklings'. Tony Blair publicly drains every drop of blood from his wife to help the injured of New York. Taking his time, George W. Bush formulates a measured response … which turns out to be the most expensive bollocking ever unleashed against shepherds. But are we starting to forget? Figures show that even as the second tower fell, people were switching off their televisions, complaining they'd seen it all before. Today in these pages, we help you make up your own mind about the absolute necessity of fighting the ongoing war that is Operation Improving Bloodbath.[2]

Before I begin to put this into context, I want to reflect for a moment on contributing to a book dedicated to Chris Morris's work. To write about Chris Morris is like writing about Stuart Hall – the use of his proper name is, more often than not, a metonym for collaborative work with others – something that complicates any study dedicated to an assessment of Chris Morris's output. Without the necessity of any facile references to Lacanian psychoanalysis, Morris, as a satirist, is already a split subject which means the authorial 'subject' of this essay might as well be referred to as 'Morriucci'. (As this chapter is a part of a publication dedicated to Chris Morris, I use the term Morriucci rather than the equally relevant portmanteau form 'Ucciorris'.) As a piece of convenient shorthand I shall refer to the authors in this way just as I will, in another abbreviation, refer to the article as the 'Atrocity Special'.

 As many fans of Chris Morris and Armando Iannucci will know, the 'Atrocity Special' was not their only collaboration: they teamed up on other projects like the parodies of current

affairs programmes found in the radio broadcast *On the Hour* (BBC Radio 4, 1991–2) and its
television counterpart, *The Day Today* (BBC 2, 1994). Iannucci, of course, had worked inde-
pendently on the satirical television shows *The Saturday Night Armistice* (BBC 2), its 'Friday
night' and 'election' incarnations between 1995 and 1999, and Morris had already developed
his controversial 'mockumentary' techniques in pseudo-documentaries he had made for tel-
evision (see below). Nor was the 'Atrocity Special' the first time Morris had published spoof
articles in the *Observer*. His series of 'Second Class Male' and 'Time to Go' pieces of 1999
(both published under pseudonyms and presented as if they were genuine, and co-authored
with Robert Katz) parodied self-obsessed journalists and (in the case of 'Time to Go')
columns written by journalists like John Diamond relating their experiences with terminal ill-
nesses (only the Morris and Katz piece hinged on the journalist's planned suicide). All these
projects helped to set the general satirical (and sometimes surreal) tone for the 'Atrocity
Special', while building up both a loyal fan base (and groups of disgruntled critics) for the
Morriucci phenomenon.

At one point in the 'Atrocity Special', Noam Chomsky is made to say: 'If you run the twin
towers footage backwards, the towers stand up again – we need to ask why has the footage
only ever been run forwards?' This may serve as a model for the structure of this essay: I shall
start with the reception of the Morriucci piece and then work backwards from a consider-
ation of its impact (via readers' letters), to an analysis of the ideological climate in the months
following 9/11 before offering a close reading and critique of the 'Atrocity Special' itself. The
close reading will use concepts mainly taken from Barthes, Baudrillard and Brecht. In this
chapter, I generally refer to Morriucci's 'Atrocity Special' as satire but I would distance myself
from claiming that Morriucci set out with *only* satirical aims – Morris has often insisted on
the primary importance of humour and denied that his work is necessarily motivated by
satirical purposes. Thus, while insisting on satirical possibilities, I resist the reductive ploy of
reducing the 'Atrocity Special' to satirical intention (although it is worth noting that the read-
ers' editor of the *Observer* in 2002 referred to Morricucci as satirists, not a surprising appel-
lation given their previous output for British radio and television).[3]

Atrocity, Controversy and Deconstructive Manoeuvres

By the time Morriucci's 'Atrocity Special' was published, parts of the British public (aided and
abetted by the tabloids) had already been scandalised by many episodes of the satirical doc-
umentary series *Brass Eye* (which Morris penned with five other collaborators and which
appeared in 1997) and, just before 9/11, by the Special episode 'Paedogeddon' in July of
2001. According to the BBC, for that one special Channel 4 received a record 3,000 official
complaints,[4] Morris achieving cult status with those who celebrated the satirical and/or off-
the-wall experimental side of the 'humour'. Thus, when Morriucci published the 'Atrocity
Special' anything associated with Morris's name was likely to provoke controversy, heated dis-
cussions, rejection or enthusiastic acceptance. This is precisely what happened. To begin, I will
outline some of the responses in order to offer some contextualisation for the later sections
of this chapter.

It is perhaps not surprising that many of the negative reactions were from readers living in the US – of the 250 letters that the Readers' Editor received in the three weeks following the publication of the 'Atrocity Special', 178 were complaints.[5] The negative reactions were mainly structured around objections which saw the piece as pathetic, lacking in humour and 'human decency', in bad taste, callous, sickening, inhuman and 'silly and gratuitously insulting and disrespectful to the memory of those who died and those who mourn'.

Some of these reproaches did, however, accept that some criticism was justified for the way George W. Bush and his allies were handling the political and military situation in the wake of 9/11. However, one reader commented that American papers had never 'parodied the suffering of the British during the Blitz, or the IRA's attacks on innocent civilians' and another, in the spirit of the black humour found in the 'Atrocity Special', wrote that he really looked forward to 'Dachau – The Laughter Years'. Of course, this raises important and legitimate questions about the ethics of journalism and satire. However, my intention here is not to consider these moral questions but to discuss the ideological climate in which it was produced because, in doing so, it is possible to see how it was not just an arbitrary series of tasteless jokes but (at least to some degree) a response to the political climate and the media's handling of the events.

The positive letters (some of which were from the US) about the 'Atrocity Special' emphasised the need to puncture the 'self-righteous cant and hyperbole' surrounding the events and the crucial role satire could play in this. Others defined the piece as brave, incisive satire which was both hilarious and frightening and which exposed the 'cynical exploitation of 11 September for the benefit of American foreign policy'. Dissent was seen as vital to the prevailing political climate (Bush and Blair being targeted for bias) and one reader stressed that, despite the fact that innocent people were killed on 11 September, there were those who also reacted with horror when the Bush administration 'attacked and massacred innocent men, women and children'. In this way the Morriucci article 'summed up what the Americans were doing' and helped readers remember that 'many more innocent people were killed in brutal attacks on Afghanistan'.[6]

Thus, those expecting a representation of 9/11 to be a solemn in-depth analysis full of compassion for the victims encountered a disturbing parody, where the concept of 9/11 as tragedy was displaced and its meanings thrown into disarray. Morriucci could be said to have adopted a 'deconstructive manoeuvre', insofar as they challenged certain important oppositions.[7] Readers were confronted with light-hearted playfulness and mockery instead of solemnity, serious analysis and sympathy. The 'Atrocity Special' reversed all the usual privileged terms of reporting catastrophe so that the conventions of what is expected of 'serious' journalism were frustrated, thereby dislodging and freeing meanings from prevailing expectations (see below). Whereas the DVD of Morris's film *Four Lions* (2010) includes, in the bonus material, documentary interviews with Asian youths (which suggest that the director is concerned about the Asian community), the 'Atrocity Special' did not include anything that might palliate its possible (offensive) negative effects. But to answer why the piece may have deliberately sought to provoke readers, it is necessary to consider the ideological climate that was developing in the immediate months following 11 September.

Dixie Chicks, Ideology and Bushwhacking

Given that the 'Atrocity Special' was published only six months after the attacks, when feel-
ings were still running very high, Morriucci's satire was almost guaranteed to offend some
readers but its publication also coincided with an orchestrated effort by George W. Bush and
his administration (and its allies) to silence all criticisms of the US's handling of the events
and, particularly, of its foreign policy. To put this in Althusserian terms, this can be understood
to have taken place at both state and ideological levels.[8] As had been well documented at
the time by writers like Susan Sontag and Noam Chomsky,[9] at the level of oppressive state
apparatuses, the Bush administration threatened civil liberties and cynically exploited the fear
of terrorist attacks to increase executive power and get endorsement for its repressive pro-
grammes, especially with relation to the Patriot and War Powers acts – acts which Nancy
Chang saw as sacrificing political freedoms in the name of national security.[10]

 One might say that Morriucci were involved in a considerable amount of 'Bushwhacking'
– as can be seen in the section quoted above where Bush's 'measured response' is 'the most
expensive bollocking ever unleashed against shepherds' and where Morriucci claim to be
helping readers to make up their own minds 'about the absolute necessity of fighting the
ongoing war that is Operation Improving Bloodbath'. In this, Morriucci neatly summed up
the ideological climate post-9/11: readers could make up their own minds, but only as long
they kowtowed to the prevailing Bush strategy of doing violence on all those deemed by
his administration and military machine to be involved in the terrorist attacks. This aspect
of the 'Atrocity Special' reflected the hoax 'Bushwhacked' mp3 files (and later video mon-
tage) that Morris assembled only months after the 9/11 attacks from miscellaneous bits of
George W. Bush's speeches. In what might be referred to as satirical 'Bush baiting', Morris
concocted absurd but also canny lines ('the White House, a place where American
Presidents have become outlaws and murderers themselves'), which seemed to lay bare
the Bush administration's bullish politics in the Arab world and cavalier attitude to issues like
the environment.[11]

 The general point I want to stress here is that it is important to see the 'Atrocity Special'
(and reactions to it) in the context of the oppressive ideological pressures and political poli-
cies designed to silence any voices dissenting from the views being put forward by the Bush
administration and to erode political liberties. I want to emphasise that coercive ideological
forces operated at all cultural levels, whether associated with intellectual or popular forms
of culture. One of the consequences of 9/11 in the United States was the pervasive air of
persecution: anyone who tried to analyse the acts of terrorism with relation to the history
of US foreign policy or military intervention, or criticised the Bush administration's military
aggressions in Afghanistan or Iraq, was considered a bad citizen, a traitor or a terrorist sym-
pathiser. This was exemplified by the case of Susan Sontag who, only thirteen days after the
World Trade Center collapsed, expressed her indignation at the way the public was being
infantilised by 'the self-righteous drivel and outright deception being peddled by public fig-
ures and TV commentators', pointing to the 'ineptitude of American intelligence and counter-
intelligence' and the 'sanctimonious, reality-concealing rhetoric spouted by American officials
and media commentators'.

Sontag also called for a 'few shreds of historical awareness' while urging readers of the *New Yorker*: 'Let's by all means grieve together. But let's not be stupid together.'[12] As Michael Bronski observed, this led to her being accused of being a traitor, a quisling, a 'pathetic aya-tollah of hate' and a fifth columnist by the Right;[13] she was subjected to the rhetorical ques-tion, 'What do Osama bin Laden, Saddam Hussein and Susan Sontag have in common?' – the answer? Trying to dismantle America.[14] The *New York Post* proposed she be 'drawn and quar-tered' and she was branded a pedant and had her intellect questioned by writers like Melissa Byles.[15] As Sharon Lerner suggested, the response to Sontag's *New Yorker* essay 'neared witch-hunt proportions'.[16] These *ad hominem* attacks were reflected in the Morriucci piece but directed back at Bush and allies like Tony Blair. For example, Bush is depicted in an emer-gency conference when aides explain the 'appalling gravity' of the situation and the President is heard screaming: 'Phone Al Gore and tell him he won.' Bush's reputation as a simpleton was reflected in the President's mock announcement: 'It may take another ninety-eight years to find bin Laden unless we've got him already.'

The insults against Sontag were only part of the attacks on intellectuals who dared to confront the political realities of US foreign and domestic policy. Gore Vidal's 7,000-word *Observer* article, 'The Enemy Within', suggested that the Bush administration was either fully complicit in the attacks (the war on Afghanistan being motivated by oil interests, very close to the Bush-Cheney junta) or the events were the product of gross incompetence (which went without any formal political reprimand).[17] Like other critical responses published within a year or so of 9/11 (from critics like Sontag, Zinn, Žižek, Chomsky, Said and Tariq Ali),[18] Vidal responded to Bush's claim that the US was hated because other nations envied its wealth, power and ideals by pointing out that al Qaeda and similar fundamentalist organisations were products of North America's Cold War strategies in Afghanistan. These assertions, plus Vidal's suggestion that America is, itself, a terrorist nation (aligning him with Morris's 'Bushwhacking' tendencies mentioned above) and his claim that the Bush administration was complicit in the attacks, led to him being represented as a member of the lunatic left (not uncharacteristic given his long history of polemical attacks on successive US governments).[19]

Morriucci, while playing on anti-American feeling, suggested that anything that tried to take up a distanced, critical view of the US would be considered a hostile attack:

> Shock scientific survey proves that America really did have it coming. The results of a new study
> show that at the time of the 11 September attacks, America was unequivocally asking for it. … Test
> supervisor Bill Porman said: 'I'm sorry to say but spend any time with these people and you start to
> think, sure, I'd do it, they're absolutely fucking insufferable.' Security Chief John Ashcroft is said to be
> demanding that, from now on, objective scientific research be classified as an act of terrorism.

This kind of 'humour' (repeated in '"Yessssss!" First reaction of many British people who subse-quently claimed to be appalled') echoed jokes drawing on crude forms of prejudice against the US (the Internet was replete with these kinds of jokes following the attacks on the Twin Towers) and would hardly endear the writers to a traumatised North American public. However, return-ing to the rabid attacks on Sontag, Sharon Lerner, in the *Village Voice*, made the point that 'it's hard for anyone to stray from the political mainstream, and harder still for women'.[20] This was also

true with relation to popular culture. For example, even a year and a half after the attacks, it was difficult to question the Bush administration. At a concert in Shepherd's Bush, London, the country singer, Natalie Maines (a member of The Dixie Chicks country trio) told the audience that the trio did not want the war in Iraq and was ashamed that the President was from their hometown, Texas. This led to The Dixie Chicks suffering all kinds of abuse (being labelled and libelled as big mouths, traitors, Dixie Sluts and 'Saddam's Angels'). One 'Bush' led to another. This comment in Shepherd's Bush led to the imposing shadow of another Bush: that is, those prepared to defend George W. Bush through concerted attempts to silence the Texas-based singers, which involved pro-Bush press and radio stations urging listeners to dump their Dixie Chicks albums and boycott their tours – the trio even received death threats.[21]

In the United States, questioning the handling of 9/11 in any sense was to risk putting oneself in the line of 'Bush fire', which meant having one's loyalty to the Stars and Stripes questioned. Morriucci aim some of their sharpest satire at this enforced patriotism and the Bush administration's hawkish drives:

> US bombs hit a Red Cross emergency centre on the outskirts of Kabul, but the Pentagon refuses to apologise, blaming the Red Cross logo for 'looking like the crosshairs on a viewfinder'. Spokesman Paul Wolfowitz says: 'I'd ask this clearly self-loathing organisation to change its suicidal insignia before they kill us all.' The Red Cross complies immediately and changes its logo to a blue baseball hat.

In another section of the 'Atrocity Special' Tony Blair declares that Britain 'must share in America's pain as Education Secretary Estelle Morris announces plans for children to drop French and instead spend two hours a day chewing gum'. The symbols of baseball caps and chewing gum emphasised the importance to the US administration of clear demonstrations of patriotism and pro-American thinking.

This reference to dropping French recalls how the French fry itself was targeted in the wake of 9/11. When the French government disputed the Bush administration's intentions to ignore United Nations' resolutions and attack Iraq on the grounds that Saddam Hussein possessed weapons of mass destruction and posed an immediate and serious threat to US security, a number of reports described how some North Americans boycotted French goods. French fries were to be re-christened 'freedom fries' or 'liberty potatoes' as a sign of patriotic pride.[22] Given these phenomena it seems to me that the kind of satire found in the 'Atrocity Special' is an effective way of challenging what Edward Said described at the time as the 'narrathemes' of 9/11: the narrative devices that construct a sense of the collective 'we' of national identity where 'our' interests are seen as 'self-defensive, without ulterior motive, and "innocent"' and where history is irrelevant and 'any mention that the US once armed and encouraged Saddam Hussein and Osama bin Laden' is considered anti-American.[23]

Morriucci's Blunderbuss Technique

In many ways, the effectiveness of Morriucci's 'Atrocity Special' was due to the way it manipulated powerful symbols for comic or satirical ends. The first and last things that meet the

reader's eye are full-page images. The first page depicted George W. Bush's concerned face in front of the burning Twin Towers (with the caption 'Bush reacts with horror to the news that Enron has gone bankrupt') and the final page (entitled 'A specially commissioned piece of commemorabiliart') depicted a displaced reference to the towers which featured drawings (in the style of before and after) of Gilbert and George being struck down by airplanes (with the captions 'Tut tut' and 'Oh dear').[24] Some of the 'humour' of the 'Atrocity Special' is reminiscent of the controversial 9/11 *Private Eye* cover which announced that 'Bush takes charge' and where an official says to Bush 'It's Armageddon, sir' and Bush replies 'Armageddon outa here'.[25] This reflects one important aspect of the 'Atrocity Special's narrative approach: creating puns or 'humour' out of any circumstance regardless of whether it may offend. The sensitivity to the use of images of the attacks was perceived by Morriucci when they wrote:

> The US public is still so sensitive to images of New York that Woody Allen is forced to remake
> *Manhattan* shot for shot but with all views of the city taken out. Furious that the new version,
> Quebec, will lack resonance, the director comforts himself by giving the part of Diane Keaton to
> eight 17-year-old girls.

This insight is typical of Morriucci's approach: an awareness of the ideological climate in which the images circulated was combined with what might be called a 'blunderbuss approach' to the satirical target. That is to say, the 'Atrocity Special' focused not only on 9/11 but used it as a basis for jibes against celebrities and public figures who often had nothing to do with the events themselves (these included, apart from Allen, Alastair Campbell, Michael Jackson, Arnold Schwarzenegger, REM, Bon Jovi, Beck and The Rolling Stones). While the politicians, public figures, political tactics and terrorists serve as the main targets, the blunderbuss approach allowed all kinds of what might be called (appropriately) satirical 'collateral damage'. Thus, my emphasis on the satirical possibilities of the 'Atrocity Special' is partial insofar as I generally ignore these other victims.

'The Spirit of Terrorism', the 'Atrocity Special' and the Rhetoric of the Image; or, Begging for 'Horizontal Baudrillard' (in a Sand Dune)[26]

One factor that helped to make the 'Atrocity Special' particularly controversial has to do with the forms of comic ingenuity that were applied to the tragic events of 9/11. However, public opinion (as seen above) was divided in terms of whether these techniques were appropriate, in good taste, satirical or funny. I shall not reflect on questions of why audiences may have understood the piece as satirical as these and similar questions are taken up in the chapter written by Sam Friedman but here I want to argue that Jean Baudrillard's early reaction to 9/11 (in the essay he published as 'The Spirit of Terrorism' in *Le Monde* in November of 2001) can help to situate and illuminate what I see as the satirical aspects of the 'Atrocity Special'.

At the beginning of his essay, Baudrillard described the attacks as the 'mother' of all events – a kind of 'pure event' of 'all the events that have never taken place'.[27] This might be

seen as a predictable Baudrillardian tactic which empties the 'event' of all content but which, at the same time, forces readers to consider in what ways it may be questioned as 'event' or in what ways the 'real' may be overwhelmed by the symbol.[28] Baudrillard's development of this argument refers to the way the image (exploited by the terrorists) was intensified in the media to the point where it led to the event itself being taken (in an ironically apt term) 'hostage'. In this way, the image 'consumes' the event and 'offers it for consumption' and so becomes an 'image-event'.[29] Morriucci took the image-event of 9/11, now six months into its evolution (and which, according to Diana Kishan Thussu, had been commodified by the news services as 'infotainment'),[30] and reflected it back as an unrecognisable hybrid. That is to say, Morriucci manipulated the typical conventions of both the mainline sensationalist press and more 'serious' investigative journalism and turned them back on themselves. The opening page (mentioned above) featuring George W. Bush's concerned face against the background of the smoking Twin Towers does not receive the expected caption about his concern for the victims but, rather, pushes interpretation in another direction by reminding readers of the Bush family's interest in oil (and more specifically in Exxon). All this is highly reminiscent of the way Morris and his collaborators manipulated and parodied the conventions of TV documentary and investigative journalism in *The Day Today* and *Brass Eye* (explored in other chapters of this book).

One might say that Morriucci take the 9/11 'image-event' hostage, consume it and regurgitate it for satirical ends which, at least for some readers, had the effect of provoking speculation about the media handling of it and how this had become overwhelmed by a dominant set of symbols which tended to downplay the history of US foreign policy in the Middle East and increasingly belligerent attitudes towards the Arab world in general. Media hyperbole was met with its opposite: ludicrous understatement in the shape of proclamations like:

> New figures reveal that the number of people who perished in the attacks on 11 September may be as low as three. Counsellors are on standby to help New Yorkers deal with the trauma of being more upset than they needed to be. Twelve days after the collapse of the World Trade Centre, amazed rescue workers uncover an entire floor that is still doing business. Despite falling 890 feet and being buried under 12,000 tons of rubble, all workers at Leeman Sachs Trading Inc. are unharmed.

For some readers this looked all too much like kicking victims when they were down with its sly reference to implied exaggerated North-American post-traumatic therapy. This jibe (like the one where footage of the collapsing towers is played backwards so they are seen to stand up once again) can serve to remind readers of the power of the media to hype up or downplay an event. As more than one reader remarked,[31] atrocities associated with the US military were either underplayed or ignored (and the widespread attacks on figures from Sontag to The Dixie Chicks in the media tended to discourage too much reflection). In the essay referred to above, Baudrillard made the point that there is no 'good' usage of the media: 'they are part of the event', part of the terror itself[32] and this bleak conclusion seems to lurk in the interstices of Morriucci's 'Atrocity Special' with its constant playing with journalistic formats

and narrative styles. It also informs another Morriucci collaboration that appeared later the same year (November and December) as the 'Atrocity Special', namely the webpage-based journalistic pieces entitled *Smokehammer*, which confronted readers with headlines like 'Attempted follow-up attacks reveal bin Laden has acute "second album" trouble …' and included spoof reports like:

> A New York banker whose car was hit by a man jumping out of the burning North tower of the World Trade Centre is suing the dead man's estate for not curling up into a neat ball and minimising the damage.[33]

Returning to Baudrillard, his general point was that any attempt to reduce 9/11 to a particular meaning was futile – a failure to understand that the brutality of the spectacle was irreducible. The mediatisation of 9/11, or more particularly, the spectacle of terrorism, imposes 'the terrorism of spectacle upon us'.[34] Baudrillard's claim that spectacle is prone to saturating the public to the point of ennui is something Morriucci reflect in in their bathetic taunt: 'Figures show that even as the second tower fell, people were switching off their televisions, complaining they'd seen it all before.'

For Baudrillard, mediatisation creates a 'Manhattan disaster movie' combining the two facets that have fascinated the masses in the twentieth century: 'the white magic of cinema and the black magic of terrorism'.[35] Linking this to common Baudrillardian themes, this is the *simulation* or hyperreality of media forms which seem more real than reality itself[36] but, as Baudrillard reminds his readers, for the consumers of media the violence of the real does not precede the representation with the added *frisson* of the image but vice versa. The image comes first and provides the *frisson* of the real as an added extra.[37] Baudrillard's news as terrorism is reflected in Morriucci's approach which, in highlighting journalistic forms linked to some understatement and the hyperbole of preposterous claims, makes a dystopia of the news itself. Morriucci managed to place their disruptive satire in a 'serious' Sunday newspaper (not unlike 'Second Class Male' and 'Time to Go' – the seemingly serious journalistic pieces Morris published in the *Observer* in 1999 which, it might be argued, functioned like a revolutionary cadre operating in enemy territory). That is to say (and to change the metaphorical basis of this comparison), the technique was akin to what Fredric Jameson termed a 'homeopathic strategy' where an artist introduces that which is considered corrupt into the very institutions in which they circulate in order to condemn (and possibly cure) them – just as a homoeopathist introduces microscopic traces of potentially dangerous elements for curative ends.[38]

However, in terms of Roland Barthes's understanding of the rhetoric of the image through the concept of *anchorage*,[39] Morriucci can be seen as strategically politicising and re-anchoring the imagery and meaning of 9/11. What their strategy tends to expose is the way that the media attempt to anchor meanings through the unification of text and image in order to facilitate what Stuart Hall has termed preferred readings (the products of dominant codes).[40] At the same time, the complexity of Morriucci's strategy also evokes inconvenient references to the US's fraught relationship with Arab countries while exposing the connections between the oil industry, foreign policy and the Bush administration. '911' – once

associated with emergency telephone numbers in the US, Canada and other countries (and, for the sports car enthusiast, the luxury two-door sports coupé manufactured by Porsche) – was, in 2001, appropriated as one of the key signs (or *the* key sign) of Arab fundamentalist barbarity. Morriucci 'de-*anchor*' the term, helping to open it up to alternative readings. Whereas directors like Ken Loach (in his section of the film *11'09"01* [2002]) helped to re-anchor the term through moving references to other significant (and largely forgotten or ignored) dates associated with 9/11 (by pointing out that the *coup d'état* in Chile – aided and abetted by the CIA – occurred on another 11 September in 1973 when the democratically elected Allende was ousted), Morriucci, as I shall try to show, mount similar de-anchoring strategies – but without the solemnity.

What might be referred to as Morriucci's 'manic drive' to exploit 9/11 for jokes and jibes can be seen as a variation on Barthes's technique in *Mythologies* where he saw himself as practising a form of '*semioclasm*' – a kind of semiotic iconoclasm.[41] Just as Barthes persistently undermined what he defined as bourgeois myths, which obfuscated culture and nature, Morriucci doggedly refused to ignore the incompetence, absurdity, Islamophobia and aggressive and increasing militarisation associated with the Bush administration. Phrases like 'Bush announces the start of Operation Bomb Islamics' and Bush 'tells the US that coalition members agree this title is not offensive to "good muslims"' can be viewed as mocking *semioclasm*, a refusal to adopt the official (and expected grave) tone in favour of luxuriating in ridicule laced with satirical barbs to reveal what the official solemnity generally kept out of view. Of course, this semiotic iconoclasm – this undermining of official representations and imagery – cannot be said to motivate all of the humour – as mentioned above, some of it is directed at celebrities or media figures– but there are very few paragraphs which do not refer to world leaders (particularly Bush and Blair), governments, ludicrous military strategies to counter terrorism or the terrorists themselves (although the latter receive relatively little attention – something else which may have helped to alienate Morriucci from readers expecting satire or critique sympathetic to the US and its allies and directed against the Muslim world).

This *semioclasm* can also be linked to a possible interpretative strategy that resembles Althusser's symptomatic reading where the writers open up gaps and silences that serve as reminders of realities beyond the surface level of improvising jokes around a tragic set of circumstances and events.[42] This is typified in sections like the one where Morriucci write that speculation is growing about US retaliation:

> Expert opinion is divided over whether the 'medievalist' regime of Afghanistan should be bombed back to the Stone Age or forward into the twenty-first century. The prevailing hawk argument runs: 'There's a big stone at the back of the Stone Age and we'll bomb them so hard back into that, they'll bounce all the way forward to 2002.'

While this might have appeared to be part of the wild satirical imaginings of Morriucci, it reflected some of the hyperbolic US rhetoric on retaliating against the Taliban and bombing Afghanistan. As Tamim Ansary (and many others) made clear at the time actual threats were made in these terms and the image of bombing Arab countries back into the Stone Age has

been circulating ever since.[43] Another example of Morriuccian *semioclasm* that evokes sensitive subtexts relates to the jibes mentioned above which are directed against the hi-tech, clean-war mentality. The spoof reports of an 'intelligent missile' that is too smart and so refuses to go into war on the grounds that violence leads to more violence and flies home, and the 'Condeleezza Cappuccino' devised to flush out enemies hiding in caves and deliver a sarcastic sprinkling of cocoa powder on them, can serve as reminders of the large number of casualties inflicted on the Afghan civilian population post-9/11 (estimated at between 3,000 and 3,400 between October 2001 and March 2002).[44]

Coming back to Baudrillard, while Morriucci can hardly be said to have any clear academic or theoretical aim, the 'Atrocity Special' can be used to reflect on the media simulations that Baudrillard associated with the hyperreal. Morriucci's constant jibes can be seen as creating an effect where 9/11 as 'event' is overwhelmed by constant satirically motivated 'spin' akin to the way all media events are subject to political and mediatised interventions and manipulations. However, Morriucci, rather than downplay the propagandistic machinations of the spin doctors, foreground the processes by exaggerating them. A glance at the layout of the pages that appeared in the 'Atrocity Special' reveal how they appropriated time lines, descriptive sketches and information boxes to give the article an air of contemporary investigative journalism.

In *Simulacra and Simulation*, Baudrillard emphasised that contemporary society was engulfed in the incessant exchange of signs mistaken for the real in such a way that hold-ups, plane hijacks, etc. are simulations 'in that they are already inscribed in the decoding and orchestration rituals of the media, anticipated in their presentation and their possible consequences'.[45] The media services are seen as encoding 'events' according to their own conventions in such a way that the domination of these codes is so complete that the actual events are merely secondary, something upon which the media services (and government agencies) work in order to construct the kind of stories or fictions that suit their purposes. In this way, Morriucci not only undermined the dominant 'narrathemes' that Said saw as structuring the Bush administration's ideological whitewashing of events but destabilised the pro-Bush myths perpetuated by the media (particularly the news media) while drawing attention to the limited ideological frameworks through which the news media so often work.[46] I would argue that the 'Atrocity Special', in its outlandish parodies of media hype, helped to foreground precisely what Baudrillard sees as hidden.

The 'Atrocity Special' as Epic Theatre

To conclude, Morriucci created a Brechtian *Verfremdungseffekt* ('alienation effect')[47] where a constant awareness and emphasis on convention and form (added to the stylistic exaggerations of journalistic techniques including dramatic rhetorical questions) render the events of 9/11 strange. This is partly dependent on a strategy that differed so much from what was considered acceptable or tasteful in the six months following the events. What I want to argue here is that Morriuccian defamiliarisation can be said, echoing Brecht, to strip an event of its 'self-evident, familiar, obvious quality' and create 'a sense of astonishment'[48] – and, in the case of the 'Atrocity Special', a sense of outrage.

Finally, this Brechtian comparison can be pushed further because Morriucci's undermining of expectations through foregrounding techniques is akin to Brecht's notion of 'Epic Theatre'. This does not attempt to get spectators to engage emotionally with a theatrical work for the ends of Aristotelian catharsis but to detach itself so that audiences can adopt a more distanced, critical perspective in order to understand injustices and inequalities and thereby attempt to challenge them.[49] As stated earlier, I am not arguing that Morriucci started out with such grand designs but pointing out that they tended to challenge the ideological climate of the time by *refusing* to sympathise with the US and its allies and offer consolation or catharsis of any kind. Of course, the reception of the work implies that these alienating devices did not always provoke the distanced and more critical perspectives that I am suggesting here but it does confirm that at least some readers appreciated these possibilities and reacted in a more detached and analytical way. Given these strategies one might ask if the word 'atrocity' refers to the object of the piece (the events of 9/11), the politics of the Bush administration, or the enunciation – the 'Atrocity Special' itself. In short, it is possible to see the 'Atrocity Special' as an example of counter-hegemonic strategies that wrested 9/11 from the dominant meaning-producing discourses to rearticulate it in challenging ways through parody and satire.

Notes

1. This title is taken from a letter of complaint written to the *Observer* in Stephen Pritchard, 'I Remain, Sir, Disgusted of America' (readers' letters), *Observer* (7 April 2002), <http://observer.guardian.co.uk/readerseditor/story/0,,680302,00.html>. This chapter has been facilitated by a research project sponsored by the Fundación Séneca (number 15397/PHCS/10). Chris Morris and Armando Iannucci, 'Six Months That Changed a Year: An Absolute Atrocity Special', *Observer* (17 March 2002), <http://www.guardian.co.uk/world/2002/mar/17/september11.terrorism>.
2. Iannucci and Morris, 'Six Months That Changed a Year'. All ellipses are in the original.
3. Pritchard, 'I Remain, Sir, Disgusted of America'.
4. Unknown Author, 'TV Satire Could Face Police Probe', *BBC News* (13 August 2001), <http://news.bbc.co.uk/2/hi/entertainment/1488371.stm)>.
5. Pritchard, 'I Remain, Sir, Disgusted of America'.
6. All letters quoted in ibid.
7. I have suggested that Morris has practised deconstructive manoeuvres in *Brass Eye*. See David Walton, 'Getting at Language, Power and Ideology after 9/11: An Intervention into "Bushness Studies"', in Dagmar Scheu Lottgen and José Saura Sánchez (eds), *Discourse and International Relations* (Bern: Peter Lang, 2007), pp. 249f.
8. See Louis Althusser, *Lenin and Philosophy and Other Essays* (New York: Monthly Review Press, 1971), p. 128.
9. Susan Sontag, 'Real Battles and Empty Metaphors', *New York Times* (10 September 2002); Noam Chomsky, *9-11* (New York: Seven Stories Press, 2002).
10. Nancy Chang, *Silencing Political Dissent: How Post-September 11 Anti-terrorism Measures Threaten Our Civil Liberties* (New York: Seven Stories Press, 2002).

11. The Bushwhacked material can be listened to and viewed on< http://thesmokehammer.com/>
 and on *YouTube*. The original mp3 entitled '*Bushwhacked*' was hosted on Warp's website.
 See Unknown Author, 'Bushwhacked by Morris', *New Musical Express* (2 November 2001),
 <http://www.nme.com/news/chris-morris/9849>.

12. Susan Sontag, 'The Talk of the Town', *New Yorker* (24 September 2001), <http://www.newyorker.
 com/archive/2001/09/24/010924ta_talk_wtc>.

13. Michael Bronski, 'Brain Drain. In Defense of Susan Sontag, Noam Chomsky, and Gore Vidal',
 Phoenix (19–26 September 2002), <http://www.bostonphoenix.com/boston/news_features/
 other_stories/multipage/documents/02441651.htm>.

14. See Lawrence Kaplan, 'No Choice. Foreign Policy after September 11', *New Republic* (1 October
 2001), <http://www.tnr.com/article/politics/no-choice>.

15. Melissa Byles, 'Open Letter to Susan Sontag', *Off Course* no. 11 (Fall 2001), <www.albany.edu/
 offcourse/fall01>.

16. Sharon Lerner, 'Feminists Agonize over War in Afghanistan', *Village Voice* (1 November 2001),
 <http://www.villagevoice.com/2001-10-30/news/what-women-want/>. I go into much more
 detail about the attacks on anyone prepared to question US foreign policy or the handling
 of events post-9/11 in Walton, 'Getting at Language, Power and Ideology after 9/11. Some of the
 points I make here can be found in that essay.

17. Gore Vidal, 'The Enemy Within', *Observer* (27 October 2002).

18. Sontag, 'The Talk of the Town'; Howard Zinn, *Terrorism and War* (New York: Seven Stories
 Press, 2002); Slavoj Žižek, *Welcome to the Desert of the Real* (London: Verso, 2002);
 Chomsky, *9-11*; Edward W. Said, 'The Alternative United States', *Le Monde Diplomatique*
 (3 March 2003); and Tariq Ali, *Clash of Fundamentalisms: Crusades, Jihads and Modernity*
 (London: Verso).

19. See also Gore Vidal's *Perpetual War for Perpetual Peace: How We Got to Be So Hated* (New York:
 Thunder's Mouth Press, 2002). One of the most detailed replies to Vidal was Ron Rosenbaum,
 'Protocols of Elder Named Gore Vidal: Wacko 9/11 Piece', *New York Observer* (7 May 2003),
 <www.observer.com>. Of course, it is possible to question or reject Vidal's conspiracy theories
 about 9/11 but still acknowledge some of his trenchant criticisms concerning the handling of the
 attacks and the political and military circumstances in which they occurred.

20. See Lerner, 'Feminists Agonize over War in Afghanistan'.

21. Unknown Author, 'Dixie Chicks Pulled from Air after Bashing Bush', *CNN Website* (15 March
 2003), <http://edition.cnn.com/2003/SHOWBIZ/Music/03/14/dixie.chicks.reut/> and
 Unknown Author, 'Dixie Chicks "Get Death Threats"', *BBC Website* (24 April 2003),
 <http://news.bbc.co.uk/2/hi/2972043.stm>. In the United States, a song critical of the Bush
 administration could win a certain subcultural cachet but get very little airplay, and this led to
 rappers (and those on the edges of hiphop) to release songs on websites, creating what I have
 called 'a critical internet underground'. See Walton, 'Getting at Language, Power and Ideology
 after 9/11', p. 243. However, to see censorship as merely external and institutional is to
 oversimplify the situation: there is evidence, too, that musicians were 'quietly censoring
 themselves'. See Jeff Chang, 'Hiphop's 9/11 Blues. Bush's War Takes Hard Edge off Rap's Kickass
 Message', *Now* vol. 2 no. 34 (25 April to 2 May 2002), <http://www.nowtoronto.com/
 news/story.cfm?content=131932>. A very useful article on popular music responses to 9/11 is

Teresa Wiltz's 'Musicians Weigh in on War, across All Genres', *Washington Post* (26 March, 2003), <http://directorydir.montreal.qc.ca/articles/Musiciansweighinonwar.html>.

22. Unknown Author, 'Dixie Chicks Pulled from Air after Bashing Bush'.

23. Said, 'The Alternative United States'.

24. These images can be seen in the pdf files at <http://observer.guardian.co.uk/review/page/ 0,,671683,00.html>.

25. See *Private Eye*, 'Bush Takes Charge' (cover) (21 September 2001).

26. The subtitle refers to the title of one of Morris's 'Second Class Male' columns (written under the pseudonym Richard Geefe) where he arbitrarily throws in a reference to Baudrillard. See Chris Morris, 'I would light up Gitanes. She would beg for horizontal Baudrillard in a sand dune', *Observer* (11 April 1999), <http://www.guardian.co.uk/theobserver/1999/apr/11/ featuresreview.review9>.

27. Baudrillard, *The Spirit of Terrorism* (London: Verso, 2002), p. 4.

28. I argue elsewhere that part of Baudrillard's value as a cultural critic is to be found in the way he provokes readers to question media 'events' though the construction of seemingly absurd, contradictory or preposterous statements. See David Walton, *Doing Cultural Theory* (London: Sage, 2012), p. 220.

29. Baudrillard, *The Spirit of Terrorism*, p. 27.

30. See Diana Kishan Thussu and Des Freedman, 'Introduction', in Diana Kishan Thussu and Des Freedman (eds), *War and the Media: Reporting Conflict 24/7* (London: Sage, 2003), p. 9.

31. Pritchard, 'I Remain, Sir, Disgusted of America'.

32. Baudrillard, *The Spirit of Terrorism*, p. 31.

33. The *Smokehammer* material can be viewed at <http://www.cookdandbombd.co.uk/forums/ index.php?page=morrismirrors>.

34. Baudrillard, *The Spirit of Terrorism*, p. 30.

35. Ibid., pp. 29–30.

36. Jean Baudrillard, *Simulacra and Simulation* (Ann Arbor: University of Michigan Press, 1981/1994), pp. 2f.

37. Baudrillard, *The Spirit of Terrorism*, p. 29.

38. Fredric Jameson, *Postmodernism, or, the Cultural Logic of Late Capitalism* (London: Verso, 1991), p. 158.

39. Roland Barthes, 'Rhetoric of the Image', in Stephen Heath (ed.), *Image, Music, Text* (New York: Hill & Wang, 1964/1977), p. 39.

40. Stuart Hall, 'Encoding and Decoding in Television Discourse', in Stuart Hall, Dorothy Hobson, Andrew Lowe and Paul Willis (eds), *Culture, Media, Language* (London: Hutchinson, 1973/1980), p. 135. Of course, Hall emphasised that 'there is no necessary correspondence between encoding and decoding' (p. 136). My argument is that the Morriucci duo helps to foreground the processes.

41. Roland Barthes, *Mythologies* (New York: Noonday Press, 1957/1972), p. 8.

42. For 'symptomatic reading', see Louis Althusser and Étienne Balibar, *Reading Capital* (London: Verso, 1968/2006), pp. 18f.

43. Tamim Ansary, 'Bomb Afghanistan to Stone Age? It's Been Done', *Minneapolis Star Tribune* (19 September 2001), <http://www.commondreams.org/views01/0919-02.htm>.

44. See Marc Harold's 'A Dossier on Civilian Victims of United States' Aerial Bombing of Afghanistan: A Comprehensive Accounting' (2002). This can be accessed at <http://cursor.org/stories/civilian_deaths.htm>. Of course, dropping bombs on Afghans did not begin after the events of 9/11. As Harold makes clear, there was already the legacy of ten years of indiscriminate bombing owing to the civil war during the 1980s.

45. Baudrillard, *Simulacra and Simulation*, p. 21.

46. I would like to thank the editors of this volume for helping me to clarify this last point.

47. For convenience I use this term but critics like Brooker reject 'alienation' as an adequate translation, preferring 'de-familiarisation', 'estrangement' or even 'de-alienation'. See Peter Brooker, 'Key Words in Brecht's Theory and Practice of Theatre', in Peter Thomson and Glendyr Sacks (eds), *The Cambridge Companion to Brecht* (Cambridge: Cambridge University Press, 1994), p. 193.

48. I am referring to Brecht's *Gesammelte Werke* as quoted in Brooker, 'Key Words in Brecht's Theory and Practice of Theatre', p. 191.

49. See Bertolt Brecht (ed. John Willett), *Brecht on Theatre: The Development of an Aesthetic* (London: Methuen, 1974), pp. 22f. Here I only indicate the first essay by Brecht on the 'Epic Theatre' published in this collection but I have summarised ideas from a number of essays in the same book.

11

'WELL FUTILE':[1] *NATHAN BARLEY* AND POST-IRONIC CULTURE

ADAM WHYBRAY

'We are what we pretend to be, so we must be careful about what we pretend to be.'

(Kurt Vonnegut)[2]

From Fuzz to Focus

Chris Morris and Charlie Brooker's 2005 sitcom *Nathan Barley* (Channel 4) was not universally lauded. There was a general sentiment across the national press at the time of the programme's broadcast that it lacked the satirical sharpness of Morris's previous vehicles,[3] notwithstanding some notably favourable reviews from Mark Lawson, Andrew Billen and Damien Love.[4] Assertions such as Paul Hoggart's curtly dismissive comment – 'Chris Morris has made some of the most brilliant satire seen on British television, and will surely do so again. This isn't it.'[5] – rested upon privileging the image of Morris as the satirist of *Brass Eye* (Channel 4, 1997; 2001) or *The Day Today* (BBC 2, 1994) rather than as the absurdist of *Jam* (Channel 4, 2000) or *My Wrongs #8245–8249 & 117* (2002). However, if *Nathan Barley* was often recognised generically as a satire, then there seemed to be a difficulty in pinning down precisely what it was a satire *of*. Those commentators who declared that the series had arrived too late, argued that the programme's satire was geographically and temporally specific to the fashionable Shoreditch and Hoxton areas of East London around the turn of the new millennium.[6] Even those journalists who praised the show were still wont to see its satirical focus as a limited one. Alison Graham and Mark Lawson, for example, both saw the series as a media satire;[7] while Kathryn Flett, Andrew Billen and Christopher Howse all read the series as targeting 'youth culture'.[8]

What I will argue across this chapter is that though critics accurately noted some of the themes the programme touched upon, they failed to read the series as reflecting Morris and Brooker's broader concerns about a mode of discourse I shall refer to as 'post-irony' (a term that will require clarification). Through removing behaviour from a space of authenticity, post-ironic discourse enables privileged sections of society to be protected from ethical judgment. The individuals who adopt this stance in *Nathan Barley* are predominantly

young, male journalists who work for the fictional *SugarApe* magazine. However, I will demonstrate that post-ironic discourse and behaviour can be evidenced on a wider cultural scale in magazines, on television and on the Internet. Finally, I will argue that the critique *Nathan Barley* makes of post-irony can be extended to the programme itself. The way *Nathan Barley* exemplifies the behaviour it condemns fogs its satirical vision, leading to the confusion and disappointment of critics who were unable to identify this vision through disentangling it from the programme's own form.

Defining Post-irony

In the first episode of *Nathan Barley*, Ned Smanks (Richard Ayoade) inadvertently describes the process of post-irony. Ned is explaining Nathan's (Nicholas Burns) infantile rock/paper/scissors clone 'cock/muff/bumhole' to the assembled staff of *SugarApe* magazine. 'It's good', says Ned, '... 'cause it looks like it's good because it's rude!'[9] If one takes 'cock/muff/bumhole' seriously to be infantile and unpleasant, then one is open to the accusation of not having understood the fact that it 'looks like it's good because it's rude' rather than merely being rude in and of itself. Under this shroud of simple-minded irony, *SugarApe* magazine can court controversy by producing content which grabs attention through its perceived offensiveness, while being smugly able to not take offence itself, due to always being one order of meaning removed from any apparent intent. At the meeting where Ned explains the game, the staff are engaged in a discussion to change the magazine's logo to 'RAPE' with an almost invisible 'SUGA' nested within the 'R'. The idea being that people will 'think they're getting pissed off by "rape" but in actuality the magazine's name is still *SugarApe*'. Of course, this ironic pretence of words meaning other than what they appear to mean is so patently paper-thin that by the end of the episode the tiny logo next to the offices' security buzzer just reads 'RAPE' – the 'SUGA' having disappeared. Later in episode three, at an art exhibition he has been commissioned to review, Dan Ashcroft (Julian Barratt), is identified as a journalist from simply 'Rape' magazine.[10] This demonstrates how easily post-irony can fall into being the (unpleasant, unethical) thing itself, due to a lack of satiric differentiation.

To clarify what I mean by post-irony will require a brief explanation of irony. Irony is traditionally a gap in meaning between two positions (such as between what is said and what is known) that takes us to a new meaning. To give an unintentional example of traditional irony: when the *Daily Mail* reported on the *Brass Eye* 'Paedophilia' Special (2001) with a headline reading 'Unspeakably Sick', it was printed after photographs that showed the thirteen-year-old Princess Beatrice and the eleven-year-old Princess Eugenie in bikinis.[11] So, the headline given by the *Mail* takes the position that a programme about paedophilia is 'unspeakably sick'; the photograph of pre-pubescents in bikinis takes the position that the sexualisation of children is acceptable. A gap in meaning is opened between the two positions. We move across this gap towards a new understanding, which is of the hypocrisy of the *Mail* and more broadly, that it is possible to unwittingly engage in the sexualisation of children, while decrying anything that engages with the issue of paedophilia.

By contrast, something that is post-ironic does not provide us with a new meaning through juxtaposition or an inferred reading, but entrenches a position while removing it from critical debate. So, for example, if I were a musician with very limited talent (as happens to be the case) then I might justify my poor guitar playing by claiming that it was ironically bad. My guitar playing is now rendered 'so bad it's good' and those who recognise this are afforded a position of cultural superiority. Meanwhile, there is little onus on me to actually improve my guitar playing and so be legitimately compared through received cultural standards (having one's instrument in tune is preferable to having it out of tune; harmony and rhythm are to be aimed for, etc.) to a proficient guitar player. Anyone who did so, I would accuse of being naive. We might then call this form of irony 'faux-ironic', since it fails to be authentically ironic. Jimi Hendrix failing a guitar audition would be ironic. Calling myself a poor guitar player insinuates that there is some *othering* factor that enables someone to understand my poor guitar playing in a different light, but crucially the statement refuses to elaborate what that factor might be. It is the aura of irony bestowed without legitimate difference.

Some commentators have disputed the use of post-ironic as a viable term, while agreeing on its symptoms. Zoe Williams, in an indispensable article on irony, provides a litany of examples that I would classify as being post-ironic; including: '*Scary Movie 2, Dumb and Dumberer*, posh women who go to pole-dancing classes, people who set the video for *Big Brother Live*' and 'people who have *Eurovision Song Contest* evenings'.[12] For Williams, the aforementioned phenomena all seem to proclaim: 'I'm not saying what you think I'm saying, but I'm not saying its opposite, either. In fact, I'm not saying anything at all.'[13] However, Williams refuses to use the label post-ironic, since she believes that this would suggest: 'i) that irony has ended; ii) that postmodernism and irony are interchangeable, and can be conflated into one handy word; or iii) that we are more ironic than we used to be.'[14] Williams and myself are clearly describing the same strategy that misrecognises itself as irony, but differ on a matter of semantics. For me, those false assumptions are implicit in the notion of post-irony itself, rather than negating the use of the term. Though a reader sympathetic to Williams might argue that 'false irony' or 'faux-irony' would be a more accurate descriptive, I shall persist in the use of post-ironic as this form of (failed) irony could only exist *after* the concept of irony had been homogenised and assimilated into the cultural mainstream. Wholly contrary to my own usage, Kevin Guilfoile uses the term 'post-ironic' to refer to works, such as David Foster Wallace's *Infinite Jest* (1996), where irony is viewed by the author as inescapable and thus used, through necessity, as a means to achieve an 'earnest', rather than a cynical effect.[15] Similarly, Matthew Collins calls works, such as Werner Herzog's *The Bad Lieutenant: Port of Call New Orleans* (2009), that render irony indistinguishable from earnestness, post-ironic.[16] It would be difficult to say whether Herzog's claim that he does 'not understand irony'[17] refutes or corroborates Collins's reading. Post-irony in the sense that Guilfoile and Collins define it, as irony used towards earnest or sentimental ends, features little in *Nathan Barley* and so the difficulty of using the same word for an opposite phenomenon can be avoided. In such an instance when I might wish to describe irony as a means to reach an earnest meaning, I would use the phrase 'new sincerity' as per Jesse Thorne's 'A Manifesto for the New Sincerity'.[18]

'NOW EVEN MORE SUPERFICIAL/OVER 100 PAGES OF HYPE & LIES'[19]

Post-ironic Magazines

Dan Ashcroft, despite writing for *SugarApe*, attempts to resist the post-ironic tendencies of the magazine. Much of *Nathan Barley* follows Dan's attempts to expose the magazine's staff and their related friends and cliques as 'idiots'. The most offending idiot from Ashcroft's wearied perspective is the titular Nathan Barley, a self-promoting fashionista who hangs around the *SugarApe* offices and the trendy enclave of Hosegate (a portmanteau word that plays on Hoxton and Shoreditch) where Dan works. Episodes of the programme tend to revolve around a beleaguered Dan attempting to earn money, whether by writing a cover feature or applying for a bank loan, while staving off the 'idiots'. These he identifies in an opening monologue in episode one,[20] that quotes from his 'Rise of the Idiots' article, which critiques his co-workers at *SugarApe* and trendy scenesters like Nathan, who witlessly fail to recognise themselves in the article. Alongside scenes in which Dan seeks to escape this enclosed new-media environment are ones in which Nathan and his friends engage in aberrant, post-ironic behaviour which Dan, against his better judgment, often ends up being drawn into. A figure of admiration for his colleagues, Dan is hailed as a 'preacher man' by the very 'idiots' he despises and by the end of the series, having nearly succeeded in humiliating and ousting Nathan, finds himself signing a contract to appear in his newly commissioned television show.[21]

In *Disgusting Bliss*, Lucian Randall writes that

> Nathan was born of an undefined sense of bitterness that Charlie Brooker had felt years before towards the confident, young media types hanging out near the flat he could ill afford just off Chepstow Road in gentrified Westbourne Park.[22]

This story of the autobiographical origin of *Nathan Barley* suggests that the character of the disillusioned Dan forced into close proximity to 'the idiots' can be read as an authorial insertion figure for Brooker. Brooker had contributed to the writing of the 2001 *Brass Eye* 'Paedophilia' Special, using expertise gained from his time as a journalist for game review magazine *PC Zone* to help pen the episode's segment on 'HOECS' games.[23] Brooker had come to Morris's attention through his work on *TVGoHome* and they were formally introduced by a mutual friend at a dinner party.[24] *TVGoHome* was a *Radio Times* spoof penned anonymously by Brooker online from 1999 to 2003. Nathan Barley appears as the subject of a recurring documentary feature titled simply 'Cunt'. Therein we receive a glimpse of Nathan's solipsistic existence as a moment from his daily life is described. A representative entry reads:

> While filming himself receiving fellatio from a coke-twisted anorexic work experience girl plucked from the corridors of his uncle's TV production company, Nathan Barley momentarily interrupts his warm-gummed prickbliss to read a text message from the Ananova automatic news update service informing him of the latest Afghan death toll, before sliding his hideous gitprong back into position

and intuitively grasping the back of her head like a man trying to pierce a basketball with his fingers.[25]

Some entries, like this one, are transplanted almost directly into the programme's script. So, in episode five, the unnamed work experience girl becomes Mandy (Ophelia Lovibond), a cocaine-addicted model who fellates Nathan after he lends her £270.[26] While the character of Dan Ashcroft doesn't appear in *TVGoHome*, Brooker explains in an interview with *Flak Magazine* that he has some basis in the anonymous figure of the writer of the listings; as Brooker says, 'the angry narrator in the listings is clearly a hugely frustrated and confused sod, which I think was roughly the origin there'.[27] *TVGoHome*'s unseen commentator also provided inspiration for the secondary character of Claire Ashcroft (Claire Keelan), sister of Dan, who functions as an earnest though occasionally hypocritical counterpoint to Nathan.

Essential to the programme's *mise en scène*, but absent from the concept's original *TVGoHome* incarnation, are the offices of *SugarApe* magazine, the hub of much of the series' action. At the time Brooker was penning *TVGoHome*, from 1999 through to 2003, style and culture magazines such as *i-D* and the *Face* (their first issues both produced in 1980) and lifestyle and fashion magazines such as *Sleazenation* and the American *Vice*, were enjoying sales from the young, urban demographic filling the apartments of a gentrified East London vitalised by the millennial dotcom boom. Such magazines are knowable by their covers. *Vice*, which is still running, has covers that tend towards trash Americana, psychedelic or satirical illustration and gonzo photographs of rave culture and drug-taking; *Dazed and Confused*'s covers comprise slick fashion-shoot photography of music or fashion icons in *haute-couture* costume, often underneath a white sans-serif font; while the covers of *Sleazenation* tended to utilise typography and design alongside an iconic image or post-ironic statement. *SugarApe*, the imaginary magazine in *Nathan Barley*, seems inspired by all these magazines. An image gallery of *SugarApe*'s covers is available on the *Nathan Barley* DVD and on the promotional website for the show.[28] A cover featuring a toddler dressed as a Nazi recalls *Vice*'s often ethically dubious use of child and prepubescent models, such as Jamie-James Medina's 'Still Hungry' photoshoot of starving Bangladeshi children wearing designer clothing;[29] a cover with VJ Dajve Bikinus (Celia Meiras) who features in episode four and the programme's pilot, employs the high-saturation and airbrushing techniques used to tweak the cover models of *Dazed and Confused*; while a cover featuring a pictographic cartoon of a blindfolded duck on which is written 'dad', with the words 'HAPPY NOW?' underneath is not dissimilar to the covers with a glib *non sequitur* caption below an iconographic image that were designed by Scott King for *Sleazenation*.

One of Scott King's famous designs for the magazine came emblazoned with 'NOW EVEN MORE SUPERFICIAL/OVER 100 PAGES OF HYPE & LIES'[30] across the cover. Immediately, this strikes the person browsing the magazine aisle as a knowing comment that parodies the vapid content of fashion magazines. It winks in complicity with the reader; but the self-satire also serves as a defensive strategy, as it pre-emptively dismisses its own content and any attempt at authenticity, idealism or truth therein. Likewise, the 'ABSOLUTE SELL OUT' edition of October 2001. This is self-parody that merely entrenches a cynical position while also pre-emptively defending this position from critique. Thus, we never move across

the gap to an illuminated understanding, but become stuck in an infinite regress of self-regard (*Sleazenation* is pretending to be pretending to be pretending to be superficial/to have sold out, etc.). As such, it may not even be correct to regard this as irony *per se*, since there is only a pretence of irony.

A *Village Voice* article on *Vice* magazine captures these magazines' (anti-)ideological stance: 'Concepts like "underground" and "selling out" are quaintly irrelevant to the *Vice* reader. After all, why *wouldn't* you sell out? Anyone who carps at the successfully crossed-over is just a player-hater.'[31] Though there is a sense here of a more established, self-regardingly sophisticated magazine (*Village Voice*) attempting to put down its yapping, feral rival, there is also a genuine concern that for *Vice*'s readers, earnestness is something to be scoffed at. The article voices an anxiety that this may be a strategy adopted to obscure and defend an anti-progressive agenda; that through stridently attacking 'the paper tiger of political correctness', they achieve nothing as subversive as protecting the attitudes and interests of the 'white boys with foul mouths and loathing in their hearts'[32] who already dominate the cultural landscape. Through its colloquial style, punk aesthetic and gonzo photography, combined with a long-running free-distribution strategy, *Vice* can package reactionary content within a zine format. Of course, the zine itself (an independent magazine) is simply a medium – it would be entirely possible to self-publish and freely distribute a 'bourgeois homeowners zine' for instance – but essentially the form retains strong associations with the counter-culture. As Anita Harris writes, 'The purpose of these media [zines] has been to create an inexpensive, self-produced site for expression for those without access to or interest in mainstream forms'. An example of those who benefit from zine production that Harris provides are 'young women marginalized by poverty and geography'.[33] Thus, *Vice* co-opts the 'zine', which has predominantly served as a subversive, counter-cultural force and uses the format to further entrench the prejudices of the dominant mainstream, while maintaining a pretence of counter-culturalism through adhering to a cynical, anti-mainstream attitude. To quote Timothy Bewes, 'irony as an end in itself represents the rapid commodification of a strategy that once provided a legitimate means of challenging the dominant operational mode of ideology'.[34] The rhetoric of provocation and challenge is kept, while the content of protest and idealism is abandoned.

By 2004, and by the end of *TVGoHome*'s run, the bottom had fallen out of the dotcom market,[35] over-saturation had led the once indisputably cool London boroughs to now seem passé[36] and the *Face* and *Sleazenation* had both ceased production. However, *Nathan Barley* had a long period of gestation and then took a few years in production. Nicholas Burns, who plays Barley, commented to the *Observer* upon the thoroughness of the research he was required to undertake to develop the role. 'We have been working on it for quite a long time', he told Gemma Clarke, '… a few years. We spent ages researching it, going to places where we thought we'd meet lots of "Nathans".'[37] This long transition from spoof Internet column to screen is what prompted commentators like Neil Boorman and Ben Deedes to accuse the programme of airing several years past the point of cultural relevance.[38] Indeed, it might even be argued that Stewart Lee and Richard Herring had in *This Morning with Richard Not Judy* (BBC 2, 1998–9) already spoofed magazines with subcultural pretensions written by commentators entrenched in the mainstream, in their recurring sketch 'The Ironic

Review', in which the journalists of a style magazine studiously avoid committing themselves to any opinions that might appear uncool, by claiming to be voicing all their opinions ironically. However this criticism of *Nathan Barley*'s cultural irrelevance by the point of broadcast only holds true if we insist upon seeing its focus as isolated to a critique of the style magazines that were shedding readers and closing their doors by 2005. However, if we see the characters' behaviour as indicative of a wider cultural practice, then we might even read the programme as being prescient. Johnny Dee, writing for the *Guardian*'s 'Box Set Club' in September 2011, recommends the show for being 'in many ways … ahead of the times' and notes that

> today, in the *Facebook* age, we're used to people talking about themselves as if they were brands but Barley's Internet self-promotion was in its infancy in 2005. It also pre-dated *YouTube* which has subsequently filled with the *Jackass*-style clips Barley uploaded to trashbat.co.ck.[39]

Charlie Brooker himself voices a similar sentiment when an interview with *Empire* magazine touches upon *Nathan Barley*. Telling the interviewer that he recently rewatched some of the show, Brooker muses, 'It's quite frightening to think that it pre-dated *YouTube* … . At the time I remember people thinking that it was set in the future – which would make sense because it sort of was.'[40] While Brooker's claims about contemporaneous opinion of the show run counter to those I've come across, I concur with his notion that the programme, especially in its technological focus, was borne out in the years that followed it, especially in the proliferation of post-ironic behaviour upon the Internet.

Lulz and Memes: Post-irony on the Internet

Three of six of *Nathan Barley*'s episodes open upon a browser window displaying Nathan's website, like a framing device for the programme's central narrative that transitions us, via a loading screen (replete with a puerile faux-political animation cycle, such as Osama bin Laden and Saddam Hussein tugging on each other's beards – see p. 183) into a post-ironic mode of viewing; as though the programme took place within the murky backwaters of the Internet itself.

Charlie Brooker's career has comfortably straddled both the Internet and print journalism, in the same way that Morris's has straddled both television and radio. *Nathan Barley*, as mentioned, originated on Brooker's online *Radio Times* spoof *TVGoHome*. Previous to this, Brooker had worked as a journalist for *PC Zone*. Some of Brooker's early output – namely his comic strips – was later made available via his webpage. As of the time of writing, his Twitter account has 567,678 followers.[41] Speaking in interview with Neil Kennedy, webmaster of comedy forum *Cook'd and Bomb'd*, Brooker says of Twitter that it acts as an 'echo chamber',[42] amplifying by increasingly hyperbolic turns, the opinions of users who are writing for an Internet audience. This concern has found recent expression in the first episode of Brooker's 2011 series *Black Mirror*, in which a conceptual-artist-cum-terrorist forces the Prime Minister (Rory Kinnear) into having sex with a pig live on air. Though television news channels cover

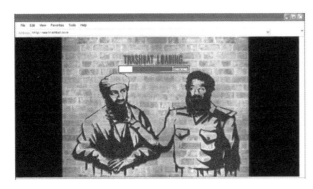

A loading screen for Nathan's website trashbat.co.ck in which Saddam Hussein and Osama Bin Laden are reduced to the status of Internet memes in an empty gesture of faux-political commentary

the story with restraint, the affair trends on Twitter, with such tweets posted as, 'Callow gonna get pig AIDS LOL' and 'I think it's snoutrageous.'[43] Something which is authentically horrible is treated as an entertaining spectacle for glib, dark humour, because the distance afforded by the act's mediation allows for cynical, smirking detachment. In the aforementioned interview, Brooker provides a real-life example of this phenomenon with the online reaction to Rebecca Black's 'Friday'.

Rebecca Black was a thirteen-year-old girl who for her birthday had been given studio time to record a song with her friends, co-written and produced by Ark Music Factory. The ineptitude of the song was such that the video, uploaded onto *YouTube*, received over 150 million views, but also prompted numerous insults and death threats via online channels such as Twitter, *YouTube* and email.[44] Brooker speaks of the 'strange falseness and melodrama'[45] of the Internet that catalysed an unprecedented number of people into sending death threats to a thirteen-year-old girl and recognises that in such an instance, participants are responding to a mediated version of the subject of abuse, but have access to channels direct enough in their delivery of this abuse, that the real person behind the mediation gets hurt. This notion is illustrated beautifully in American webcomic *Achewood* when serial killer Nice Pete develops a USB device fitted with a retractable blade that collects votes from users on the Internet and then drives the blade through the heart of its victim. As Nice Pete proclaims, 'They call me crazy, but they can't call me guilty! Not with millions of hands on the blade!'[46] The same might be said by the (diegetic) creator of *Nathan Barley*'s 'Scum Vegas' website, of which Nathan, Dan and the staff of *SugarApe* partake.[47]

'Scum Vegas' allows users to bet on competitions in which Russian homeless men are cajoled into racing while being assaulted with cattleprods, or have their teeth removed with pliers. 'Scum Vegas' is a parody of the *Bumfights* video series,[48] the first of which was released in 2002 as *Bumfights: A Cause for Concern*. The films were produced when Ryen McPherson, along with friends, paid several homeless men to perform harmful stunts and fight before the camera. Drug-taking, teenagers brawling and acts of vandalism were also recorded. To capture the low-fidelity, underground aesthetic of the *Bumfights* videos, the 'Scum Vegas' race footage is filmed with a hand-held digital camera and sputters as the video streams. We see the racing in low resolution in a pop-up window framed by Dan's monitor. As with responses to Rebecca Black's 'Friday' video, the profound disconnect felt by the person at their computer screen for the recipient of their actions, combined with the anonymity of

A screengrab of Nathan's website in which one of his vicious pranks on his friend Pingu can be glimpsed, alongside one of Nathan's masturbating monkey animations from the 'other shit' section of his website

their position, takes the edge off unethical behaviour for the user, so they can feel as though they are *performing* cruelty, rather than *being* cruel in and of themselves. For example, Ned remarks with gleeful incredulity while watching the men get beaten and lined up to race, 'That's fucking carnage!' and 'This is wrong!' By voicing these observations, Ned perversely strips them of their moral potency. 'Immorality' is placed within inverted commas. It is not enough to say that the material is viewed by Nathan, Rufus and Ned as though it were fictional, since the notion of the 'fictional' can only exist as the dialectical other to the 'real'. Fiction/non-fiction – it is all just *stuff*; distractions; memes. A 'meme' is a unit of information that is replicated. The term was famously coined by Richard Dawkins[49] and has found wide expression in the phrase 'Internet meme' that refers to images or phrases with humorous or novel content distributed via email, video-sharing sites and online forums. The 'lolcat' – a humorous image of a cat, accompanied by a poorly spelt statement from the cat's perspective – is in 2012 probably still the most well-known Internet meme. Susan Blackmore writes of memes generally: 'Memes spread themselves around indiscriminately without regard to whether they are useful, natural or positively harmful to us.'[50] That is to say, memes merely look to be passed on. As such, the most successful memes are those imbued with novelty. McPherson, the creator of *Bumfights*, in interview with Chad Freeman, describes his collective of film-makers as, 'just a bunch of desensitized kids who think in terms of intrigue. Not humor or shock value.'[51] McPherson's comments help to confirm my argument that the unethical behaviour enabled through post-irony is concerned with *novelty*, divorced from other values, such as making people laugh, or engaging them ethically.

Within *Nathan Barley*, the 'idiots' are able to treat the entire world and its sufferings as memes, as though it were all filed under the 'other shit' section of Nathan's website. For me, this is where the programme was genuinely prescient. 'Scum Vegas' points towards a broader Internet culture that has flourished since the programme's broadcast, that places such an emphasis upon novelty that any phenomenon, no matter how abhorrent, asinine or immoral, is treated as little more than an entertaining and diverting spectacle. We might think, for example, of *YouTube* compilations of 'epic fails' that comprise sporting defeats and bail-outs, painful accidents and car crashes;[52] the Internet phrase 'for the lulz', used to justify offensive behaviour;[53] even the less overly egregious lolcats are testimony to the way in which the artistic, intellectual or moral value of what proliferates upon the Internet, pales in comparison to its

Dan Ashcroft pleads with a crowd of assembled 'idiots' at the end of episode two – 'I'm not a preacher man!' as their chants of 'PREACHER MAN!' grow louder. Any insult he throws at them is accepted in the spirit of irony and assimilated

novelty value. Tramp-racing; monkey animations; a video of a woman being bummed by a wolf; a young man being electrocuted with a car battery, in what is little more than unembellished torture given *Jackass*-style presentation (all equivalent fictional examples from within the series) are just 'other shit' done or watched for the lulz (see p. 184).

Leading into the discussion on Rebecca Black, Brooker talks of his dismay at receiving correspondence from a fan who, inspired by the celebrity-berating rants in his *Guardian* 'Screenburn' columns, had written gratuitous vitriol about Kerry Katona. Detectable is an anxiety about misinterpretation – that comedy deriving from the ludicrousness of getting vitriolic about inane subjects, might get mistaken as simply vitriol and imitated. When in episode two, Dan Ashcroft, dressed as a preacher man, shouts 'I'm not a preacher man!' to a party of assembled 'idiots' who beg to differ (see above), it is easy to read Dan as an authorial-insertion figure for Brooker, concerned about the mindless reverence and imitation of fans.

The artist/comedian's fear of being misinterpreted may also inform Morris's contributions to the series (although, of course, without knowing how scriptwriting duties broke down, one can only speculate). In episode five, the callousness and ironic distance with which the *SugarApe* staff talk about paedophilia[54] has, perhaps, been ushered in by the irreverence of the *Brass Eye* 'Special' which despite a satirical focus upon the hysterical and lurid reportage that stories involving paedophilia receive, also included absurdist jokes such as a 'paedophile disguised as a school',[55] which might be accused of exploiting the subject matter to less high-minded ends. This ambivalence of intent is perhaps most striking in Morris's radio series *Blue Jam* (BBC Radio 1, 1997–9) and its later adaptation for television, *Jam* (Channel 4, 2000). Sketches that focus upon child abuse, rape, suicide and murder often lack a discernible message, but instead play through the absurd ethical hypocrisies and contradictions bound up in characters' and the listeners' often intuitive responses to these acts and situations. However, these nuanced workings are also blended with more glib and sometimes puerile treatments of the same subjects, in which 'doctor doctor' jokes are reworked as macabre body-horror skits, and a clear glee is taken in the wanton, slipshod approach to subjects that more conventional broadcasting would treat with due sensitivity. Significantly, Julia Davis, who acted in both the radio and the television series, went on to produce her own series *Nighty Night* (BBC 2, 2004–5) in which 'dark' subject matter is treated with an astonishing, irritating and sometimes exhilarating glibness. It might be of interest to note that the

casting of Davis's husband, Julian Barratt, as Dan Ashcroft, came after 'The Mighty Boosh' had established itself as an Edinburgh Fringe act (1998–9) and latterly on BBC Radio 4 (2001) and television (BBC 3, 2004–). Work on *Nathan Barley* would have coincided with the broadcast of their first television series (BBC 3) in 2004. Noel Fielding, Barratt's comedy partner, also appears in a minor role, as Claire's housemate, Jones. In the aforementioned interview with *Flak* magazine, Morris seems to dismiss the notion that the use of the pair within the programme was a piece of 'stunt casting', focusing instead upon their brilliance in audition.[56] Now, *The Mighty Boosh* is generally too daft and joyous to be considered pernicious in the way that the media parodied in *Nathan Barley* could be, but it does seem apposite to note that a *Google* search for 'the mighty boosh' + random, provides almost 20 million results. A cynical viewer might raise an eyebrow at the casting of Barratt and Fielding, as though Morris were critiquing them, through their very casting, as agents of the meme-riddled culture that prizes novelty over meaning, that the 'idiots' of the programme celebrate and contribute to. In this sense, not only the character of Dan, but the actor Julian Barratt himself is a 'preacher man' who has, in a small way, contributed to the rise of 'lulzy' humour.[57]

You're as Bad as They Are! *Nathan Barley* as Self-parody

This concern over a perceived closeness between subject and satirist, in which Morris and Brooker are regarded as not having maintained sufficient distance from their targets, was a much-discussed issue on the *Cook'd and Bomb'd* forums, where opinions were sharply divided about *Nathan Barley*. Even just after the first episode aired there was a discussion between those who believed apparently hackneyed elements such as the overly naturalistic acting, jolting camera work, crash zooms and the video being 'field removed' to make it resemble film, were due merely to ineptitude on the part of the creators or represented deliberate parody.[58] T. J. Worthington in his *Off the Telly* review of the programme's first episode writes that the 'visual techniques' employed in *Nathan Barley* are 'exactly those favoured by the real-life Nathan Barleys'.[59] In mimicking these, he asserts, the programme 'is not so much highlighting, attacking or subverting the current malaise as it is, presumably unintentionally, becoming a part of it'. Although he also toys with the possibility that the use of these techniques 'may be a deliberate statement of irony in itself', Worthington seems sceptical of the notion.[60] In the 'Fucking with Your Head Yeah?' para-textual booklet that comes with the Nathan Barley DVD, Nathan lists his own inspirations as a *mélange* of directors, criminals, musicians, events and imaginary characters, ranging from 'Kubrick' to 'Harvey Oswald' to 'Benn (Mr and Tony)'.[61] Through listing these figures next to each other without comment or comparison, their difference is flattened. Real people and imaginary alike are reduced to pop-cultural representations of the zeitgeist, which is broad enough to cover 'Plato' in the third century BC to 'Pac-Man' in the 1980s. These references, when divorced from any context or explanation, become hollow memes, propagated at the level of the signifier, as though they were all members of some all-embracing high/low cultural star-rating system. History and culture are reduced to the level of a Top 100 clip show. As such, it is appropriate that those gleaming white surfaces of the programme's *mise en scène* should be equally as traceable to

Kubrick's *A Clockwork Orange* (1971) as they are to the cyber-rave clothing shop 'Cyberdog' in Camden, as this is a critique of a culture that allows us jolts of name-checking recognition, without the ability to move to a further, deeper understanding. If we follow this logic we might then describe *Nathan Barley* as a parody *of pastiche*, that puts an empty gleaming surface before an empty gleaming surface which we watch until we, like one *Cook'd and Bomb'd* user, reach the 'horrible realisation that life is imitating Channel 4'.[62]

If source material is imitated with such precision that it becomes mistakable for the real thing, is it more accurately described as imitation or does it (unwittingly) become what Wes Gehring defines as a parody of 'reaffirmation'?[63] A parody like this resembles its source(s) to such a degree that the pleasure the audience derives from the parody is indistinguishable from the kind of pleasure it would have derived from its source. Such work bolsters (and indeed reaffirms) rather than deflates or satirises what it parodies. In the Foreword to Gerhring's work, Scott Olson provides the example of *Scream* (1996) as a reaffirming parody since it 'as much epitomizes a slasher film as parodies one'.[64] Yet, this is true to the intentions of the film – as Olson states, director Wes Craven clearly adores slasher films and has also produced straighter work, such as *A Nightmare on Elm Street* (1984) in the genre, albeit with differing degrees of parodic intent. *Wes Craven's New Nightmare* (1994) for instance, revisits *A Nightmare on Elm Street* and transforms it into a metafictional work. Unlike Craven, Morris and Brooker make quite clear in interview (and in the title of *TVGoHome*'s original column) that *Nathan Barley* is no affectionate send-up.[65] It would seem vitally important not to create a parody of reaffirmation if one does not wish in any way to reaffirm what one is parodying and so, to paraphrase another *Cook'd and Bomb'd* user, castrate one's own critique by celebrating what one seeks to disparage.[66]

Earlier it was mentioned that Dan might be considered an autobiographical insertion figure for Brooker. Dan's anxiety that he actually resembles the idiots he critiques is a concern that has been explored by Brooker at the personal level, with a surprising degree of candidness, throughout his oeuvre. Certainly, the irony implicit to the *Screenwipe* (BBC 4, 2006–) programmes, that we are watching a television programme about the insufferable nature of television programmes, is never meant to be lost on us. In an early episode, when Brooker lists the four more common types of television presenter, he inserts himself as a particularly egregious example at the end of his list. More recently, the second episode of *Black Mirror* (Channel 4, 2011), penned by Brooker with his wife Konnie Huq, concerns a character, 'Bing' Madsen (Daniel Kaluuya) who allows himself to be co-opted after he recites a bitter monologue about the exploitative practices of the reality show *Hot Shots*, while appearing on that very programme. Eventually Bing is given his own programme in which he makes similarly searing comments, but now from the comfort of a penthouse apartment. The subversive rhetoric is kept in place as a marketing tool, but the content behind the rhetoric is completely defanged. One might draw a parallel with Brooker's own career from an anonymous Internet presence critiquing televisual culture, to the presenter of a niche BBC 4 programme, to a celebrity who makes the same critiques on Channel 4's *10 o' Clock Live* (2010–). Also, I do not feel it would be disingenuous to draw this parallel as the metafictional and personal aspects of Brooker's earlier programming invite us to read his work autobiographically. Since Morris has always distorted his persona on television in a way which

obscures any sense we might have of the *real* Chris Morris, one would have to be more tentative in assuming that Morris is equally as concerned by the notion that he might be a false 'preacher man', deriding what he actually embodies. However, since the most publicity he had received prior to *Nathan Barley* was for his treatment of paedophilia in the *Brass Eye* Special, the media furore within the fifth episode of *Nathan Barley* over *SugarApe* publishing compromising and pornographic images of purportedly underage girls, invariably brings that affair to the viewer's mind. Receiving less publicity were Morris's 1994 Radio 1 shows. These broadcasts often involved pranks such as announcing the death of Johnnie Walker live on air and phoning security in order to ask them to remove the body and then taxidermists to stuff it (of course, many of these segments were cutaways, pre-recorded for the show). Additionally, Paul Garner was often dispatched to fulfil juvenile and bizarre instructions at Morris's behest, relaid to him from the studio. Now, Morris's pranks on the Radio 1 shows are, as one might expect, more sophisticated and less abusive than Nathan's, but clear parallels can be drawn between them. In show nineteen, Morris phones Peter Baynham's father to inform him that his son has stolen a baby, which has been dressed as a fly and is now called Big Spoon Baby Balloon, to Peter's father's utter bewilderment. On the *Nathan Barley* DVD extras, one can listen to a fictional podcast recorded by Nathan, Ned and Nathan's housemate Toby (Rhys Thomas). Nathan prank calls Toby's mother to Toby's distress, who is placed in a low-status position not unlike Baynham's own. Furthermore, the dispatches given to Paul Garner by mobile relay, find a convincing parallel in *Nathan Barley*'s last episode, when Dan blackmails Nathan into performing humiliating behaviour in public; like Morris with Garner, instructing him over a mobile phonecall. When *Nathan Barley* is considered in the context of both its creators' careers, we can see that not only might the programme embody aspects of what it seeks to criticise, but that post-ironic behaviour in which unethical behaviour is *performed* as though it weren't real or deflated through arch metacommentary, is common to both their careers; sometimes, as with phoning Peter Baynham's unwitting father, in instances that can't be simply classified as fictional.

Returning to *Nathan Barley* itself, we can see that Morris and Brooker set themselves a paradox. They needed to make a comedy programme about people laughing at stupid things, without making the viewers at home feel stupid and unable to laugh. Since the 'idiots' within the programme justify their enjoyment of puerile idiocy like 'cock/muff/bumhole', with the claim that they're laughing at the idea of stupid people finding these things funny, then the viewer is put in a compromising position. When watching *Nathan Barley*, if we laugh, we are in danger of laughing along with the idiots; sharing in their post-ironic enjoyment of degrading and puerile media. If we replicate Nathan's asinine catchphrases, then we are, whether ironically or not, imitating him and these memes are transmitted from the programme to the real world. We may choose to imitate these memes with an awareness of their stupidity, but this does not alter their content. We may try to suggest through context that we're 'ironically' quoting these ironic catchphrases, but this only further entrenches the pernicious phenomena the programme is critiquing. Essentially memes do not *care* about the context of their use; when repeated, they ably adapt to and succeed within a new context, as asinine as ever. However, fatally, *Nathan Barley* is structured around a traditional sitcom format. If the viewer does not laugh, if he/she does not repeat the programme's catchphrases, then they

are left just watching Nathan and the 'idiots' with a look of disapproval and a feeling of dis-
taste, like Dan. We can either indulge ourselves in stupidity, or watch with a jaundiced eye.
One viewer on the *Cook'd and Bomb'd* forum seemed to transcend this dilemma by watch-
ing the programme with a near zen-like acceptance, instructing others to 'just decide to like
it until you do and then you will'.[67] The viewer should give him or herself over to laughter,
not analysis.[68] Under such advice, it would be futile for Dan to resist the temptations of the
'idiots' and he should throw himself with abandon into his pursuits of tramp-racing and
games of 'cock/muff/bumhole'. The programme is structured so as to be pessimistic about
Dan's chances for escape. When he claims to be leaving the magazine, he's back working
there at the end of the episode. Many of the fads engaged in by his co-workers, he ends up
partaking in himself. Likewise, though Claire often voices her disapproval of Nathan, she is
clearly shown to be hypocritical, whether through laughing at Nathan's cruel pranks on Pingu
(Ben Whishaw) or selling her documentary to unscrupulous production companies. Both
cynicism (Dan) and idealism (Claire) are shown to be fallible in the face of cheerful amoral-
ity, since both represent a viewpoint (the world is contemptible and cannot be changed/the
world is contemptible and should be changed) that when confirmed in the case of cynicism
or defeated in the case of idealism, leaves the individual more bereft than they were before.
By contrast, Nathan lives a tautological existence – cool because he knows himself to be
cool. Only when the cynicism of Dan or the idealism of Claire encroaches upon his world
does he become unhappy, such as when Dan forces him to paint 'idiot' on his chest and stand
in his underwear in front of a webcam,[69] or when Claire criticises him for having sex with a
girl Nathan believed to be underage.[70] Yet in these instances Nathan deploys the mechanism
of post-irony to regain the higher status. In the case of his ousting by Claire, he finds that his
acquaintances actually think it's cool that he slept with a thirteen-year-old (in actual fact he
didn't, but Nathan believed she was at the time she was giving him fellatio, not having known
her age up to this point). The episode ends with Nathan bragging about his conquest over
the phone, asking the person at the other end of the line to guess the girl's age: 'younger …
younger … technically a Polanski'. Here Roman Polanski is invoked as an icon, as with the list
of interchangeable inspirations in the DVD booklet. Polanski's statutory rape of a
thirteen-year-old is not treated as an act of ethical and legal immorality, but as a cultural
meme. The shift of 'Polanski' from a name to an act, slips cultural capital into Nathan's behav-
iour – Polanski's status as a 'cool' director, his rape of a thirteen-year-old and Nathan's
fellatio from Mandy all become conflated, as though each were associated with the others
in mutual legitimacy, rather than contamination. It is not any moral value that Polanski con-
fers, but rather his iconic value, that bestows worth. This is why, of course, Saddam Hussein
and 9/11 can both be included in Nathan's list of inspirations.

Nathan Barley's reference to Polanski was compared unfavourably on *Cook'd and Bomb'd*
to a similar reference in a 2001 episode of *Family Guy* (Fox, 1999–) in which the evil baby
Stewie is playing house and when questioned, says he is playing 'Roman Polanski's house'; this
was seen to be a legitimate joke, while the use of Polanski in *Nathan Barley* was said to be
merely a reference.[71] In fact, I'd argue exactly the opposite – its use in *Barley* is a critique of
what *Family Guy* is doing, which is asking the audience to recognise a reference as an invita-
tion to laughter without analysis. In the *Family Guy* joke, 'Gary Glitter's house' or 'John Wayne

Gacy's house' might have been used interchangeably with 'Polanski's house' without chang-
ing the meaning of the joke. Much could be written about the cheery nihilism of *Family
Guy* and its apolitical stance in contrast to *The Simpsons* (Fox, 1989–) or *South Park*
(Comedy Central, 1997–) but that would be a different, although not entirely unrelated,
kettle of fish.

When it seems that Dan, at the end of the series, has finally humiliated Nathan, Nathan
triumphs through having his 'Prank'd' videos recognised by a television executive (Stephen
Beresford) Claire is pitching to, who admiringly describes them as 'Swift as *Jackass*.' 'Or even
faster!' is Nathan's reply.[72] Here, Nathan is witlessly rescued by the assumption of irony on
the part of the commissioning executive. It is assumed that his *Jackass*-style pranks must be
working ironically; that they are a commentary upon, rather than an embodiment of, the cru-
elty of the 'prank generation'. Again, this is post-irony, so there is no gap in meaning –
Nathan's cruel pranks are taken as an ironic commentary about themselves; a self-satire.

David Foster Wallace and the Televisual Co-option of Irony

So, there is no content to attack, only deferral – how does one thrust a knife through some-
thing that has no substance? Clearly, idealism as represented by Claire and cynicism as rep-
resented by Dan, both fail within the programme. Idealism is too easily co-opted or exposed
as hypocrisy. Cynicism is inactive, emasculated and self-defeating (by the end of the series,
Dan has thrown himself from the window of Nathan's flat). Likewise, how does one produce
satire of 'a formless and opinionless cloud'?[73] Judging by the reactions of the critical press,
what is being satirised in *Nathan Barley* is so diffuse and immaterial, that the target of the
satire went either un- or misrecognised. Judging by Internet commentary, the satire failed to
differentiate itself from its source material and so merely ended up replicating it. The reason
for this, I would contend, is that the programme sought to imitate both the form *and* the
content of what it was satirising. So if, as I have argued, the programme is attempting to
ridicule a tendency towards post-irony (that is, self-regarding faux-irony that reinforces rather
than critiques an existent position) within increasingly dominant sections of mainstream cul-
ture (independent magazines and the Internet; both often written about and celebrated by
academics and users as subcultural) it not only imitates the content of these vehicles of post-
irony (pranks, empty pop-cultural references, juvenile obscenity which is 'good cause it looks
like it's good because it's rude') but also the form of these vehicles (heavily processed DV
with excessive post-production effects; insipid Flash animations; glossy magazine covers). In
1993, David Foster Wallace wrote that, 'for at least ten years now television has been ingen-
iously absorbing, homogenizing and re-presenting the very cynical postmodern aesthetic that
was once the best alternative to the appeal of low, over-easy, mass-marketed narrative'.[74] If
Foster Wallace was correct in noticing that the proliferation of post-irony[75] was endemic to
television by the early 1990s, then critiquing the phenomena in the form of a cynical televi-
sion programme will result in inevitable assimilation, as any commentary made ironically (such
as Nathan nodding smugly along to the 'Rise of the Idiots' article that criticises an archetype
he witlessly embodies or Dan shouting 'I'm not a preacher man' while dressed as a preacher

man) belongs to a mode of critique already long co-opted. Foster Wallace says the same of those 1990s fiction writers who took televisual culture as their subject matter; that such a literature was 'doomed by its desire to ridicule a TV-culture whose ironic mockery of itself and all "outdated" value absorbs all ridicule'.[76] As Nathan himself says, 'Today ridicule … tomorrow, *really cool!*'[77]

Though Foster Wallace is referring specifically to *tele*visual culture, he also argues that a more democratic medium (the Internet goes unmentioned) would not be immune to the same problems, but rather;

> in the absence of any credible, noncommercial guides to living, the freedom to choose is about as 'liberating' as a bad acid trip: each quantum is as good as the next, and the only standard of an assembly's quality is its weirdness, incongruity, its ability to stand out from a crowd of other image-constructs and wow some audience.[78]

This brings us to the Internet culture of 'epic win' and 'epic fail' in which the most successful memes are those imbued with novelty, which self-referencing post-irony can help facilitate. Within *Nathan Barley* it is this feature that ensures the success of The Bikes' song 'Terrorists Are Gay' or of Nathan's crude masturbating monkeys Flash animation, but likewise these can only maintain the interest of the viewer through either their incongruity within the television schedule or else through congratulating the knowing viewer who realises that these spectacles should be received ironically, in which case the programme ends up inviting 'complicity between its own witty irony and veteran-viewer Joe's cynical nobody's-fool appreciation of that irony'.[79] Again, the critique of irony becomes assimilated into an overriding televisual irony, thus neutering the technique.

Of course, not all of *Nathan Barley* is directly concerned with the infinite regression of post-irony and its prevalence within mediated forms of communication like magazines and the Internet. The series is broad and digressive enough to include sideswipes about the inanity of modern art, the way technological style has eclipsed genuine usefulness and the ludicrousness of twenty-first-century club music. Yet even these similarly disparate phenomena can be subsumed under or at least somewhat explicated by a cultural prevalence of post-irony. The modern artist send-up figure in *Nathan Barley*, 15Peter20 (Iddo Goldberg), who takes photographs of celebrities urinating, exploits a spectatorial assumption that the work is somehow, in some unspecified way, *ironically* puerile – that the work's puerility must be a commentary upon the very puerility of modern culture. Nathan's phone – fake billboard posters of which advertised the show – the 'Wasp T12 Speechtool', comes equipped with a giant number five button, purportedly because it's the most commonly pressed number.[80] Clearly, this is aesthetics masquerading as ergonomics, as is the fact that the phone is 'shark proof'. The very functionlessness of the phone becomes its selling point. The phone is being marketed as a hyperrealisation of mobile-phone technology and so is more of a self-aware stylistic gesture than it is a real phone.[81] The phone is a post-ironic statement about itself and, as such, must *by necessity* be functionally useless. With regards to the music, I suspect that Morris and his longterm musical collaborator Jonathan Whitehead just enjoy cooking up glitchy, discordant, ridiculous music, but even Nathan's DJ set is but a

host of 'ironic' cultural references to bands of the 1980s, like ABC, without any compelling thematic or rhythmic reasons rationale linking the tracks. As well as dancing, the clubgoers are expected to nod their heads ironically to music no longer merely 'good because it's bad', but which has elided the categories of 'good' and 'bad' altogether so that we are left with not music, but noise.

Well Futile?

Post-irony subsumes, consumes and renders culture homogenous. If, in this chapter, it has seemed a rather elusive and magical concept, spread too thinly over a diverse array of phenomena, I can but apologise and plead the defence that once one starts looking at culture from a post-ironic perspective, everything appears post-ironic. Earnestness seems suspect. Authenticity becomes just another affectation. Perhaps, if we are to take any lesson from the subcultures of the Internet, it should be, 'Don't feed the troll.'[82] By giving 'Nathan Barley' attention – both, diegetically, the character and non-diegetically, the programme – the post-ironic meme is propagated. To return to the notion of memes described earlier by Susan Blackmore: through stickering, flyposting and graffiti campaigns, Nathan distributes 'Nathan Barley' as a meme or, in his own words, 'a self facilitating media node'.[83] The insidious ubiquity of this particular meme is evident in the very title of the programme, as though the virulence of Nathan's self-promotion were such that his branding had broken free from the diegesis of the programme and plastered itself across the paratextual space of DVD covers and television listings. This deeper insinuates Nathan into the sitcom's form itself. The programme – with its catchphrases, gleaming surfaces, twitchy editing, glitchy soundtrack, offensive content, the parodying of pranks from Morris's own career and the casting of actors from the 'random' *Mighty Boosh* – seemingly exemplifies what it seeks to criticise. Whether this is a brilliant rhetorical manoeuvre in which form reflects content, or a failure to disentangle the focus of the satire from the satire itself, is a matter as ambivalent and non-committal as post-irony itself.

Notes

1. A paraphrasing of one of Nathan's catchphrase-like descriptives from episode one of *Nathan Barley*. Chris Morris and Charlie Brooker, Channel 4 (2005), DVD.
2. Kurt Vonnegut, *Mother Night* (London: Vintage, 1992), p. vi.
3. Paul Hoggart, 'Nathan and Joey Fail to Make Their Marks', *The Times* (14 February 2005), <http://www.cookdandbombd.co.uk/forums/index.php?page=cabkbarticle&id=303>; Rowland White, 'Sunday Times TV Review', *Sunday Times* (20 February 2005), <http://www.cookd andbombd.co.uk/forums/index.php?page=cabkbarticle&id=300>; Taras Young, 'Morris's New Clothes', *Student Newspaper* (21 February 2005), <http://www.cookdandbombd.co.uk/forums/index.php?page=cabkbarticle&id=298>.
4. Mark Lawson, 'Public Enemy Number Two', *Guardian* (4 February 2005), <http://www.cookd andbombd.co.uk/forums/index.php?page=cabkbarticle&id=271>; Andrew Billen, 'Triumph of

Idiots', *New Statesman* (14 February 2005), <http://www.cookdandbombd.co.uk/
forums/index.php?page=cabkbarticle&id=286>; Damien Love, 'The Face of a New Generation',
Sunday Herald (4 February 2005), <http://www.cookdandbombd.co.uk/forums/
index.php?page=cabkbarticle&id=280>.

5. Hoggart, 'Nathan and Joey Fail to Make Their Marks'.

6. Neil Boorman, 'Too Little, Too Late', *The Times* (5 February 2005), <http://www.cookd
andbombd.co.uk/forums/index.php?page=cabkbarticle&id=273>; Ben Deedes, 'Out of Style',
Big Issue (7 February 2005), <http://www.cookdandbombd.co.uk/forums/index.php?page=
cabkbarticle&id=287>.

7. Lawson, 'Public Enemy Number Two'; Alison Graham, 'Radio Times Preview', *Radio Times*
(7–13 February 2005), <http://www.cookdandbombd.co.uk/forums/index.php?page=
cabkbarticle&id=285>.

8. The phrase belongs to Kathryn Flett, 'Beyond Satire', *Observer* (13 February 2005),
<http://www.guardian.co.uk/theobserver/2005/feb/13/features.review37>; Billen, 'Triumph of
Idiots'; Christopher Howse, 'Nathan Barley Is So Laughable He Makes You Want to Cry',
Telegraph (18 February 2005), <http://www.telegraph.co.uk/comment/columnists/
christopherhowse/3614975/Nathan-Barley-is-so-laughable-he-makes-you-want-to-cry.html>.
Both concur with this reading of the series' concerns.

9. *Nathan Barley*, episode one.

10. *Nathan Barley*, episode three.

11. Euan Ferguson, 'Why Chris Morris Had to Make *Brass Eye*', *Observer* (5 August 2001),
<http://www.guardian.co.uk/uk/2001/aug/05/news.film>.

12. Zoe Williams, 'The Final Irony', *Guardian* (28 June 2003), <http://www.guardian.co.uk/
theguardian/2003/jun/28/weekend7.weekend2>.

13. Ibid.

14. Ibid.

15. Kevin Guilfoile, 'Irony, It Has Happened to Me', *Infinite Summer* (27 August 2009),
<http://infinitesummer.org/archives/1546>.

16. Matthew Collins, 'Post-irony Is Real, and So What?', *Georgetown Voice* (4 March 2010),
<http://georgetownvoice.com/2010/03/04/post-irony-is-real-and-so-what>.

17. Werner Herzog quoted in Paul Cronin (ed.), *Herzog on Herzog* (London: Faber and Faber, 2002),
p. 26.

18. Jesse Thorne, 'A Manifesto for the New Sincerity', *Maximum Fun* (26 March 2006),
<http://www.maximumfun.org/blog/2006/02/manifesto-for-new-sincerity.html>.

19. Scott King, 'Editorial', *Scott King Projects*, <http://www.scottking.co.uk/projects/editorial>.

20. *Nathan Barley*, episode one.

21. *Nathan Barley*, episode six.

22. Lucian Randall, *Disgusting Bliss: The Brass Eye of Chris Morris* (London: Simon & Schuster, 2010),
p. 242.

23. Ibid., p. 243.

24. Charlie Brooker quoted by Bruce Dessau, 'Can TV's King of Satire Do Sitcom?', *Evening Standard*
(8 February 2005), <http://www.cookdandbombd.co.uk/forums/index.php?page=
cabkbarticle&id=283>.

25. Charlie Brooker, *TVGoHome* (10 October 2001), <http://www.tvgohome.com/1010-2001.html>.

26. *Nathan Barley,* episode five.

27. Charlie Brooker interviewed by Matthew Phelan, 'The Creators of *Nathan Barley*', *Flak Magazine* (2 January 2008), <http://www.flakmag.com/features/nathanbarley.html>.

28. See *Nathan Barley* online image gallery. 'Barley. Gallery', <http://www.trashbat.co.ck/barley/gallery.html>.

29. See Jamie-James Medina, 'Vice Fashion – Still Hungry', *Vice* (2006, month unknown), <http://www.viceland.com/int/v13n3/htdocs/fashion2_uk.php>.

30. King, 'Editorial'.

31. Joy Press, 'Vice Bust: Kicking the Jackass of the Magazine World', *Village Voice* (12 November 2002), <http://www.villagevoice.com/2002-11-12/news/vice-bust/2>.

32. Ibid.

33. Anita Harris, 'gURL Scenes and Grrrl Zines: The Regulation and Resistance of Girls in Late Modernity', *Feminist Review* no. 75 (2003), p. 45.

34. Timothy Bewes, *Cynicism and Postmodernity* (London: Verso, 1997), p. 41.

35. Boorman, 'Too Little, Too Late'.

36. Jess Cartner-Morley, 'Where Have All the Cool People Gone?', *Guardian* (21 November 2003), <http://www.guardian.co.uk/lifeandstyle/2003/nov/21/fashion1>.

37. Nicholas Burns interviewed by Gemma Clarke, 'Interview with Nicholas Burns', *Observer* (13 March 2005), <http://www.cookdandbombd.co.uk/forums/index.php?page=cabkbarticle&id=318>.

38. Boorman, 'Too Little, Too Late', and Deedes, 'Out of Style'.

39. Johnny Dee, 'Box Set Club: Nathan Barley', *Guardian* (20 September 2011), <http://www.guardian.co.uk/tv-and-radio/tvandradioblog/2011/sep/20/box-set-club-nathan-barley>. *Jackass* (2000–2) was an MTV programme in which a group of men performed dangerous stunts, often inflicting considerable physical pain to themselves or each other in the process.

40. Charlie Brooker interviewed by Ali Plumb, 'Charlie Brooker Talks Black Mirror', *Empire* (February 2011),<http://www.empireonline.com/interviews/interview.asp?IID=1467>.

41. Charlie Brooker, 'Underwhelmist', Twitter (3 July 2012), <http://twitter.com/#!/charltonbrooker>.

42. Charlie Brooker interviewed by 'Neil', 'Comedy Chat #15' podcast, *Cook'd and Bomb'd* (5 July 2011), <http://comedychat.co.uk/2011/07/05/a-chat-with-charlie-brooker>.

43. David Lewis, '*Black Mirror:* "The National Anthem" Review', *Cult Box* (4 December 2011), <http://www.cultbox.co.uk/reviews/episodes/2560-black-mirror-the-national-anthem-review>.

44. ABC News, 'Worst Song Ever? Rebecca Black Responds: "I Don't Think I'm the Worst Singer"', *YouTube* (18 April 2011), <http://youtu.be/AjFlzWjT5I4>.

45. Brooker, 'Underwhelmist'.

46. Chris Onstad, *Achewood* (11 January 2007), <http://achewood.com/index.php?date=01112007>.

47. *Nathan Barley*, episode two.

48. Cragside, *Cook'd and Bomb'd*, 'Nathan Barley – Episode Two' thread (18 February 2005), <http://www.cookdandbombd.co.uk/forums/index.php?topic=6990.60>.

49. Susan Blackmore, *The Meme Machine* (New York: Oxford University Press, 1999), p. 4.

50. Ibid., p. 7.

51. Ryen McPherson interviewed by Chad Clinton Freeman, *Polly Staffle*, 'Hell's Tour Guide' (July 2006), <http://www.pollystaffle.com/questionsandanswers/ryenmcpherson.shtml>.

52. See twisternederland7, 'Fail Compilation December 2010', *YouTube* (28 December 2010), <http://youtu.be/q3rlNv0n_eo> and Blaster7492, 'Best of FAILS 2010 Compilation', *YouTube* (15 January 2010), <http://youtu.be/Ln_omwmlEu4>.

53. A glib, but telling definition provided by various users at <www.urbandictionary.com>: 'Lulz is the one good reason to do anything, from trolling to rape.' Examples given of things one might do 'for the lulz' include setting people on fire, bombing the World Trade Center and posting an image of fifty Hitlers. Again, the reality or fiction of these acts is not considered relevant and they are all eminently interchangeable. All that matters is that they were done for the lulz.

54. *Nathan Barley*, episode five.

55. Chris Morris, Michael Cumming and Tristram Shapeero, *Brass Eye*, Channel 4 (2007), DVD.

56. Morris in *Flak*.

57. For a definition of 'for the lulz' – a bastardisation of 'lol' – please see endnote 49.

58. Various users, 'Nathan Barley – Episode One', *Cook'd and Bomb'd* (February 2005), <http://www.cookdandbombd.co.uk/forums/index.php?topic=6879.420> through to <http://www.cookdandbombd.co.uk/forums/index.php?topic=6879.510>.

59. T. J. Worthington, 'Nathan Barley', *Off the Telly* (11 February 2005) (Online) <http://www.offthetelly.co.uk/?p=4250>.

60. Ibid.

61. 'Fucking with Your Head Yeah?' booklet with the *Nathan Barley* DVD: 'Inspirationz & Salutz'.

62. Burpmitosis, 'Nathan Barley – Episode One', *Cook'd and Bomb'd* (11 February 2005), <http://www.cookdandbombd.co.uk/forums/index.php?topic=6879.90>.

63. Wes D. Gehring, *Parody as Film Genre* (Westport, CT: Greenwood Press, 1999), pp. 6–7.

64. Scott Olson, 'Preface', in Gehring, *Parody as Film Genre*, p. xiv.

65. Morris and Brooker interviewed by Stephen Armstrong, 'It's Hard to Be an Idiot', *Sunday Times* (27 March 2005), <http://www.cookdandbombd.co.uk/forums/index.php?page=cabkbarticle&id=324>.

66. Jutl, 'Nathan Barley – Episode Five', *Cook'd and Bomb'd* (12 March 2005), <http://www.cookdandbombd.co.uk/forums/index.php?topic=7306.120>.

67. Slackboy, 'Nathan Barley – Episode Three', *Cook'd and Bomb'd* (27 February 2005), <http://www.cookdandbombd.co.uk/forums/index.php?topic=7126.300>.

68. A sentiment which intriguingly resembles my younger brother's explanation of the humour of lolcats to me as being funny *because* they're funny.

69. *Nathan Barley*, episode six.

70. *Nathan Barley*, episode five.

71. Mayer and Rats, 'Nathan Barley – Episode Five', *Cook'd and Bomb'd* (14 March 2005), <http://www.cookdandbombd.co.uk/forums/index.php?topic=7306.270>.

72. *Nathan Barley*, episode six.

73. 'Nathan Barley – Episode One', *Cook'd and Bomb'd* (13 February 2005), <http://www.cookdandbombd.co.uk/forums/index.php?topic=6879.450>.

74. David Foster Wallace, 'E Unibus Pluram: Television and U.S. Fiction', in *A Supposedly Fun Thing I'll Never Do Again* (London: Abacus, 1998), p. 52.

75. My phrase of course, not Wallace's; though I would argue we are describing the same state of affairs.

76. Wallace, 'E Unibus Pluram', p. 81.

77. *Nathan Barley*, episode four.

78. Wallace, 'E Unibus Pluram', p. 79.

79. Ibid.

80. *Nathan Barley* spoof 'Wasp T12 Speechtool' advert. 'Wasp T12', <http://www.trashbat.co.ck/t12/index.html>.

81. Here I am building on an argument made by Jean Baudrillard in *The System of Objects* that 'automatism' in the design of objects can be connotative of their hyperfunctionality even when this automatism necessitates design choices which render the object *less*, rather than more usable. Jean Baudrillard, *The System of Objects*, trans. James Benedict (London: Verso, 2005), pp. 117–18.

82. An Internet phrase that encourages users to not engage in dialogue with individuals who are seen to be 'trolling' for a response through irritating, belligerent or obnoxious behaviour.

83. *Nathan Barley*, episode one.

12

'DAD'S ARMY SIDE TO TERRORISM':[1] CHRIS MORRIS, *FOUR LIONS* AND JIHAD COMEDY

SHARON LOCKYER

Chris Morris's debut feature film, *Four Lions* (2010), focuses on a small group of jihadi Islamist terrorists from Sheffield, England.[2] *Four Lions* received a wealth of media and public attention, which is perhaps unsurprising given Morris's reputation as a taboo-breaking controversial satirist who some describe as 'unacceptably tasteless and needlessly shocking'.[3] Such attention was largely positive, for example Jonathan Romney described *Four Lions* in the *Independent as* a 'bold venture [which] shows that Morris dares laugh where others only splutter with nervous embarrassment: *Four Lions* puts the error in terror'.[4] However, there were less favourable reviews. In an article entitled 'Lions Are Not a Roaring Success', Christopher Tookey argued that '[i]n the end, Morris's attempts to explore the boundaries of humour is exploded [sic] by a lethal combination of furtive political correctness and transparently terrible taste'.[5] Despite these differing views, journalists, film critics and audiences were united in their interpretation of *Four Lions* as a *comedy* and acknowledged the comedic *intent* of the film (even if some audiences did not find *Four Lions* particularly funny).

Positive coverage described *Four Lions* as a 'suicide bomber comedy';[6] the 'world's first comedy film about jihadist terrorists';[7] 'a comedy about an inept group of home-grown jihadist suicide bombers';[8] and the *New York Times* referred to it as 'hilarious, stiletto-sharp satire … unsparing and yet curiously affectionate'.[9] Similarly, negative responses labelled it 'a new comedy by *Brass Eye* creator';[10] 'not so much sophisticated satire as sitcom humour';[11] a 'black comedy';[12] 'an irreverent farce about suicide bombers';[13] and the *New York Post* argued 'He's [Morris] taken what might make a funny sketch and forced it to run more than an hour and a half.'[14] Others who recognised both positive and negative aspects of *Four Lions* referred to it as a 'dark comedy';[15] 'a comedy about British suicide bombers';[16] and a 'comedy' which seeks 'to satirise four aspiring suicide bombers'.[17] This shows *Four Lions*' status as a *comedy* was widely acknowledged and largely undisputed. Despite this, media and public discussions surrounding the intent and reception of *Four Lions* failed to consider or debate *how* the film operates as a *comedy*. This chapter rectifies this imbalance by interrogating the film's narrative, characterisation, linguistic features and performativity through a theoretical lens in order to examine how the film operates comedically. The theoretical lens draws on three main comedy theories – the superiority theory, the incongruity theory and the relief

theory. The analysis concludes with a discussion of the opportunities and limitations afforded to contemporary comedy. Particular emphasis is given to the sociopolitical limits of comedy.

Introducing *Four Lions*

Four Lions was written by Morris, Jesse Armstrong and Sam Bain, with additional material by Simon Blackwell. It was directed by Morris and produced by Mark Herbert and Derrin Schlesinger. The main cast are Riz Ahmed (who plays Omar), Kayvan Novak (Waj), Nigel Lindsay (Barry), Adeel Akhtar (Faisal) and Arsher Ali (Hassan). *Four Lions* premiered at the Sundance Film Festival in January 2010 where it was also nominated for the Sundance Film Festival's World Cinema Narrative Prize.[18] The UK premiere took place at the end of March 2010 at the Bradford International Film Festival and it was later released in the UK on 7 May 2010. During its opening weekend box-office takings totalled £609,000 from 115 screens.[19] Since then it has been shown in over twenty-five countries including France, Sweden, the Czech Republic, Estonia, Italy, the US, Australia, South Africa, Russia and Singapore.[20] It was released on DVD and Blu-ray at the end of August 2010. The UK television premiere of *Four Lions* took place on 4 September 2011 as part of Channel 4's season of programmes marking ten years since 9/11.[21]

Four Lions follows four bumbling radicalised would-be suicide bombers from Sheffield who hatch a plan to kill thousands of participants and spectators at the London Marathon. They encounter a number of problems in doing so because as terrorists they are inept. The terror cell is led by Omar who is disillusioned by Western society and equally frustrated by the incompetence of his fellow cell members. These initially include the intellectually challenged Waj, ill-tempered White Islamic convert Barry and Faisal, the quietest and gentlest of the group, who attempts to teach crows to become bombers and accidentally blows himself up in a field. Barry later recruits young student and rapper Hassan to the terror cell.

The Sundance Film Festival described *Four Lions* as 'a comic tour de force; it shows that while terrorism is about ideology – it can also be about idiots'.[22] One of the *Four Lions* writers, Sam Bain, has explained what the creators of the film see as their target: 'None of us wanted to write a film ridiculing Islam or Muslims … . But we did want to write a film ridiculing terrorists.'[23] Another writer, Jesse Armstrong, has argued that they wanted to focus on how 'there was a ridiculous nature to some of their [terrorists'] actions'.[24] As the title of this chapter suggests, Morris has described *Four Lions* as representing the 'Dad's Army Side to Terrorism'. *Dad's Army* was a BBC sitcom (BBC 1, 1968–77) about the Home Guard's incompetent efforts to prepare to protect Britain in the event of a Nazi invasion. Thus the creators of *Four Lions* were united in what they regarded as the target of their comedy – the perpetrators of suicide bombings, their incompetence and the absurdity of human behaviour.

Although different in format and content to Morris's previous productions, such as *Brass Eye* (Channel 4, 1997; 2001), Morris approached the production of *Four Lions* as he approached earlier comedic productions. As discussed by Randall, Morris and Armando Iannucci carefully observed news programmes prior to writing *On the Hour* (BBC Radio 4,

1991–2) and *The Day Today* (BBC 2, 1994).[25] Research for *Four Lions* was 'said to concern UK-based Islamic fundamentalists [and] included lengthy discussions and correspondence with former Guantanamo Bay inmate Moazzam Begg as well as intensive study of the nuances of Islam'.[26] The 'extras' on the *Four Lions* DVD include material gathered during the research phase of the film's production.

The director of *Four Lions*, its writers and some of its lead actors have won a number of awards for the film. These include a BAFTA for Outstanding Debut by a British Writer, Director or Producer (2011); a British Comedy Award for Best British Comedy Performance in Film (2010); an Empire Award for Best Comedy (2011); a Special Jury Prize at the Monte Carlo Comedy Film Festival (2010); and a San Diego Film Critics Society Award for Best Original Screenplay (2010).[27] *Time Magazine* placed *Four Lions* in the top ten films of 2010.[28] Thus Morris seems to have been successful in his desire to generate comedy from an unlikely comedic topic – suicide bombers. How then can the comedy be understood in *Four Lions*? Comedy theory can help us answer this question.

Comedy Theory and *Four Lions*

Although there is 'no single adequate theory of comedy'[29] there are many explanations regarding how particular features of comedy work that derive from a range of disciplines, including sociology and psychology and mathematics and linguistics. Three main theoretical approaches dominate academic debate regarding the workings of comedy – the superiority theory, the incongruity theory and the relief theory. Stott refers to these as the 'most durable explanations' of comedy.[30] These theories suggest that comedy fulfils social, psychological and physiological needs and desires.[31] As several detailed accounts of comedy theory exist,[32] and in the interests of space, a brief summary of each theory is included here in order to situate the analysis of *Four Lions*.

Superiority Theory

Philosophers have grappled with the complexities of comedy for over 2 thousand years. The oldest theory of comedy, the superiority theory, maintains that laughter occurs when we feel superior to other people and this superiority may be intellectual, physical, psychological and/or moral. Plato and Aristotle believed that laughter was generated by the inadequacies of other people, and Aristotle viewed humour as 'a sort of abuse'.[33] Palmer notes that here 'the pleasure of laughter is in itself not a worthy aim; its justification is that it can serve to educate wrongdoers by deriding them'.[34]

There are many instances in *Four Lions* where Morris employs jokes and comic narratives that sit within the superiority theory of comedy. These occasions deride the beliefs and behaviour of Islamist terrorists and present them as laughable and incompetent individuals. The first example of this takes place in the opening scene where Faisal, Waj, Barry and Omar are attempting to record a martyrdom video. The limited knowledge and intellect of most

Faisal, Waj, Barry and Omar record a martyrdom video

of the group's members, in particular Waj, are revealed. In this scene, which Brew refers to as 'one of the finest beginnings for a comedy movie in recent times',[35] Waj, being filmed by Barry, holds a 'replica' AK-47, which is much smaller than a genuine AK-47. In response to Barry's question 'What's with the gun?', Waj replies 'Proper replica man'. When Barry argues that it is too small and more appropriate for an Action Man, Waj explains that it is 'Not too small, brother … . My hands … . Big hands … I'll hold it near to the camera. That'll bigger it' as he moves closer to the camera so that the gun looks bigger (which of course is not the case) much to Omar's despair (and to the audience's amusement).

 This opening scene also ridicules the propagandist communication strategies, or self-representational techniques, used by terrorists in their martyrdom videos and the power that such jihadist videos are perceived to hold by their creators. Critiquing the role, position and perceived power of contemporary media and the lack of understanding surrounding new communication technology are staple ingredients of Morris's work (for example, *On the Hour* and *Brass Eye*) and are scattered across *Four Lions* as well. For example, Barry demands that mobile-phone SIM cards should be swallowed to prevent the terror cell members being tracked by the police and that they should violently shake their heads from side to side as an 'anti-surveillance strategy' to prevent detection and identification on CCTV.

 Waj and Barry are not the only cell members shown to be lacking intelligence, so providing some audiences with a sense of superiority over them. When questioned by Barry about how he managed to purchase large quantities of liquid peroxide from the same shop during his three years of stockpiling Faisal explains how he put on different voices – his own voice, an IRA voice and a woman's voice. However, all of these voices sound the same; asked by Barry why he covered up his chin and mouth when affecting the woman's voice, Faisal half-heartedly explains, 'Cos she's got a beard', thus revealing how unconvincing his disguise was. In this scene, as with many others, we see Hassan using a video camera to record their conversations and actions. Later in the narrative, we learn that Hassan has failed his Media

Studies examination, again highlighting the fact that new communication technologies remain beyond some people – although Hassan presents himself as technologically savvy with an almost obsessive compulsion to record everything, his academic grasp and appreciation of new technology is extremely limited failing to meet the minimum formal examination requirements.

The members are also presented as childlike and childish throughout, via their constant infantile bickering and confused (and confusing) arguments – for example, over what should be the target of their suicide bombings (a mosque, Boots the chemist, the Internet or the London Marathon) or following Faisal's unexpected death, whether or not he was a martyr – and specific comic moments illustrate their juvenility. These include Waj explaining to Omar's uncle when they arrive in Pakistan that his teddybear is a 'Prayer Bear, he does me prayers', pushing the bear's stomach so that it begins to recite prayers and Waj taking a children's book entitled 'The Camel That Went to the Mosque' to Pakistan. This is further extended when Waj and Omar justify their planned suicide bombings in metaphorical terms as wanting to be on the Rubber Dinghy Rapids ride at Alton Towers and not simply in the queue waiting for the ride. Further, in slapstick fashion Omar misfires a rocket launcher (due to him holding it back-to-front) when he and Waj are in Pakistan, destroying the training camp. Later it is revealed that Omar's mistake killed Osama bin Laden, who was residing at the camp.

Presenting would-be suicide bombers in an idiotic fashion was considered particularly powerful by some audience members. For example, Mendelson, who referred to *Four Lions* as 'oddly comforting', also noted that there 'is a weird kind of hope in witnessing the incompetence of your enemies'.[36] Instead of presenting suicide bombers to be all-threatening and powerful, the comedy in *Four Lions* renders them ridiculous, and the laughter generated is, in Thomas Hobbes's terms, the feeling of 'sudden glory',[37] where we find another person, or group of people, ludicrous. Critchley argues that through laughter at 'power, we expose its contingency, we realise that what appeared to be fixed and oppressive is in fact the emperor's new clothes, and just the sort of thing that should be mocked and ridiculed'.[38]

Incongruity Theory

The dominance of the superiority theory was challenged in the eighteenth century by the incongruity theory, which is often regarded as the most widely accepted theory of comedy.[39] This theory draws attention to the structure of comedy and emphasises the importance of cognition in the comedy process. It recognises the significance of the surprise element as laughter is generated by the unexpected, the odd, inconsistent or anything deemed out of place. Incongruity can be created by fusing two situations, ideas, concepts or individuals usually regarded as separate and distinct. Wordplay can also generate incongruity as one word or phrase can have two different meanings. Typically, the joke teller and audience are united by applying one meaning to the word or phrase whereas the joke's target imputes a different meaning (which is recognised by the joke teller and the audience). Contrary to the views of incongruity theorists Immanuel Kant and

Arthur Schopenhauer, the comic opportunities thus afforded are not limitless.[40] An element of plausibility or logic is necessary, which Palmer refers to as the 'logic of the absurd'[41] or 'simultaneous plausibility and implausibility'.[42] This is needed so that audiences can understand and appreciate why the incongruity was produced.

There are several examples in *Four Lions* where words and phrases have been carefully chosen by Morris because they have more than one meaning. Towards the end of the film, Waj holds a hostage in a kebab shop in London and has a mobile phone conversation with Ed, a Special Branch Officer. In order to find out more about Waj and to keep him talking, Ed asks Waj if he likes women – 'What about girls? I bet you like the ladies … . Right so what sort of girls are you into, then, Waj?' Waj says he likes ones with 'big jubblies and that … . And nice fit arses too, man.' Ed responds 'You're an arse man, aren't you, Waj? I knew you were, bro. You're an arse man. You're a massive arse man.' When Waj asks what Ed is saying, Ed replies 'I'm saying you're an arse man, Waj.' Waj replies, annoyed, 'You giving me batty chirps, bro? You calling me a whammer? … . Fuck off!' Comic weight is given to the differing meanings attached to key words in this conversation. Whereas Ed is using the term 'arse man' to refer to Waj's preference for women's backsides, Waj interprets it to mean homosexual practices, and so becomes offended. This strategy is also used to ridicule the Metropolitan Police Service. During the London Marathon scenes, two armed police officers positioned on the roof of a high building are informed over their radios that their targets are an 'ostrich and grizzly bear. Ostrich and grizzly bear are the targets.' One officer shoots a bear and the following exchange ensues:

POLICE OFFICER 1: (into radio): The bear is down. Repeat, the bear is down. I got the bear.
POLICE OFFICER 2: I think that's a Wookiee. That's a Wookiee.
POLICE OFFICER 1: No, it's not, it's a bear.
POLICE OFFICER 2: (into radio): Is a Wookiee a bear, control?
OVER RADIO: The bear target has changed. Target bear is now target Honey Monster.
POLICE OFFICER 2: Is a Honey Monster a bear?
OVER RADIO: A *Honey Monster* is *not* a bear.
POLICE OFFICER 1: A Honey Monster is a bear. The Honey Monster is down. He was a target. He was a bear.
OVER RADIO: The Honey Monster is down?
POLICE OFFICER 2: The Honey Monster is not down, control. We have a Wookiee down.
OVER RADIO: What's a Wookiee?
POLICE OFFICER 1: A bear. It's a bear!
POLICE OFFICER 2: No, it is a Wookiee. You've just shot it as a bear.
OVER RADIO: Is a Wookiee a bear?
POLICE OFFICER 1: It's a bear. Repeat, it's a bear.
POLICE OFFICER 2: The Wookiee is down. The Wookiee is not the target.
POLICE OFFICER 1: Well, it must be the target. I just shot it.

Although all the London Marathon participants mentioned in the above exchange are in fancy-dress costume, in this scene we see and hear the police officers attempt to

establish factual distinctions between a grizzly bear, a Honey Monster and a Wookiee – thus factual and fictional worlds collide.[43] Police Officer 1 does not make a distinction between fancy-dress costumes that resemble a grizzly bear, a Wookiee and a Honey Monster, whereas Police Officer 2 is acutely aware of the differences between the different types of fictional animals (Honey Monster and Wookiee) which are depicted via fancy dress and a fancy-dress costume that resembles a grizzly bear. In addition to the incorrect target being shot, the absurd and incongruous nature of the exchange and the serious attempts to pin down the different creatures that the fancy-dress costumes depict render the police officers ridiculous. At the end of the film, the Metropolitan Police Service is presented as reluctant to take responsibility for shooting an innocent marathon participant (in the grizzly-bear costume), who was mistaken for a suicide bomber. Malcolm Storge MP (Counter Terrorism Strategy Unit) exclaims 'The report makes crystal clear that the police shot the right man, but, as far as I'm aware, the wrong man exploded. Is that clear?' These comic moments mock police practices and satirically comment on the procedural errors that resulted in the shooting of Jean-Charles de Menezes on the London Underground in July 2005 and the media and communications strategies used by the police to present and defend their actions to the public. Thus the police are derided for being as bumbling and ineffectual as the would-be suicide bombers. This is reinforced elsewhere in *Four Lions*, for example, when the police mistakenly raid Omar's brother's house.

Visual incongruities pepper the film, one of the most striking taking place towards the end of the narrative when Omar, Barry, Waj and Hassan are in fancy-dress costume – a Honey Monster, a Teenage Mutant Ninja Turtle, a comedy ostrich and an inverted clown respectively – in order to bomb the London Marathon.[44] This visual incongruity is effective because the audience knows (due to the framing of the scene) that the fun and colourful façade of the fancy-dress costumes are countered by the threatening bombs that they conceal. The comic potential of this is increased when combined with verbal incongruity. A police officer says to the four in fancy dress 'You're gonna die in that gear, lads.' Omar sniggers and then says 'That's more than likely' and Waj responds 'Proper likely' and Barry confirms 'We're all going to die, yeah.' Omar adds 'It's all for a good cause, though.' Here the double meaning is specifically applicable to the phrases 'gonna die' and 'a good cause'. The police officer says 'gonna die' figuratively to refer to the physical effort it will be to run 26.2 miles in hot, cumbersome fancy dress, whereas the four aspiring suicide bombers interpret the phrase literally to mean that deaths will result from their explosives. 'Good cause' is used by Omar to refer to jihad whereas its alternative meaning, to raise money for a worthy charity, can be applied in the context of the London Marathon fun run.

A number of unexpected events occur in the film which enhance the comic pleasure derived by the audience. These include Faisal accidentally blowing himself up in a field of sheep when transporting explosives from Barry's flat to Barry's allotment and Hassan gathering up Faisal's scattered body parts and placing them in a black binbag (except for Faisal's head which later falls out of a tree onto a dog walker). Seconds before the explosion, Barry and Waj encourage Faisal to run faster and to jump over the field wall while Hassan is recording Faisal's actions on his mobile phone. This light-hearted mood rapidly changes

Visual incongruities in *Four Lions*

once they realise Faisal has blown himself up. This swift shift to a sombre mood is unexpected and it is precisely this surprise that, according to the incongruity theory, generates the comedy. Disposing of Faisal's body in a black binliner generally used for household waste is incongruous as it negates the respect normally given to dead bodies such as formal burial rituals.

Relief Theory

The nineteenth and twentieth centuries witnessed a shift towards what is referred to as the relief or release theory of comedy. This theory views jokes as pressure valves and joking as a 'socially sanctioned way of letting out taboo thoughts and feelings'.[45] This theory was developed by some key thinkers, including Sigmund Freud, and highlights the 'functional relationship between the joke and the ecology of the mind'.[46] Freud argued that comedy works because it appeals to our unconscious thoughts that usually remain concealed in our everyday conversations and interactions.[47] Comedy results in pleasure because we have not had to invest psychological energy in the suppression of taboo thoughts and feelings; this surplus energy is discharged as laughter. Comedy and laughter can fulfil a positive, and very important, function for individuals and societies as, according to Freud, psychosis can occur if repressed thoughts do not have an outlet.[48]

Although stand-up comedians performing on live-comedy circuits have been making jokes about terrorists and terrorism since 9/11 (e.g. Omid Djalili, Shazia Mirza, Russell Peters, Dave Chappelle, Jeff Dunham and Achmed the Dead Terrorist), this is less evident in conventional mediated comedy. *Four Lions* introduced jokes about this 'most authentically taboo topic'[49] to mainstream British film. Sam Bain, one of the writers of *Four Lions*, is acutely aware how comedy on taboo topics can act as a safety valve:

I remember watching Paedogeddon! … and going 'Oh my God, thank God someone's released the pressure valve and we can all laugh at this, a bit.' I think there's something culturally healthy about that. Hopefully, this film [*Four Lions*] might achieve that a bit with terrorism.[50]

Death and dying (whether human, animal or bird-related, or intended or accidental) and the associated consequences are constant themes in the film. Although addressing taboos about suicide bombers is the overarching purpose of *Four Lions*, there are some other comic moments in the film that are unrelated and can be explained by the relief theory. There are frequent examples of what Freud regarded as tendentious jokes – jokes that are either hostile or obscene.[51] Obscene and hostile jokes about male sexual organs and bestiality seem to take precedence. For example, when driving Omar and Waj to the airport so that they can travel to Pakistan, Barry erratically pulls over when Omar refuses to allow him to go on their Pakistan training camp trip. Barry reacts childishly by swallowing the car key to prevent them continuing their journey. As Waj ties Barry up before throwing him in the boot of the car, Barry claims: 'They'll crack you like babies' fingers. They'll pump you full of Viagra, make you fuck a dog … . You'll end up on YouTube blowing Lassie in a ditch.' When Omar and Waj return from Pakistan, they are introduced to Hassan, who has been recruited to the cell by Barry. Omar is not convinced that Hassan can be trusted and Barry exclaims 'He's been tested.' When Omar asks Hassan how Barry tested him, Hassan embarrassedly explains 'he made me do that bean thing, man … . You know, when you put a bean up the end of your knob, man', much to the amazement of Omar and Waj. Later in the same scene, Omar threatens Hassan that he will 'floss your [Hassan's] balls with razor wire' if he is unable to steal a van for Omar. Later in the narrative Waj reveals that Barry is

not a good emir, brother Omar. He made me do bad stuff in the woods … . He said, if I was a proper mujahid, I'd wiz in my own mouth … . It felt really bad, bro. It's not too tricky once you get the aim right, but it just feels like really proper wrong. All wee splashing off your teeth.

Visibly shocked, Omar responds by saying 'Bro, I swear, bro, I may ask you to blow yourself up, but I will never ask you to piss in your own mouth … promise.' In addition there are jokes made about homosexuality, such as the 'arse man' jokes mentioned previously and other instances where accusations are made by Barry's neighbour that Omar, Barry, Waj, Faisal and Hassan are 'Paki-bashers, Mountie boys and gays'. The comic pleasure derived from such narratives and jokes relates to audiences recognising that topics such as death, dying, sexuality, bestiality and violence are not usually talked about in British (Western) society.

On the Limits of *Four Lions*

Through the narrative, characterisations, linguistics and performativity in *Four Lions*, Chris Morris demonstrated how comedy can be a useful and powerful vehicle to convey information on terrorism and suicide bombing, the actions of the Metropolitan Police, the role,

position and perceived function of the media, and the self-representational strategies of sui-
cide bombers. One comedy critic argued:

> Some of the most valuable counterterrorism experts are comedians … .They are doing more than
> anything the government is doing. A lot of what these terrorists say and claim to believe is actually
> pathetic and juvenile. It has to be exposed and comedians are the best people at doing that.[52]

Three main comedy theories – superiority, incongruity and the relief theory – have been
investigated here to develop our understanding of the core comedic elements in *Four Lions*.
Although Mills notes that the three main theories of comedy are theories of social humour,
and were not designed to be applied to mediated comedy,[53] the above analysis demon-
strates that they can be utilised in regard to the comic working of complex mediated texts
such as *Four Lions*. Additionally, although each theory attends to different features of the
comedy and each has its limitations, taken together, they can significantly advance our com-
prehension of the dynamics of the important phenomenon that is comedy. As Berger argues:
'We have to apply a number of different techniques when analysing humor and there is no
royal road to understanding a joke or any other example of humor'.[54]

It is vital to note that, although we may laugh at the comic elements in *Four Lions* (and
other comic texts), laughter can be combined with embarrassment, guilt and shock. For
example, the analysis shows that, when Faisal blows himself up and Hassan gathers Faisal's
body parts in a binbag, the incongruity theory explains why this may cause amusement.
However, this amusement may be tinged with shock for some members of the audience
and some may question whether (accidental) death to be treated in a comic manner. The
fact that comedy can cause an ambivalent response is also a key component of the socio-
political power of comedy. As novelist Jasper Fforde has highlighted: 'The really great comics
are not necessarily the people you always laugh at, but the people who make you think:
Ooh, should I be laughing at that?'[55] The opportunities *Four Lions* has to make audiences
consider the topic of suicide bombers, the behaviour of the police and the role of the
media in contemporary society are extended by Morris's carefully constructed mix of
comedic and serious scenes. Given the focus of the chapter, the analysis has prioritised the
comic elements of *Four Lions*, some of which are hostile and physically and verbally violent.
However, there are some serious and thoughtful moments in the film. For example, we see
Omar at home seriously discussing his suicide bombing plans with his supportive and
understanding wife, Sofia (Preeya Kalidas), and their son. Then, on his return from the
Pakistan training camp trip Omar tells his son a bedtime story – a jihadist version of *The
Lion King*[56] – which indirectly alludes to Omar's actions, feelings and thoughts following his
training camp trip. Again, we see the fusion and collision of the factual and the fictional
worlds. Combining comic and serious moments within one text is an effective strategy that
may encourage acceptance of some of the more controversial and taboo aspects of the
comedy performance.

Comedian and actor Omid Djalili, who has made jokes about the media representations
of terrorists and Western responses to terrorism, combines political jokes and narratives with
physical comedy. Explaining the benefits of this strategy, Djalili notes:

I would always undercut the political commentary with belly dancing and Godzilla impressions just to keep a kind of impish absurdity to what I was doing so people wouldn't say, 'Oh he's one of those serious comics.' With the running jokes, the bits of physicality like the belly dancing, the bingo numbers, you keep the laughs all bubbling along with very high energy, I found the political points that I did make were made stronger because the audience really were in effect softened by being in such an entertained state. They would take the political points more.[57]

Combining comedy with more serious sociopolitical discourse is an established journalistic strategy. Campbell refers to this as 'investigative satire'[58] common to successful and long-standing magazines, such as *Private Eye*,[59] and other films such as Michael Moore's *Roger and Me* (1989), *Bowling for Columbine* (2003) and *Fahrenheit 9/11* (2004). However, while this assimilation of serious and non-serious can facilitate appreciation and understanding of the comedy, there are limits to its success in communicating the comic intent to audiences. For example, in order for audiences to relate to the incongruity in *Four Lions*, as discussed above, they must understand the two different meanings of words, phrases, situations and/or behaviours to appreciate how the joke teller and the target of the joke are ascribing *different* meanings to the *same* word, phrase or image. Failure to recognise the duality of meaning (for example with 'arse man', 'gonna die' and 'good cause') will result in the failure of the attempt at comedy. Culturally specific references, such as names, places and objects hinder the comedy process.[60] Thus in *Four Lions* references to rides at the UK theme park, Alton Towers, and/or or baked beans and music by the British band Toploader will have limited resonance and humorous meanings for audiences unfamiliar with such places, products and bands.

Although Morris would be likely to resist referring to his comedic productions as primarily satirical, they contain satirical elements. His work is usually underpinned by serious messages, is primarily critical and typically has a target which may be a person, group, idea or opinion. These are the main ingredients of satirical comedy.[61] *Four Lions* is no exception. In his examination of satirical comedy, Nilsen maintains that the audience must be able to identify with what is being satirised in order to recognise and understand the satire.[62] Satirical comedy is therefore related to an identifiable 'reality', which is distorted through satirical techniques (such as exaggeration or reduction) in order to critique its target and thus facilitate a more critical engagement with the subject.[63] Failure to recognise the satirical intent of the comic narrative or joke will limit its transgressive potential. Such a limit was evident in the audience response to Morris's other work, such as the *Brass Eye* Special 'Paedogeddon'. The target of 'Paedogeddon's' satire was the British media and the ways in which it treats and sensationalises child-sex offenders and their crimes,[64] yet some people interpreted the mock-documentary as an attack on child-abuse victims and/or children's charities.[65] Such differences in interpretation illustrate Colebrook's argument that we can never 'fully think or calculate the forces of our speech. There are always effects that exceed speech and intention.'[66]

Such disparity between the intent and interpretation of satirical discourses is not surprising when we consider the underlying features of satire. Satire is based on functional principles that are diametrically opposite to those governing serious discourse.[67] Satirical discourses are characterised by ambiguity, contradictions and interpretative diversity. Satire depends on the 'discursive display of opposing interpretive possibilities … [and] as it is read

or heard, evoke[s] a complex range of possible uses and implications'.[68] Thus the opportunities for misinterpretation are substantially heightened. The *Four Lions* 'question-and- answer'[69] sessions conducted by Morris and his willingness to be interviewed pre- and post-release may have been part of a deliberate strategy to frame the film as a comedy, thus signalling to audiences that a 'satiric mentality' is necessary when engaging with *Four Lions*, or that the film is more suited to a 'satire-savvy' audience. Such pre- and post-release publicity was in direct contrast to the lack of publicity surrounding Morris's other ventures, such as *Brass Eye*, where pre-broadcast publicity simply stated that the series was a 'factual entertainment looking at topical issues in an entertaining way'[70] and Morris's refusal to be interviewed following the broadcast of the 'controversial' *Brass Eye* one-off Special, 'Paedogeddon'.[71]

Although this analysis has demonstrated the taboo-breaking nature of *Four Lions*, especially in relation to the insights provided by the relief theory, the transgressive potential of *Four Lions* may also be tempered in other ways. Some might consider its satire limited because satirical discourses rarely offer specific conclusions or solutions to the problems they critique. Kernan refers to this as the absence of 'satiric plot' or specific conclusion to satirical discourses – the 'scenery and the faces may have changed outwardly, but fundamentally we are looking at the same world, the same fools, and the same satirist we met at the opening of the work'.[72] Therefore satirical comedy may raise questions that the satirist considers fundamental, but its limits are that it will not provide answers to the questions raised,[73] thus constraining how critical and informative the satire can be. Although *Four Lions* draws attention to the flaws in the thinking, behaviour and emotional state of Islamic suicide bombers, it does not provide solutions to these problems – at the end of the film, each of the four suicide bombers (intentionally or accidentally) individually detonate their bomb, and although not on the scale they initially envisaged, their victims are members of the general public, and death and destruction results. However, for some audiences this is, and always will be, one of comedy's most powerful features – it may not provide any answers but it can certainly make some audiences stop and reflect on unsettling subject mattter.

Notes

1. This is a direct reference to how Chris Morris has described *Four Lions* – as representing the 'Dad's Army Side to Terrorism'. Quoted in Genevieve Roberts, 'Wannabe Suicide Bombers Beware: Chris Morris Movie Gets Go-ahead', *Independent* (6 January 2009), <http://www.independent.co.uk/arts-entertainment/tv/news/wannabe-suicide-bombers-beware-chris-morris-movie-gets-goahead-1228152.html >.

2. Morris's first foray into film-making was in 2002 with a short fifteen-minute film *My Wrongs #8245-8249 & 117*, about a talking dog called Rothko. In 2003 it won a BAFTA for Best Short. See Lucian Randall, *Disgusting Bliss: The Brass Eye of Chris Morris* (London and New York: Simon and Schuster, 2010).

3. Tom Leonard and Matt Born, 'Needlessly Shocking, or a Satirist in the Tradition of Hogarth?', *Daily Telegraph* (31 July 2001), p. 4.

4. Jonathan Romney, 'Four Lions', *Independent* (9 May 2010), <http://www.independent.co.uk/arts-entertainment/films/reviews/four-lions-chris-morris-101-mins-15-1968907.html>.

5. Christopher Tookey, 'Lions Are Not a Roaring Success', *Mail Online* (7 May 2010), <http://www.dailymail.co.uk/tvshowbiz/reviews/article-1274097/Four-Lions-Its-roaring-success.html>.

6. Unknown Author, 'Four Lions: Ten Things You Need to Know about Chris Morris's Suicide Bomber Comedy', *Mirror Online* (22 January 2010), <http://www.mirror.co.uk/celebs/news/2010/01/22/four-lions-ten-things-you-need-to-know-about-chris-morris-suicide-bomber-comedy-115875-21987412>.

7. Simon Brew, 'Four Lions Review', *Den of Geek* (23 April 2010), <http://www.denofgeek.com/movies/470294/four_lions_review.html>.

8. Kevin Maher, 'Chris Morris – The Most Hated Man in Britain', *Times Online* (3 April 2010), <http://entertainment/timesonline.co.uk/tol/arts_and_entertainment/film/article7085015>.

9. Quoted in Ben Walters, 'Chris Morris Pushes Four Lions But America Fails to Bite', *Guardian* (10 November 2010), <http://www.guardian.co.uk/film/2010/nov/10/four-lions-us-chris-morris>.

10. Graham Smith, 'Comedian Chris Morris Faces New Controversy over Film about Suicide Bomber Wearing Fancy Dress to Target London Marathon', *Mail Online* (25 January 2010), <http://www.dailymail.co.uk/news/article-1245887/Four-Lions-Controversial-Chris-Morris-jihadist-comedy-bumbling-suicide-bombers-premieres.html>.

11. Larushka Ivan-Zadeh, 'Four Lions Hits a Roar Nerve', *Metro* (6 May 2010), <http://www.metro.co.uk/metrolife/film/824949-four-lions-hits-a-roar-nerve>.

12. Tookey, 'Lions Are Not a Roaring Success'.

13. Romney, 'Four Lions'.

14. Quoted in Walters, 'Chris Morris Pushes Four Lions But America Fails to Bite'.

15. Jeremy Kay, 'Chris Morris's Four Lions: A Mixed Dish That Fails to Satisfy', *Guardian* (25 January 2010), <http://www.guardian.co.uk/film/2010/jan/25/four-lions-chris-morris>.

16. Stephen Armstrong, 'How Chris Morris Came to Direct Four Lions', *The Times* (2 May 2010), <http://entertainment.co.uk/tol/arts_and_entertainment/film/archive/article7110548>.

17. Cahal Milmo, 'Relatives of 7/7 Victims Criticise "Four Lions"', *Independent* (7 May 2010), <http://www.independent.co.uk/news/uk/home-news/relatives-of-77-victims-criticise-four-lions-1965614.html>.

18. Sundance Film Festival, '2010 Sundance Film Festival Announces Films in Competition' (2 December 2009), <http://www.sundance.org/pdf/press-releases/2010FilmsInComp1LAmlA.pdf>.

19. Charles Gant, 'Four Lions Has Roaring Weekend at UK Box Office', *Guardian Film Blog* (11 May 2010), <http://www.guardian.co.uk/film/filmblog/2010/may/11/four-lions-chris-morris>.

20. See 'Four Lions', *Internet Movie Database*, <http://www.imdb.com/title/tt1341167>.

21. Jay Hunt, Channel 4 Chief Creative Officer, noted that, although Four Lions is not directly about 9/11, the film was shown during Channel 4's season to mark the ten-year anniversary of 9/11 because 'it looked at the wider "geopolitical" discussion on terrorism'. Quoted in Catherine Shoard, 'Four Lions' UK TV Premiere to Coincide with 9/11 Anniversary', *Guardian* (30 August 2011), <http://www.guardian.co.uk/film/2011/aug/30/four-lions-tv-9-11>.

22. Sundance Institute Archives, *Four Lions*, 2010, <http://history.sundance.org/films/6536>.

23. Quoted in Stephen Applebaum, 'Terrorism? You're Having a Laugh', *Independent* (4 May 2010), <http://www.independent.co.uk/arts-entertainment/films/features/terrorism-youre-having-a-laugh-1961372.html>.

24. Ibid.

25. Randall, *Disgusting Bliss*.

26. Ibid., p. 254.

27. *'Four Lions'*, *Internet Movie Database*.

28. *Time Magazine*, 'Top 10 Movies' (9 December 2010), <http://www.time.com/time/specials/packages/article/0,28804,2035319_2035308_2035475,00.html>.

29. Geoff King, *Film Comedy* (London and New York: Wallflower Press, 2002), p. 5.

30. Andrew Stott, *Comedy* (New York and London, 2005), p. 133.

31. See Stott, *Comedy*; Arthur Asa Berger, 'Humor: An Introduction', *American Behavioral Scientist* vol. 30 no. 6 (1987), pp. 6–15.

32. See John Morreall (ed.), *The Philosophy of Laughter and Humor* (Albany: State University of New York Press, 1987); Jerry Palmer, *Taking Humour Seriously* (London and New York: Routledge, 1994); Michael Billig, *Laughter and Ridicule: Towards a Social Critique of Humour* (London: Sage, 2005); Brett Mills, *The Sitcom* (Edinburgh: Edinburgh University Press, 2009).

33. Quoted in Mills, *The Sitcom*, p. 77

34. Palmer, *Taking Humour Seriously*, p. 94.

35. Brew, *'Four Lions* Review'.

36. Quoted in Walters, 'Chris Morris Pushes *Four Lions* But America Fails to Bite'.

37. Thomas Hobbes, *Leviathan* (London: Everyman, 1839), p. 27.

38. Simon Critchley, *On Humour* (London and New York: Routledge, 2002), p. 11.

39. See Berger, 'Humor'; Morreal, *The Philosophy of Laughter and Humor*; Elliott Oring, *Engaging Humor* (Urbana: University of Illinois Press, 2003).

40. John Morreall, *Taking Laughter Seriously* (Albany: State University of New York Press, 1983).

41. Jerry Palmer, *The Logic of the Absurd: On Film and Television Comedy* (London: BFI, 1987).

42. Palmer, *The Logic of the Absurd*, p. 117.

43. The Honey Monster is a fictional character that since the 1970s has been used in the successful advertising campaign for the honey-flavoured breakfast cereal, Sugar Puffs, sold in the UK. A Wookiee is a fictional large hairy alien species from the *Star Wars* films.

44. The Teenage Mutant Ninja Turtles are four teenage anthropomorphic turtles that first appeared in American comic books in the mid-1980s and can now also be seen in television cartoons, films and video games. The 'comedy ostrich' was made famous by British comedian and actor Bernie Clifton who rode an ostrich called Oswald. The inverted clown costume turns the world upside down as the costume's feet are worn on hands and hands worn on feet.

45. Jimmy Carr and Lucy Greeves, *The Naked Jape: Uncovering the Hidden World of Jokes* (London: Penguin, 2007), p. 95.

46. Palmer, *The Logic of the Absurd*, p. 79.

47. Sigmund Freud, *Jokes and Their Relation to the Unconscious* (Harmondsworth: Penguin, 1905/1976).

48. Ibid.

49. Romney, *'Four Lions'*.

50. Quoted in Applebaum, 'Terrorism?'.

51. Freud, *Jokes and Their Relation to the Unconscious*.

52. Clarke quoted in Shelina Zahra Janmohamed, 'Can Terror Be Funny?', *Altmuslim Comment* (14 May 2010), <http://www.patheos.com/blogs/altmuslim/2010/05/can_terror_be_funny>.

53. Mills, *The Sitcom*.

54. Berger, 'Humor', p. 13.

55. Quoted in Randall, *Disgusting Bliss*, p. 96.

56. Produced by Walt Disney Feature Animation and released in 1994, *The Lion King* follows the story of a lion cub prince called Simba, his father King Mufasa and his uncle Scar's attempts to become King.

57. Quoted in Sharon Lockyer and Michael Pickering, 'Breaking the Mould: Conversations with Omid Djalili and Shazia Mirza', in Sharon Lockyer and Michael Pickering (eds), *Beyond a Joke: The Limits of Humour* (Basingstoke: Palgrave, 2005), p. 102.

58. Vincent Campbell, *Information Age Journalism: Journalism in an International Context* (London: Arnold, 2004), p. 185.

59. See Sharon Lockyer, 'A Two-pronged Attack? Exploring *Private Eye*'s Satirical Humour and Investigative Reporting,' *Journalism Studies* vol. 7 no. 5 (2006), pp. 765–81.

60. See Delia Chiaro, '"In English Please!" Lost in Translation: *Little Britain* and Italian Audiences', in Sharon Lockyer (ed.), *Reading* Little Britain: *Comedy Matters on Contemporary Television* (London: I. B. Tauris, 2010), pp. 183–207.

61. Arthur Pollard, *Satire* (London: Methuen, 1970).

62. Don L. F. Nilsen, 'Satire – The Necessary and Sufficient Conditions – Some Preliminary Observations', *Studies in Contemporary Satire* no. 15 (1988), pp. 1–10.

63. See Andrew Crisell, 'Filth, Sedition and Blasphemy: The Rise and Fall of Satire', in John Corner (ed.), *Popular Television in Britain: Studies in Cultural History* (London: BFI, 1991), pp. 145–58.

64. Colin Clark, 'Hysteria a Threat to Research', *Times Higher Education Supplement* (13 August 2001), p. 16.

65. See Sharon Lockyer and Feona Attwood, '"The Sickest Television Show Ever": Paedogeddon and the British Press', *Popular Communication: The International Journal of Media and Culture* vol. 7 no. 1 (2009), pp. 49–60.

66. Claire Colebrook, *Irony* (London and New York: Routledge, 2004), p. 123.

67. See Arthur Koestler, *The Act of Creation* (London: Hutchinson, 1964); Michael Mulkay, *On Humour: Its Nature and Its Place in Modern Society* (London: Basil Blackwell, 1988).

68. Mulkay, *On Humour*, pp. 26 and 40.

69. See, for example, C. Hutchinson, 'Screening of *Four Lions* (15) and Q & A Session with Director Chris Morris', *Press* (21 May 2010), <http://www.yorkpress.co.uk/leisure/film/8179316.Screening_of__Four_Lions__15__and_Q_A_session_with_director_Chris_Morris__City_Screen__York__May_22>; Walters, 'Chris Morris Pushes *Four Lions* but America Fails to Bite'.

70. Randall, *Disgusting Bliss*, p. 176.

71. See Lockyer and Attwood, '"The Sickest Television Show Ever"'.

72. Alvin Kernan, *The Cankered Muse: Satire of English Renaissance* (Hamden, CT: Archon, 1959), p. 30.

73. Ross Fitzgerald, 'The Need for Political Satire', *Australian Review* vol. 23 no. 1 (1991), pp. 11–13; see also Lockyer, 'A Two-pronged Attack?'.

13

'I DON'T WANNA BE DEAD! THERE'S NO FUTURE IN IT!': THE US AND UK CRITICAL RECEPTION OF *FOUR LIONS*

RUSS HUNTER

This chapter focuses on the critical response to *Four Lions* (2010) in both the UK and the US, investigating the complex ways in which the connections between terrorism and comedy are presented in each case. Taking a critical Reception Studies approach, it seeks to examine the way that controversy and topicality, as played out in British and American film reviews, helped to play a part in defining the reception environment.[1] The reception context of any film can rarely be reduced to a snapshot in time whereby history is effectively frozen to offer a reading that looks very narrowly at contemporaneous events. With *Four Lions*, it is tempting to view its reception as being shaped very directly by the congruence (or otherwise) between what David Bordwell terms the 'invisible college' of critical orthodoxy and events immediately prior to the film's 2010 release.[2] There are ways in which relatively ephemeral debates and controversies can influence a film's reception, but the picture is usually far more complex.[3] Instead, it is important to place critical reaction in its historical context. In this way it is possible that latent sociohistorical and cultural debates and controversies can be awakened by or intersect with the release of any given film (dependent upon its subject matter and narrative drive). As Ernest Mathijs has noted when 'taking the synchronic history of a film into account one is forced … to study the lead-up to the film's reception'.[4] To fully comprehend the critical anxieties greeting the release of *Four Lions*, an understanding of the historical climate in the period after 11 September 2001 is crucial. It is the accumulation of events related to the fear of Islamic terror in the West and the way these interplay with critical reactions to the figure of Chris Morris that best help explain the reception trajectory of the film.

Film Reception

The work of Janet Staiger and Barbara Klinger has contributed to an understanding of how specific sociohistorical contexts can influence the creation and trajectory of individual receptions, eschewing traditional text-based methods of analysis.[5] In contrast to those more classical text or reader-oriented approaches that have stressed the role of texts and individual psychologies in determining meaning, Reception Studies has instead 'shown how historical

and intertextual environments shape meanings that circulate during the time of reception'.[6] That is to say, Reception Studies is about explaining an event (the interpretation of a film) as opposed to elucidating an object (the film). As such, Reception Studies does not provide interpretations but, instead, a process of producing interpretations.[7]

Central to both Staiger and Klinger's conception of film-based Reception Studies is a critique of notions of the 'reader' as ahistorical. The key to this approach is that reception work does not 'interpret texts but would attempt a historical explanation of the event of interpreting a text'.[8] Instead, individuals actively construct meaning but they do so in relation to the dynamics of the sociohistorical circumstances within which they are situated *and* in relation to subject positions they inhabit. In this way, 'cultural artefacts are not containers with immanent meanings' and variations of interpretation are viewed as having an historical basis.[9] Put another way, it means that it is the interaction between the individual and his/her surroundings that informs the act of meaning creation and not predefined textual triggers. Any such study should therefore keep at its core the aim of describing historical interpretive strategies and explaining their particular causes while recognising that not every possible interpretation is possible at every time. Staiger contends that although such a position may infer a level of specificity that implies spectators read in individual ways, Reception Studies does seek generalisations (while applying these to individual situations) in order to provide knowledge about wider processes. Hence Reception Studies emphasises that difference is both historically constructed as well as being derived from the particularistic nature of individual social actors.[10] For Morris's film this means that, although *Four Lions* is a text that explicitly addresses issues surrounding nascent Islamic terrorism in the UK, its reception cannot be understood in purely textual terms without taking into account the preceding historical context. It is not that *Four Lions* is a film about terrorism in Britain that is crucial to its reception. It is that it is a film about terrorism that comes at a particular historical moment and that is made by a figure with a distinct media reputation.

In *Melodrama and Meaning*, Barbara Klinger follows Staiger's historical materialist approach to reception research in considering 'the contribution that contextual factors, as opposed to textual devices or viewer subjectivities, make to an understanding of how a text means'.[11] In line with Staiger, she argues for an understanding of the 'range of [interpretive] strategies available in particular social formations' and that 'the aesthetic or political value of a film is no longer a matter of its intrinsic characteristics, but the way those characteristics are deployed by various intertextual and historical forces'.[12] Here Klinger differs from Staiger in her belief that a film (or cultural artefact) can have a definitive set of historical meanings at a particular time. But importantly she sees this as subject to change 'with the ascendancy of new cultural eras', given that these force 'consideration of a film's fluid, changeable and volatile relation to history'.[13] Reception Studies has therefore attempted to understand the ways such history aids in the negotiation of individual acts of spectatorship and meaning creation.[14] For theorists such as Janet Staiger the text, then, does not shape meaning but it is the context of reading that plays the crucial role in defining understandings of it.[15] Although Staiger and Klinger both believe that the text has no intrinsic meaning, this is not to say they view it as unimportant; rather that it delivers only a loose body of ideas that are then moulded in varying ways depending upon the context within which it is 'read'.

In general terms, critical reviews (mainly from newspapers and periodicals) have formed the central nub of the source material that has provided the basis for identifying the circulating discourses and contexts within which the determination of meaning is said to take place.[16] These provide a 'tool that enables a film text to be linked to issues in society, showing that the film belongs to a culture and that that culture is capable of embracing its artefacts'.[17] There has also been a welcome recognition that critics are themselves a type of audience, whose work is a legitimate focus for investigation.[18] This focus can in itself afford valuable source material for tapping into circulating discourses at any given historical moment. As Tom Gunning notes in his Foreword to Yuri Tsivian's *Early Cinema in Russia and Its Cultural Reception*, an analysis of such critical writings can yield not only knowledge about 'the films themselves … but also about the assumptions and viewing protocols of the viewer who left the record', even 'revealing things of which the original writer was only dimly aware'. Importantly here writers cannot remove themselves from their own institutional, geographical and historical context and they therefore 'participate in the passions and tacit assumptions of their and age and nation (not to mention class and gender)' and in so doing they 'stain the image they present of the film with them'.[19] Therefore concentrating on the work of critics allows us not only to properly engage with the conventions of critical discourse within a given period, but also affords a window into 'the critical vocabulary and frames of reference that critics apply to appropriate projects'.[20]

It is possible to straightforwardly view film reviews as serving an informational function, providing a rough outline of any given film's plot before passing a value judgment upon how 'good' or 'bad' it is. But film reviews are rarely standalone pieces, detached entirely from the sociohistorical reality of when and where they are written. They don't operate in a critical vacuum or without awareness of the previous work of those involved. Instead, they can often reflect a longer engagement with the creative personnel concerned. Interventions by both Klinger and Charles Maland have explained, through an exploration of artists' public images, the ways in which 'a culture's response to an artist's work is cumulative, shifting and multifaceted'.[21] Critical responses to *Four Lions* were informed not just by the historical context but also by specific reactions to Morris and his extant body of work. But this can have a negative effect, whereby a *lack* of knowledge of Chris Morris can be just as significant, allowing for an insight into the ways in which those who have little or no prior critical relationship to the performer/director effectively 'make sense' of his work.

Four Lions: Topicality, Terrorism and Reception

Four Lions centres on Omar (Riz Ahmed), the leader of a band of British Muslims disillusioned with the way Islam has been treated in the West. Intent upon acting as foot soldiers for jihadism from their north of England base, Omar, along with his friend Waj (Kayvan Novak), Faisal (Adeel Akhtar) and a white Islamic convert Barry (Nigel Lindsay), concoct a plan that will strike a blow for their cause – spectacularly blowing themselves up during the London Marathon. Premiering at the Sundance Film Festival and eventually being nominated for five British Independent Film awards and released in the year when Kathryn Bigelow's *The Hurt*

Locker (2008) won six Oscars, the critical success of a farce about failed British jihadist terrorists nonetheless seemed unlikely. In the US, the threat of Islamic terrorism had been ever present for some considerable time prior to 2010. It is hard to underplay the significance of the 11 September attacks, the first attack on US soil since Pearl Harbor. The scars of the events of 9/11 were still healing at the time of the film's limited nationwide release in November 2010 and any treatment of Islamic terrorists seemed liable to encroach upon highly sensitive public discussions about the 9/11 experience. Traumatic as these events were in the US, their aftermath was felt worldwide, having a profound geopolitical impact, leading to a prolonged and ongoing 'war on terror' and subsequent American and British military involvement in both Iraq and Afghanistan. The UK, given the longterm military and political significance of the 'special relationship', was inextricably linked to any US-led response to terrorist threats.

A number of incidents in the latter half of the 2000s in Britain – a country that had already experienced terrorism before via the IRA's mainland bombing campaign – heightened public awareness of potential terrorist threats and the dire consequences of such actions. In the 2005 terrorist attack, very quickly labelled '7/7' because it occurred on 7 July, several co-ordinated explosions took place on London's public transport network, killing fifty-two people and injuring more than 700. Other incidents followed, such as the unlawful shooting on 22 July 2005 of student Jean-Charles de Menezes, a Brazilian national who was mistaken for a terrorist thought to be attempting to set off an explosive device on the London underground system. On 28 June 2007, two car bombs were identified in London before they had the chance to explode; several Islamist terrorists were later arrested. A day later, an attempt was made to drive a propane canister-filled Cherokee Jeep into the terminal of Glasgow Airport.

But this terrorist activity was not the first time the UK had become aware of an Islamic terrorist threat. As far back as 2001, when self-proclaimed British-born al Qaeda member Richard Reid unsuccessfully attempted to blow up an American Airlines plane from Paris to Miami on 22 December, Britain was conscious of the potential for domestic Islamic terrorist activity. Quickly dubbed the 'Shoe Bomber', Reid's activities reverberated in several important ways, the most notable of which was the introduction of body scanners at airports and a general tightening of airport security that greatly raised the visible response to the threat of terrorism. In the decade before *Four Lions*' 2010 release, then, terrorism was both a constant and high-profile threat in Britain.

Chris Morris's *Four Lions* therefore appeared during a period of increased tensions and heightened awareness of a perceived worldwide Islamic terrorist threat and at the end of a decade that had seen Islamic terror strikes in both the US and the UK. The decade proved a destabilising time. The effects caused a downturn in the world economy, leading to an economic depression in both Britain and America and both terrorist incidents and continued terrorist threats meant that changes in the geopolitical landscape were inevitable. More broadly, the general public felt the impact of the growing terrorist threat in a number of ways. Not only did terrorist attacks on both New York and London contribute to a general, intangible 'climate of fear' (or perhaps more accurately an *awareness* of the existence of such a feeling), the idea of terrorism itself was highly visible to anyone passing through airport security. Terrorism and the idea of terrorism was a highly visible phenomenon, albeit whose profile rose and fell dependent upon the levels of perceived and actual threat.

The arrival, therefore, of a 'farce' about terrorism came at a time of heightened and pro-longed anxiety over potential Islamic terrorist threats. Not surprisingly then, the release of *Four Lions* generated a certain anxiety among critics on both sides of the Atlantic. The critical response was marked by a tendency to highlight the fact that some people might be offended by the film. Indeed, Jonathan Romney, writing for the *Independent on Sunday*, expressed this broad concern by way of ironic reference to the fact that an 'irreverent farce about suicide bombers' was being made by Morris, joking '[h]ah … you nearly believed me'. His review used this trope to feed into expectations of what a film by Chris Morris might mean. So while he intones 'Honestly, did you really believe he'd make a knockabout comedy about British muja-hedin?', he also notes that Morris 'goes about it with his usual savage levity'.[22] The *Denver Post*'s Lisa Kennedy underlined the point more directly than most in laying stress on Britain's expe-rience of 'shattering violence wreaked by home-grown terrorists in July 2005' and is one of the very few American reviewers to make direct reference to the US experience in noting that '[t]hose suicide bombers – along with 9/11 hijacker Mohamed Atta and Khalid Sheikh Mohammed – are models of a sort for this comedy's protagonists'.[23] In making reference to specific historical events, Kennedy is keen to point out that the success of the film will be a 'matter of taste' and that 'the timing of a comedy about terrorism is dicey'.

Although several reviewers recognised that some may be offended by the nature of the narrative – although, in reality, few if any really were – critical notices were generally very positive. Thus, although Michael Phillips thought that *Four Lions* 'pushes its luck in every which way' and that circumstances might mean that the film's 'comic targets [could] strike some people as offensive', he nonetheless sees the film as 'appalling in all the right ways'.[24] Likewise, Kim Newman, writing for popular film magazine *Empire*, saw the film as being '[g]uaranteed to offend a lot of folk' but gives the film four (out of five) stars. Yet even those who ques-tioned if the film had not arrived 'too soon' after the events of the previous decade, such as Lisa Kennedy, reviewed the film favourably overall.[25] In short, everyone seemed aware that *someone* might be offended but no one was quite sure exactly *who*. What is notable here is a strange paradox whereby the majority of the reviewers are *anticipating* critical reverbera-tions against the film, based on its largely humanising and therefore largely sympathetic por-trayal of British jihadists, but no one actually provides that critical backlash. The point is not that individual reviewers knew the film was likely to prove offensive and chose to like it anyway in some transgressive or contrarian fashion. Instead, it stresses the fact that this was a film that critics, given recent historical events, conceptualised and positioned as one that *would offend* and there is a sense in which they are awaiting a backlash (to either their indi-vidual contribution to the critical debate or to discussions of the film in general terms).

Notably, reviewers tended not to criticise the film for its portrayal of 'sympathetic' ter-rorists but rather used this aspect of the film as a means to either retrace recent historical events or to present a critical missive to the very idea of 'the terrorist'. In this respect there was a distinct difference between the British and American receptions in each case. For British reviewers, the film afforded an opportunity to connect the film's exploration of a nascent form of Islamic terrorism in the country and, in particular, the events of 7/7. Perhaps unsurprisingly the *London Evening Standard* made a direct connection with Omar, Waj, Faisal and Barry, noting that 'the parallels with the London bombers of July 2005 are quite stark'.

The opening paragraph of Andrew O'Hagan's review is upfront in its assertion that 'nothing is more frightening in the West right now than jihadists'.[26] Similarly, the *Scotsman* was even more direct in stressing that the humour of *Four Lions* is seen to tap into

> that odd make-a-joke-out-of-it relief that bungled terrorist attacks like the one in Glasgow airport in 2007 or last weekend's failed car bomb in New York seem to inspire, if only because the alternative what-if scenarios are too horrific to contemplate.[27]

Contrastingly, American critics tended to avoid making direct connections with real-life events. Some, like the upmarket the *New Yorker*, outlined how the film intersected with recent events in Britain and had 'clear echoes of an actual atrocity'.[28] However, few referred to 9/11 or attempted to draw parallels with terrorist threats in the US. In fact, American reviewers, when they made any extratextual reference to terrorism at all, did so in a way that tended *not* to make connections to specific events.

 With a few exceptions, Reception Studies has been unable to pinpoint precisely how the *defining moments* of topicality in review materials are derived. It is not obvious in all cases, but with *Four Lions* the particular sociohistorical and cultural triggers are more evident. Given the events of the decade prior to the film's release, it is surprising that reviews of *Four Lions* did not more consistently and explicitly address terrorism itself. While some British and American critics did refer specifically to the events of 7/7, few chose to make connections to 9/11. Instead American reviewers welcomed the film for showing the mundane, simplistic lives of most terrorists and thus rendering the figure of the 'terrorist' dismissible. What is evident here is that reviewers feel 'all talked out' about the events of 11 September 2001 and so pronounce judgments on *Four Lions* that reflect this distancing from specific historical events. Indeed, one can sense both the (understandable) bitterness and weariness in A. O. Scott's opening salvo in the *New York Times* that 'Terrorism is stupid. Terrorists are stupid.'[29]

The Four Moes?

Directors and writers themselves can contribute to the circumstances for their own reception by setting earlier standards by which they are later judged. What might be considered canonical moments in an artist's career affect later conceptions of their work. The British reviewers' familiarity with Morris also meant that they could and did judge his treatment of terrorism relative to what had come before. Writing with reference to literary figures, Hans Robert Jauss has noted the way in which reactions to individuals are often shaped by what he termed a 'horizon of expectation' based upon previous engagement with and experience of a particular author's work.[30]

 Positive critical notices in the British press tended to make direct reference to Morris's other work, most notably *Brass Eye* (Channel 4, 1997; 2001) and *The Day Today* (BBC 2, 1994), and used these as markers of quality by which to assess his current project. British reviews of *Four Lions* were therefore rarely what we might term standalone pieces; instead, they drew upon Morris's own comedic back catalogue as a reference point for where and how to

attempt to place his debut feature film. References to his television work abounded, with the director being underlined as 'TV prankster Chris Morris',[31] 'The Brass Eye Guy',[32] 'the nation's most biting satirist'[33] and someone who had a track record of 'absurd and surreal … cutting edge television work'.[34] He was portrayed as a known quantity expected to deliver a very specific kind of comedic experience. This move to stress Morris's comedic heritage was alluded to by the Guardian's Phelim O'Neil when he stressed that 'the words "Chris Morris" and "terrorist comedy" come so loaded with expectation, your poor brain could fry trying to figure out how incendiary such a film could be'.[35] Therefore there was a distinct sense of who he is and what a work by him means, or perhaps more importantly what it should mean. Thus the Scotsman can call him a 'media terrorist' with an understanding that references to his earlier work will be understood here, as well as being an obvious play upon the film itself.[36]

It is perhaps unsurprising that in the US, where Morris's work was less well known and certainly less canonical in relation to mockumentary TV comedy, reviewers were less likely to mention his British TV work. In fact, most seemed unaware of it or had utilised the film's press pack to effectively 'fill in the blanks'. But in general terms it is evident that Chris Morris was very much an unknown quantity. Culturally specific knowledge and cultural understandings played themselves out in a variety of ways in the US reception. What the US reviews for Four Lions demonstrate is how a loss of subtlety of some of the textual referents impacted upon the way in which the meaning of the film was understood. Writing for the East Bay Express, Kelly Vance notes that Barry is the 'lone white man and non-immigrant in the group', thus the second-generation Pakistani northern English accents used by Waj, Faisal and Omar do not register as British but rather as an indicator of their foreignness.[37] While this, in part, merely serves to highlight a cultural misunderstanding of regional English accents and how they can mutate and transform, it also suggests a different reading strategy, whereby the fact that they are immigrants (rather than second-generation immigrants) is seen as being part of the issue. This is not necessarily to do with recognising accents or being factually accurate. Instead this illustrates how complex receptions can be and how certain cues can be missed owing to a reviewer's cultural capital. Thus, here the complicated identities of second-generation Pakistani immigrants are, quite literally, lost in translation with reviewer judging their actions as though their immigrant status was paramount and the basis of their radicalism.

To help make sense of the dynamics between the men and their British setting, US reviewers tended to employ very culturally specific frames of reference. As Morris was unknown in the US, a reference system was required that would both render his work more familiar and provide an interpretative framework for those reading individual reviews. As Daniel Martin has noted, in order to make sense of films from other cultural contexts, critics will often 'familiarise' them by making comparisons to and associations with domestic output and traditions. Martin shows how British critics rendered the Japanese Ringu (1998), a film that emanated from a then generally unfamiliar cultural and industrial context, familiar by making comparisons with a more 'native' tradition (in this instance by using the American The Blair Witch Project [1999] as a point of departure).[38] In the case of a film about four heavily accented would-be terrorists from northern England this process was crucial to the ways in which US critics could make sense of Four Lions.

The most common culturally agreed reference point among American reviewers was, at face value, unexpected. In alluding to and drawing comparisons with the work of The Three Stooges – a popular comedy outfit whose career was at its peak in the period from 1930s to the 1950s, largely associated with a now old-fashioned comedic approach – such reviews were making what appeared to be a curiously outdated connection. Yet, such a correlation was not as curious as it might at first seem. Director Sam Raimi, in particular, has regularly discussed his love of The Three Stooges and the impact they had (and continue to have) on the development of his film style.[39] His regular allusions to their work – and discussion of it in various public forums – have formed part of a strand of film-related public discourse that emphasises their continued relevance as a frame of reference. Indeed, mentions of the Stooges are numerous, tellingly occurring in positive reviews but notably absent from more critical ones. Thus a culturally lionised comedy act functions as a widely familiar frame of reference. Such references occur frequently in US reviews of *Four Lions* suggesting that they serve a very particular cognitive function. Importantly here The Three Stooges are evoked as a strategy to 'make sense' of the film's approach but also to suggest something positive about Morris's film via the connection. *Madison.com*, a site collecting together news from various Wisconsin-based print media, is typical here, picking out Omar as 'the Moe of these Four Stooges',[40] whereas John Hartl, writing for the *Seattle Times* is more explicit still, stating that '[a] more appropriate title might be "The Four Stooges"'.[41]

For critics looking for a comparison point from within their own culture, mobilising The Three Stooges, despite its potential to be anachronistic, made sense. In seeking to stress the notion that *Four Lions*' central dynamic revolved around the comic mishaps of a small group of men, each with distinct comic personae, the link to The Three Stooges provided a coherent reference point. In the *Miami.com*, Rene R, calls it a 'daring satire' while also labelling Barry 'the Moe in this pack of dangerous stooges'.[42] Those reviews choosing to use The Three Stooges as a frame of reference often mention the film's slapstick elements and stress its absurdity and 'old-fashioned wordplay', an example being that in the *East Bay Express*, where the 'screamingly sharp slapstick of the film' is very quickly followed by an allusion to The Three Stooges[43] Thus, these comparisons appear to make perfect sense in this context.

The reference also acted as a kind of validating statement. Relating the film to a culturally valorised set of performers (and by extension their body of filmic and televisual work), whose reputation had already been enshrined as iconic and significant in American comedy effectively rendered *Four Lions* critically laudable. Notably, negative reviews, such as Josh Bell's *Las Vegas Weekly* assessment, which saw the film as only 'fitfully funny' and alternating between 'lame sitcom-style gags and muddled social commentary', make no mention of The Three Stooges at all. Given Morris's lack of profile in the US prior to its release, it is perhaps unsurprising that reviews of *Four Lions* tended not only to make connections to US frames of reference such as The Three Stooges but also underscore the Britishness of Morris's work. An additional strategy here was to draw very specific attention to what was positioned as the peculiarly British nature of the film, as this represented another means by which American critics could make sense of this kind of comedy and position it as somewhat paradoxically emanating from a very specific comedic heritage (British absurdist humour) and being congruent

with a certain kind of American humour. In this way, mention of Monty Python could sit cheek-by-jowl with allusions to The Three Stooges in a way that made sense to a US audience. References to Morris tended to be tentative, noting merely that he was a 'popular British satirist'[44] or that England is a place 'where co-writer and director Chris Morris has a following'.[45] As part of this, Four Lions itself was positioned in a broader tradition of irreverent British comedies that were successful in the US, such as Life of Brian (1979) and Monty Python more generally. This stressed a continuity with a kind of British humour and helped to make sense of what is consistently labelled as a 'British satire'.

Conclusion

Critical receptions are, of course, neither monolithic nor necessarily culturally specific in all cases and with Four Lions there are clear variances as well as congruencies. Recognising the distinct address – politically, culturally and geographically – of individual newspapers is clearly important. However, this does not presuppose that receptions are so specific and particularistic as to make general observations moot. Instead, it is possible to observe commonalities and differences in the UK and US reaction to Morris's film that point to general trends. The reception trajectory identified here for Four Lions can be characterised in several ways. Reviewers were concerned about the nature of the film's narrative and how it might be received in relation to previous terrorist attacks. Morris's previous work on television – and in particular its robust, challenging mockumentary style – provided a clear frame of reference for British reviewers, who could therefore see Four Lions as an extension of a career spent challenging the conventions and mores of both television and radio. The film was then assessed upon how successfully he was able to mobilise this style in relation to contemporaneously challenging events. In the US, where Morris is less well known and where his shows are less popular, this dynamic worked very differently. Reviewers often clearly had no immediate frame of reference in which to position Morris, most being unfamiliar with his work. They therefore wanted to provide identifiable reference points that would make their reviews and the film itself sensible to their readers.

Reception is not a snapshot in time. It is an ongoing, evolving process. With this in mind, it will be interesting to see how the film is viewed over time. Ernest Mathijs has noted how the reception of films can often settle into 'final moments' whereby an agreed-upon idea of 'what the film was about' and what its cultural standing is solidifies.[46] With a topic as controversial and, at the time of release, topical as Four Lions the dynamics behind such a process will depend to a certain extent on the role terrorism plays in British and American life in the near future and thus be related to the broader geopolitical landscape change.

Notes

1. The reviews analysed here are all from professional film critics and originally appeared in print in either local or national UK and US newspapers. Some have also been published on individual

newspaper-specific websites. Where possible page numbers have been listed and where not possible a hyperlink to the appropriate review is provided.

2. David Bordwell, *Making Meaning: Inference and Rhetoric in the Interpretation of Cinema* (London: Harvard University Press, 1989).

3. See, for instance, Ernest Mathijs, '*Big Brother* and Critical Discourse: The Reception of *Big Brother* in Belgium', *Television and New Media* vol. 3 no. 3 (2002), p. 311–22.

4. Ernest Mathijs, 'Bad Reputations: The Reception of "Trash" Cinema', *Screen* vol. 46 no. 4 (2005), pp. 451–72.

5. Barbara Klinger, 'Digressions at the Cinema: Reception and Mass Culture', *Cinema Journal* vol. 28 no. 4 (Summer 1989), pp. 3–18; Barbara Klinger, *Melodrama and Meaning: History, Culture and the Films of Douglas Sirk* (Indianapolis: Indiana University Press, 1994); Barbara Klinger, 'Film History Terminable and Interminable: Recovering the Past in Reception Studies', *Screen* vol. 38 no. 2 (1997), pp. 107–29; Janet Staiger, *Interpreting Films: Studies in the Historical Reception of American Cinema* (Princeton, NJ: Princeton University Press, 1992); Janet Staiger, *Perverse Spectators: The Practices of Film Reception* (New York: New York University Press, 2000).

6. Klinger, *Melodrama and Meaning*, p. 160.

7. Staiger, *Interpreting Films*, p. 9.

8. Staiger, *Interpreting Films*, p. 81.

9. Staiger, *Perverse Spectators*, p. 12.

10. Staiger, *Interpreting Films*.

11. Klinger, *Melodrama and Meaning*, p. xvi.

12. Klinger, 'Film History Terminable and Interminable', p. 112.

13. Ibid.

14. Ibid.

15. Staiger, *Interpreting Films*; Staiger, *Perverse Spectators*.

16. A qualification does need to be added here, however. Klinger does not *exclusively* use review materials but they do form the core, to a certain extent, of her work in *Melodrama and Meaning*. Cynthia Erb and – more recently – Kate Egan have drawn upon a broader range of reception materials. See Cynthia Erb, *Tracking King Kong: A Hollywood Icon in World Culture* (Detroit, MI: Wayne State University Press, 1998); Kate Egan, *Trash or Treasure? Censorship and the Changing Meanings of the Video Nasties* (Manchester: Manchester University Press, 2007).

17. Ernest Mathijs, 'AIDS References in the Critical Reception of David Cronenberg: It May Not Be Such a Bad Disease after All', *Cinema Journal* vol. 42 no. 4 (2002), p. 29.

18. Mathijs, 'AIDS References in the Critical Reception of David Cronenberg', p. 29.

19. Tom Gunning, 'Foreword', in Yuri Tsivian, *Early Cinema in Russia and Its Cultural Reception* (Chicago, IL: University of Chicago Press, 1994), pp. xv–xvii.

20. Robert E. Kapsis, *Hitchcock: The Making of a Reputation* (Chicago, IL: University of Chicago Press, 1992), p. 12.

21. Charles J. Maland, *Chaplin and American Culture: The Evolution of a Star Image* (Princeton, NJ: Princeton University Press, 1989), p. xvi; see also Klinger, *Melodrama and Meaning*.

22. Jonathan Romney, *Independent on Sunday* (9 May 2010), p. 59.

23. Lisa Kennedy, 'Would-be Jihadists in Search of a Clue', *Denver Post* (26 November 2010), p. D-05.
24. Michael Phillips, 'Finding the Jokes in Jihad', *Chicago Tribune* (12 November 2012), <http://articles.chicagotribune.com/2010-11-12/entertainment/ct-mov-1112-four-lions-20101112_1_jihad-islamic-jokes>.
25. John Hartl, '*Four Lions*: An Ambitious, Uneven Farce about a Gang of Suicide Bombers', *Seattle Times* (4 November 2010), <http://seattletimes.nwsource.com/html/movies/2013345514_mr05four.html>.
26. Andrew O'Hagan, '*Four Lions* Is Comedy of Terrors', *London Evening Standard* (7 May 2010), <http://www.standard.co.uk/arts/film/four-lions-is-comedy-of-terrors-7419759.html>.
27. Unknown Author, 'Film Review: *Four Lions*', *Scotsman* (6 May 2010), <http://www.scotsman.com/news/film-review-four-lions-1-802956>.
28. Anthony Lane, '*Four Lions*', *New Yorker* (November 2010), <http://www.newyorker.com/arts/reviews/film/four_lions_morris>.
29. A. O. Scott, 'Hairbrained Plan by Halfwits', *New York Times* (4 November 2010), p. 26.
30. Hans Robert Jauss, *Toward an Aesthetic of Reception* (Brighton: Harvester, 1982), p. 21.
31. Graham Young, 'Movie Reviews: Robin Hood and Four Lions', *Birmingham Post* (13 May 2010), p. 20.
32. Unknown Author, 'Film Review: *Four Lions*' (2010).
33. O'Hagan, '*Four Lions* Is Comedy of Terrors'.
34. Unknown Author, 'Film Review: *Four Lions*', *Fife Today* (Thursday 6 May 2010), <http://www.fifetoday.co.uk/lifestyle/entertainment/film-review-four-lions-1-802956>.
35. Phelim O'Neil, 'The Guide: Film: DVD & Blu-ray Releases: *Four Lions* DVD & Blu-ray Optimum', *Guardian* (28 August 2010), p. 23.
36. Unknown Author, 'Film Review: *Four Lions*' (2010).
37. Kelly Vance, 'What's Worse? Klutzy Jihadist Terrorists or Vengeful Wall Streeters', *East Bay Express* (10 November 2010), <http://www.eastbayexpress.com/ebx/big-bang-theory-four-lions-and-client-9/Content?oid=2186388>.
38. Daniel Martin, 'Japan's *Blair Witch*: Restraint, Maturity, and Generic Canons in the British Critical Reception of *Ring*', in *Cinema Journal* vol. 48 no. 3 (May 2009), pp. 35–51.
39. Raimi has consistently made connections to the work of The Three Stooges in interviews, noting how his early short films were often remakes of their material.
40. Rob Thomas, '*Four Lions*: Who Knew Terrorists Could Be So Funny?' (4 February 2011), <http://host.madison.com/entertainment/movies/reviews/article_1cbe2a3e-d353-5c98-ac72-101a8fb28872.html>.
41. Hartl, '*Four Lions*'.
42. Rene Rodriguez, 'British Satire Is Timely, Fearless – and Hilarious', *Miami Herald* (29 December 2010), <http://www.miami.com/039four-lions039-r-article>.
43. Vance, 'What's Worse?'.
44. David Lewis, *San Francisco Chronicle* (12 November 2010), p. E4.
45. Phillips, 'Finding the Jokes in Jihad'.
46. Ernest Mathijs, '*The Lord of the Rings* and Family: A View on Text and Reception', in Ernest Mathijs and Murray Pomerance (eds), *From Hobbits to Hollywood: Essays on Peter Jackson's* The Lord of the Rings (Amsterdam and New York: Editions Rodopi, 2006), pp. 41–64.

THE HELIUM OF PUBLICITY: MASS-MEDIATED 'TERRIERISM'

DAVID ROLINSON

A shot of Oxford Street in London with three policemen and a knotted tape barrier is explained by reporter Eugene Fraxby: 'Oxford Street in London with three policemen and a knotted tape barrier.' This overly literal voiceover opens the 'Bombdogs' sequence from the fourth episode of *The Day Today* (BBC 2, 1994), signposting not only the series' characteristically parodic reading of broadcast news cliché but also the sequence's specific interest in the way that news bulletins on terrorist incidents can neglect contextualisation. The label 'media terrorist' is shorthand for Chris Morris's techniques of disruption and ambush, but we can read it another way: his deconstruction of media strategies raises vital issues when those strategies relate to the specific context of terrorism and the way that its relationship with the media is debated in academic discourse. Therefore, this chapter considers the extent to which the play with, and of, media strategies in Morris's work on terrorism reflects broadcasting tropes, legislation, debates on the media's narrative strategies and the spaces that those strategies provide for the discussion of terrorism.[1] Although the subject of terrorism runs through various Morris pieces, including *Nathan Barley* (Channel 4, 2005) and the Bushwhacked 'cut-ups' (2001–3), this chapter focuses on the detailed analysis of two pieces in which these elements of narrative, context, space and discourse instructively interweave: 'Bombdogs' and *Four Lions* (2010).

'Bastard?': *The Day Today*

Introducing the fictional report on 'Bombdogs' – the Irish Republican Army (IRA)'s 'mainland campaign of dog bombs' – the anchor 'Christopher Morris' derives his knowledge position from official statements and presents counterterror operations as a response to an inexplicable outbreak of violence. These ideas are underlined by the visual strategies featured in Fraxby (Morris)'s report. First, the shock caused by the appearance of a stray dog is reconstructed with a frantic hand-held camera taking the optical point of view of a panicking civilian. Second, a shot of a 'controlled explosion' conducted by the police yields to a zoom-out and slight pan to attribute the location of the camera, behind

the police line and some civilians. Like the bystander elsewhere in the sequence who is issued ornate visual instructions by a policeman, the newsgathering camera has moved to an approved position. The optical point-of-view shot and the attribution of camera position instructively connect the knowledge position of the uninformed, hysterical civilians with the camera which is forced to rubberneck from a distance. Its invasive long lens pries at the bagged remains of the dog (one of several images with equivalents in *Four Lions*) after the 'controlled explosion', a phrase that despite its internal tensions is discursively positioned as the opposite of, and solution to, the uncontrolled explosion of hysteria that preceded it.

Questions of perspective and viewpoint were central to academic texts such as *Televising Terrorism* (1983), in which Philip Schlesinger, Graham Murdock and Philip Elliott studied fiction and non-fiction programming in the context of legislation, state positions, practices within media industries and the spaces provided by different televisual forms. To develop a workable methodology with which to examine this idea of 'space', given that it refers to a text's relationship with the official perspective, it is necessary to introduce the four perspectives on terrorism that Schlesinger *et al.* identified as emanating from various sources – including security experts, academics, journalists, politicians, civil liberties activists and terrorists – and subsequently featuring in media representations. The 'official perspective' refers to 'the set of views, arguments, explanations and policy suggestions advanced by those who speak for the state' and who are engaged in a 'war against terrorism' discourse that Schlesinger *et al.* describe as 'propagandistic'.[2] Its features include stressing the illegitimacy and criminality of terrorism: 'crime is crime is crime', as Margaret Thatcher argued.[3] Policy makers might be privately aware of alternative explanations, but they are also aware that 'explanations may be mistaken for excuses', and so may prefer views such as Norman Podhoretz's: that 'the cause of terrorism is terrorists'.[4]

With the news media's position as gatekeepers seen as part of what Brigitte Nacos calls the 'calculus of mass-mediated political violence' within which communicative acts of violence operate,[5] and with the political climate in the years preceding *The Day Today* characterised by descriptions of terrorist acts as attempts to 'bomb and murder their way into the headlines',[6] many journalists operate in the terms set by the official perspective whether through legislation, censorship, media regulation or self-censorship and their adherence to preferred practice. For example, editors polled by Alex Schmid regarding their 'ethical principles' felt that they should not 'serve as spokesmen/accomplices for terrorists' but instead 'portray the cowardice, blindness, and frequent barbarism of the terrorists'.[7] Narrative strategies arise from these knowledge positions. For example, 'Bombdogs' is bookended by comments from Morris that reflect this perspective's stress on the inexplicability of terrorism, which is often conveyed through weather-like metaphors, such as the assertion by Christopher Dobson and Ronald Payne that 'terrorism ebbs and flows like the tide, one moment crashing frighteningly on the foreshores of our lives, then retreating to lie quiescent, gathering strength for its next assault'.[8] In its narrative, visual and dialogue cues, 'Bombdogs' therefore reflects the ways in which media outlets, according to Sarah Oates, 'generally do not provide analysis or background to terrorist events, making it difficult to either understand the roots of the conflict or work toward a solution'.[9]

The official perspective justifies exceptional measures such as censorship, violent action, jury-vetting and increased detention periods, but seeks to uphold the rule of law, particularly when politically motivated groups (such as the Baader-Meinhof group) seek to provoke greater repression to reveal to the majority what they see as the state's inherent violence. The official perspective is therefore concerned with 'dilemmas of the strong state' such as maintaining order within the rule of law, dilemmas which become uncomfortably public in the reporting of alleged human rights violations at Guantanamo Bay and Abu Ghraib. The 'populist' perspective, despite sharing features with the official perspective, is a more reactionary position which includes the deployment of war metaphors and putting 'the demands of order before those of the law',[10] with tactics such as assassination.[11]

By contrast, the alternative perspective questions the official one, discussing the 'implications of excessive repression for the rule of law and democratic rights' and the 'official strategy of repressing and exorcising terrorism'. Although agreeing with the official perspective that terrorism is 'not legitimate within liberal-democracies', it recommends deploying political change to tackle the causes of terrorism,[12] such as reading nationalist violence as the actions of the 'alienated' and 'dispossessed', which reveals the 'failure of the international community to recognise legitimate aspirations'.[13] Rather than providing the answer, repression might exacerbate tensions and thereby generate further terrorism. Those articulating these views risk being seen as supporting terrorists or weakening public support for the state's actions, hence the National Council for Civil Liberties' clarification that 'our opposition to terrorism is in no sense compromised by our opposition to laws such as the Prevention of Terrorism Act'.[14] Meanwhile, the 'oppositional perspective' does not merely contextualise events to counteract the official perspective's labelling of violence as irrational and criminal, but also 'justifies the use of violence in the pursuit of political ends'.[15] Within the alternative and oppositional perspectives, terrorism may be seen as 'explicable' and the effect of applying the label 'terrorism' brought into question, particularly in relation to the less often discussed idea of 'state terrorism'.[16] We shall return to definitions, perspectives and the narrative and rhetorical strategies deployed within them.

In the terms given so far, the 'Bombdogs' 'report' operates within the official perspective, but this is complicated by the fact that it simultaneously occupies two different forms: comedy and news. Indeed, it explores the discursive space within those forms. *Televising Terrorism* again provides useful methods: its examination of texts for the presence of the aforementioned perspectives includes discussion of viewpoints and formats. A 'relatively closed viewpoint' is one in which texts 'operate mainly or wholly within the terms of reference set by the official perspective', while a 'relatively open viewpoint' is one in which texts 'provide spaces in which the core assumptions of the official perspective can be interrogated and contested and in which other perspectives can be presented and examined'. A programme might have a relatively 'tight' format – in which 'the images, arguments and evidence offered by the programme are organised to converge upon a single preferred interpretation' and in which 'other possible conclusions are marginalised or closed-off' – or a relatively 'loose' format, in which 'the ambiguities, contradictions and loose ends generated within the programme are never fully resolved', thereby 'leaving the viewer with a choice of interpretations'.[17] Therefore, the nature of a news bulletin – its timeslot, length of items, its presenter's

role and so on – results in a tighter format and more closed viewpoint than *Newsnight* (BBC 2, 1980–), but that programme in turn is tighter and more closed than the author-led documentaries of John Pilger. Similarly in fiction, the action-adventure series *The Professionals* (ITV, 1977–83) features a 'tight format and reactionary populist version of the official perspective' in which the heroes' viewpoint helps to 'enlist the audience's support for powerful counter measures',[18] while single plays such as *Psy-Warriors* (1981), operating within the *Play for Today* (BBC 1, 1970–84) strand with its questioning and diverse rubric, may present a range of controversial views – for instance, the oppositional description of Palestinians who 'use their bullets to subdue the violence of the people who exploit them' and therefore 'kill to breathe' – which are contested but left relatively open. Different perspectives can all be *in play* within a text – broadcasters are not 'simply instruments of the state' – but given the assertion that 'the official perspective is over-represented in peak-time viewing' and news in particular, studying a text's formal qualities may reveal that one perspective gains priority.[19] For instance, *The Professionals* episode 'No Stone' (1983) presents a terrorist communiqué, which contains the 'anti-system variant of the oppositional perspective, which argues that terrorist violence is a response to the institutionalised violence of the society aiming to reveal the repressive reality behind democratic rhetoric', but it is 'inserted into a narrative whose whole structure is designed to discredit it as a political argument', ranging from ironies in logic to the visual devices by which the femininity of the terrorists' leader is coded as aberrant in comparison with a counterterror operative's wife.[20]

Taken as a news report, 'Bombdogs' similarly enlists audience support for counterterrorist action and discredits the political dimension of terrorist actions and statements. Of course, it's *actually* a sketch in a comedy series, so its tight format and closed viewpoint exist in a problematised discursive space in which the tightness and closedness of the report are revealed through methods which are loose and open. For instance, when the jolly scampering of a dog results in panic, we are told that 'the police had no choice' but to open fire, though this sits uneasily with the comic excess of the panic and the poor visibility of the target. The legitimacy of the police action is emphasised by shifting agency – an innocent dog and three people are 'dead from guns', not those firing them or the political or legislative climate that licenses and legitimises the action – and the memorable claim that 'being old, they would've died soon anyway'. *Four Lions* has an equivalent scene, involving snipers, which pivots on definitional issues.

The sequence moves into a eulogy to the dog 'shot to ribbons in its prime', after the camera zooms and seems to find the dog's body: the noticeable visual jolt signposts the constructed sense of unplanned observational technique that sells the fiction's faux-news grammar, but also draws attention to the lurching repositioning through which the report moves from describing animals as legitimate targets to mourning their loss. Maintaining smooth movement and narrative logic through the nimble editing between the end of the previous scene and the pan and zoom into Fraxby, the first Fraxby report ends with a lament for the man–dog relationship (articulated through reductive gestures of stroking and shooting) and the statue 'In memory of "Spider"' (see p. 227).

Human-interest angles and the 'language of sentiment' were among the issues discussed in studies of the news coverage of the 20 July 1982 bombings of Hyde Park and Regent's

In memory of Spider

Park. Fraxby's prioritisation of an animal victim raises parallels with that coverage. The bomb-ings killed eleven people, but in the following days Sefton, a cavalry horse injured in the attack, appeared in most British news coverage.[21] This coverage, and books and television biographies, celebrated Sefton's recovery, revealing the media's preoccupation with the 'health and welfare of animals, particularly those loyal to the state'; ITV's profile *Sefton, A Household Name* (1982) 'offered a powerful reaffirmation of the British will to survive, one that extended even to anthropomorphised animals'.[22] The fact that *The Day Today*'s dog has the name 'Spider' – disjunctive to the point of cognitive dissonance – recalls a dog called Rats, whose fame as the longest-serving member of the British Army in South Armagh included a *Nationwide* (BBC 1, 1969–83) profile in 1979. 'Given the famous British predilection for ani-mals,' notes Liz Curtis, 'Rats was an army propagandist's dream'.[23] Spider's shifting reputation also recalls the circulation of several false black propaganda stories depicting the IRA as 'cruel to dogs', including the allegation in 1972 that IRA members had shot dogs for target prac-tice.[24] Fraxby's eulogy to Spider joins real broadcasts like the *News at Ten* (ITV, 1967–99; 2001–4; 2008–) report on Sefton and Rats opening an Imperial War Museum exhibition on 'Animals in War', after which newsreader Alastair Burnet opined that 'If Sefton and Rats were standing for election, they'd be elected'.[25] Schlesinger *et al.* felt that this projection of nation-hood deserved 'serious investigation' because 'popular sentiment about animals' was being 'mobilised in ways that support official views of terrorism'. Its place in 'the propaganda war' meant that such animal stories were 'only superficially amusing, sentimental and trite'.[26]

Indeed, responses to animals' injuries and deaths have been related to the aforemen-tioned perspectives and knowledge positions. Colonel Andrew Parker-Bowles, Commanding Officer of Sefton's regiment, stated that 'the mind boggles that anyone could pack these nails round explosive in order to kill and maim horses',[27] while Thatcher stated that 'these callous and cowardly crimes have been committed by evil and brutal men who know nothing of democracy'.[28] These views 'reaffirmed the official view of terrorism as an essentially mean-ingless eruption threatening order' and the tributes to Sefton restated the military's 'ancient ability' to 'turn the scars of battle into memories worth saving'.[29] Comparable views feature

in Fraxby's tribute to Spider: his death is a random act displaced onto an overall battle narrative that is eulogistic in tone.

The 'Bombdogs' report continues with a graphics package on the counterterror deployment of technology, here resin with dog-propelling side effects, and an insert about legislation allowing the shooting of suspicious domestic pets, reflecting the dilemmas of the strong state. Knowledge positions are again invoked as an eyewitness (Steve Coogan) describes events in the language of Hollywood action films (whose reinforcement of official or populist perspectives has also featured in academic discourse). The 'meaningless eruption' idea is reinforced by this moment and subsequent updates by Morris and Fraxby that 'seven more dogs have gone off … without warning' near government buildings. Government responses articulate this position through the impotent anger of fictional politicians and condemnatory archive statements by Prime Minister John Major and former Cabinet minister David Mellor, even if Mellor's articulation of the official perspective – 'the terrorists have shown an insolent contempt for public opinion' – is interrupted by Fraxby's assertion that 'Journalist David Mellor added little of interest.'

Beginning a section on the terrorists themselves, anchor Morris appears in front of a screen on which the heading 'BASTARD?' accompanies an image of fictional Sinn Fein deputy leader Rory O'Connor (Coogan) (see p. 229). The use of 'bastard' further demonstrates perspectives in play in the 'report'. For example, newspapers attributing the IRA's killing of Lord Mountbatten in 1979 to 'diseased minds rather than political calculation' (*Daily Telegraph*) and 'evil men' (*Daily Mail*) used such terms as 'Murdering bastards' (*Sun*) or just 'bastards' (*Star*).[30] This displaced the oppositional perspective embodied by the IRA's description of Mountbatten as an 'absentee landlord' who was part of a 'military machine' that 'has enslaved Ireland', and so a legitimate target because of 'the military and political machine he symbolised'.[31] The targeting was therefore a communicative act constituting 'one of the discriminating ways in which we can bring to the attention of the British people the continuing occupation of our country'.[32] Within the terms of the official perspective, these actions were criminal and irrational, and reports avoided (or denied the relevance of) context. Just as the dead of Hyde Park and Regent's Park were not described as 'soldiers' but as 'people', so Lord Mountbatten was discussed not in the symbolic terms employed by the IRA but as a family man. The idea of family contrasts with the fatherlessness implied by the word 'bastard', which in turn parallels the construction of people without a history. The 'bastards' response can be placed in the discourses of the time, as in comparison with the *Sun*'s 'Gotcha!' Belgrano cover,[33] but persists today: American forces' killing of Osama bin Laden in May 2011 produced such headlines as 'We Got the Bastard!' (*Philadelphia Daily News*) and 'Got Him! Vengeance at Last! US Nails the Bastard' (*New York Post*).[34] Clearly the word is loaded when invoked by the 'Bombdogs' sequence.

Morris warns us that 'under broadcasting restrictions', O'Connor during his interview 'must inhale helium to subtract credibility from his statements'. Although the use of helium brings to mind elements of the Morris 'myth', such as the story that he filled 'a news studio with helium seconds before a broadcast, resulting in the announcer reporting a motorway pile-up in the voice of a smurf',[35] there is an obvious parallel between O'Connor's enforced helium inhalation and the broadcasting ban which was in operation between 1988 and 1994.

Subtracting credibility

BASTARD?

Not so much new legislation as the enactment of pre-existing provisions – Clause 14(4) of the BBC's Licence and Agreement and Section 29(3) of the Broadcasting Act 1981, which gave the Home Secretary powers intended for wartime use – broadcasters were required not to transmit 'words spoken by representatives of [eleven] Irish organisations, and of words spoken in support of those organisations', including eight groups already banned under the Emergency Provisions Act or the Prevention of Terrorism Act (including the IRA, INLA [Irish National Liberation Army] and Ulster Freedom Fighters) and three groups who were still legal when the ban was introduced, including Sinn Fein.[36]

The broadcasting ban was not a new or self-contained development. Journalists had long since contended with legislation including the Official Secrets Act and the Prevention of Terrorism Act, under which a Jeremy Paxman-led crew's footage of a propagandistic IRA roadblock in Carrickmore, County Tyrone was seized by police.[37] Pressures had risen since the 'Troubles' began in 1969: politicians in the 1970s called for 'patriotic censorship', the BBC according to its Chairman viewed the IRA's 'campaign of murder with revulsion' and 'cannot be impartial', while the Chairman of the Independent Television Authority stated that 'Britain is at war with the IRA in Ulster and the IRA will get no more coverage than the Nazis would have done in the last war.'[38] It is beyond this chapter's scope to detail the many 'banned, censored or delayed' programmes between 1959 and the early 1990s.[39] However, some consideration of the broadcasting ban is relevant to the discourses at work in *The Day Today* and the ban is revelatory of Prime Minister Margaret Thatcher's tough line on terrorism. This line was signposted by her responses to BBC reporting in 1979 such as Carrickmore ('both the Home Secretary and I think it is about time they put their house in order') and a *Tonight* interview with the INLA who had killed Airey Neave, at the time the Conservatives' Shadow Northern Ireland Secretary, in the Palace of Westminster car park ('I am appalled it was ever transmitted and I believe it reflects gravely on the judgement of the BBC').[40] The line included a refusal to grant the status of political prisoners to hunger strikers including Bobby Sands and the denial of voice in Thatcher's assertion, regarding the publicity received by Arab terrorists for hijacking planes, that 'we must try to find ways to starve the terrorists of the

oxygen of publicity on which they depend'.[41] Announcing the ban in Parliament in 1988, Home Secretary Douglas Hurd stated that terrorists 'draw support and sustenance from having access to radio and television and from addressing their views more directly to the population' and so 'the time has come to deny this easy platform', which Cynthia L. Irvin categorised as an 'official perspective' belief that 'if the media refuse to cover acts of terrorism, terrorists will disappear'.[42]

Faced with initially vague restrictions, broadcasters drew up guidelines which 'interpreted the ban very broadly' with the result, according to Curtis, that 'any opposition to government policy on Ireland became suspect', as did 'critical questioning of the army' or Unionist politicians.[43] Programme-makers evolved methods to implement the ban, and some 'creatively interpreted' it in order to 'get information across' or even to 'mock the ban', although even the most playful journalists stopped short of helium.[44] The most common implementation of the ban involved broadcasting interviews but removing the interviewee's voice, either subtitling their words or dubbing them with the voice of an actor. These methods featured throughout British television news and current affairs programmes in the period leading up to The Day Today. For example, the controversial Real Lives (BBC 1984–5) documentary 'At the Edge of the Union' includes interviews with Sinn Fein's Martin McGuinness and Gerry Adams, who discuss achieving the withdrawal of British troops through combining the Armalite and ballot box. More contentious for many was the depiction of McGuinness's family life, although the programme similarly featured the domestic life of Democratic Unionist politician Gregory Campbell. 'At the Edge of the Union' was banned in 1985 by the BBC's Board of Governors, prompting acrimony and a BBC strike until it was broadcast later in the year.[45] However, a repeat in BBC 2's Twenty-five Bloody Years season in 1994 fell during the broadcasting ban, necessitating instructive changes: accompanied by captions indicating that government restrictions were responsible, interviews with McGuinness and Adams were voiced by actors and chants of 'Up the 'RA' were replaced by silence and subtitles. Campbell's words are broadcast without restriction, despite seeming to advocate terroristic vigilantism.[46] The very visibility of these restrictions made them counterproductive for broadcasters and authorities alike, as Curtis notes: the army felt that they may undermine public confidence in the credibility of released information (making it preferable to manage the media and plant stories through the Information Policy unit) and the BBC wanted to avoid subtitling news bulletins because it seemed like a critically dramatic intervention.[47]

The Morris/O'Connor interview draws upon the tensions of the times, both in the nature of the interview and the mediation of broadcasting restrictions. The perspectives discussed by Schlesinger et al. are in play: O'Connor's description of the bombdog incidents as 'inevitable given the position of the British government', of the IRA being 'forced into this position' and of Sinn Fein as 'a legitimate political party', being contested by Morris's attempt to get the Sinn Fein representative to state his support for the IRA's 'campaign of violence' and Morris's direct statement that it 'supports terrorist actions'. The restrictions' support for the official perspective by denying legitimacy is echoed by the timing of one intake of helium directly before the O'Connor statement that uses the word 'legitimate' (lent a serendipitous extra edge in performance, as Coogan needs two attempts to change his voice with helium and in the process changes the start of the sentence from 'The IR-' to 'Sinn Fein'). Viewed as

a report, its closure on O'Connor's aggressive statement that 'Your tone is antagonistic and you're making me very angry' shows the closing-off of alternative or oppositional readings. In the logic of *The Day Today*, however, the disjunction between statement and helium-inflected vocal performance adds to the mathematical cause-and-effect logic of Morris's introduction – inhaling helium 'to subtract credibility from his statements' – to underline the absurdity of the restrictions.

Morris's tone as interviewer is as revealing as Coogan's helium-affected vioice. Editors and reporters face particular challenges and guidelines when handling interviews. Given the prevailing belief that 'news media bestow a certain status on terrorist leaders simply by inter-viewing them',[48] and that by 'giving any coverage to "terrorists", particularly in a format that allows them to voice their views directly (i.e., live interview), investigators grant them legiti-macy and strengthen their position',[49] some editors believed that they should 'ensure that terrorist frontmen are never given an easy ride and that their support for violence is always questioned'.[50] BBC Producer Guidelines from the late 1980s attempted to minimise 'the publicity value of news' by avoiding 'anything which would glamorise the terrorist or give an impression of legitimacy'. Therefore, programmes should 'avoid terms by which terrorist groups try to portray themselves as legitimate' and not 'show terrorists or people closely associated with them in a favourable light'.[51]

In moments including the police's response to the inexplicable deployment of bombdogs and the adversarial logic of the interview, 'Bombdogs' draws upon the news frames that dom-inate mainstream coverage of terrorism. As Pippa Norris, Montague Kern and Marion Just noted, news stories are understood via 'news frames' which 'simplify, prioritise, and structure the narrative flow of events'. Journalists use these 'interpretive structures' to 'set particular events within their broader context', bundling together 'key concepts, stock phrases, and iconic images to reinforce certain common ways of interpreting developments' and forming a process of 'selection to prioritise some facts, images, or developments over others, thereby unconsciously promoting one particular interpretation of events'.[52] There are various such simplifying storylining frames, including 'conflict' and 'economic' frames, and the 'horse race' frame used in election campaign reporting to make political conflicts more 'comprehensible' through 'personifying' them.[53] News frames 'never provide a comprehensive explanation of all aspects of any terrorist act', but account for 'factors which best fit the particular interpre-tation': in international affairs, framing serves 'agenda-setting', 'cognitive priming' and 'evaluation' functions by, respectively, highlighting problems facing American interests, identifying threats and offering policy recommendations. 'Bombdogs' deploys the 'terrorist and anti-terrorist frame' which helps practitioners and public to 'quickly sort out, interpret, categorise and evaluate these conflicts' without knowledge of 'the particular people, groups, issues, or even places involved'.[54] Replacing the 'Cold War' frame, the 'war on terror' frame was adopted by the Bush administration with its own narrative features ('either you are with us, or you are with the terrorists'). It served as a 'perceptual frame' for justifying action in Iraq and elsewhere, and 'offered a way for American politicians and journalists to construct a narrative to make sense of a range of diverse stories about international security, civil wars, and global conflict'.[55]

Framing has effects: as Brian L. Ott notes, 'language homogenises' terrorists, with terms such as the 'Axis of Evil', 'fundamentalists' and 'terrorists' itself 'reinforcing the prevailing

perception that they are all the same and can be treated as one nameless, faceless enemy'.[56] This 'relationship between language and violence' is most keenly felt in incidents of the torture and abuse of terror suspects.[57] The homogenisation of language finds playful form in 'Bombdogs', for instance in 'Terrierists', the playfully reductive conflation that appears on a screen behind Morris. While pre-dating the specifically post-9/11 variant of the war on terrorism, 'Bombdogs' demonstrates the simplifying effect of such news frames, the language they require and the spaces within which journalists operate. Justin Lewis notes that journalists resist the 'explicit codification of news values' as if it might privilege 'structure over agency, diminishing a journalist's capacity and freedom to exercise skill and judgement' and making journalism seem 'inevitably defined and constrained by the conditions and values of news production' and 'social practices'.[58]

For Lewis, the actions that followed 9/11 were 'determined, in part, by the enormity of the event in news terms, unleashing a series of narrative conventions that had little to do with any credible body of evidence'.[59] The war on terrorism story has proved more durable than the climate change story despite the latter, according to Lewis, having an evidential rather than speculative base. While the war on terrorism has seemingly immediate 'ever-present' threats, causes within 'a straightforward story of good versus evil', relative unanimity in the need for war and vested interests who stand to profit from it, climate change's threats are longterm, its causes longterm and benign – 'a structural condition created with no ill-intent',[60] contributed to by consumer travel and economic growth – and lobbyists have vested interests in deflating the threat with 'pseudo-controversy'.[61] These factors 'diminish its value as a news story'.

The simplifying effect of dominant news tropes is underlined in Morris's wrap-up line: 'and since we conducted that interview, all sides in the conflict have had a meeting and have sorted everything out'. This resolution is absurd given the context of the conflict and its very simplicity comments on the worldview represented by the report's narrative approach. It is also revealing that the report is abruptly closed as soon as violence is removed. 'Bombdogs' therefore reinforces Peter Taylor's claim, writing on the IRA and Sinn Fein, that:

> the media has little time for background and context. Violence and confrontation are what it feeds off. Sound bites are easier to digest than analysis explaining why and how things happen. ... Yet it is history that makes sense of it all.[62]

In Morris's anchor pieces, Fraxby's report, graphics and O'Connor's interview, 'Bombdogs' pre-empts some of the studies of audience responses to the 11 September 2001 attacks and their aftermath: as Oates summarises, 'the initial coverage was as confusing and chaotic as the events themselves', and the move to rolling news 'did not lead to more meaningful political and historical context'.[63] The problem was partly a lack of context from which to draw, owing to 'a cycle of disinterest in foreign news'.[64] Also, there was initially 'no existing frame for the story – as there are with events such as elections, natural disasters, or even riots'.[65] Focus groups felt that reports deploying the colour-coded Homeland Security Advisory System a terror alert chart warning that threat levels were either severe, high, elevated, guarded or low – were 'becoming as banal and meaningless as weather reports', a phrase

that echoes the 'weather-like metaphors' itemised by Schlesinger *et al.* Providing reassurance rather than resolution, the ending is a reminder of Charles Townshend's point that without analysis, 'combating terrorism seems a baffling contest against an indefinite threat'.[66] It also foregrounds the role played by narrative conventions, a role that can be further explored through the correlations between news and fiction narrative in *Four Lions*.

'Fuck Mini Babybels': *Four Lions*

Like *The Day Today*, *Four Lions* explores form and narrative in relation to the media's strategies toward terrorism and the wider discourses revealed by those strategies. The film's darkly comic approach poses the sort of questions that Schlesinger *et al.* raised regarding the deployment of the SAS in newspaper cartoons and *Whoops Apocalypse* (ITV, 1982) after the May 1980 Iranian embassy siege: 'Where does fiction begin and fact end? And what should we make of the comedy of terror?'[67] The difficult play of sympathy, mockery and researched insight into British-Muslim experience helps the film to question the media's use of the post-9/11 'war on terror' frame, in particular through its exploration of definitional issues and a range of perspectives. Although it is beyond the scope of this chapter to fully interrogate the film's manifestations of the British-Muslim experience, selected examples can facilitate the study of the media's relationship with terrorism.

Four Lions' concern with media strategies is clear from the first few scenes. The film opens with the rhetoric of the jihadi video, as Waj (Kayvan Novack), holding a distractingly small replica AK-47, makes a doomed attempt to articulate his cause (see p. 234). His opening phrase, 'Ey up, you unbelieving kuffar bastards, I'm gonna turn you baked beans', establishes the group's origins and confused worldview, with its mixture of South Yorkshire and Arabic address, belief, fast food ('Chicken Cottage, proper halal, bargain bucket') and profanity, in this case reversing the attribution of 'bastard' discussed in this chapter's first section. Image definition, design and composition evoke the aesthetic of jihadi videos but the constructedness of this communication (by the characters) is signposted and breaks down through off-camera criticism of Waj's posture and props, his attempt to see himself through the viewfinder and Omar (Riz Ahmed)'s subsequent, pained viewing of the footage. In a second video, Omar contextualises their planned terror attack as a 'wake-up call' inviting Britain to consider its 'western imperialist culture'. A familiar element of news coverage from its contested use in bulletins, the jihadi video is a variant of the statements that terrorists make in order to claim responsibility for actions, to 'provide meaning to otherwise often inexplicable violence', to 'present their own well-considered stories, without the intervention of interviewers'[68] and, with the direct posting that is possible in the Internet age, to 'circumvent the traditional media's gatekeepers'.[69] The sequence echoes the videos of 7/7 [7 July 2005] bombers Shehzad Tanweer and Mohammad Sidique Khan and media responses to them, but their influence runs deeper than the characters' Yorkshire accents.

Moving into the film's titles, *Four Lions* deploys a long-distance zoom which isolates a section of the exterior of Sheffield's Meadowhall shopping centre to stress its resemblance to a mosque. As well as adding to the dialogue in the first scene and the title *Four Lions* as

That'll bigger it

a signifier of pulls within British-Muslim identity,[70] this shot echoes Omar's description of McDonald's as a 'capitalist church', which makes it even more ironic that Omar protects this space in his job as a security guard.[71] The next three shots could support Omar's concerns with 'superficial materialism' – the use of lines and space heightens the emptiness of the out-of-hours mall – but also foreground ways of seeing, since the third shot clarifies that the second shot was from a CCTV position. Soon, another movement between scenes is bridged by a zoom from an extreme long shot across Sheffield in daytime, finding the window of the flat used by Omar's terror cell. Underlining ways of seeing, the zoom is accompanied by voiceover dialogue including Barry (Nigel Lindsay)'s belief that 'the Feds' can 'see you everywhere', Waj's question 'Can they see you if you're not there?', and Faisal (Adeel Akhtar)'s question 'Are they looking at us through cameras?' Faisal's line accompanies – or motivates – the end of the zoom and a cut into the flat, which underlines the resemblance between these zooms and long-range surveillance, although the scrutiny that they are under is our own rather than the diegetic gaze of the intelligence services.

The paranoia and stupidity of individual group members will clearly be part of the 'comedy of terror' here. However, this type of representation has been queried as symptomatic of the official perspective: Philip Purser argued that *Eighteen Months to Balcombe Street* (1977), an ITV docudrama directed by Stephen Frears, displayed 'the sheer incompetence of the four terrorists, worthy contenders all for starring roles in Thick Irish Jokes … fanatics caught up in violence for its own sake'.[72] Co-writer Shane Connaughton wanted to remove his name from the credits,[73] and felt the play 'presented them as psychopaths and omitted the reasons for their actions' while he had been promised the scope to discuss 'political explanations'.[74] Incompetence and depoliticised actions abound in *Four Lions*, but if the official perspective is in play, it is balanced not merely by the equally comic depiction of counter-terror representatives but more importantly by the questioning of that perspective, the discourses underlying it and its media manifestation.

Later, another long zoom opens a sequence featuring the college debate 'ISLAM – Moderation and Progress', in which Malcolm Storge MP (Alex McQueen) of the Counter Terrorism Strategy Unit stresses that British Muslims are not all 'out fighting British foreign policy'. Such events fit the 'Prevent' initiative, intending to tackle 'root causes', by which the government's CONTEST counterterrorism strategy sought to understand and prevent radicalisation through more 'proactive' means than legislation and force alone, and to 'increase

the flow of intelligence coming from communities'.[75] Storge's assertion is consistent with Home Secretary John Reid's statement in September 2006 that the 'fight against terrorism is … a conflict of values, not a clash of civilisations' or of religions, and a conflict that exists 'within Islam' as well as 'outside it', meaning that the struggle against radicalisation involves fighting 'extremism, intolerance and terror', not 'Islamic values and teaching'.[76] As Steve Hewitt documented, post-9/11 foreign policy was discussed as a motivating factor, but Prime Minister Tony Blair was among those disputing its importance, aware that measured responses could provoke 'allegations that [the government] is engaging in appeasement',[77] especially given the perception that Britain was a 'safe haven' for international terrorists which led French intelligence to dub London 'Londonistan'.[78]

Disrupting the meeting, Hassan Malik (Arsher Ali) states that 'You think we're all bombers' and asks, 'Why shouldn't I be a bomber if you treat me like one?' His protest takes the form of a mock suicide bombing in which he sets off party poppers – as neat an image of *Four Lions*' marriage of form and content as the helium of publicity was for 'Bombdogs' – but his accusation, and the extent to which it informs his subsequent radicalisation by Barry, is left relatively open. Hassan's words find reinforcement in Omar's later speech to the group:

> We have instructions to bring havoc to this bullshit, consumerist, godless, Paki-bashing, Gordon Ramsay, *Taste the Difference* specialty cheddar, torture-endorsing, massacre-sponsoring, 'Look-at-me-dancing-pissed-with-me-knob-out' *Sky One Uncovered*, 'Who-gives-a-fuck-about-dead-Afghanis?' Disneyland.[79]

We also learn that Omar's cousin Faz 'died defending a mosque in Bosnia'. These statements chime with arguments in Peter Kosminsky's television drama *Britz* (Channel 4, 2007). While Sohail (played by *Four Lions*' Riz Ahmed) is recruited to MI5 and investigates his own community, his sister Nasima (Manjinder Virk) is recruited as a suicide bomber: their stories are split across two parts, and their choices dramatise tensions between and within British and Muslim identities. Nasima's political motivation is driven by upsetting experiences of repressive legislation. Like the 7/7 bombers who Kosminsky described as 'second-generation Pakistani-Muslim Britons' who 'were so angry or alienated that they felt themselves unable to express what was upsetting them through normal means',[80] those researched by Kosminsky indicated strong feelings about 'the huge raft of recent legislation, much of which affects habeas corpus' and 'the effect on Muslims of Britain's foreign policy', in particular support for Israel in the Middle East and wars in Iraq and Afghanistan.[81]

Britz is particularly concerned with the recent introduction of control orders under which people can be placed under indefinite house arrest without charge, which Hewitt uses to illustrate how 'heavy-handed tactics enacted or proposed by the government' have been 'damaging to community relations'.[82] Omar's jihadi statement in *Four Lions* finds its equivalent in Nasima's video in *Britz*, in which she tells the British public that 'You are not innocent … as long as you sit on your hands while they pass these laws which you know are wrong.' Nasima's video in turn echoes Shehzad Tanweer's statement to 'the non-Muslims of Britain' that they voted for politicians who 'oppress our mothers, children, brothers and sisters, from the east to the west, in Palestine, Afghanistan, Iraq, and Chechnya' and 'openly supported the

genocide of over 150,000 innocent Muslims in Falluja'.[83] Hassan's question 'Why shouldn't I be a bomber if you treat me like one?' chimes with Nasima's political awakening.

However, competing perspectives are in play, in particular the oppositional and official, as Omar's 'We have instructions' speech is followed by Waj's off-camera interjection, 'Fuck Minibabybels'. While symptomatic of Waj's skill for grasping the wrong point, it echoes Omar's own cheese reference and depoliticises Omar's points when taken alongside the personal motivations in his statement: they have no 'instructions' because they messed up their training in Pakistan. *Four Lions* therefore partly echoes Schlesinger *et al.*'s reading of 'No Stone', in that the articulation of motivations is 'inserted into a narrative' which may 'discredit it as a political argument'.[84] Other examples include the timing of a cut from Omar's statements about materialism in his jihadi video to his living room with its consumer goods. However, there is space for the articulation of the British-Muslim response to media and state narratives, indirectly – for instance, in the aforementioned foregrounding of surveillance – and directly. Problematising the group's motivations opens various knowledge positions.

Reflecting the idea that 'values' and not 'religions' are in conflict, unthinking fanaticism is downplayed as motivation, for instance, because of the group's conflicting practices. They disagree on various issues including whether it is 'haram' to appear on camera (hence Faisal's cardboard box headwear in a jihadi video) and where Mecca is after they have travelled to Pakistan. Omar's devout brother attempts to persuade Omar to reject violence (fulfilling the aims of Prevent), but Omar rejects his reference to Islamic scholars regarding non-violence and the role of women. Convert Barry's greater commitment is to terrorism – 'I'm the most al Qaeda one 'ere' – and as an outsider claims that 'Islam is finished' if he cannot go to the training camp. Omar's pejorative use of 'Disneyland' problematically echoes his references to *The Lion King* (1994) – which he cites more often than Islamic sources – and his need to translate life and jihad into terms that Waj can understand: Alton Towers amusement park rides Nemesis and Oblivion (Waj's response is the less doom-laden (mis)naming of Rubber Dinghy Rapids). Their unclear motivation rebuts essentialising discourses regarding the nature of 'Islamist' terrorism.

Interrogating those discourses is helped by considering the connections between state, news and fiction narratives. Schlesinger *et al.* contended that 'there are strong links between television fiction and journalism' as 'news stories are often presented like fictions', and NBC's Reuven Frank argued that 'every news story should … display the attributes of fiction, of drama' structured along the lines of 'conflict, problem, denouement'.[85] News/fiction narrative correlations can have sensitive implications when used to represent specific groups. As Brigitte Nacos and Oscar Torres-Reyna noted, the 'stereotypical portrayals of Arabs and Muslims' featured in 'popular fiction' may also appear in news because 'popular culture and news reporting do not operate in a vacuum but seem to feed on each other'.[86] Carl Boggs and Tom Pollard's description of the depiction of Arab terrorists in films such as *The Delta Force* (1986) as 'crude, semi-civilized, shady, violent, beyond redemption, capable of horrendous crimes' and therefore 'suitable for extermination',[87] a description reinforced by their reference to Edward Said's argument that 'Muslims and Arabs are essentially covered, discussed, apprehended as suppliers of oil or as potential terrorists', is echoed by studies of news treatments of Muslim-Americans, including Muslim New

Yorkers' claims that the 'prejudiced news media' had a 'tendency to stereotype Muslim males as violent and Muslim women as submissive'.[88]

 Such narrative correlations, in the context of news frames and news values, contribute to the attraction that terrorist acts have for news companies. The lions are partly aware of this: Barry's attempted jihadi video begins: 'Right, mister newsman in the newsroom, after three.' The legislative and ethical quandaries facing journalists when handling interviews are heightened when dealing with direct statements from terrorists. In the months following 9/11, the White House felt that Osama bin Laden was getting more coverage than Bush, and asked American networks to stop screening bin Laden's full videos, with the consequence according to Nacos that 'so-called experts interpreted and commented on specific passages … without providing their audiences with the basic information needed to understand' their discussion.[89] Similarly, the use of the 7/7 bombers' videos became a news story in itself. Waj's attempt to compensate for his diminutive AK-47 by holding it closer to the camera because 'That'll bigger it' is an appropriate reflection of what Lewis has called 'the overrepresentation of terrorism as a threat' in the media.[90] Similarly, Omar's colleague Matt (Craig Parkinson) assures us that 'most loud bangs are not bombs. They're scooters backfiring.'

 Barry's confidence that newsrooms will find the attack and associated footage news-worthy is well founded. Lewis describes terrorist attacks as a 'checklist of elements that feature on most definitions of news value: notably violence, conflict, drama, a threat to public safety and an ability to register high on the political agenda'.[91] Asked why acts of terrorism have a high news value, news editors noted that these 'sensational news events' contained 'drama rooted in the fact that it could happen to each of us'. 'Bad news is news,' stated another, and there were personalising elements such as the presence of 'moral dilemmas' and the opportunity to 'identify with the victims'.[92] As Michael W. Traugott and Ted Brader summarise, the criteria of 'newsworthiness' fulfilled by terrorist stories include 'timeliness, proximity, impact, conflict, sensationalism and novelty'. The very 'deviance' of such acts is news-worthy in that 'the confluence of impact, conflict, sensationalism and novelty … makes them newsworthy'.[93] Terrorist incidents form useful packages for modern news companies, given Nacos's argument that the 'profit-oriented' crowding out of '"hard" news' in favour of '"soft" news' has resulted in more 'infotainment', which 'thrives on the very images and themes that terrorist incidents offer – drama, tragedy, shock, anger, grief, fear, panic' and narrative features such as continuity, heroes and villains.[94] However, as Lewis notes, news values form just one factor: there is 'a political context that makes some forms of terrorism more newsworthy than others'.[95] Therefore, an Islamic narrative has come to dominate disproportionately,[96] while the 'well-established terrorist tradition' of 'white, right-wing Christian extremism' does not, to the extent that news narratives discussed the 1995 Oklahoma bombing and the 2011 shooting of Gabrielle Giffords in terms of 'individual pathology'.[97]

 Narrative features therefore pivot upon definitional issues, which find expression in *Four Lions* when two police snipers (Kevin Eldon and Darren Boyd) try to locate terrorists among the fancy-dress runners at the London Marathon. One target is misidentified as a grizzly bear, then a Honey Monster, but one of the snipers actually kills a Wookiee, having 'shot it as a bear' and they seek definitional clarification: 'Is a Wookiee a bear, Control?'; 'Is a Honey Monster a bear?'[98] The first sniper's statement that 'it must be the target. I just shot it' locates

the attribution of definition within discourses of power, a relationship which reverberates through this film and the correlations between state, news and fiction narratives that are at the core of academic debates on terrorism.[99]

There is 'no single, universal definition' of terrorism,[100] but definitions are formulated by states, such as these from the United Kingdom and United States respectively: 'the use of threat, for the purpose of advancing a political, religious, or ideological course of action against any person or property' and 'the calculated use or threat of violence to inculcate fear, intended to coerce or intimidate governments or societies'.[101] The US State Department describes 'premeditated, politically motivated violence perpetrated against non-combatant targets by subnational groups or clandestine agents usually intended to influence an audi-ence'.[102] Violating criminal law, intimidating and coercing civilians, influencing the policies of governments by intimidation: all feature in various official definitions,[103] which in turn shape the spaces available for news narratives. For instance, a 1974 BBC memo told reporters that 'terrorist' is particularly applicable when violence affects 'civilians' rather than 'military per-sonnel' although there are times when 'guerrillas', 'raiders', 'hi-jackers' or 'gunmen' may be more accurate.[104] Peter Taylor noted reporters' awareness of 'semantic subtleties' and the political implications when naming places (Ulster, Northern Ireland, the province, the North of Ireland, the Six Counties), situations (conflict, war, rebellion, revolution, criminal conspiracy, liberation struggle) or actors (terrorists, criminals, murderers, guerrillas, freedom fighters).[105] Given that studies have identified 109 definitions of terrorism, that figures such as Nelson Mandela have been relabelled in changing contexts, and there is 'no independent and reliable way of assessing what constitutes a terrorist act', there are 'instead definitions: socially con-structed understandings of events'.[106]

The word 'terrorist' comes with narrative connotations. It is a term applied to people 'by others, first and foremost by the governments of the states they attack'.[107] Subsequently, 'the news media uses the t-word to describe some political violence but avoids the term when reporting on similar incidents of violence for political ends'.[108] Definitions often compare ter-rorism and war: while armies have legitimate military targets, terrorists make 'random' and 'indiscriminate' attacks on civilians; terrorism is 'impressive' and 'mental' in nature while war is 'coercive' and 'physical'.[109] Definitions also compare terrorism and 'state terrorism': for exam-ple, the IRA stressed its military structure and emphasis on military targets, while scholars have debated the extent to which the definitions listed above may apply to actions com-mitted by the British or American states. Although governments may use 'terroristic violence', the 'dominant official discourse' stresses that 'terrorism is used by extremists – rebels – against the established order – the state',[110] and 'most observers do not consider civilian casualties of declared wars or other military actions as the victims of terrorism'.[111] Despite attempts at reversal – the al-Aqsa brigades 'declared themselves "honoured" to be labelled a terrorist organisation by the world's greatest terrorist, the US government'[112] – the ter-rorism label legitimises state force and is 'used to slur organisations which are perceived as illegitimate by implying that the violence they use is particularly unpleasant', which 'prejudges the issue'.[113]

Therefore, definitions matter – according to Richard Jackson, words 'can never be employed in a purely objective sense', and 'the act of naming things is always a highly charged

process that can have serious political and social consequences'.[114] The idea that the terrorism narrative prejudges events, rather than simply describing them,[115] demonstrates the appropriateness of *Four Lions* for a study of the conglomeration of state, news and fiction narratives. The idea recalls Edward Branigan's terms when describing narrative as 'a perceptual activity' which organises data into a 'pattern which represents and explains experience', forming 'a cause-effect chain' that 'embodies a judgement' about, and the ability 'to know', events.[116] I have written elsewhere on the ideological functions of narrative in dramas on terrorism such as *Elephant* (BBC 2, 1989),[117] but state discourse too has been viewed in terms of narrative construction, such as the problematic 'us' and 'they' in George W. Bush's question 'why do they hate us?'[118]

The language of the 'war on terrorism' is therefore a 'carefully constructed *discourse*' consisting of a 'deliberately and meticulously composed set of words, assumptions, metaphors, grammatical forms, myths and forms of knowledge'.[119] Studying discourse, as a 'way of talking about the world and understanding' it, the 'language used within a specific field' and forms of 'social practice', Jackson finds in the war on terrorism discursive formations and discursive constructions which 'promote a limited range of meaning' and 'shape what is possible and impossible to say'. Language and knowledge combine within discursive practices, and the 'war on terrorism' discourse 'has a clear *political* purpose' as 'the deployment of language by politicians is an exercise in power' and 'the *practice* of counter-terrorism is predicated on and determined by the *language* of counter-terrorism'.[120]

Several moments of *Four Lions* open up readings of counterterror operations using these methods, from the naming and classification of bears to the brandishing of a Weetabix as evidence of what 'we know' in the end credits as Omar's brother is taken to the extrajudicial space of the trailer that constitutes Egyptian territory. However, the impact of these discourses on the media's responses to Islamic groups is a particularly relevant case study. The 'war on terrorism' narrative frame involves the depiction of 'shadowy networks' of 'undifferentiated' Muslim groups, a 'seamless transnational terror network',[121] but rather than being 'monocausal', the motives and goals of such terrorists involve the overlapping of 'separatist or national or religious' elements,[122] and labelling can erase 'the profound difference between [groups such as] al-Qaeda and Hezbollah',[123] leaving the 'grossly simplistic' and 'counterproductive' bundling together of Muslims to create a reductive, 'unitary form of terrorism connected to Islam under the label of "Islamofascism"'.[124] International terrorism has replaced the 'Cold War' frame and become dominant: Freedman and Thussu note that of the sixty-two terrorist incidents that occurred within the United States between 2006 and 2008, none involved Islamist factions but instead neo-Nazis, animal liberation groups and the Ku Klux Klan, and yet domestic terrorism is so far removed from the narrative that the 1995 Tokyo nerve agent-attack and Oklahoma bombing would not now be recorded on most terror databases.[125] Therefore, the Islam-centred narrative 'conceals more than it reveals' and 'distorts both the scale and character of the terrorist threat, encouraging ill-informed, aggressive responses in a bid to control the narrative'.[126] According to Lewis, the replacement of ideological variation with 'one particular form of religious extremism' in official discourse 'offers glimpses of certain truths (some terrorists are Muslims) in a larger obfuscation', placing people who are 'moderate in their practice of Islam' in a 'continuum with terrorists at one

end of it' and demonising them. This 'shows us that the way the news media choose which stories to tell – and how to tell them – matters'.[127]

The 'war on terror' frame has impacted upon discussions of multiculturalism, as Gholam Khiabany and Milly Williamson observed in studies of newspaper language and political statements. Ignoring the 'criteria including ethnic and national origins, class and generation' or the 'diversity of geography, history, politics, language' which differentiate Muslims from each other, the 'perceived heterogeneity of "Muslimness" is created … by discursive practices which define a singular Islam'.[128] A 'homogenised Islamic culture is set in opposition to another invention – Western culture and, in the UK, "British culture"', and a 2011 piece in the *Economist* is one example of how European Muslims are deprived of their 'Europeanness' by 'stressing deep and unchangeable cultural traits'.[129] This 'culturalisation of acts of violence', which creates a 'decontextualisation of the "war on terror"',[130] finds its response in Omar's group's constant Western cultural signifiers.

Therefore, just as *Britz*, according to Riz Ahmed, managed to 'rehumanise young Muslims in the public eye' by stressing that 'these are people, across the board',[131] *Four Lions* manages, through the group's shambolic individuality, to respond to news and fiction discourses on homogenised Muslim positions and all-encompassing international terror networks. The official positions outlined above are reflected in the arrest of Omar's brother, whose open religiosity and cultural markers make him visible to the state while the terrorists are not, a point underlined by the editing misdirection (reminiscent of *The Silence of the Lambs* [1990]) in crosscutting between the group inside a house and the police about to storm a house. Additionally, as Helga Tawil-Souri notes, 'Just as there is no such thing as a unified "global jihad", in cyberspace too, jihadists [sic] spaces are neither homogenous, uniform, secure, nor static': therefore, the chaotic compilation of the group's video is not far from the 'ordered disorder' of information in 'jihadist media'.[132]

A similar sense of 'ordered disorder' and cluttered communication emerges from Omar's targeting of the London Marathon. Brigitte Nacos claims that terrorists have 'four media-centred goals': to attract 'the attention and awareness of various audiences' and 'condition their targets for intimidation', to attain 'the recognition of their motives', to gain 'the respect and sympathy of those in whose interests they claim to act', and to gain 'quasi-legitimate status'.[133] Therefore, the selection of targets is important, hence the timing of the 7/7 attack to dominate 'breaking news' at the expense of a G-8 summit,[134] and the targeting of 'sentimental landmarks' that was recommended by the *Manual of the Afghan Jihad* to 'generate intense publicity with minimal casualties'.[135] After rejecting Barry's desire to bomb a mosque to radicalise moderates, Omar's targeting of the London Marathon is outwardly consistent with these aims but problematic as a communicative act given that it is so noisy with other meanings.[136] The group's costumes include clowns and cartoon heroes as if in reflection of their self-image as terrorist actors and epitomising 'sensationalism and novelty'. Barry dresses as a figure that was itself subject to definitional renaming and controversy (Teenage Mutant Ninja Turtles being renamed in Britain as Teenage Mutant Hero Turtles). The ostrich and 'bear' costumes continue the film's concern with birds and animals, including crows, puffins (a virtual meeting zone which could be compared with studies of Internet resources and eterrorism) and dogs. As in 'Bombdogs', news coverage glimpsed in *Four Lions*

Alarm point

centres on the welfare of a dog, which in this case has been hit by Faisal's head falling from a tree, to which Barry responds elsewhere: 'Good. Dogs contradict Islam.' Faisal does not survive to wear a costume but his remains are bagged with those of sheep, from which he becomes indistinguishable.

Faisal's futile accidental demise is a jarring moment, even if the darkly comic tone finds occasional echoes in academic studies, such as Jackson's observation that 'statistically, there is a greater chance of choking to death on one's lunch than of dying in a terrorist attack'.[137] The emotional variations caused by the deaths of the lead characters in a comedy film are not tonal problems but strengths which challenge our responses – although they stress self-defeating futility and waste (particularly given the ironic sites and situations for their deaths), there is, as in the dark Ealing comedy *The Ladykillers* (1955), sadness where a happy ending might conventionally occur, given the plot that has been thwarted. The fun run is an appropriate setting, given Dowling's contention that 'terrorists fail because of the distance between their acts and their audiences. Their acts become entertainment and do not inspire terror'.[138] This is an apt description of the terrorist cell depicted in *Four Lions*, and though critics might apply this to the film itself (it fails because its acts become entertainment), there is a correlation between news and fiction narratives and the appeal of terrorist 'packages' for modern 'infotainment' news which opens up the application of the term to the terrorist act itself. The end credits stress this correlation, and the film's attention to the media's representational strategies, as we see CCTV images of the fun run and Omar's earlier visit to Sophia, images that would normally be the start of a news story for the audience. Even Hassan's doolally rhyming during the end credits evokes these correlations: having witnessed these actions from the inside, we now either 'know what the boom-boom means' or are more aware of the strategies that restrict such knowledge. In war reporting, gunfire sequences have been referred to as the 'bang-bang', with limited representational capacity: Barry Fox of ABC news thought that 'the story gets lost, because the "bang-bang" is used as the sexy bit at the front … once you've extracted it out of its context it loses its meaning, it becomes an entertainment in its own right'.[139]

Although media theory discussions of terrorism include 'the dynamics of its discursive construction', Freedman and Thussu remind us that 'not all forms of terrorism take place in and through the media'.[140] The ubiquity of images of real and simulated destruction in news and fiction may have led us to 'focus on the spectacular and marginalize the banalities of the

terror we do not, or are not allowed to, see'.[141] *Four Lions* leaves us with unresolved hints about British complicity with electrode-wielding 'hellish Egyptians', and the fate awaiting Omar's brother out of sight of cameras. Waj perhaps put this best in one of his many deceptively profound comments: 'Can they see you if you're not there?'

Thanks to students on my University of Stirling module Terrorism in the Media in 2010 and 2012.

Notes

1. The phrase 'Morris's work on terrorism' should be viewed as shorthand, and not a denial of the vital contributions made by the different writing teams on *The Day Today* and *Four Lions*. Debates on authorship are beyond the scope of this chapter, but are discussed elsewhere in this book.
2. Philip Schlesinger, Graham Murdock and Philip Elliott, *Televising Terrorism: Political Violence in Popular Culture* (London: Comedia, 1983), p. 2.
3. Charles Townshend, *Terrorism: A Very Short Introduction* (Oxford: Oxford University Press, 2002), p. 83.
4. Schlesinger *et al.*, *Televising Terrorism*, p. 5.
5. Brigitte L. Nacos, *Mass-mediated Terrorism: The Central Role of the Media in Terrorism and Counterterrorism* (Lanham, MD: Rowman & Littlefield, 2007), pp. 15–16.
6. MP William Whitelaw, quoted in Schlesinger *et al.*, *Televising Terrorism*, p. 12.
7. Alex P. Schmid, 'Editors' Perspectives', in David L. Paletz and Alex P. Schmid (eds), *Terrorism and the Media* (London: Sage, 1992), p. 126.
8. Christopher Dobson and Ronald Payne, *Terror! The West Fights Back* (London: Macmillan, 1981), p. 1, quoted in Schlesinger *et al.*, *Televising Terrorism*, p. 3.
9. Sarah Oates, *Introduction to Media and Politics* (London: Sage, 2008), p. 135.
10. Schlesinger *et al.*, *Televising Terrorism*, p. 27.
11. As one Ulster Defence Association figure put it, 'The Israelis have the right attitude. You seek out your enemy and you destroy him.' Ibid., p. 25.
12. Ibid., pp. 16–17.
13. Ibid., pp. 18–19.
14. Ibid., p. 22.
15. Ibid., p. 27.
16. Ibid., pp. 17–18.
17. Ibid., p. 32.
18. Ibid., p. 87.
19. Anne Karpf, 'Blanket Protest', *Listener* (9 March 1989), pp. 8–9.
20. Schlesinger *et al.*, *Televising Terrorism*, pp. 90–2.
21. Liz Curtis, *Ireland: The Propaganda War – The British Media and the 'Battle for Hearts and Minds'* (Belfast: Sásta, 1998), p. 116.
22. Schlesinger *et al.*, *Televising Terrorism*, pp. 47–9.

23. Even if British soldiers in Crossmaglen were 'disconsolate' when Rats received more fan mail than them. Curtis, *Ireland*, pp. 85, 116.
24. They were actually shot by British soldiers on night patrol. Ibid., p. 119.
25. Ibid., p. 87.
26. Schlesinger *et al.*, *Televising Terrorism*, p. 50.
27. *Sefton, A Household Name*, quoted in ibid., p. 49.
28. Ibid., pp. 43–4.
29. Ibid., p. 49.
30. Ibid., p. 29.
31. Ibid., p. 30.
32. Ibid.
33. Oates, *Introduction to Media and Politics*, p. 120.
34. For a slideshow of American newspaper responses to the killing of Osama bin Laden, see <http://www.wcvb.com/news/national/-/9848944/12150682/-/5cfeul/-/index.html>.
35. Lucian Randall, *Disgusting Bliss: The Brass Eye of Chris Morris* (London: Simon and Schuster, 2010), pp. 101–2.
36. Curtis, *Ireland*, pp. 289–90.
37. Ibid., p. 169.
38. Ibid., p. 10.
39. For an annotated list of these programmes, see Curtis, *Ireland*, pp. 277–99. See overviews in Dave Rolinson, *Alan Clarke* (Manchester: Manchester University Press, 2005) and Dave Rolinson, 'A Documentary of Last Resort? The Case of *Shoot to Kill*', *Journal for the Study of British Cultures* vol. 17 no. 1 (2010), pp. 47–58.
40. Curtis, *Ireland*, pp. 167, 164.
41. Michael Leapman, *The Last Days of the Beeb* (London: Coronet, 1987), p. 297.
42. Cynthia L. Irvin, 'Terrorists' Perspectives: Interviews', in Paletz and Schmid, *Terrorism and the Media*, p. 65.
43. Curtis, *Ireland*, pp. 290, 14.
44. Ibid., p. 290.
45. See Lisa O' Carroll, 'The Truth behind Real Lives', *Guardian* (12 December 2005), <http://www.guardian.co.uk/media/2005/dec/12/mondaymediasection.northernireland>. This online version is accompanied by official documents giving the Home Secretary's and BBC Board of Governors' responses, a useful insight into the pressures of the time.
46. This is consistent with Curtis's point that 'there were few censored interviews with loyalist paramilitary representatives' – Curtis, *Ireland*, p. 290.
47. Ibid., pp. 11, 56.
48. Nacos, *Mass-Mediated Terrorism*, p. 22.
49. Irvin, 'Terrorists' Perspectives', p. 64.
50. Schmid, 'Editor's Perspectives', p. 127.
51. Karpf, 'Blanket Protest', p. 9.
52. Pippa Norris, Montague Kern and Marion Just, 'Framing Terrorism', in Pippa Norris, Montague Kern and Marion Just (eds), *Framing Terrorism: The News Media, the Government, and the Public* (London: Routledge, 2003), pp. 10–11.

53. Ibid., pp. 13–14.

54. Ibid., pp. 10–11.

55. Ibid., p. 15.

56. Brian L. Ott, '(Re)Framing Fear: Equipment for Living in a Post-9/11 World', in Tiffany Potter and C. W. Marshall (eds), *Cylons in America: Critical Studies in Battlestar Galactica* (New York: Continuum, 2008), p. 17.

57. Ibid.

58. Justin Lewis, 'Terrorism and News Narratives', in Des Freedman and Daya Kishan Thussu (eds), *Media & Terrorism: Global Perspectives* (London: Sage, 2012), p. 257.

59. Ibid., p. 258.

60. Ibid., p. 261.

61. Ibid., pp. 260–1.

62. Peter Taylor, *Provos: The IRA and Sinn Fein* (London: Bloomsbury, 1998), p. 7.

63. Oates, *Introduction to Media and Politics*, pp. 141, 143.

64. Ibid., p. 143.

65. Ibid., p. 141.

66. Townshend, *Terrorism*, p. 2.

67. Schlesinger et al., *Televising Terrorism*, p. 70.

68. Robin P. J. M. Gerrits, 'Terrorists' Perspectives: Memoirs', in Paletz and Schmid, *Terrorism and the Media*, p. 52.

69. Nacos, *Mass-mediated Terrorism*, p. 115.

70. The title *Four Lions* resembles 'Three Lions', the title of the hugely successful 1996 single by The Lightning Seeds in collaboration with comedians David Baddiel and Frank Skinner. The single accompanied the England football team's participation in the 1996 European Championships, which were staged in England, prompting the lyric 'It's coming home' (in Omar's analysis, the West's terror is coming home), though the song has been an anthem for England football supporters in subsequent tournaments. The title refers to the three lions that appear on England footballers' kits. (The Crusader connotations of the lions – often underlined by the wearing of Crusader outfits by a tiny number of supporters or even players in build-up coverage encouraged by the press – further complicate identity questions in relation to Muslim-British identity.)

71. Equally, the brutally dissonant scenes later, in which his loving family support his suicide mission, are heightened by the uniform worn by his wife Sophia (Preeya Kalidas), who works for the NHS.

72. Curtis, *Ireland*, p. 131. Quoting Philip Purser, *Sunday Telegraph* (27 February 1977).

73. Ibid., quoting *Irish Post* (26 February 1977).

74. Ibid., quoting letter from Shane Connaughton to Jonathan Hammond.

75. Steve Hewitt, *The British War on Terror: Terrorism and Counterterrorism on the Home Front since 9-11* (London: Continuum, 2008), pp. 55, 98–9, 107.

76. Ibid., p. 116.

77. Ibid., pp. 76, 116.

78. Ibid., pp. 62, 63–4.

79. *Sky One Uncovered* is Omar's reference to factual entertainment series, such as *Ibiza Uncovered* (Sky One, 1997–9), which unflinchingly (or salaciously, according to taste) depict young British

people on holidays organised around hedonistic, lewd behaviour. Omar's reference supports the group's perception of British youth as godless, consumerist and vacuous. On consumerism, Omar references 'Taste the Difference' (a food range marketed by the Sainsbury's supermarket chain as high quality) and Gordon Ramsay (a celebrity television chef). Omar's reference is confused because 'Taste the Difference' was promoted by Ramsay's rival celebrity chef Jamie Oliver.

80. Benji Wilson, 'Making Waves', *Radio Times* (27 October–2 November 2007), p. 35.

81. Ibid., p. 36.

82. Hewitt, *The British War on Terror*, p. 114. See ibid., pp. 92–3 and legislation listed in the context of Muslim communities in Gholam Khiabany and Milly Williamson, 'Terror, Culture and Anti-Muslim Racism', in Freedman and Thussu, *Media & Terrorism*, pp. 144–5.

83. Hewitt, *The British War on Terror*, p. 77. As leader, Mohammad Sidique Khan's video is a particularly relevant comparison to Omar's.

84. Schlesinger *et al.*, *Televising Terrorism*, pp. 90–2.

85. Ibid., p. 72.

86. Brigitte L. Nacos and Oscar Torres-Reyna, 'Framing Muslim-Americans before and after 9/11', in Norris *et al.*, *Framing Terrorism*, p. 134.

87. Carl Boggs and Tom Pollard, *The Hollywood War Machine: U. S. Militarism and Popular Culture* (Boulder, CO: Paradigm Publishers, 2007), p. 191.

88. Nacos and Torres-Reyna, 'Framing Muslim-Americans before and after 9/11', p. 134. These Muslim New Yorkers were focus-grouped before 9/11. Nacos and Torres-Reyna find an increase in coverage – and positive coverage in particular – of American-Muslims after 9/11.

89. Nacos, *Mass-mediated Terrorism*, pp. 162–3.

90. Lewis, 'Terrorism and News Narrative', p. 262.

91. Ibid., p. 258.

92. Schmid, 'Editors' Perspectives', pp. 114–15.

93. Michael W. Traugott and Ted Brader, 'Explaining 9/11', in Norris *et al.*, *Framing Terrorism:*, p. 183.

94. Nacos, *Mass-mediated Terrorism*, p. 37.

95. Lewis, 'Terrorism and News Narrative', p. 262.

96. For example, of 583 terrorist incidents in EU countries in 2007, 88 per cent were attributable to separatist groups, and only a small proportion to Islamic groups – ibid., p. 264.

97. Ibid., pp. 252, 263.

98. For readers without Internet access, the Honey Monster is a character from advertising campaigns for the Sugar Puffs breakfast cereal and Wookiees are an alien species from the *Star Wars* franchise. Clearly their relative resemblance to bears is a topic of dispute here.

99. There are also uncomfortable echoes of the shooting of Jean-Charles de Menezes, of relevance to the relationship between definitions and power, not only in the shooting but in Storge's claim (relating to a later incident) that 'the police shot the right man, but … the wrong man exploded'.

100. Oates, *Introduction to Media and Politics*, p. 135.

101. Townshend, *Terrorism*, p. 3.

102. Des Freedman and Daya Kishan Thussu, 'Introduction: Dynamics of Media and Terrorism', in Freedman and Thussu, *Media & Terrorism*, p. 8.

103. Richard Jackson, *Writing the War on Terrorism: Language, Politics and Counter-Terrorism* (Manchester: Manchester University Press, 2005), p. 14.

104. Curtis, *Ireland*, p. 135.

105. Ibid., pp. 133–4.

106. Freedman and Thussu, 'Introduction', p. 7.

107. Townshend, *Terrorism*, p. 3.

108. Nacos, *Mass-mediated Terrorism*, p. 8.

109. Townshend, *Terrorism*, p. 15.

110. Ibid., p. 23.

111. Nacos, *Mass-mediated Terrorism*, p. 25.

112. Townshend, *Terrorism*, p. 24.

113. Curtis, *Ireland*, p. 136.

114. Jackson, *Writing the War on Terrorism*, pp. 22–3.

115. See also Nacos, *Mass-mediated Terrorism*, p. 17.

116. Edward Branigan, *Narrative Comprehension and Film* (London: Routledge, 1992), p. 3.

117. Rolinson, *Alan Clarke*.

118. As the chapter goes on to demonstrate, the use of 'they' impacts upon the framing of 'Islamist' terrorism. It can also be related to the alienation of British-Muslim and American-Muslim communities described elsewhere in the chapter. However, Boggs and Pollard also found the use of 'us' problematic in attributing 'a wounded innocence' and 'victim status' that in their opinion bypassed debates on the United States' actions and attitudes towards 'international laws and agreements' – Boggs and Pollard, *The Hollywood War Machine*, p. 49.

119. Jackson, *Writing the War on Terrorism*, p. 2.

120. Ibid., pp. 2–3.

121. Freedman and Thussu, 'Introduction', pp. 2–3.

122. Hewitt, *The British War on Terror*, p. 58.

123. Ott, '(Re)Framing Fear', p. 19.

124. Hewitt, *The British War on Terror*, p. 58.

125. Freedman and Thussu, 'Introduction', p. 6.

126. Lewis, 'Terrorism and News Narrative', p. 268.

127. Ibid.

128. Khiabany and Williamson, 'Terror, Culture and Anti-Muslim Racism', p. 138.

129. Ibid., pp. 138–9.

130. Ibid., p. 134.

131. Wilson, 'Making Waves', p. 36.

132. Helga Tawil-Souri, 'The "War on Terror" in the Arab Media', in Freedman and Thussu, *Media and Terrorism*, p. 246.

133. Nacos, *Mass-mediated Terrorism*, p. 20.

134. Ibid., pp. 20–1.

135. Quoted in Nacos, *Mass-mediated Terrorism*, p. 19.

136. The *Four Lions*' targeting of a London sporting event distantly echoes the aforementioned 'Three Lions', in which Wembley (England's national football stadium, at which England played their Euro '96 matches) was the venue for the song's hope that despite admitted flaws and

defeats in the past ('thirty years of hurt' since last winning an international tournament), the team could still restore pride. Providing further noise, while 'Bombdogs' centres around a dog called Spider, this film's climax features the titular lions as various animals, disrupting similar sites to those of the bombdogs.

137. Jackson, *Writing the War on Terrorism*, p. 6.
138. Dowling, via Paletz and Schmid, *Terrorism and the Media*, p. 9.
139. *Eye of the Storm* (BBC 2, 7 November 1992).
140. Freedman and Thussu, 'Introduction', pp. 10–11.
141. Ibid., p. 12.

APPENDIX: LIST OF WORKS BY MORRIS

All dates below are for initial broadcast only.

Radio

In addition to the 'pre-recorded' shows listed below, Morris worked as a radio presenter/DJ between c. 1986–94 hosting programmes for BBC Radio Cambridgeshire (c. 1986–7), BBC Radio Bristol (1987–90), Greater London Radio (1988–93), BBC Radio 5 (1992) and BBC Radio 1 (1994).

On the Hour (BBC Radio 4, 1991–2)
Series 1: 9 August–13 September 1991 (episodes broadcast on Fridays, 11.00–11.25 pm)
Christmas Special: 24 December 1991 (10.30–11.00 am)
Series 2: 23 April–28 May 1992 (episodes broadcast on Thursdays, 6.30–7.00 pm)
Available on CD in two volumes (Warp, 2008)

Why Bother? (BBC Radio 3, 1994)
Episode 1: Eels, Love and Guns (10 January)
Episode 2: Bear (11 January)
Episode 3: Christ (12 January)
Episode 4: Prisoner of War (13 January)
Episode 5: Drugs Etc (14 January)
Available on CD (BBC, 1999)

Blue Jam (BBC Radio 1, 1997–9)
Series 1: 14 November 1997–19 December 1997 (episodes broadcast on Fridays, 12.00–1.00 am)
Series 2: 27 March 1998–1 May 1998 (episodes broadcast on Fridays, 1.00–2.00 am)
Series 3: 21 January 1999–25 February 1999 (episodes broadcast on Thursdays, 12.00–1.00 am)
An edited CD of sketches from the programme is available (Warp, 2000)

Television (Broadcast Work Only)

Up Yer News (1990)
Broadcast on the Galaxy Channel, which existed briefly in the early 1990s on the short-lived British Satellite Broadcasting Platform. Morris contributed occasional segments to this satire show, along with figures including Armando Iannucci, Stewart Lee, Richard Herring, Patrick Marber, Steve Coogan, Rebecca Front, Doon Mackichan and David Schneider. No programme details/dates available.

The Day Today (BBC 2, 1994)
Episodes broadcast on Mondays, 9.00–9.30 pm.
Episode 1 (19 January)
Episode 2 (26 January)
Episode 3 (2 February)
Episode 4 (9 February)
Episode 5 (16 February)
Episode 6 (23 February)
Available on DVD (2 Entertain Video, 2004)

Brass Eye (Channel 4, 1997; 2001)
Episodes broadcast on Wednesdays 9.30–10.00 pm.
Episode 1: Animals (29 January)
Episode 2: Drugs (5 February)
Episode 3: Science (12 February)
Episode 4: Sex (19 February)
Episode 5: Crime (26 February)
Episode 6: Moral Decline (5 March)

Brass Eye Special: Paedophilia (26 July 2001)
Available on DVD (Channel 4, 2002)

Jam (Channel 4, 2000)
Episodes broadcast on Wednesdays, 10.30–11.00 pm.
Episode 1 (23 March)
Episode 2 (30 March)
Episode 3 (6 April)
Episode 4 (13 April)
Episode 5 (20 April)
Episode 6 (27 April)
Available on DVD (4DVD, 2003)

Jaaaaam (Channel 4, 2000)

A 'remix' of *Jam*, broadcast early Sunday mornings at various times.

Episode 1 (9 April)

Episode 2 (16 April)

Episode 3 (23 April)

Episode 4 (30 April)

Episode 5 (This was not broadcast because of disputes over inclusion of controversial material. It does appear on the *Jam* DVD, however.)

Episode 6 (7 May)

Also included on the *Jam* DVD

Nathan Barley (Channel 4, 2004)

Episodes broadcast on Fridays, 10.00–10.30 pm.

Episode 1 (11 February)

Episode 2 (18 February)

Episode 3 (25 February)

Episode 4 (4 March)

Episode 5 (11 March)

Episode 6 (18 March)

Available on DVD (Channel 4, 2005)

Film

My Wrongs #8245–8249 & 117 (2002)

Producer: Warp Films

Length: 12 mins

Available on DVD (Warp, 2004) and as part of the collection *Cinema 16: European Short Films* (Warp, 2006)

Four Lions (2010)

Producer: Warp Films

Length: 97 mins

Available on DVD (Optimum, 2010)

INDEX